MW00799663

Seasons at Selah

This first edition is presented
with appreciation from
South Texas Money Management, Ltd.

★ ★ ★ ★
SOUTH TEXAS
MONEY MANAGEMENT
——— LTD ———
HELPING INDIVIDUALS, INDIVIDUALLY.™
SAN ANTONIO · AUSTIN · DALLAS · HOUSTON
1.866.805.1385 | STMMLTD.COM

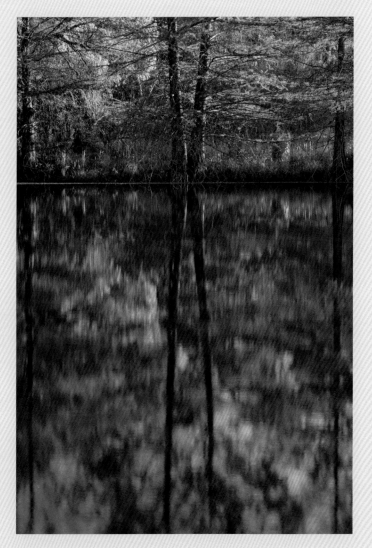

Myrna and David K. Langford
Books on Working Lands

*We wish to thank the following people
who made this book possible.*

Bonnie Baskin and Bob Elde
Jenny and Brett Cook
Ethel and Chap Hutcheson
Emily and Patrick Incerto
Nancy Powell Moore
Pam and Michael Reese
Ren and Jesse Scarantino
Douglas Sprunt

Seasons at Selah

The Legacy of Bamberger Ranch Preserve

Andrew Sansom

Photography by Rusty Yates and David K. Langford

Foreword by Carter P. Smith

TEXAS A&M UNIVERSITY PRESS COLLEGE STATION

Copyright © 2018
by Andrew Sansom, Weldon M. Yates,
and David K. Langford
All rights reserved
First edition

This paper meets the requirements of
ANSI/NISO Z39.48–1992 (Permanence of Paper).
Binding materials have been chosen for durability.
Manufactured in China
through Four Colour Print Group

LIBRARY OF CONGRESS CATALOGING-IN-PUBLICATION DATA

Names: Sansom, Andrew, author. | Yates, Rusty, 1952– artist, photographer. |
 Langford, David K., 1942– artist, photographer.
Title: Seasons at Selah : the legacy of Bamberger Ranch Preserve / Andrew
 Sansom ; photography by Rusty Yates and David K. Langford.
Other titles: Myrna and David K. Langford books on working lands.
Description: First edition. | College Station : Texas A&M University Press,
 [2018] | Series: Myrna and David K. Langford books on working lands |
 Includes bibliographical references and index.
Identifiers: LCCN 2017035274| ISBN 9781623496340 (book/cloth : alk.
paper) |
 ISBN 9781623496357 (e-book)
Subjects: LCSH: Bamberger Ranch Preserve (Tex.)—History. | Bamberger
Ranch
 Preserve (Tex.)—History—Pictorial works. | Seasons—Texas—Bamberger
 Ranch Preserve—Pictorial works. | Bamberger Ranch Preserve
 (Tex.)—Description and travel. | Wildlife
conservation—Texas—Bamberger
 Ranch Preserve. | Photography, Artistic.
Classification: LCC F392.B18 S26 2018 | DDC 976.4/64—dc23 LC record
available at https://lccn.loc.gov/2017035274

Map on page viii by Winifred Riser.

Dedication

To the memory of Margaret Bamberger

FROM RUSTY

To my mother, whose love of gardening and the natural world planted seeds of wonder and respect that have inspired my photography—and my life.

And to the next generations of conservationists, who can follow in the footsteps of J. David Bamberger by caring for the land deliberately, responsibly, and with the clear-eyed goal of leaving it better than you found it.

FROM DAVID K.

For all those who already know, and those who will learn, that stewardship of land and all natural resources benefits everyone.

FROM ANDY

And to the children of Texas. May they always have access to visionaries like J. David Bamberger and to places like Selah—for fun, learning, health, and inspiration.

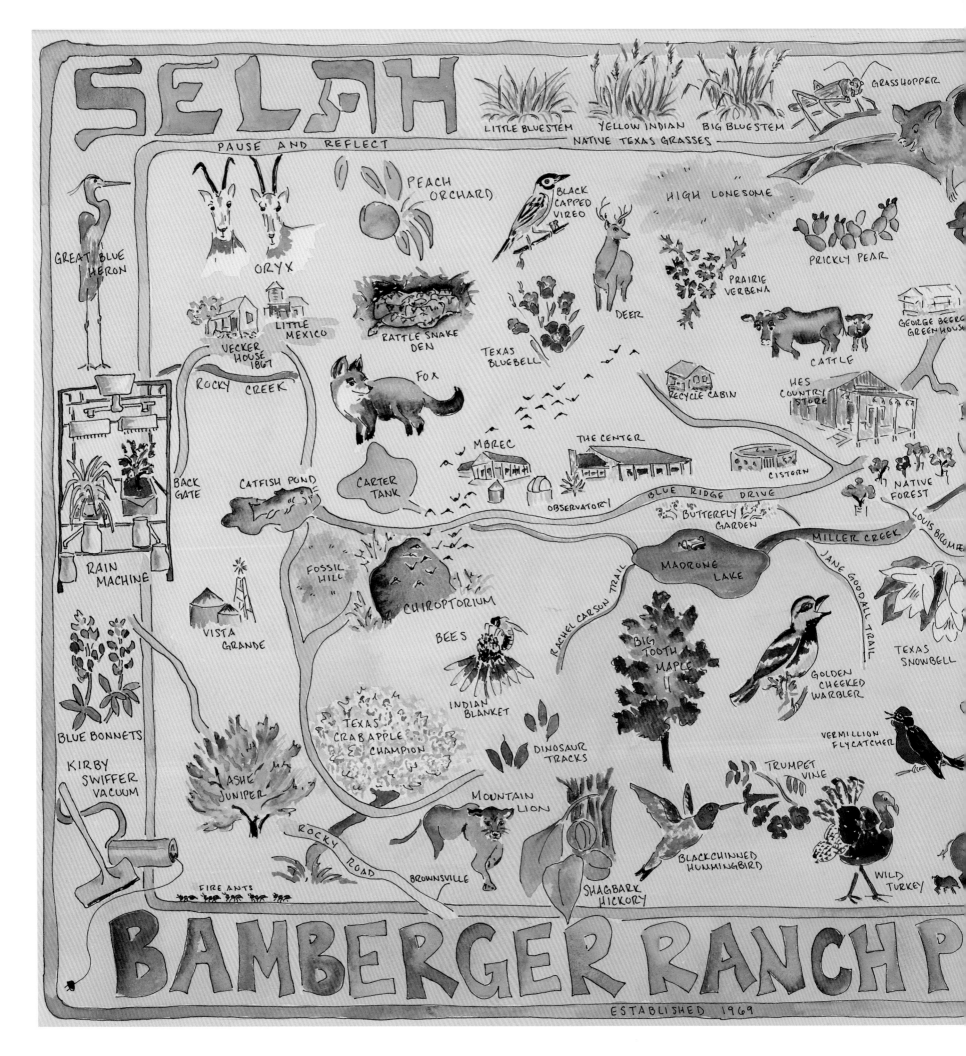

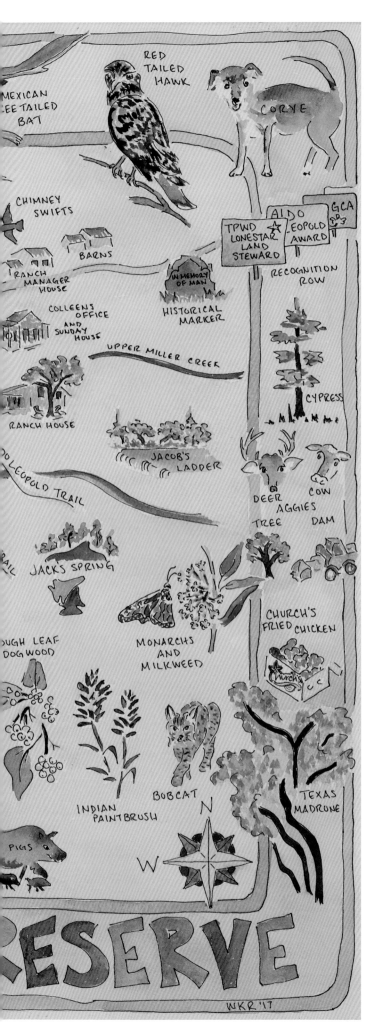

Contents

Dedication vii

Foreword, by Carter P. Smith xi

Acknowledgments xiii

Photographers' Notes xvii

The Beginning 1

The Cathedral Builder 13

Spring 15

Summer 73

Autumn 129

Winter 183

Index 241

Foreword

It is one of those quintessential Hill Country roads. You know the kind. Picturesque and pastoral, scenic and serpentine. Big and small country places are tucked into the narrow creek valley and the sweeping verdant hills with their well-kept fences, tidy fields, meadows painted with wildflowers, a smattering of grazing stock, and game aplenty.

It is the kind of road that makes you want to linger longer, to reflect upon it long after you have begrudgingly traded in the caliche for your old nemesis, the blacktop. It is the kind of place where the scenery seems to go on forever, and you can't wait to see what is around the next bend.

Winding up and around Miller Creek, the little country road offers something else for reflective types, a glimpse of the country that has both beckoned and bedeviled its Hill Country owners and occupiers for generations. First, it was the stockmen who came for the luxuriant stands of grass, and later the hunters who came for the bountiful herds and flocks of game. And later still it was the city dwellers who came for a refugium, hungry for a big dose of nature, wildlife, and the peace and quiet of country living.

To a one, they've all learned the same thing, some quicker than others. In times of plenty, the creeks and springs flow with vigor, the wells run strong, the wildflowers burst with improbable beauty, and the savanna-like pastures are laden with cluster after cluster of little bluestem and sideoats grama, waving their inflorescences prominently and unflaggingly in the gentle breeze. The game flourishes, and the stock prospers.

But in plenty of other times, they don't.

I doubt many along that country road, and perhaps across the whole state, understand that dichotomy and those paradoxical conditions better than one J. David Bamberger. Bamberger, a Texan by choice and the founder of the ranch known as Selah, is synonymous in the land, conservation, and wildlife management circles of Texas with the notion and practice of stewardship.

Bamberger, or J. David—people call him both—is as close to an Aldo Leopold–like figure as we've got. A natural-born raconteur with the gift of gab and a work and conservation ethic that appears to know no bounds, Bamberger is a tireless ambassador for the health of the land and all that comes with, on, and under it.

His love? Spreading the gospel of stewardship from all he has learned during the nearly five decades he has held the reins of that old Blanco County ranch. From his wars with the cedar to the renaissance of the Texas snowbells, from his restoration of the springs to the resurgence of the grass, Bamberger has tried and just about done it all on the 5,500 acres of hardscrabble he proudly calls home.

For goodness' sake, what other rancher do you know that conceived and actually built a chiroptorium—his word, by the way—to bring back the bats to control the insects and to pollinate the native plants?

In the best Leopoldian tradition, he has done it with the help of the axe, the cow, the plow, the flame, and the gun. Bamberger knows to manage the ranch for the tough times, not the best of 'em. He is not a lock it up and throw away the key type, one who hopes for the best from the mercurial and unpredictable Mother Nature. No, Bamberger has earned his stewardship stripes at Selah in the same way he

has earned his money and the respect of those who know him—the old-fashioned way.

Bamberger hires good people for the ranch and coaxes the best out of them, and together they focus on one thing and one thing only: results. And rest assured, you can see them in the gurgling springs and crystal-clear creeks, the abundance and diversity of plant and animal life, and the imperiled species that aren't so imperiled anymore thanks to the ranch.

Plenty affable, Bamberger leaves his ranch gate open to anyone who wants to learn what he knows and see what he's done. Plenty practical, he isn't much on waiting around for fancy government studies or for someone else to do the work. Plenty assured, he doesn't much suffer fools gladly, and he is plenty capable of speaking truth to power. And when he gives you praise, you've plenty earned it.

Over the years, just about every award you could imagine has been bestowed upon him for the stewardship of the place he calls Selah, a reference to a biblical verse encouraging us to pause and take it all in. Now, let me let you in on a little secret about that. That name isn't for him. It is for us. Rest assured, the only time J. David will pause is when he passes on.

But for the rest of us mere mortals who share his love of wild things and wild places, we now have in these pages a book that offers us plenty of reasons to pause, to appreciate through rich and spectacular imagery what Bamberger has witnessed on the ranch each spring, summer, autumn, and winter.

A steward lives and works by the seasons. Bamberger is a steward. So, too, are the men whose pictures and words grace these pages and who tell the story of Selah and the Bambergers' seasons of place and life.

The storytellers, Andy Sansom, Rusty Yates, and David K. Langford, are cut from the same cloth as Bamberger. Quite simply, you couldn't ask for three finer and more fitting people to tell this story. They've traveled the same long and arduous roads of conservation and stewardship as Bamberger. And just like him, they too have run things and fought for things—things that matter, like the future of our home ground.

To a one, they know the country round because they own, live on, and/or steward ranches like his. They are conservationists and ranchers, neighbors, teachers, and peers. They like and respect him for his work. He likes and respects them for theirs.

As for the photographers, I don't think either Yates or Langford would ever be so bold as to call himself an artist. That would likely seem too presumptuous, too self-absorbed, putting on airs that maybe don't quite fit. But when you turn these pages and take in the sheer beauty they have captured of Selah in all its seasonal finery, it is hard to think of them as anything but.

As for the book's wordsmith, he too offers his own rather eloquent and artistic flair. Through the seasons of Selah, Sansom shares memorable and colorful accounts of how his life and Bamberger's intersected at key points along the way. Their influence on one another is unmistakable. So, too, is the friendship and deep and abiding respect they have for each other. They are two conservation warhorses whose journeys have each been made more complete by the other.

Ultimately, I believe it takes a steward to really tell another steward's story, particularly of a place as storied and as singularly special as Selah. We are lucky that Sansom, Yates, and Langford are just that. Bamberger wouldn't want it, or have it, any other way.

—Carter P. Smith
Texas Parks and Wildlife Department
June 25, 2017

Acknowledgments

From a Shared Viewfinder

Gratitude illuminates as surely as light.

While the book you hold in your hand showcases our shared view of Bamberger Ranch Preserve's landscape and therefore its story, it represents the efforts, creativity, and commitment of a group that extends far beyond us.

Obviously, none of this would have been possible without J. David Bamberger. His insatiable curiosity and desire to leave a positive, lasting mark on Texas prompted him to reclaim a hardscrabble piece of the Hill Country and transform it into a living monument to committed stewardship.

When J. David's incredible team, including executive director Colleen Gardner, ranch manager Steven Fulton, and biologist Jared Holmes, opened the ranch gates to us, they gave us complete access to not only the land and facilities, but also to their knowledge and their time. Administrative assistant Lois Sturm's help and guidance was exceptional and appreciated. The assistance of the Selah staff was priceless, as was the support of Joanna Rees, who was a source of some good ideas and many delicious lunches.

Renowned conservationist and respected author Andrew Sansom allowed us to provide images, without any restrictions, to complement, support, and illustrate the conservation story he tells in this book. As a colleague, conservationist, and friend, Andy has always been a role model we hold in the highest esteem.

Once again, the staff at Texas A&M University Press, under the capable leadership of Shannon Davies, Edward R. Campbell '39 Press Director; Stacy Eisenstark, acquisitions editor for the natural environment and agriculture; Mary Ann Jacob, design manager and production manager; Patricia Clabaugh, associate editor; and Kevin Grossman, assistant design and production manager, took our loose-knit ideas, rough-edged words, and photographs and crafted an attention-grabbing book worthy of both coffee tables and libraries. Their work always holds up under the scrutiny of the reading public and demanding photographers. And we are confident that marketing manager Gayla Christiansen and her team will provide the best distribution effort possible.

As he has done for decades, trusted colleague and consummate professional Lee Young at Adtech Photo Imaging ensured that our images met exacting standards—ours and those of the press. The peer reviewers, Linda Campbell and Michael Murphy, carefully and thoughtfully read our manuscript, providing insightful comments that polished the final product to a high sheen.

And last but not least, our hats are off to Bamberger Ranch Preserve's staff, volunteers, and supporters. These forces of nature make things happen on the ground at the ranch—and in the world. When they got wind of this project, the necessary funding appeared like bluebonnets in the spring. We've listed the generous sponsors, who are all active conservation advocates in their own right, on a separate page.

We stand humbled by the talents and support of this diverse group. Their collective excellence pushed us to bring our A game each and every day. Of course, the phenomenal conservation story that is Selah deserved nothing less.

FROM RUSTY'S PERSPECTIVE

From the beginning, my entire family has supported my involvement with this project, especially my wife, Ellen. She is my confidant, trusted critic, and inspiration who has always encouraged me to pursue my passion for photography.

This book would not have been possible without the talents of David K. Langford. As a collaborating photographer, an experienced author, a true "Texas Conservation Hero," and most importantly a dear friend, he nurtured and inspired me while keeping us on task. For this and so much more, I am grateful.

FROM DAVID'S PERSPECTIVE

My journey as a photographer would never have started if Bob Hipp had not given Myrna and me our first "real" camera as a wedding present, or if Bill West had not suggested that I "take pictures of cows." Without the vigilance of Eric Rindler, my career would have ended too early. And over the past twenty-plus years, I would have wasted a lot of time trying to figure out exactly what I wanted to say if it weren't for my writer friend Lorie A. Woodward.

If Rusty Yates had not agreed to take the lead role in our effort to depict J. David Bamberger's conservation legacy in photos, I would not—and could not—have tackled this mammoth project. Rusty's artistic vision, photographic talent, conservation acumen, and teamwork spirit are unrivaled. Moreover, when the long nights turned into early morning hours, as they often did, he and Ellen opened their home and provided five-star lodging, meals, and hospitality.

The person who said that "behind every successful man is a woman" got it wrong. My wife Myrna stands alongside me just as she has for the past fifty-plus years, lending her immense talents, innate curiosity, keen intellect, and good humor to whatever we're tackling, whether it's raising a family or writing a book. Her love and support make me better than I could ever be alone.

FROM ANDY'S PERSPECTIVE

I am just honored and fortunate to be able to include memories of one of my most treasured friends between the sensational images of these two incredibly talented photographers.

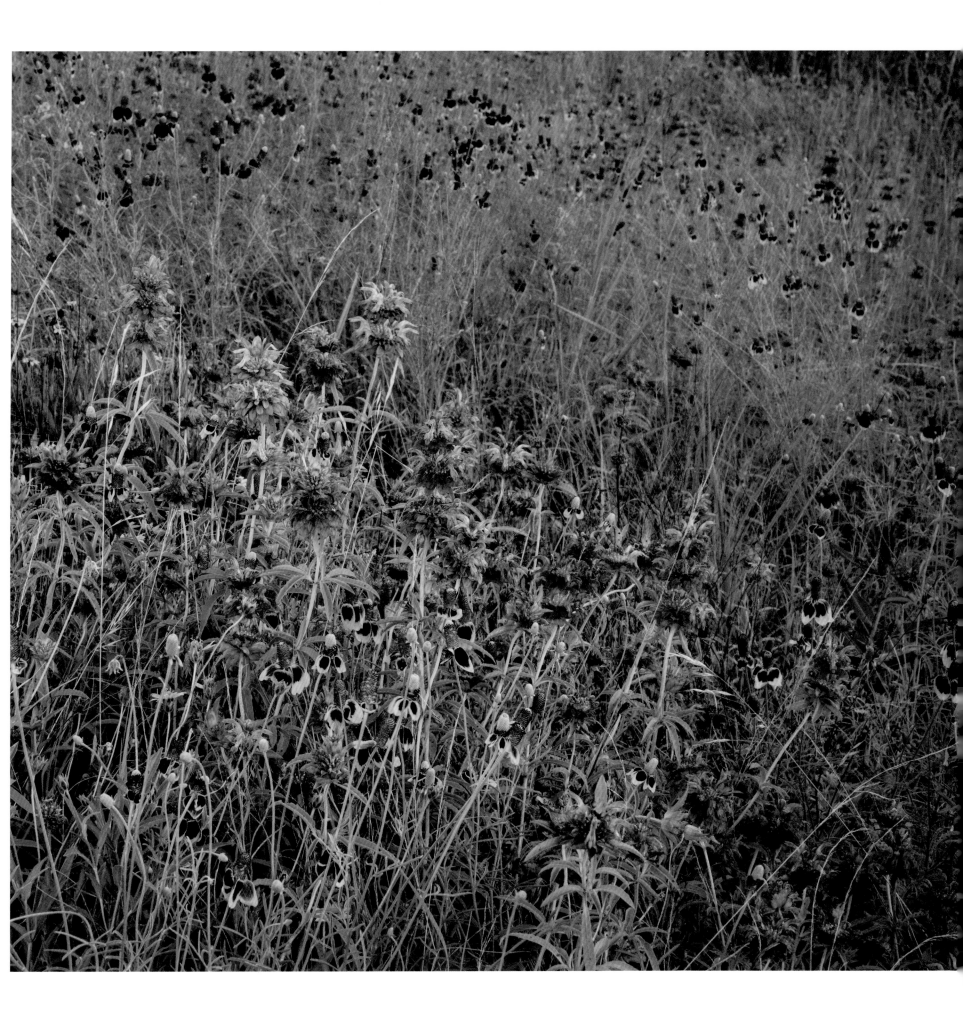

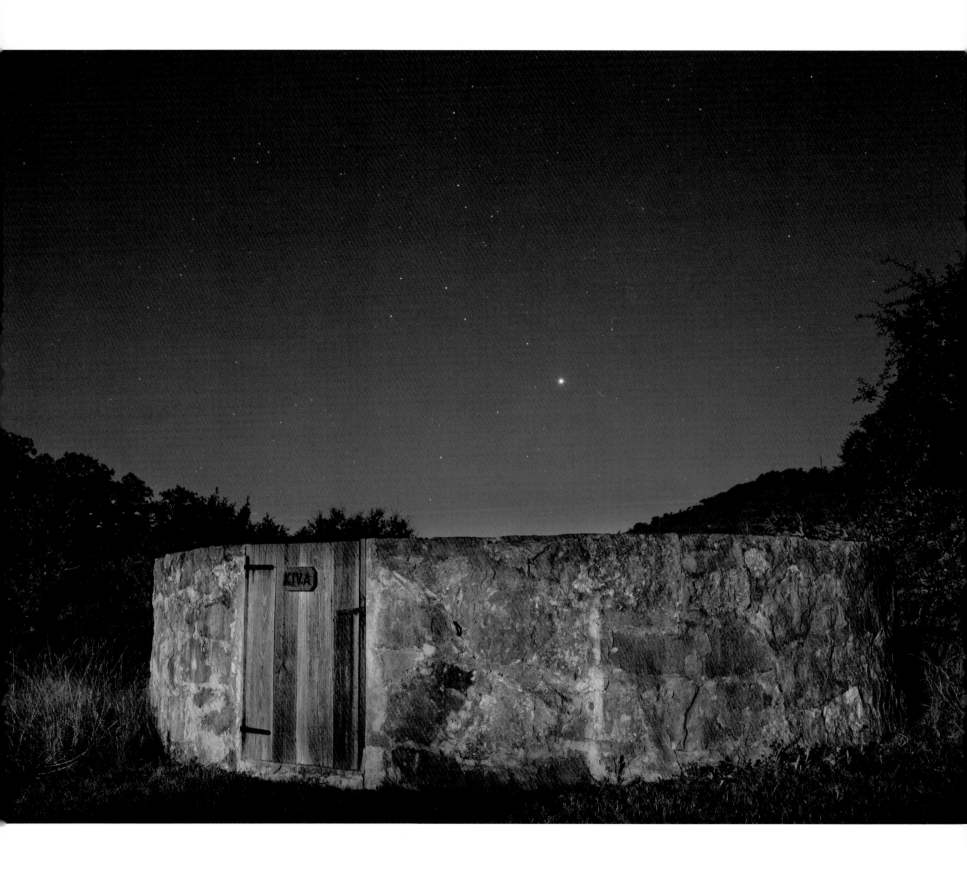

Photographers' Notes

This book resulted from the collaborative efforts and combined talents of Rusty Yates and David K. Langford. While they share a passion for the Texas Hill Country, conservation, and beautifully lit photography, the two professionals "chase the light" in styles that are complementary, but unique to themselves. Interestingly, they both got their start photographing purebred cattle and horses for ranch advertising. Livestock photography is a difficult specialty to master, making it an ideal training ground for photographers who love land, livestock, wildlife, and the people who care for them.

David K. accepted the book assignment on the condition that Rusty be his photographic partner. Rusty is not only a neighbor of Bamberger Ranch Preserve but also serves on the board of directors; therefore, he is a regular presence on the land. Together, they had the rare combination of immediacy and distance, intimacy and objectivity. Theirs is a multifaceted portrait of a landscape.

As a reader, you have the exceptional opportunity to savor the beauty of the Hill Country captured from two perspectives. If you look beyond the composition, clarity, color, and light in the photos, you can see the confidence that comes from completely trusting the skills and discernment of an artistic colleague. It is obvious that David K. and Rusty are members of a mutual admiration society.

A SNAPSHOT FROM RUSTY

Several years ago I began contemplating a book about Bamberger Ranch Preserve. I went so far as to explain the need for a legacy art book to J. David Bamberger and Colleen Gardner. It remained a good idea relegated to a back burner until David K. Langford called and said, "Texas A&M University Press wants me to do a book on Selah. I told them I wouldn't do it without you." I accepted.

Today, I know that I would not—and could not—have done it without him. I cannot think of a better collaborator than David K. Our working partnership exceeded our high expectations.

Here we are five years and more than eight thousand exposures later just from me. The fieldwork was pure joy. Selecting the images for the book was pure agony. How do you choose the best from a chest of jewels?

The majority of the photos for this book were shot using a Canon EOS 5D Mark III camera with Canon EF 24–70mm f/4 L and Canon EF 100–400mm f/4.5–5.6L IS II USM lenses. My equipment list also includes Canon TS-E 24mm f/3.5 L and Canon TS-E 90mm f/2.8 tilt/shift lenses. I also like the stability of a tripod and am willing to tote mine over hill and dale to ensure that my camera is motionless when it should be. Because I make my exposures using the Zone System developed by Ansel Adams, the camera is almost always set to manual mode. Many of the images require long exposures, so I lock the mirror up and use a cable release.

When it comes to the photographic process, I'm a bit of a control freak, and in my private photography business I complete every step myself, from shooting and all postcapture work with Adobe Lightroom and Photoshop software to selecting the mats and frames. Nothing is left to chance.

I've been enamored with light since I was a child. Pho-

tography gives me a laboratory to explore light. In fact, it was this passion that allowed me to push through the many moments of mind-numbing frustration that come with teaching yourself a new skill. My work is greatly influenced by Vermeer; J. M. W. Turner, a Romantic landscape artist; the Hudson River school artists; and the "Luminists." And I've been inspired to continue learning by the great photography masters such as Adams and Galen Rowell. Keith Carter, a fine-art photographer and lifelong friend, expresses himself through magical realism, and his work motivates me to tell a story with each image. Of course, there's David K. Langford, who, along with his advertising colleague Bill West, prompted me to pick up a camera and approach its use more than casually. At the time, I was the manager of Angelina Farms, a Simmental ranch in East Texas. David K. and I have come a long way together in the past thirty-plus years.

My advice to amateur photographers is to find someone's work you admire. Study it. Determine what you like about it. Emulate it. Practice and work hard at it. Over time, your own style will emerge. Artists, like conservationists, stand on the shoulders of those who came before.

A SNAPSHOT FROM DAVID K.

This marks my third book with Texas A&M University Press. It is the second time that the overarching idea came from someone else. In fact, I was pitching a proposal for a completely different project to press director Shannon Davies, who also serves as my editor, when she said, "Andy [Sansom] and I want you to do a book on Selah."

I shifted gears—and immediately asked to have Rusty as a partner. As a photographer, I capture moments in time. But I live ninety minutes away from Bamberger Ranch Preserve. In the time it takes me to get from our family's part of Hillingdon Ranch to Selah, fog can dissipate, snow can turn to sleet, rainbows can vanish, and the ever-ephemeral light can shift. Rusty shares a fence line with J. David Bamberger. His work inspires me. I know a win-win when I see it.

My insistence on this collaboration has been one of

my better ideas. In this book, the whole is greater than the sum of its parts. Plus, it's been incredible to see how many times—without preknowledge—we shot the exact same scene from a different perspective. Even when the images were similar, we always agreed easily which was best for the book, whether it was taken by Rusty or by me.

For this book, I relied primarily on my Sony a7RII body and my Sony FE 24–240mm f/3.5–6.3 OSS lens. For several images, I used my Canon EOS 7D Mark II and my Canon EF 100–400mm f/4.5–5.6L IS II USM lens. Anyone can purchase this equipment. While the images are digital, they have not been enhanced beyond the capabilities of a traditional photography darkroom. In this age of Adobe Photoshop, I remain an old-school photographer. My photography captures a moment in time as it was revealed to me. And while I appreciate and am often in awe of the beauty of photographic digital art, it is simply not my style. Tripods are not my style either. While I'm wrestling with the equipment, I miss too many of the images that present themselves at a rapid clip. Cowboys, livestock, wildlife, weather, and sunlight do not stand still. I cannot tolerate missing a good shot if it can be prevented. Instead, I use anything handy as a sturdy brace, such as a fence post or tree trunk, or a beanbag rest hung on the door or set on the hood of my beat-up 4 × 4 pickup.

Although I've been a professional photographer for almost fifty years, I still study other photographers' work. Inspiration comes from many sources, from the grand masters and my colleagues such as my good friends Wyman Meinzer and Rusty Yates, to our grandkids who are making their first attempts.

My advice for outdoor photographers, whether they are seasoned professionals or rank amateurs, is this: gratitude illuminates as surely as light. Our avocation immerses us in beauty. Awe and wonder are the side effects. In those moments, getting the perfect shot pales in comparison to the experience. Be thankful for our natural bounty and your work will reflect your grateful respect. A lifetime behind the camera has taught me that beautiful photographs are made with the heart, not equipment.

The Beginning

The 12 images in this chapter represent Selah "before"
the Bamberger Ranch and five decades of stewardship

Courtesy of Selah, Bamberger Ranch Preserve

Before being purchased by J. David Bamberger, Selah, Bamberger
Ranch Preserve was either mostly bare ground or almost com-
pletely choked with cedar.

Originally, the creeks on the ranch were not in good condition.

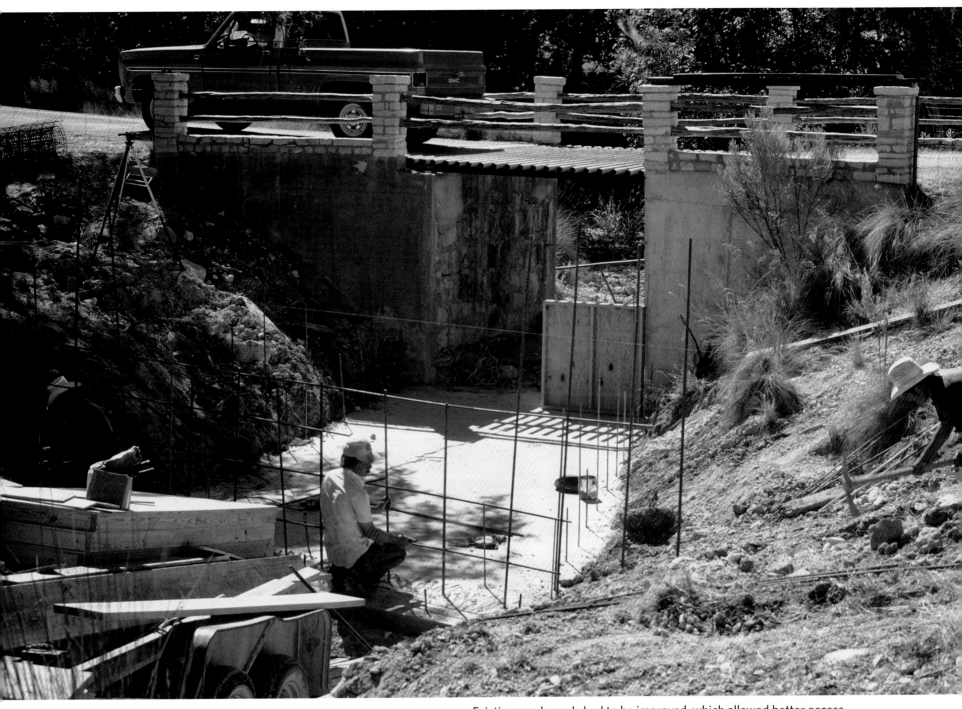

Existing ranch roads had to be improved, which allowed better access, especially for large equipment.

Work begins with future goals at the forefront.

Madrone Lake was among the ponds and lakes that were constructed.

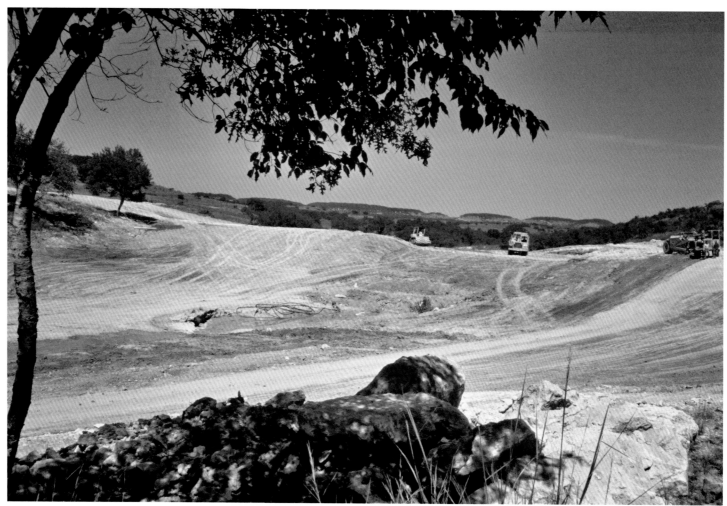

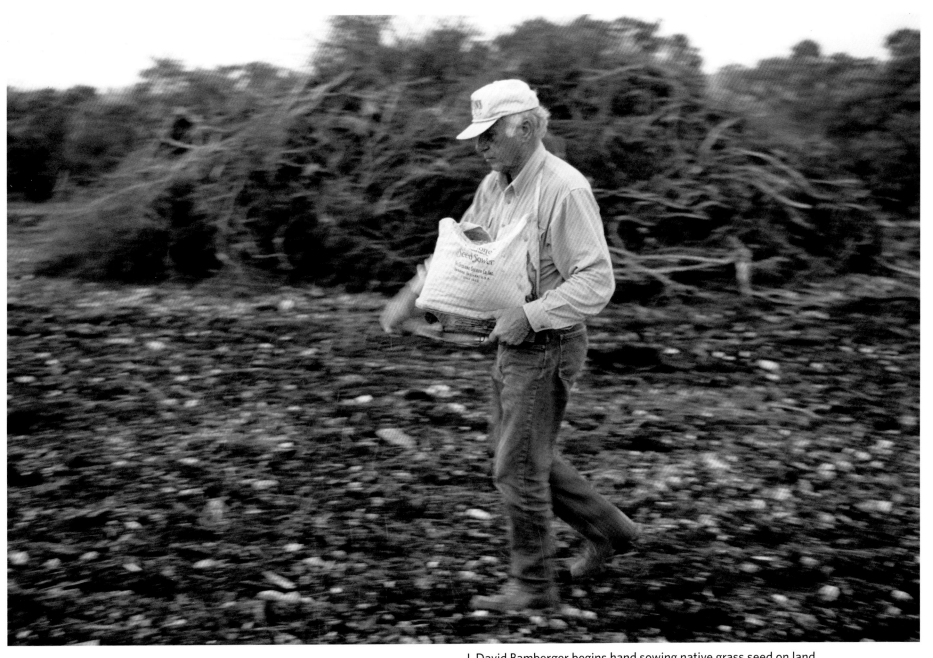

J. David Bamberger begins hand sowing native grass seed on land that has been prepared for improvement.

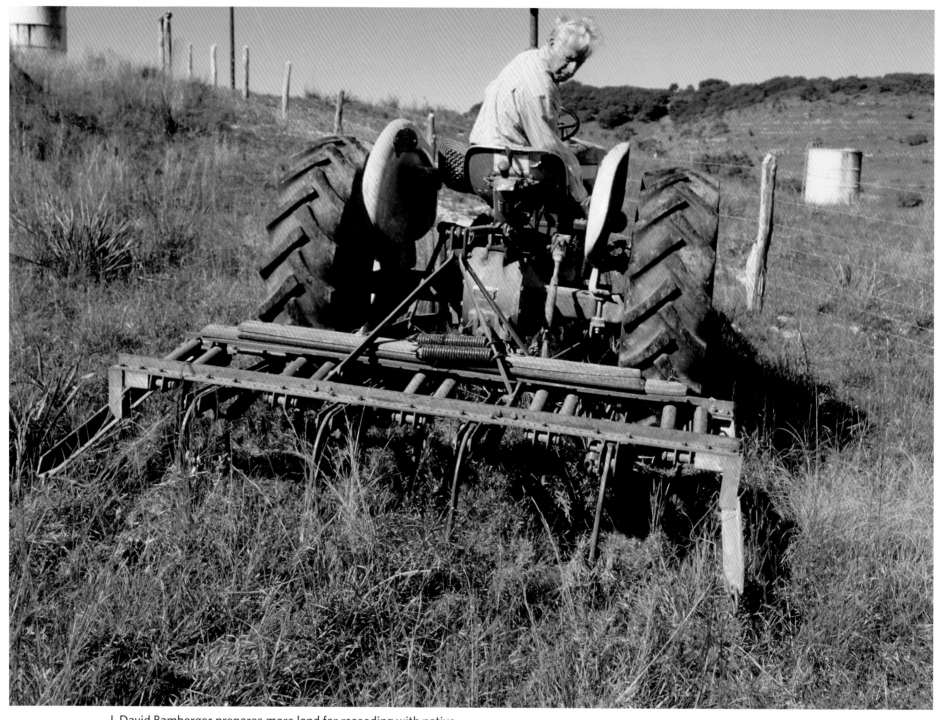

J. David Bamberger prepares more land for reseeding with native seeds.

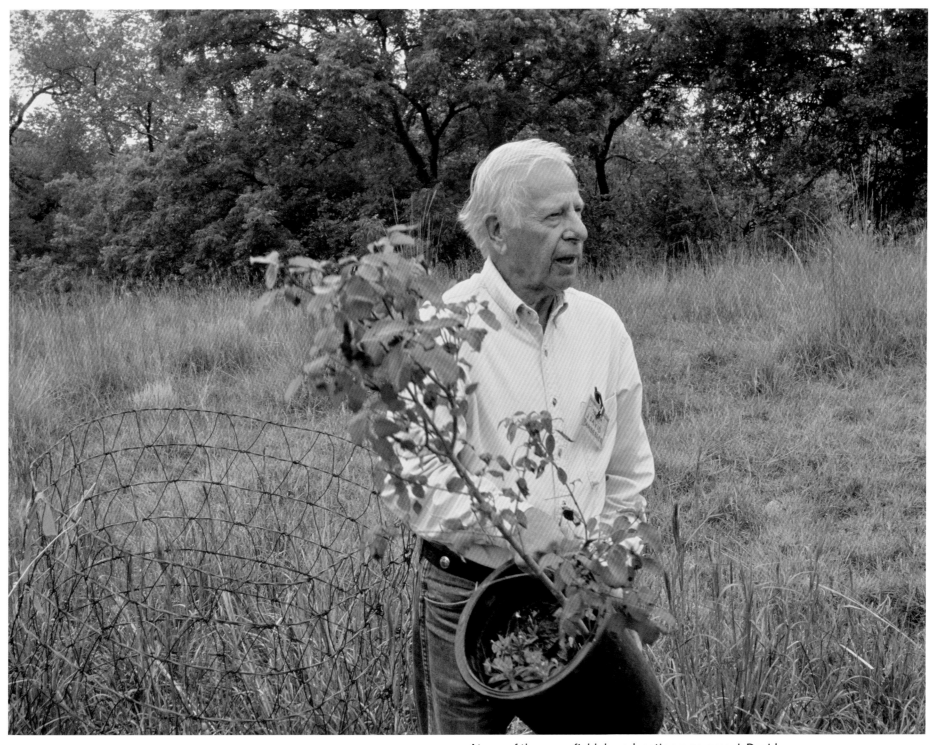

At one of the many field day education programs, J. David Bamberger talks about his restoration projects for the federally endangered Texas snowbell.

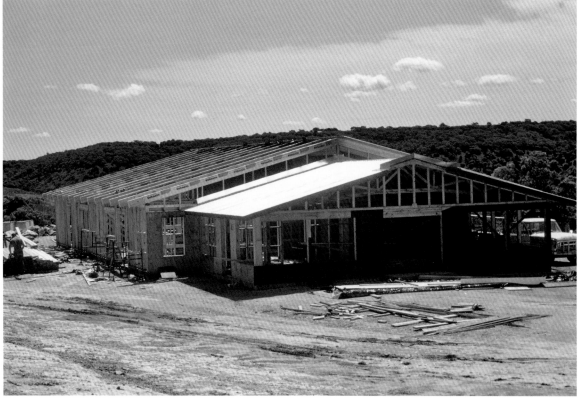

The first phases of constructing the Education Center.

Next to a perimeter fence, J. David Bamberger measures heights of grasses.

A view from above of the ranch's prestewardship condition.

Here is the result all had worked for! This is the "Genesis Spring." As the aquifers began to respond to all the efforts, water began flowing from springs on the ranch.

Bamberger Ranch Preserve practices land stewardship by example and offers landowner workshops and off-site consultations on land reclamation and restoration, watershed management, native grasses, forestry, prescribed burns, game management, predator control, and conservation. The ranch serves as a research lab for botanists, zoologists, and other scientists and offers training for interns and volunteers.

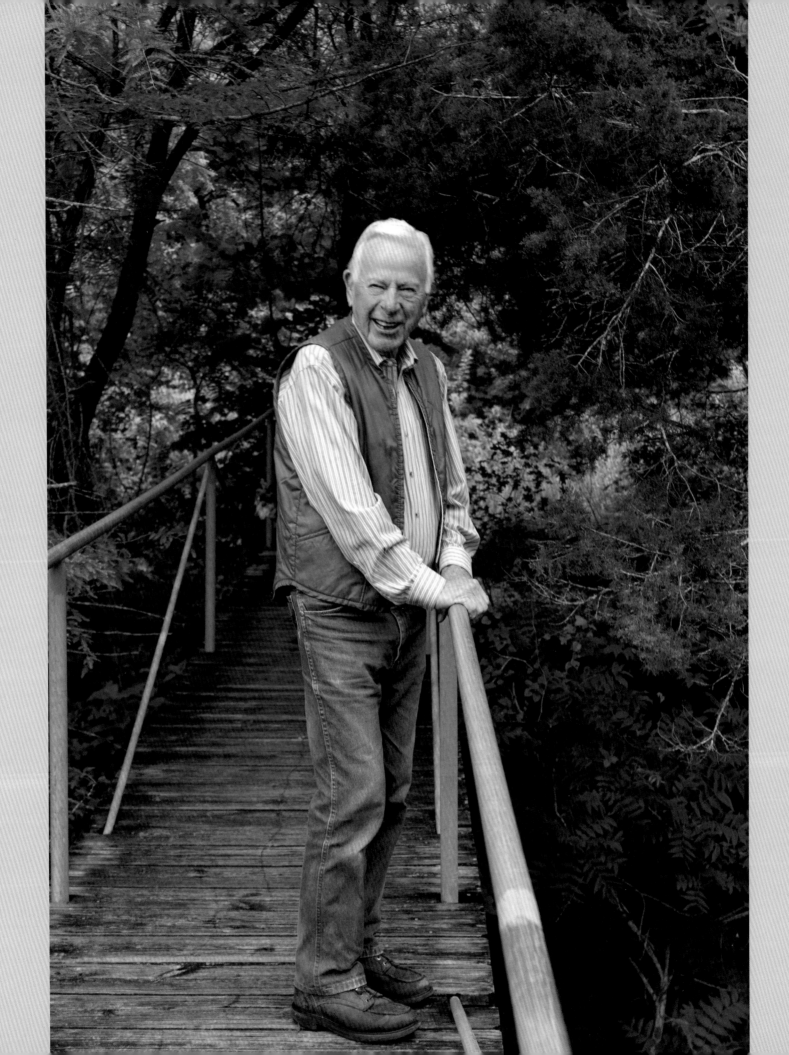

The Cathedral Builder

Andrew Sansom

*At certain times in our lives, opportunities arise to make changes . . . for us to look
at what we have done and perhaps rearrange our lives with new thinking, new priorities.
This isn't about getting rid of the past but more about adding something new.*

*This happened to me when I was forty years old, shortly after I bought Selah.
With a change in philosophy, a great difference came into my life.*

—J. DAVID BAMBERGER

American syca-
more tree just
beginning to bud
in early spring,
with a blooming
Texas redbud in its
understory.

SPRING

We stood in the twilight on a hillside at Selah, the fabled ranch in Blanco County owned by J. David Bamberger. The word "selah" is Hebrew, meaning "stop, pause, and reflect." A gathering of J. David's friends had come together in the Texas Hill Country to celebrate the launch of a new research and education center named for his late wife, Margaret.

We listened to the sounds of the lovely spring evening and to Colleen Gardner, executive director of Bamberger Ranch Preserve, the nonprofit formed in 2002 to support the conservation work and educational mission at Selah. Using a familiar but compelling metaphor, she described their work at the ranch as being akin to the building of the world's great cathedrals.

The builders of the grand cathedrals of Europe knew when they started that they would never see the fruits of their labor. Completion of the magnificent structures would not come for hundreds of years, well beyond the lifetimes of their children and even their grandchildren. The cathedral builders, including stonemasons, blacksmiths, carpenters, and more, understood that the inspiration ultimately produced by their labor was not a by-product of that labor but rather its essential purpose. Thus, said Colleen, as the deepening shadows of our spring evening at Selah enveloped us, the cathedral builders understood not only that they would not live to see the completion of their work, but also that their work was inspired by that understanding.

"In the Old Testament, I found the word 'Selah' 71 times. It means to stop, pause, and reflect and I promised myself that if I ever owned a ranch, I would call it Selah."

I first met J. David Bamberger when I worked for The Nature Conservancy in the early 1980s. At that time, the conservancy's Texas office was located above a pornography shop on rowdy Sixth Street in Austin. There were but a handful of permanent employees and fewer than thirty members who gave the organization $100 or more, and we were $3.5 million in debt. Back then, that was real money. I had very little experience raising money and none running an organization. My lack of confidence in our future prospects and

in myself were such that I did not risk moving my family to Austin but left them in our home on the Texas coast while I tried to dig out of the hole I had gotten myself into.

For various reasons, not the least of which was to get away from our working conditions in Austin, we moved The Nature Conservancy in Texas to San Antonio, where there was already a history of strong support for our work. At the time, rumor had it that a corporate chieftain in Alamo City was making generous contributions to conservation organizations such as the Sierra Club. His name was J. David Bamberger, and I was desperate to meet him and make a pitch for the conservancy.

But I couldn't get past the front door. My repeated attempts to contact him failed. It turned out that Bamberger had problems of his own. He had returned to the chairmanship of Church's Chicken, a company he had founded years earlier, for the second time in order to address nagging problems in the corporation, and he had his hands full.

About that time, another pied piper of conservation, Merlin Tuttle, founder of Bat Conservation International, walked into my office on Alamo Plaza with a fruit bat named Zuri hanging on his arm. Merlin, who lived at the time in Milwaukee, was considering moving his fledgling organization to Texas, and he informed me that the largest concentration of mammals on earth was located just a few miles north of San Antonio at a place called Bracken Cave, summer home to as many as twenty million Mexican free-tailed bats.

At Merlin's urging, I began negotiations on behalf of The Nature Conservancy with the Marbach family, owners of Bracken Cave, to purchase it. Elgin Marbach, the aging patriarch, gave me a set of keys to the site, and the first thing I did was to hand deliver an invitation to J. David Bamberger to visit the cave with me and watch the incredible evening emergence of the bats. Within minutes of receiving my letter, Bamberger called me. The first words he ever said to me were "I'll bring the chicken!"

There began a relationship that has spanned more than thirty years. Following our trip to Bracken Cave, J. David became a mentor, an inspiration, a sounding board, an ally, and a treasured friend.

In a serendipitous coincidence that convinced me things are often meant to be, my early visits to J. David's ranch, Selah, were actually family affairs. By that time, the conservancy had begun to stabilize and I had moved my family to San Antonio, where my daughter, April, joined the band at her school. There she met Dax Bamberger, one of J. David's grandsons. Inspired by our children's first teenage romance, we spent many halcyon spring days together at the ranch marked by spectacular wildflowers and two absolutely smitten kids.

In those early years, as J. David and I walked along the clear-running creeks and swam in Madrone Lake together, I began to realize that my new friend, who was viewed by fellow Texas landowners and others as somewhere between an eccentric and a crackpot, probably thanks to his politics and to his unconventional thinking about land restoration and management, was in the process of creating something extraordinary on his ranch, an inspired effort that would transcend our lives and those of our lovestruck children.

J. David Bamberger arose from humble roots in Ohio and came to Texas in the 1950s to sell Kirby vacuum cleaners. His indefatigable spirit and uncanny salesmanship made him, in his own regretful words, dangerous, as time after time he would walk away from the door of a family that was barely able to meet basic needs but was now in possession of a brand-new Kirby and a bunch of monthly payments.

Bamberger's success as a salesman propelled him to regional manager of Kirby sales in San Antonio, where one of his salesmen was a man named Bill Church. Church's aging parents operated a true mom-and-pop fried chicken business in San Antonio, and they had reached a point in their lives where they could no longer manage it alone. Thus, when Bill Church approached his supervisor to ask for time off to help his folks, there began an adventure that would change their lives and ultimately lay the groundwork for the Bamberger legend at Selah, Bamberger Ranch Preserve.

At that time, the practice in commercial fried chicken establishments was to dispose of used cooking oil or shortening every night upon closing. This essential ingredient was second in cost only to the chicken itself, and Church

realized that if he could figure out a way to use it more than once, it would add to the bottom line and give him an edge on his competition. Remember, these guys were vacuum cleaner people. Building on the filtration system of the vacuum cleaner, and with a $500 investment from Bamberger, Bill Church developed a system to filter the shortening and thus get more than one day of use out of it.

Accounts of J. David and Bill's adventures with Church's Chicken have been written elsewhere, and I will reluctantly refrain from retelling all of them here. But there is one anecdote that has such meaning for me that I can't help myself.

It is widely known that one of J. David's major breakthroughs was the unique partnership he forged with Sam Walton, founder of Walmart, in putting what he called "chicken stands" in Walmart parking lots. He tried many times to call Walton to discuss his ideas, but the retail giant's secretary would never put his calls through. So J. David wrote a personal letter with his proposal to Walton and instructed his pilot to fly to Bentonville, Arkansas, hand deliver it to the retail king, and not return until it was in Walton's hands. The pilot, who was apparently very dashing, persistently showed up at the reception desk for five days and finally charmed Walton's secretary into giving him five minutes to deliver his letter to the great man. In an uncannily similar harbinger of my own first contact with J. David many years later, when Walton read the hand-delivered letter, he picked up the phone and called down to San Antonio, saying, "Bamberger, my daughter is a student there at Trinity University, and she thinks I am so cheap that whenever I come to visit her, she makes me take her to Church's Chicken. Let's make a deal!"

Selah, Bamberger Ranch Preserve is in the heart of the Texas Hill Country, very near the birthplace of the region's greatest son, Lyndon Baines Johnson. When Johnson's ancestors made their way west, keeping ahead of what they viewed as ever-encroaching government, they encountered a vast sea of grass, stretching as far as the eye could see. They were especially taken with the rolling hills of the Edwards Plateau, twenty-four thousand square miles of stirrup-high grass dotted with occasional mottes of live oak.

"Conservation does not happen by considering a single component or by looking only at the present. How human beings interact with the landscape, how the environment has changed for better or for worse, the ecosystem's past and future—all must be considered in successful conservation efforts."

Under the trees and in the spring meadows lay a carpet of wildflowers woven with bluebonnets, Indian paintbrush, blanketflowers, Mexican hats, and many more. Throughout the Hill Country, clear springs burst out of the hillsides to form the most beautiful and productive streams the new arrivals had ever seen. The clear-flowing waters carved unique passages through the hills shaded by cool galleries of towering cypress trees lining the streams, with thickets of Ashe juniper, commonly called cedar, growing along the slopes of the canyons.

But it was the grassland that captured their imagination and fueled their dreams. Many of these men and women had escaped the cotton fields of the old South and the predatory system that virtually indentured them to merchants who supplied them with essential goods on credit, taking payment out of whatever cotton they were able to produce. What living they made for themselves they made off the land in small-scale farming and livestock, and the deep grass

of the Texas Hill Country seemed a dream come true.

The tallgrass prairies of the Hill Country evolved over many centuries, their existence sustained by periodic prairie fires set by lightning or indigenous people, and grazing herds of free-ranging bison, both of which controlled the growth of brush—especially the hardy native Ashe juniper—and also allowed the grass to grow back. The soil in the Hill Country sits thinly on the limestone substrate, and the hillsides are prone to erosion when the rains come but for the grass, whose roots both absorb the water and hold the soil. So, as lush and beautiful as the grass was, it was there by virtue of the rhythms of natural disturbance over very long periods of time and the ability to persist in what humans would learn were fragile conditions.

In what now seems the blink of an eye, the new migrants from the East changed it all.

Encouraged by the veritable ocean of grass and the government of Texas, which went to great lengths to stimulate settlement along the frontier, thousands of cowmen began to arrive after the Civil War. Where they came from, the annual rainfall was often as much as sixty inches; in their new country, the average was less than thirty inches a year at best and often as low as fifteen inches. Still, visions of prosperity on the savannas of the Hill Country led the new Texans to bring hundreds of thousands of cattle to feast on the grass that covered the land. To their good fortune, beef became a very valuable commodity as the rise of urban communities in the Northeast and Midwest brought increasing demand for meat. Those cattlemen who could assemble vast herds in the Hill Country and survive raiding outlaws, Comanches, and stampedes to get them to Kansas often returned to Texas carrying bags of gold. For men who had moved west into Texas with little or nothing in their pockets, the Hill Country offered all the grass and water they would need to gather cattle for the drive north, and the prospect, for the first time in their lives, of affluence.

But it was not sustainable.

In less than thirty years of intense grazing in a land of scarce rainfall and thin soil, the grass was gone. Much of what little soil there was washed away, the wander-ing bison were slaughtered along with the Indians, and the prairie fires were subdued. The newcomers brought thousands of cattle, sheep, and goats, all of which ate grass. Their impact was even greater as barbed-wire fencing was introduced and, by prohibiting the domestic animals from roaming to greener pastures, increased the pressure on the resource. The grass disappeared.

Without control from grass, its historical competitor, the cedar, which does not need much topsoil to take root, moved up out of the canyons and choked the hillsides, sucking water from the earth to such an extent that most springs disappeared, creeks went dry, and what immigrants once described as a "land of milk and honey" became a wasteland. The devastation was such that by the time Lyndon Johnson began his rise to power, the Hill Country of Texas was one of the poorest regions in the United States, along with Appalachia.

This bleak picture was largely unchanged when, in 1969, Church's Chicken went public, and two days later, J. David Bamberger purchased what he described as the most cedar-infested, played-out ranch in the Hill Country, near Johnson City. In the following years, though he continued for a time to run one of the most successful food service companies in America, his work at the place now known as Selah defined his life and established him as one of the most respected conservationists in America.

As a child in Massillon, Ohio, growing up in a shack with no electricity or water, J. David could not have imagined ever owning a 6,000-acre ranch in Texas, but his connection to the land surely began there. His mother, Hester or Hes, was a self-taught nurse who had an intense passion for gardening and a love of nature that she passed down to her son, who spent hours as a child roaming the farms and forests of rural Ohio, often gathering berries and nuts in the woods and meadows for the family to eat. His father managed to buy a four-acre farm outside of town, where the future chicken tycoon walked a quarter mile every day to the well on the next farm to get water for his family.

Along with his mother, the other great influence on J. David's life with respect to conservation was Louis

Bromfield. Born at the turn of the twentieth century, also in Ohio, Bromfield was a very successful novelist who studied agriculture at Cornell University before turning to journalism at Columbia University, ultimately publishing thirty novels and winning a Pulitzer Prize. In the years leading up to World War II, Bromfield and his family, who had been living with other expatriate writers in Paris during the Depression, returned to Ohio and purchased one thousand acres that he named Malabar Farm, which became the central focus of his life until his death in 1956.

Malabar Farm, the site of the wedding of Humphrey Bogart and Lauren Bacall, was the test bed for Bromfield's theories of organic farming and sustainable agriculture. It was at Malabar Farm that he wrote the book *Pleasant Valley*, which was presented to J. David Bamberger by his mother, Hes, and became, along with her, a guiding force at Selah. One of my most treasured possessions is a copy of Bromfield's book that J. David gave to me with the inscription that it was the inspiration of his life's work at Selah.

Today, Malabar Farm is an Ohio state park visited annually by thousands of people, and the conservation practices pioneered there continue to impact agricultural operations around the world, as well as at Selah, where J. David began to experiment with habitat restoration practices. Some of these were considered unconventional at the time, but they fundamentally changed the landscape not only at Selah but also on thousands of acres in Texas and beyond.

J. David read that mature cedar, or Ashe juniper, could pull as much as thirty gallons of water a day from the soil. When he purchased the ranch, it was completely infested with this native but aggressively invasive plant, and there was no water on the property. The dense cedar thickets, still common in much of the Hill Country, also made it difficult for beneficial plants, including grasses, to flourish, especially when they were subject to grazing pressure and poor soil conditions.

Bamberger went after the cedar with the same determination and lack of regard for convention that had marked his success with vacuum cleaners and fried chicken, and once again he proved that he was ahead of his time.

Following his acquisition of the ranch, J. David began assembling a team of devoted employees, including the professionals he called his Tree Aggie, Cow Aggie, Deer Aggie, and so on, because most were associated in some way with Texas A&M University. Among them was Leroy Petri, whom J. David dubbed the Dam Aggie. Leroy came to Selah as a young man, fresh out of the Army Corps of Engineers. He has been at the ranch from the beginning, and J. David will tell you that he could not have done all that needed to be done in order to restore Selah without Leroy.

The first thing J. David and Leroy did was to buy a used Caterpillar bulldozer and attack the cedar. There were those at the time who said the dozer would disturb the thin soil so severely that even more erosion would occur, and indeed some of that happened, as J. David freely admits. They learned to by and large stay away from the steeper slopes, leaving the job there to chain saws and loppers. Some cedar was left in thickets for wildlife cover and in the arroyos where it had historically occurred. They followed the bulldozer with a cultivator to break up the soil and prepare it for the planting of native grass seed. J. David bought so much seed from local suppliers that he was accused of cornering the market, which, he regrets with a smile, he was never able to do with chicken.

Where possible, Leroy created terracing to further protect against erosion, and J. David and his sons spent many

hours spreading seed on the cultivated soil, working it in with boughs of downed cedar. Though rain in the Hill Country can often come fast and furious, washing away the best of intentions, most of their work held, and by summer the hills of Selah began to glow a vibrant green.

In those early years, J. David struggled to get potable water to the ranch. What well water was there was undrinkable, and repeated attempts to drill additional wells were unsuccessful. However, as Leroy continued to hack away at the cedar and more and more native grasses were planted, fewer raindrops ran off the land. Rather, they were absorbed into the restored landscape, recharging the shallow "perched aquifers" just below the surface and slowly but surely resurrecting the springs.

Today, the most astonishing aspect of Selah is that there is water everywhere. Entering the ranch, one repeatedly crosses a now-perennial stream with periodic deep pools holding fish and lovely waterfalls. There are six spring-fed ponds, including the aquatic centerpiece of the ranch, Madrone Lake, which is truly an oasis in a parched land. Five families exist solely on water from springs that did not exist when J. David and Leroy arrived. There are no wells, no pumps, and no motors. And the secret is grass.

> *"Planting a tree, shrub, or grass is more than digging a hole in the ground. You are seeing what else may live there. You are holding in your hands the very basis of life itself. I sometimes like to plant a tree when I am alone. It allows me to think and to appreciate the natural world. I believe that planting and nurturing a living organism builds character."*

The work at the Bamberger ranch helped lead to the widespread acceptance that rampant cedar growth negatively affects soil moisture and that the presence of cedar on the land deteriorates groundwater, which is the source of the once-prolific Hill Country springs. Recent research has indicated that the Ashe juniper is not the only native Hill Country tree that uses large amounts of water. A mature oak tree consumes as much as 50 gallons per day, while pecan trees can absorb an astonishing 150 to 250 gallons per day during the hottest time of the year. Other high-demand trees are elms and cottonwoods, both common in the Texas Hill Country. Investigators have also found that the soil below even a fully mature Ashe juniper may absorb more moisture than the soil under grass, and some credible range scientists now believe that it is a pervasive myth that cedar sucks the water out of the land and is detrimental to our water resources.

Nevertheless, the profuse flowing waters of Selah speak for themselves and, if nothing else, demonstrate that the hydrologic cycle of the Hill Country depends on a mix of woodlands, savannas, shrublands, grasslands, and everything in between. The more we can learn about the nexus of water and landscape, the better our successors will be able to manage both in the years ahead.

Of the many hours I have spent with J. David Bamberger over the last thirty years, surely among the most compelling have been those spent at the foot of a hillside at Selah, where, like an evangelist, he opened a small viaduct in the rocks, allowing water to flow out of the earth and fill yet another pond.

On top of this hill, J. David, like Tom Sawyer, talked hundreds of Selah volunteers—a committed group of people drawn to the conservation legacy this ranch and its owner will leave for everyone—into building shallow rock berms conforming to the hill's contours and further enhancing the vital, life-giving capture of the one substance without which no plant or animal can exist: water.

> *"To me, the Webster dictionary definition of a volunteer does not go far enough. It doesn't mention that they work without financial reward, nor the fact that personal expense usually is involved, that time with family is given up. It doesn't describe the person's qualities, their personality and character. It doesn't do justice to the volunteers I have known. It doesn't say they are America's unsung heroes."*

Surely, there must be some kind of continuum beyond our understanding that enables Hes to look down on the work of her son, who, like the old cathedral builders, attracts these disciples, these volunteers who come from all walks of life. From those of modest means bringing their time and labor, to wealthy patrons providing financial support, all toil in their own way in the service of the earth on a special piece of land in the Texas Hill Country.

And none too soon.

I write from another very special Hill Country ranch just across the county line from Selah, which was owned by one of J. David's most ardent admirers and another great conservationist and close Bamberger friend, Terry Hershey. The Hershey Ranch has an old right-of-way across it that was established in 1928 for a pipeline that brought crude oil from the Permian Basin to the refineries along the Houston Ship Channel. In 1928, in order to get all the way across Gillespie County, the pipeline company dealt with twelve landowners. In 2011, the pipeline was removed, and this time, across that same county, the pipeline company had to deal with two thousand landowners, the beneficiaries of the fragmentation of large land holdings into smaller and smaller pieces of real estate. And this in a county we still consider "rural."

The state of Texas is today more than 95 percent owned by private citizens, unlike most of the other western states, which are composed largely of public land. This means that the fate of virtually all our watersheds, aquifer recharge areas, wildlife habitat, and open space is in private hands. Against this backdrop, the biggest single terrestrial environmental problem we face is the continued breakup of family lands. Texas loses rural and agricultural land faster than any other state, and this inexorable fragmentation threatens not only the landscape and our sense of place but also the water supply upon which our children will depend.

The US Census Bureau found in 2013 that Texas had seven of the fifteen most rapidly growing cities in America, and according to *Forbes* magazine, the nation's next great metropolis is taking shape on the doorstep of the Texas Hill Country. The corridor of counties along the Balcones Escarpment, which is the eastern face of the Hill Country along Interstate 35 between greater Austin and greater San Antonio, is expanding faster than any other region in the United States.

Hays County, which borders Blanco County, where Selah is located, is expected to grow by an astounding 454 percent by 2050, making it one of the fastest-growing counties in the country. Comal County, to the south, has shown annual job growth of 37 percent, six times the national pace. Kendall County, to the west, is now the second fastest-growing county in America according to the latest studies.

Statewide, from 1997 to 2012, we lost over 1.1 million acres of working farms and ranches to other uses, primarily suburbanization, and more than half of that occurred in the fastest-growing counties, including those in the Hill Country. It is alarming that in the twenty-five counties that make up the Texas Hill Country, we lost more than 590,000 acres of rural "working lands" in the same period. These were historic farms and ranches where families made their living for generations. Overall, as ancestral lands continued to break up in those years, the average size of privately owned land decreased by nearly 10 percent.

Although he would not live to see this transformation taking place on his home ground, Selah neighbor and former president Lyndon Johnson foretold its implications when he said, "Saving the water and the soil must start where the first raindrops fall."

In Texas, they fall on private land at places like Selah. The implication of the loss of our open spaces goes beyond future water supplies to the security of our sources of food, our natural resources, our rural and small-town economies, and our very identity.

We can be grateful that throughout human history, visionaries like J. David Bamberger have come into our lives to show us another way. The real meaning of Bamberger Ranch Preserve is to show that there are two kinds of landowners: those that take from the land and those that give to the land.

On the hillsides of Selah, we experience the latter.

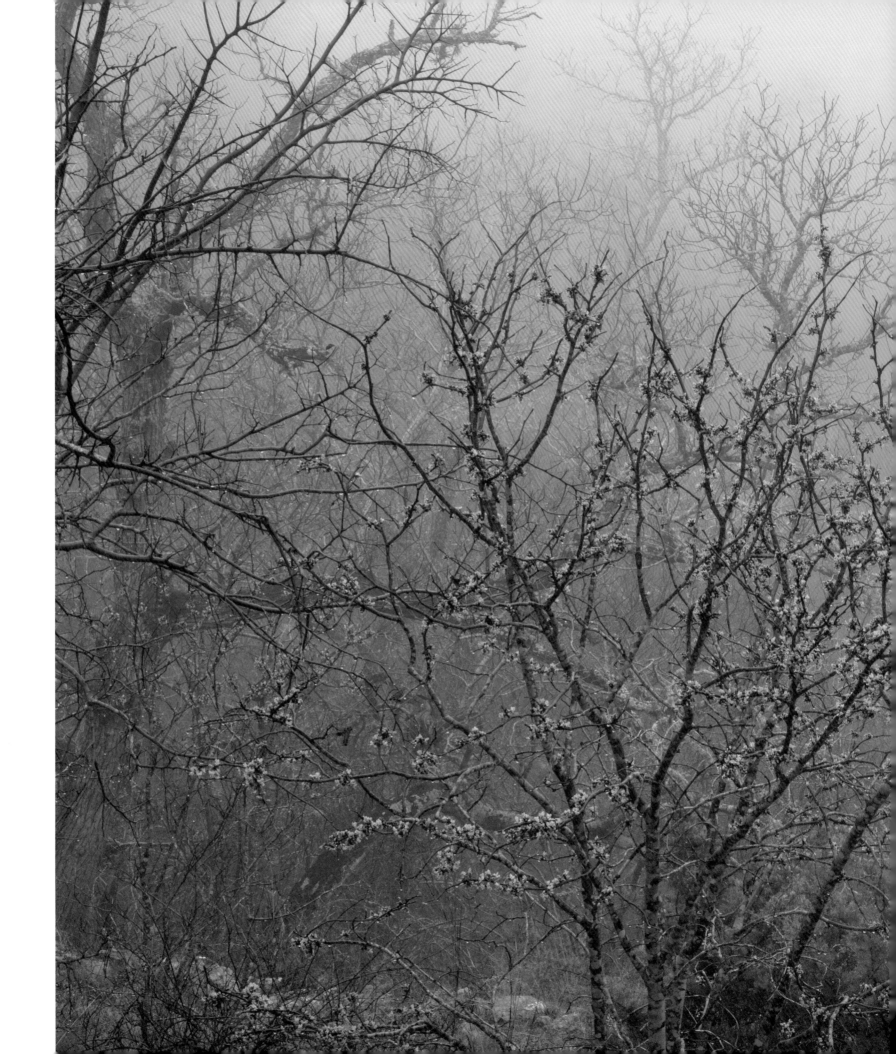

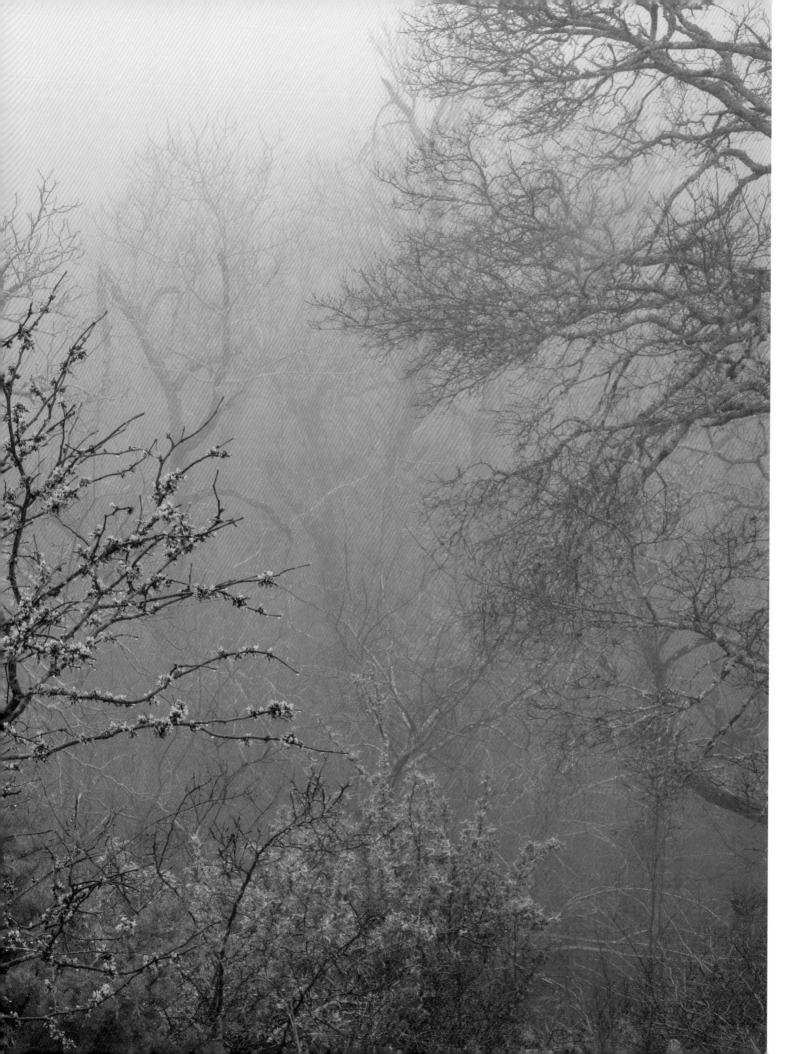

A vibrant Texas redbud adds color to a mist-shrouded canyon.

23

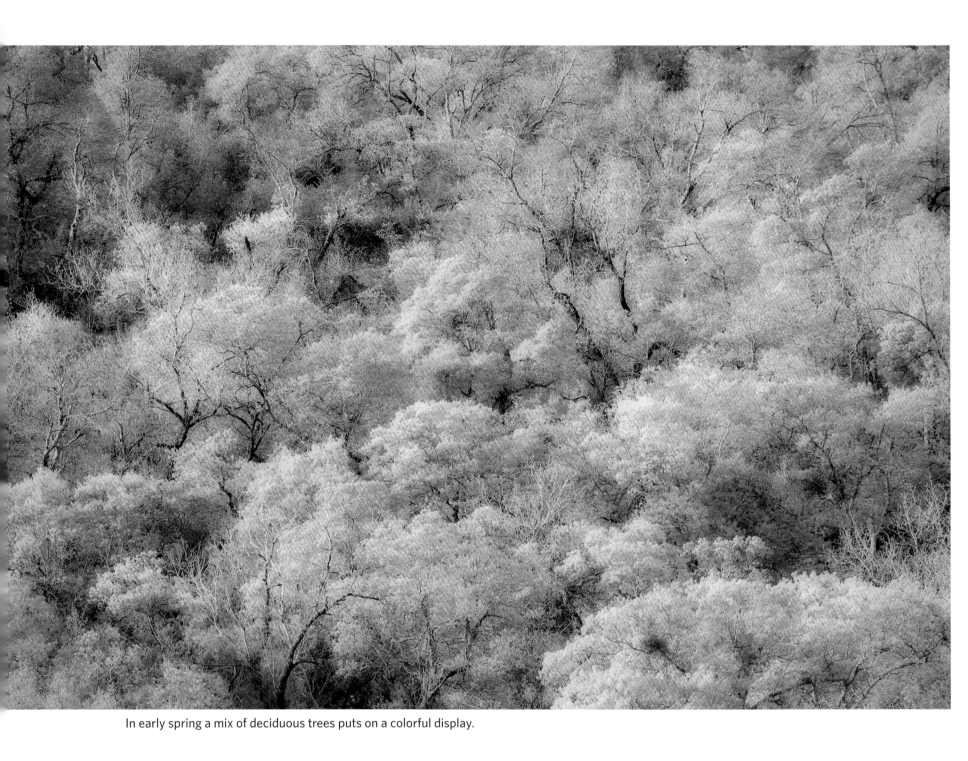

In early spring a mix of deciduous trees puts on a colorful display.

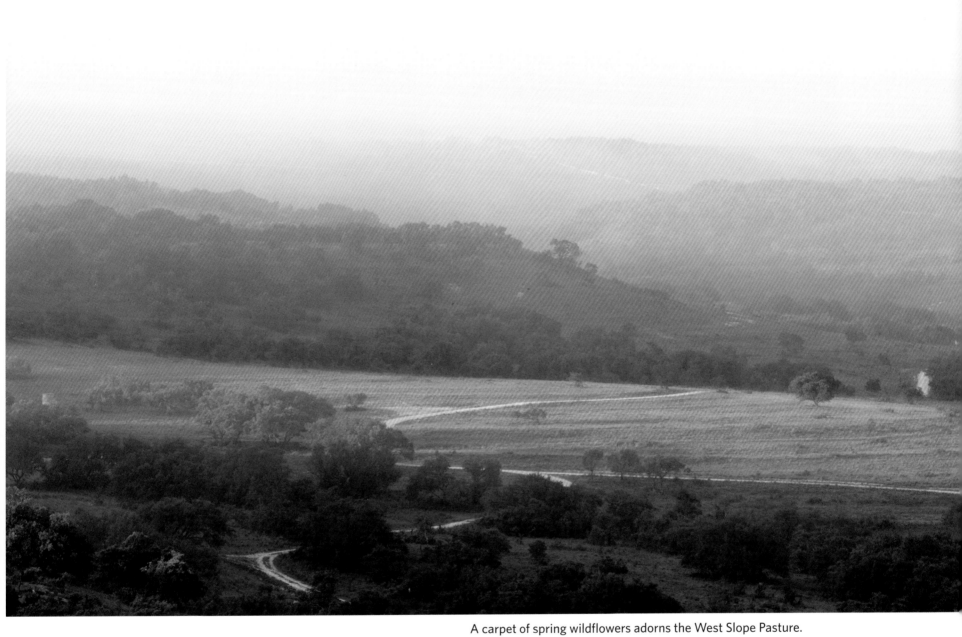

A carpet of spring wildflowers adorns the West Slope Pasture.

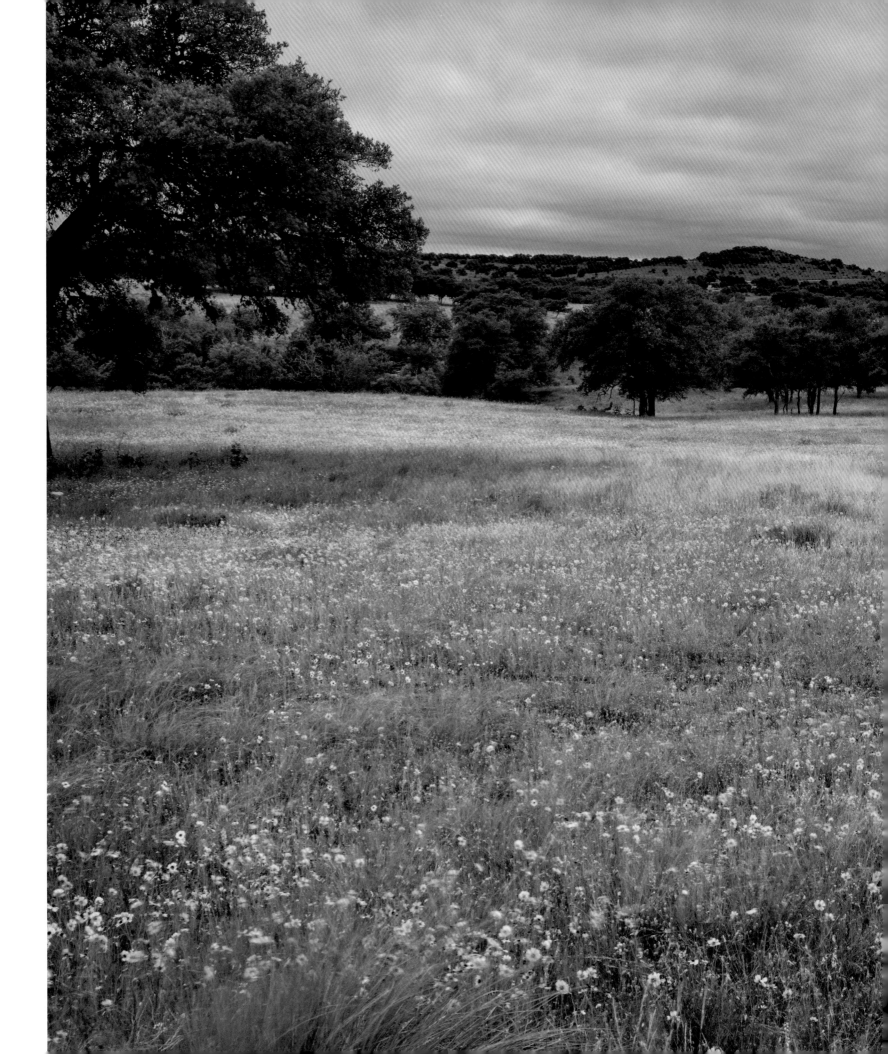

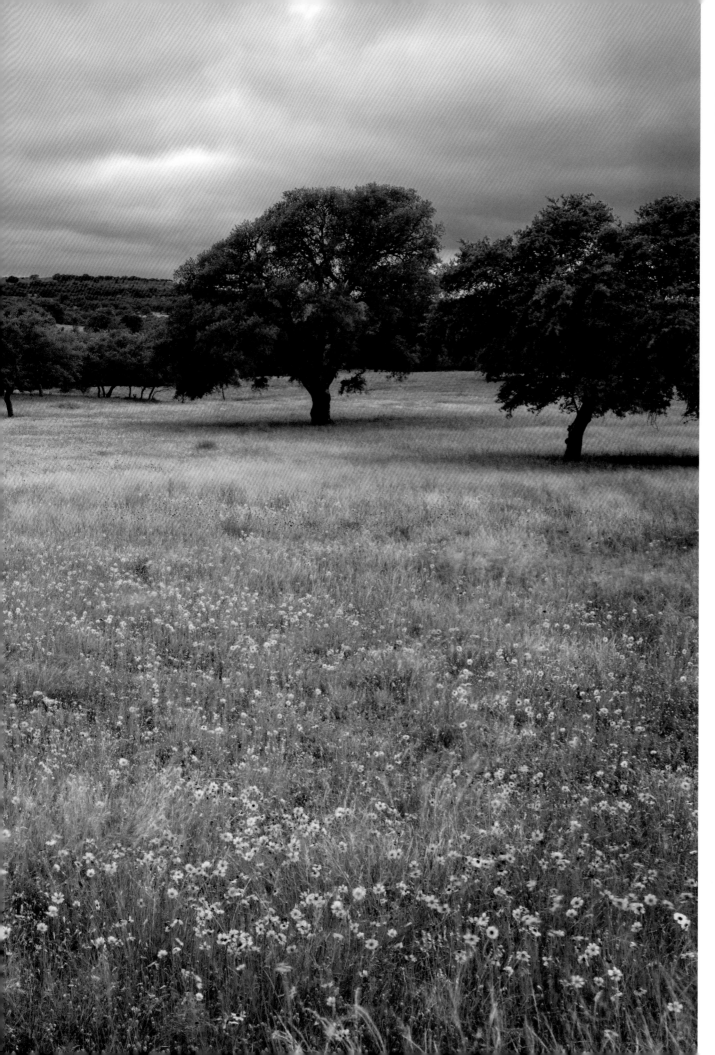

An assortment of wild-flowers in the Little Mexico Pasture.

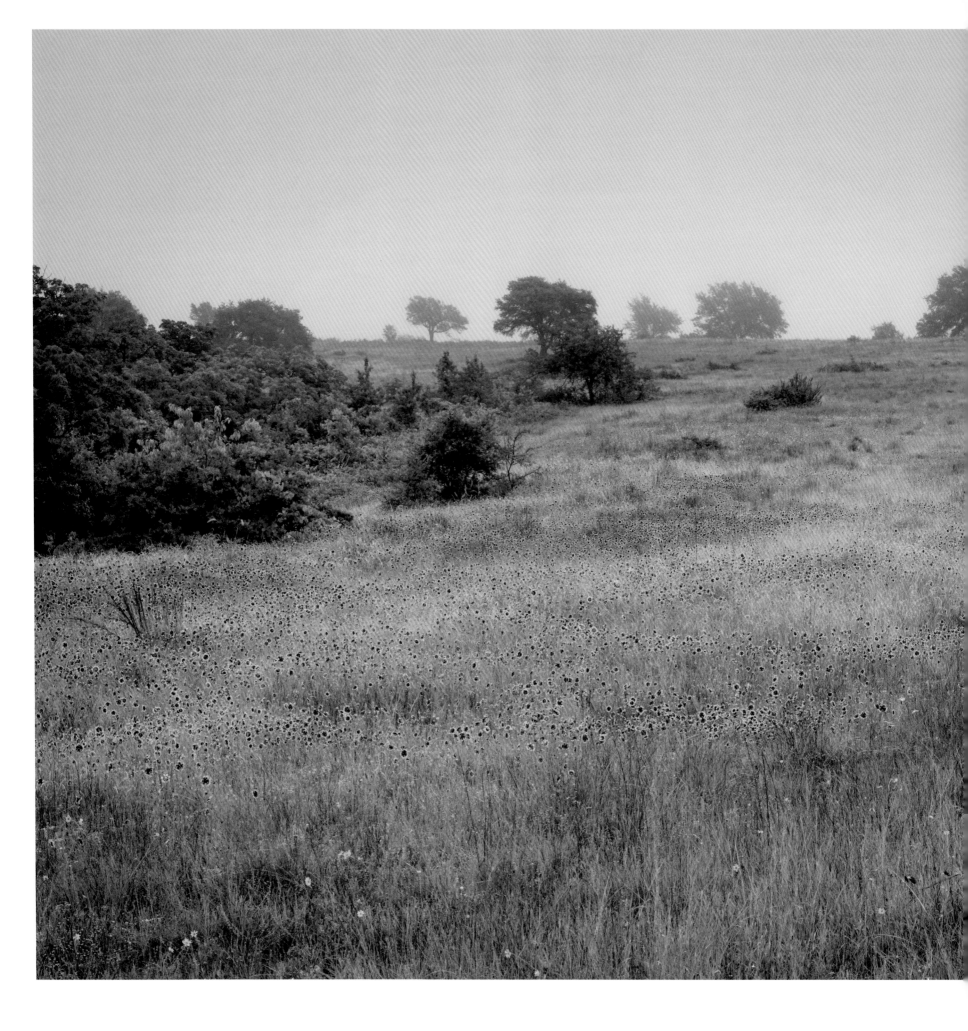

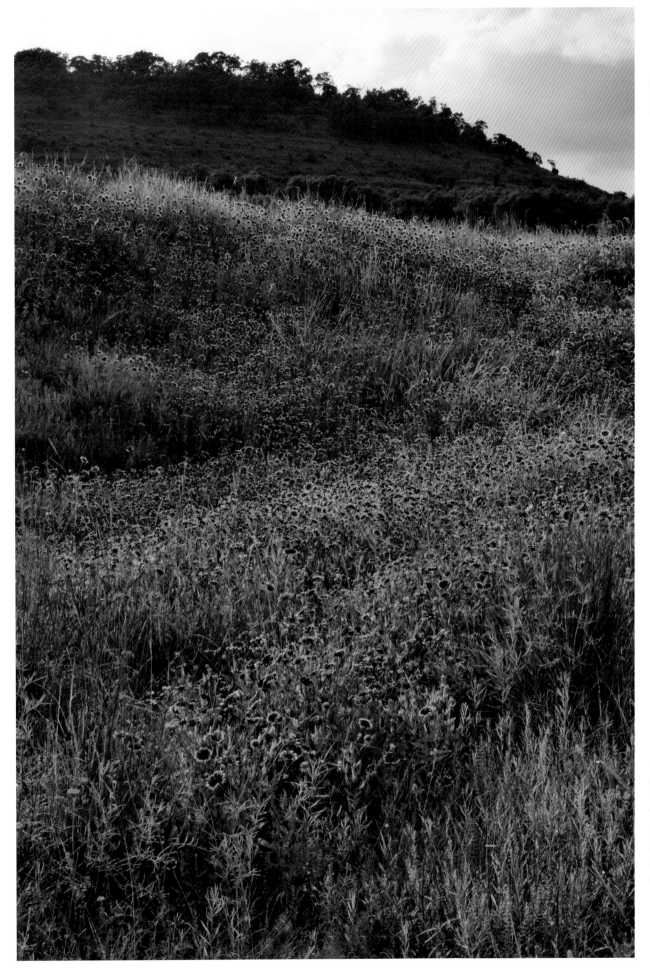

Firewheels glow at sundown in the Big Valley Pasture.

(far left) An upland meadow of the Wildlife Preserve #1 Pasture covered with wildflowers.

29

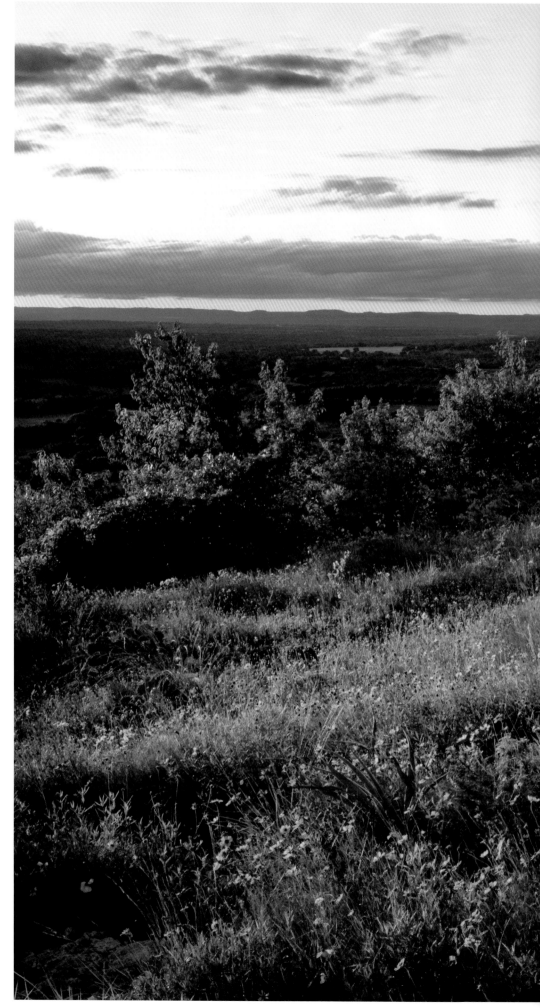

A springtime view looking north from Vista Grande.

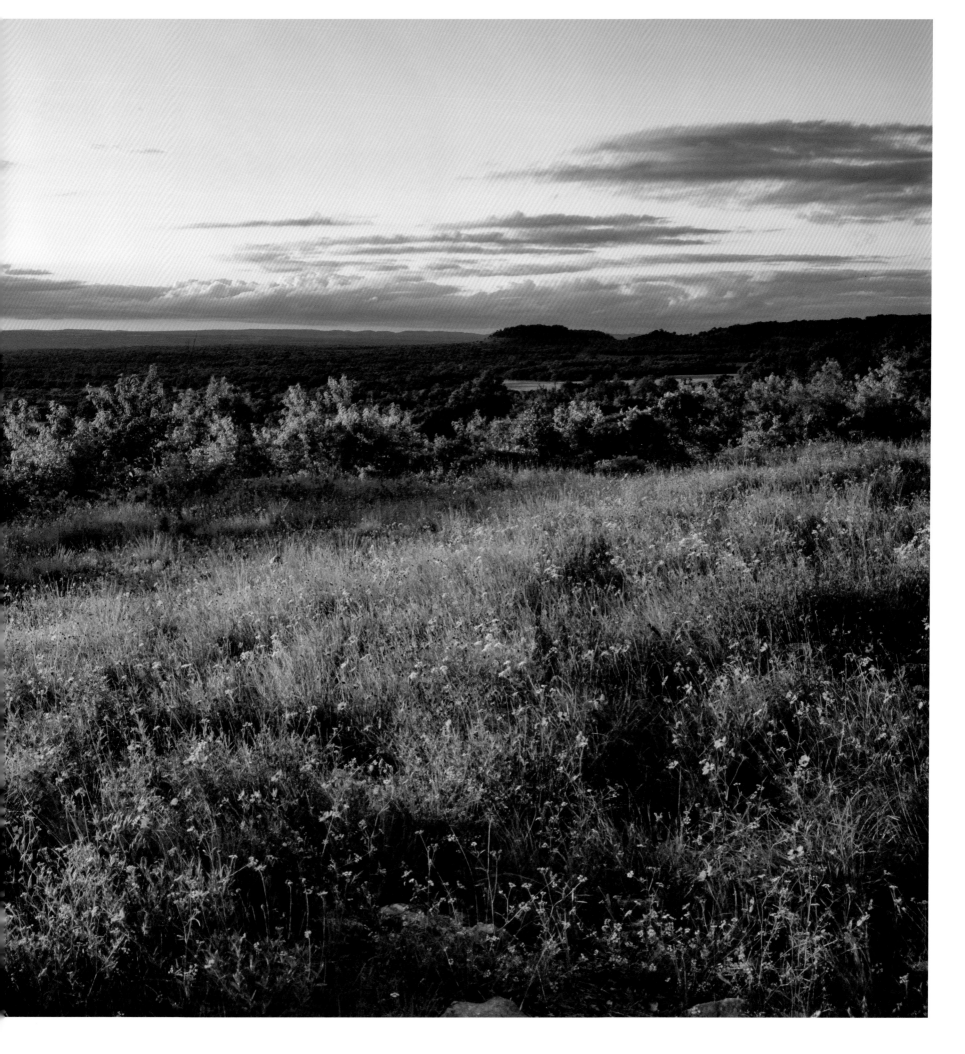

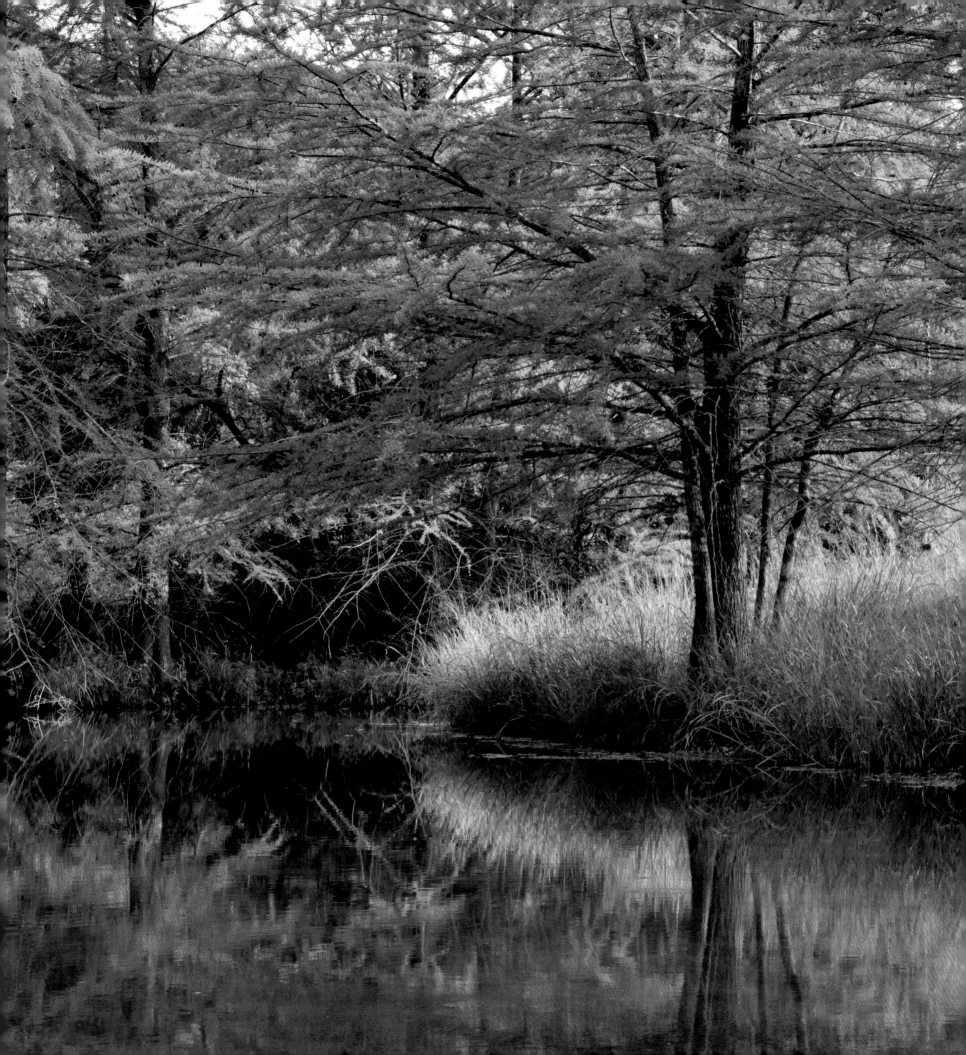

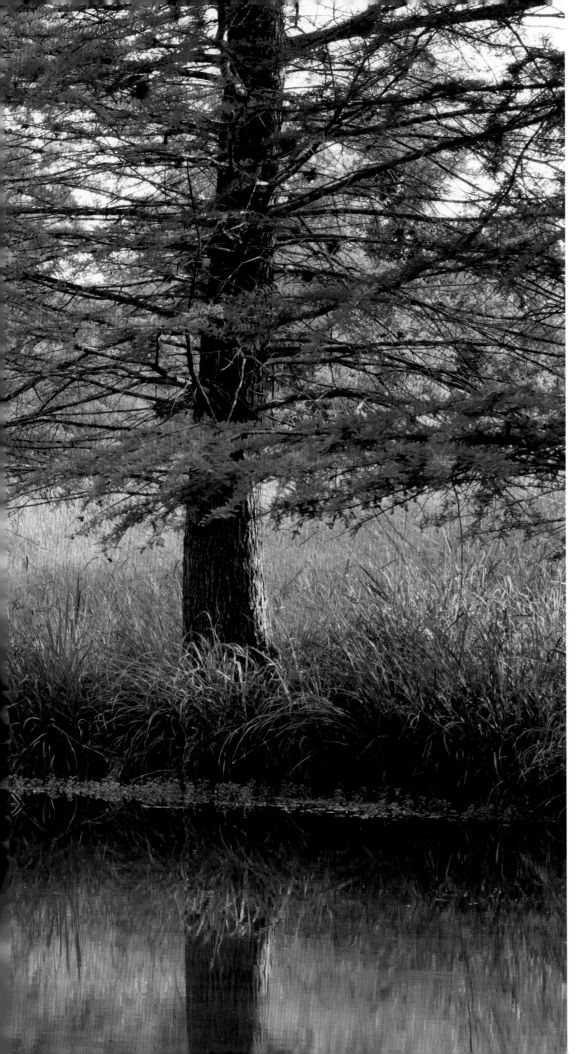

Jacob's Ladder Pool bathes in the soft late after-
noon light.

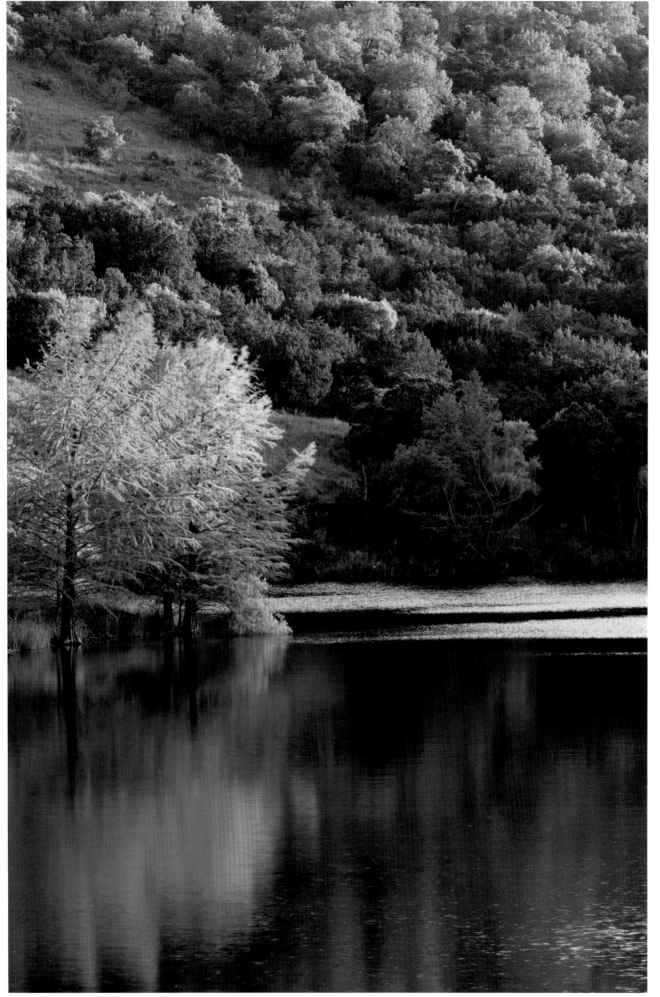

Spring bald cypress reflections in Madrone Lake.

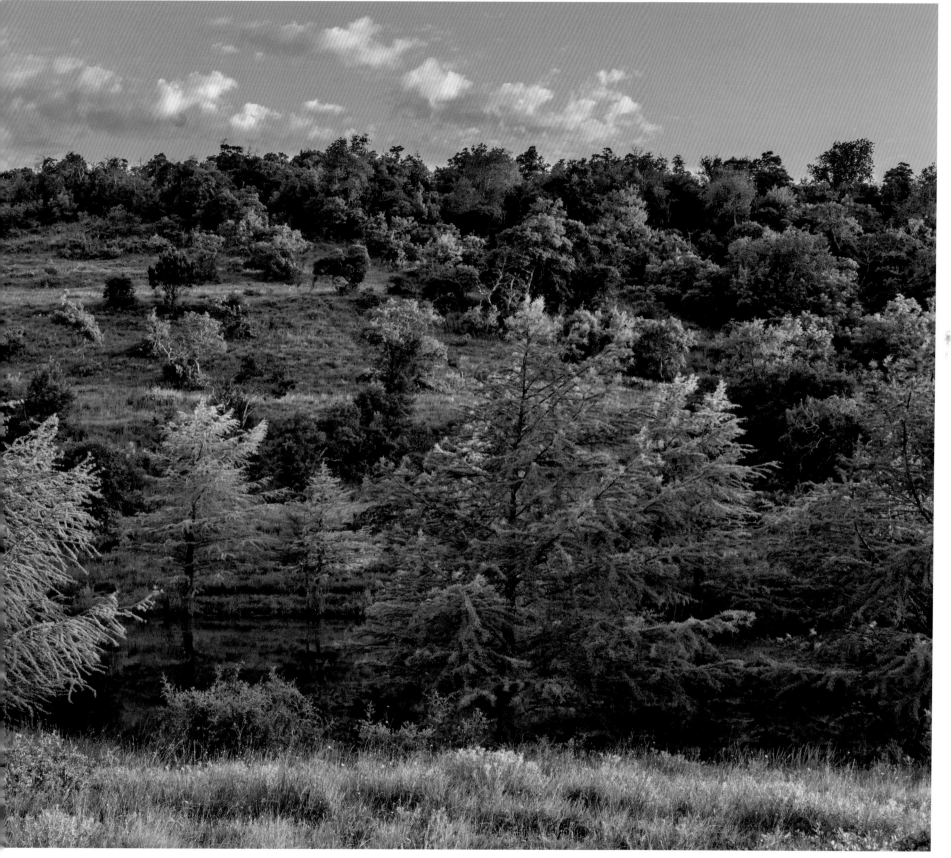

Middle West Slope pond reflects spring colors of bald cypress.

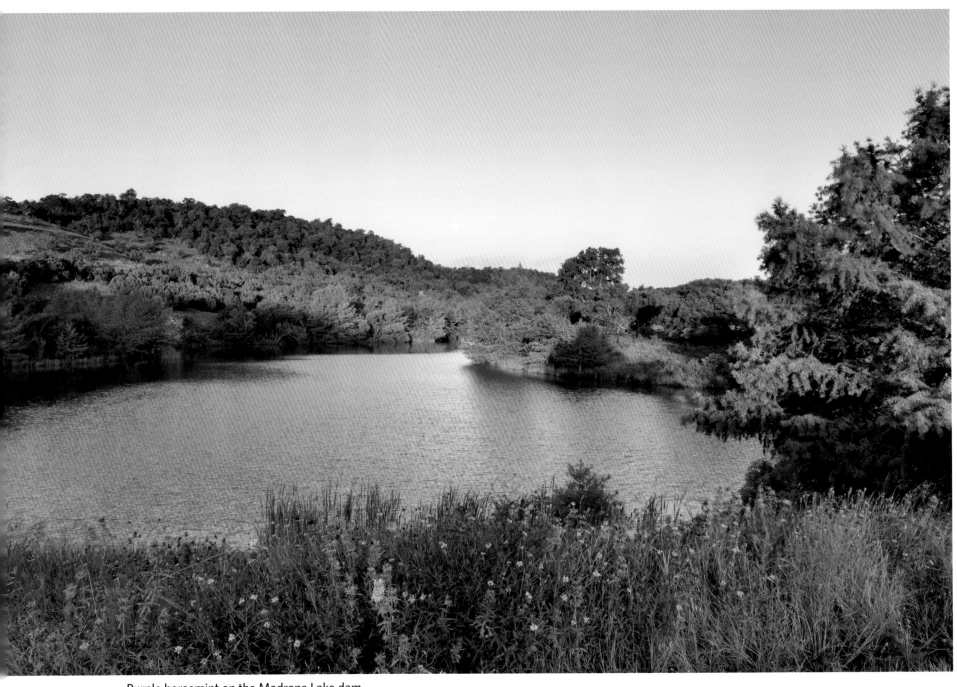

Purple horsemint on the Madrone Lake dam.

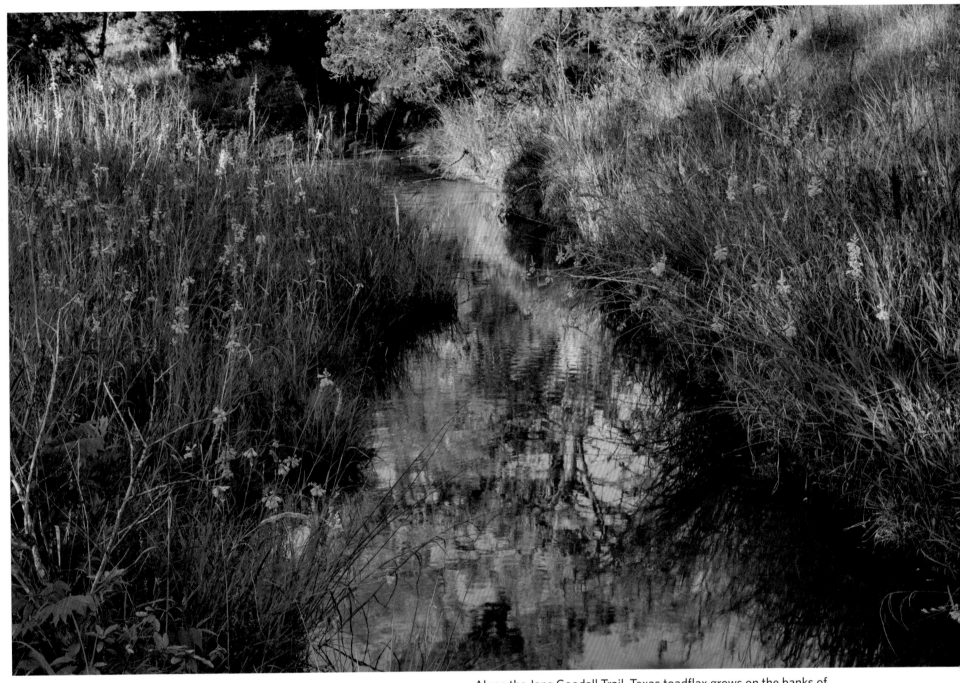

Along the Jane Goodall Trail, Texas toadflax grows on the banks of Miller Creek.

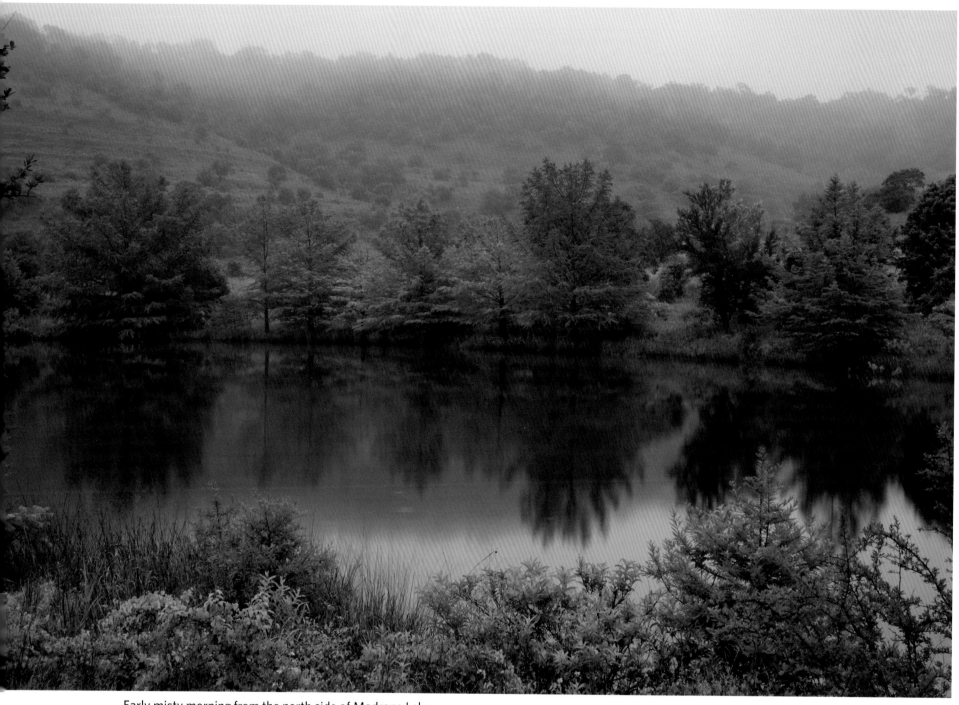

Early misty morning from the north side of Madrone Lake.

A female Carolina wren searching for insects to feed her chicks.

Bald cypress trees and inland sea oats along the Arboretum Trail.

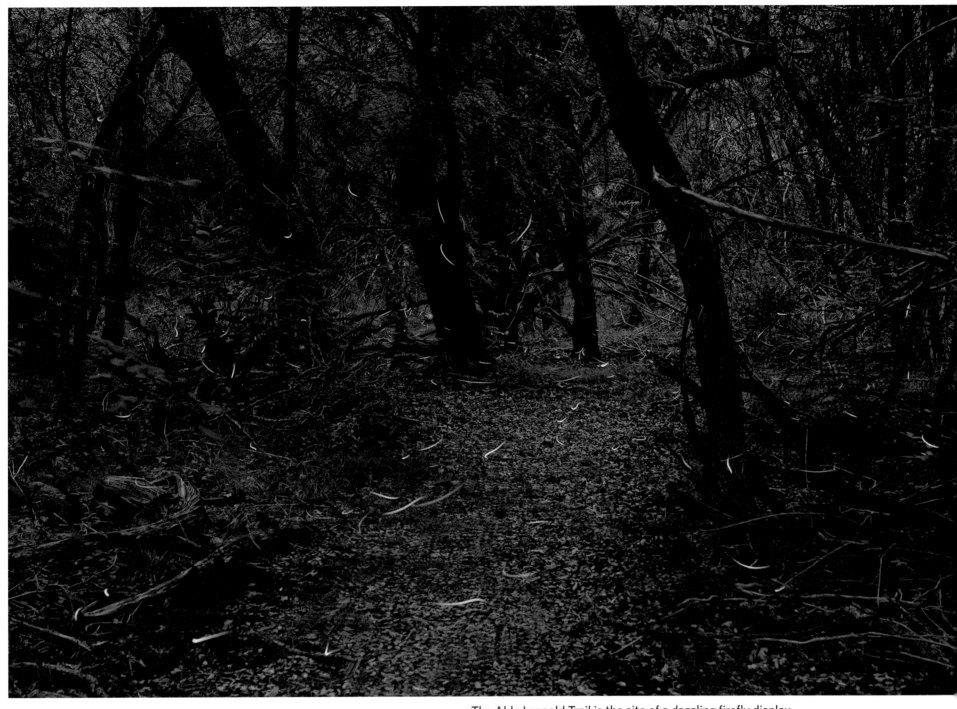

The Aldo Leopold Trail is the site of a dazzling firefly display.

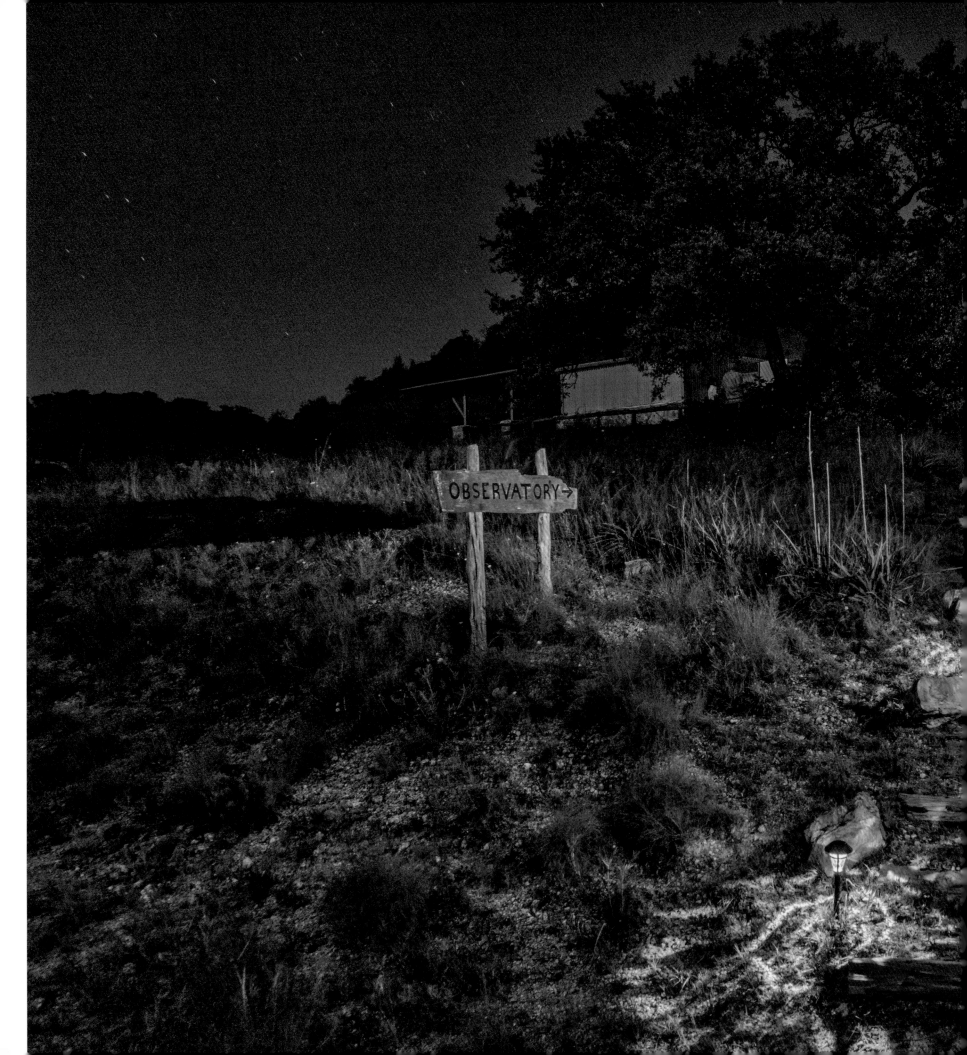

A scheduled tour group stargazes in the Observatory.

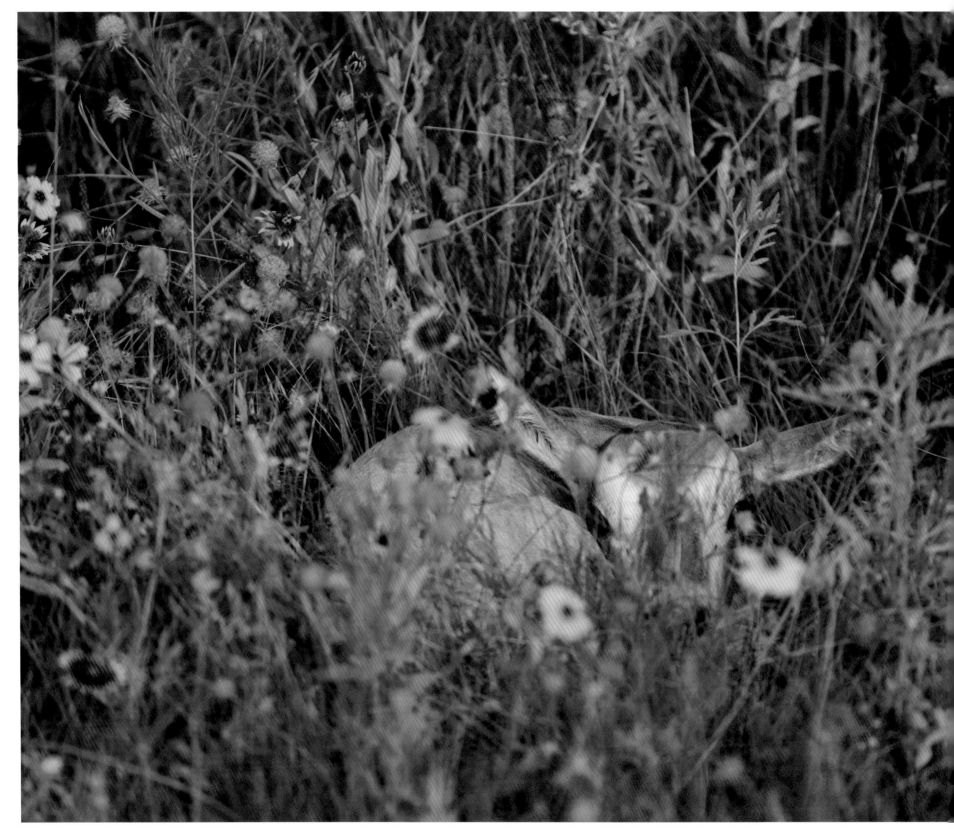

A newborn scimitar-horned oryx bedded down among the wildflowers.

A male painted bunting sings for its mate.

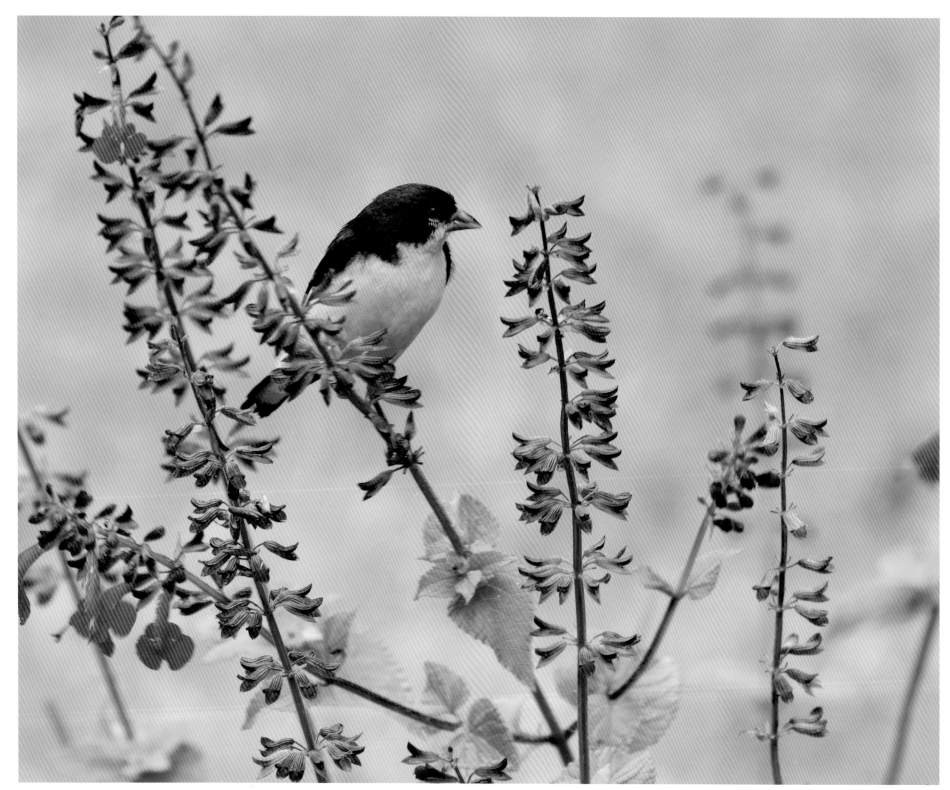

A male lesser goldfinch rests briefly on cedar sage.

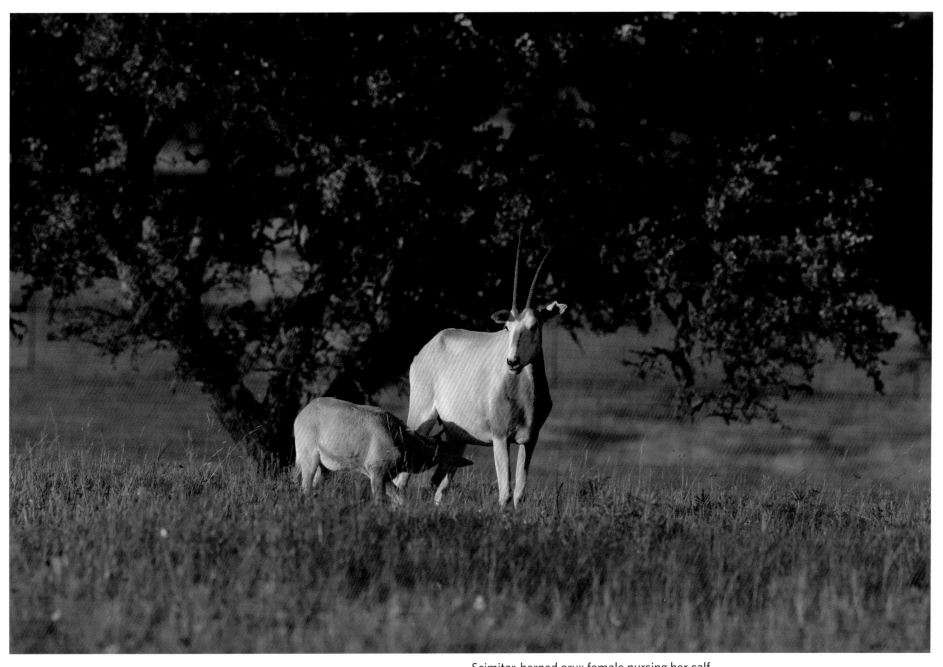

Scimitar-horned oryx female nursing her calf.

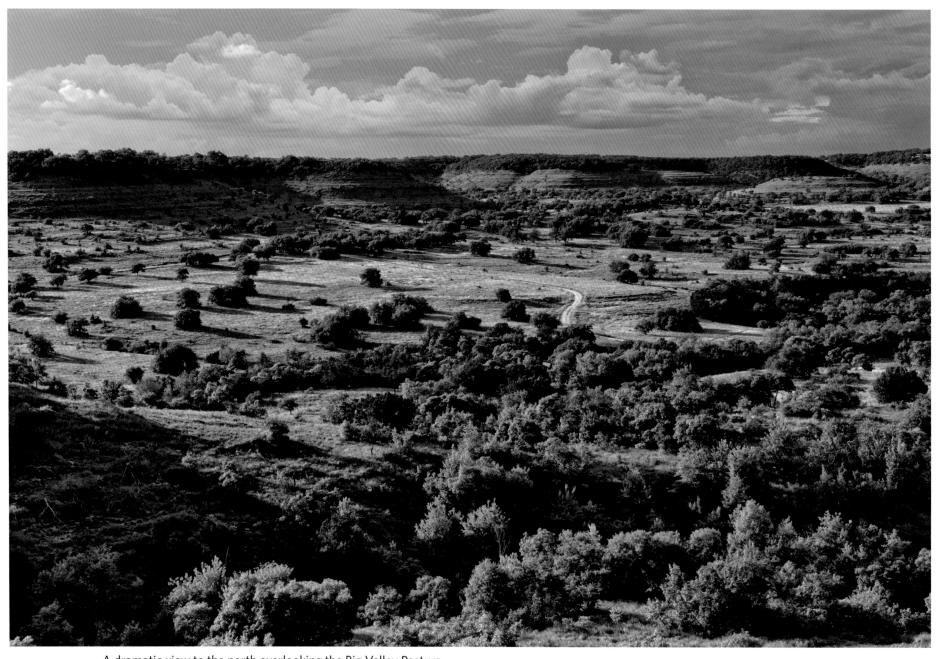

A dramatic view to the north overlooking the Big Valley Pasture.

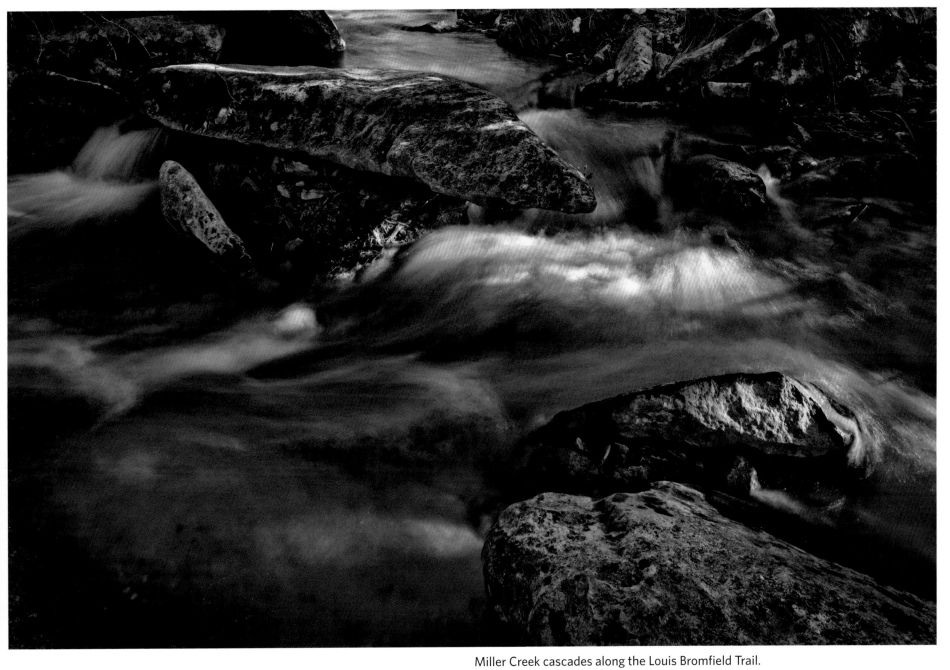

Miller Creek cascades along the Louis Bromfield Trail.

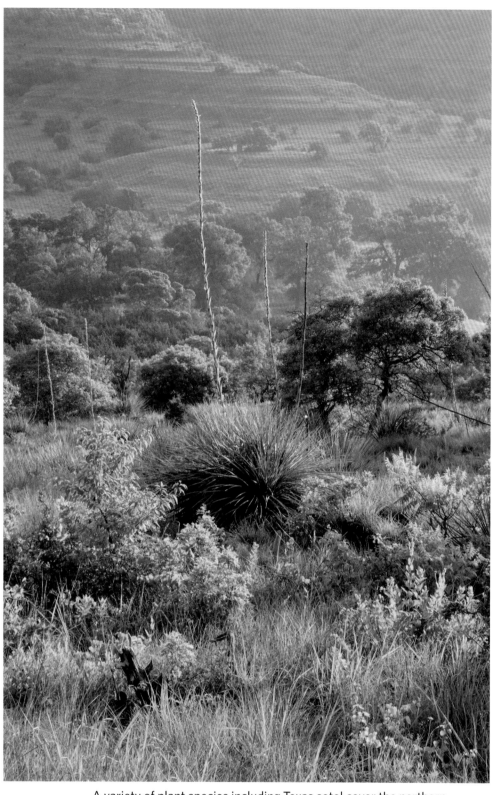

A variety of plant species including Texas sotol cover the northern slopes of this portion of the High Lonesome Pasture.

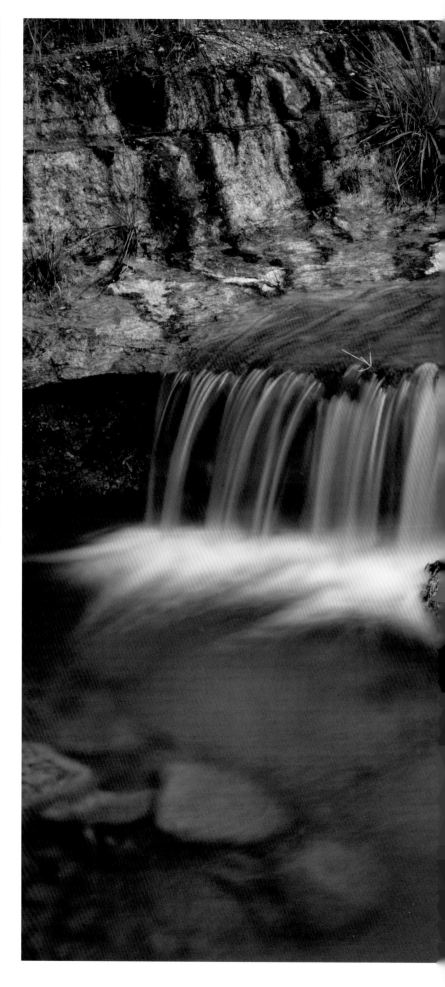

A beautiful cascade along the Jane Goodall Trail.

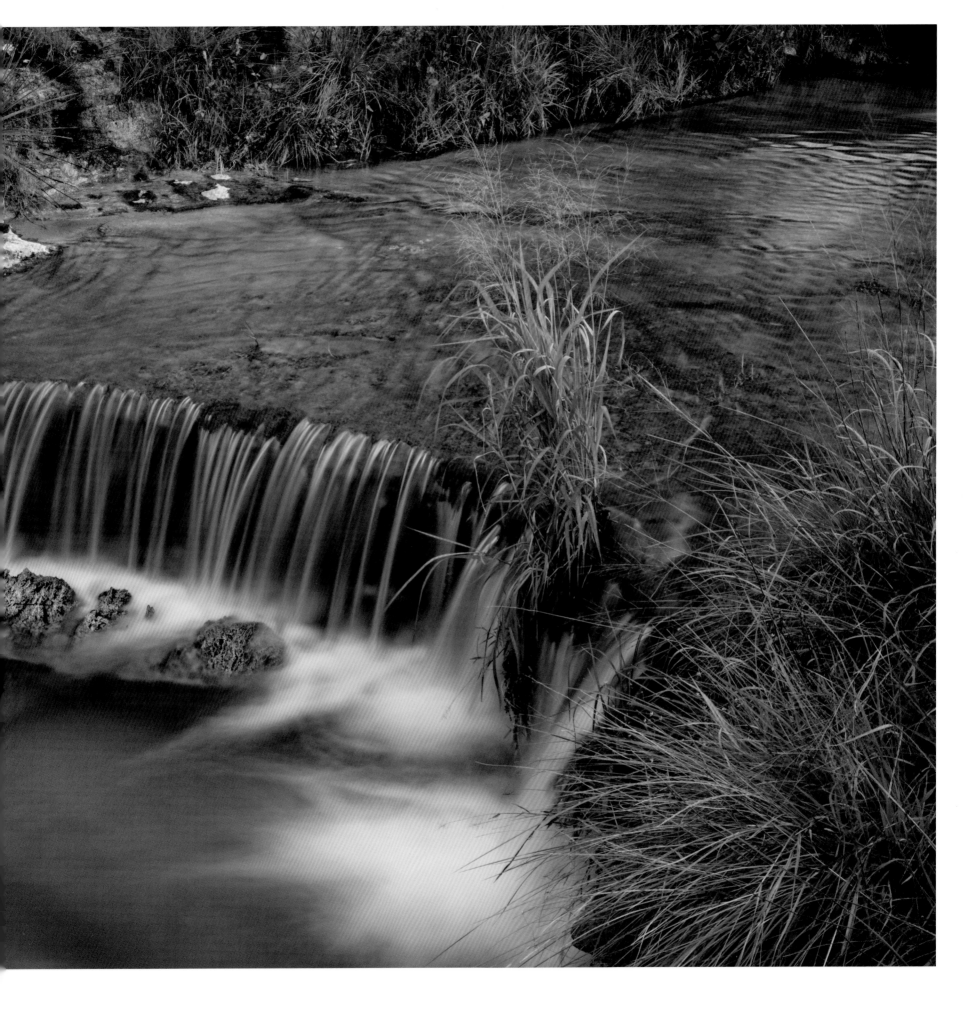

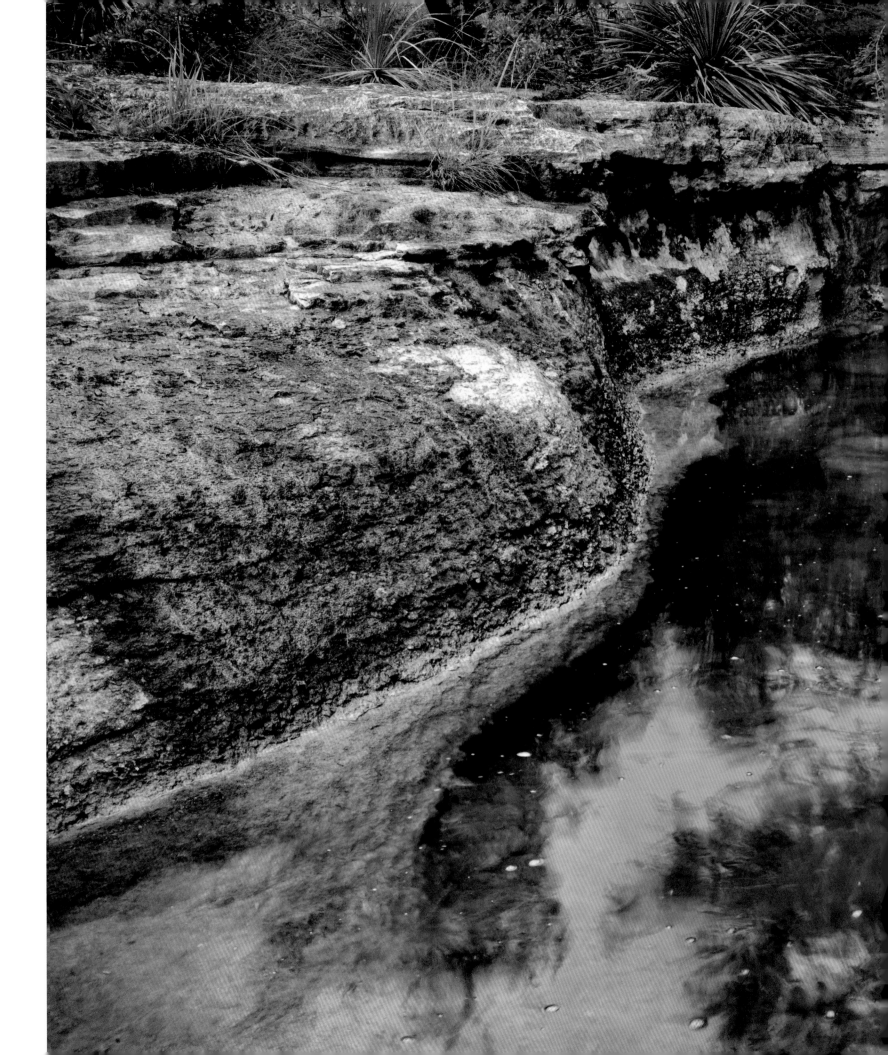

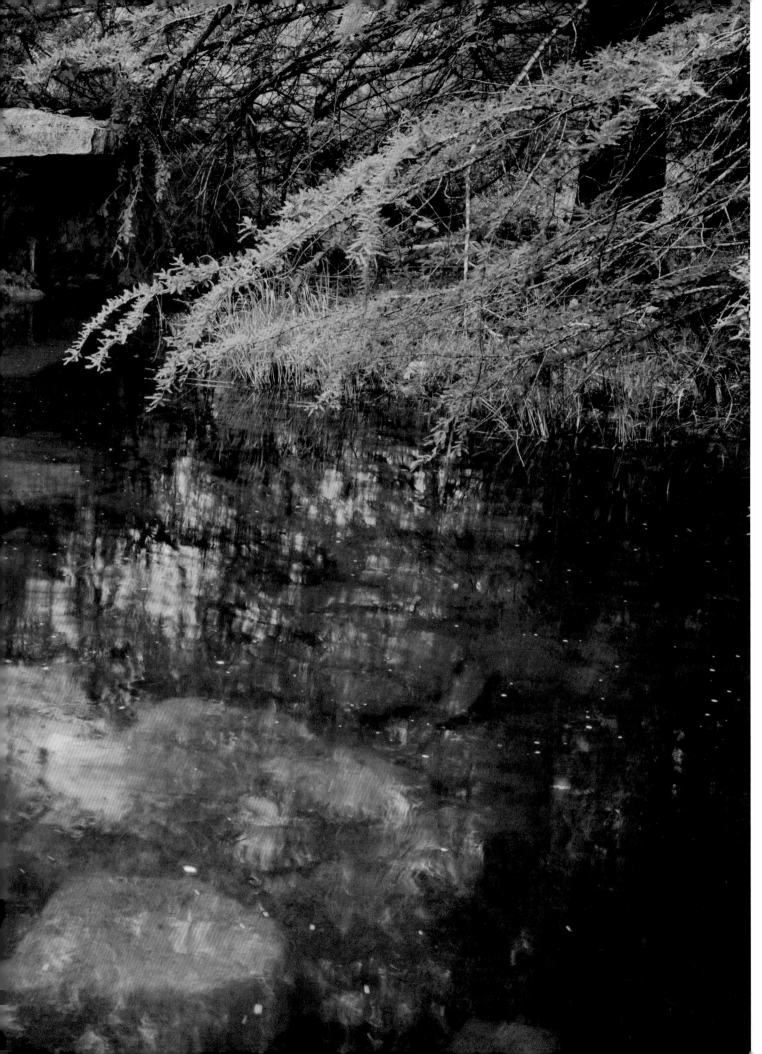

Miller Creek has calm water as well as cascades.

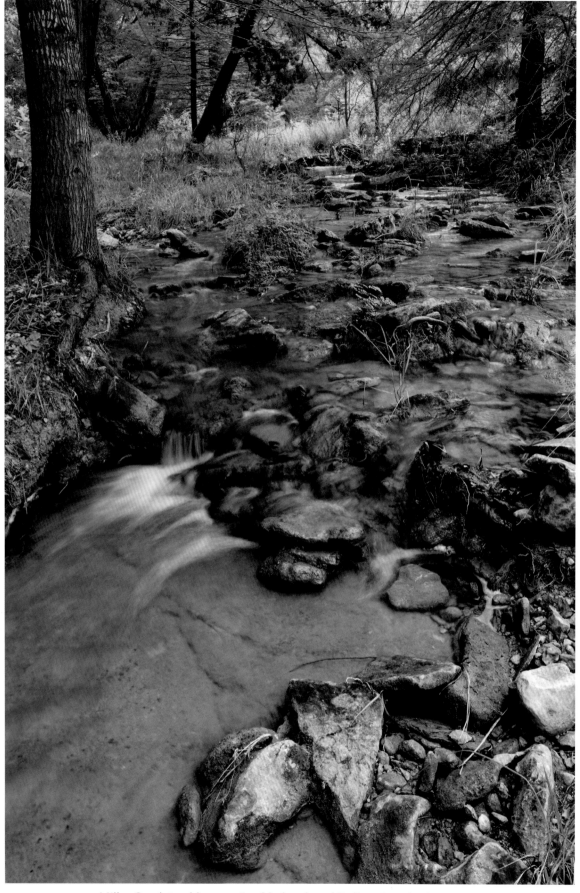

Miller Creek tumbles over jumbled rock and its limestone bed.

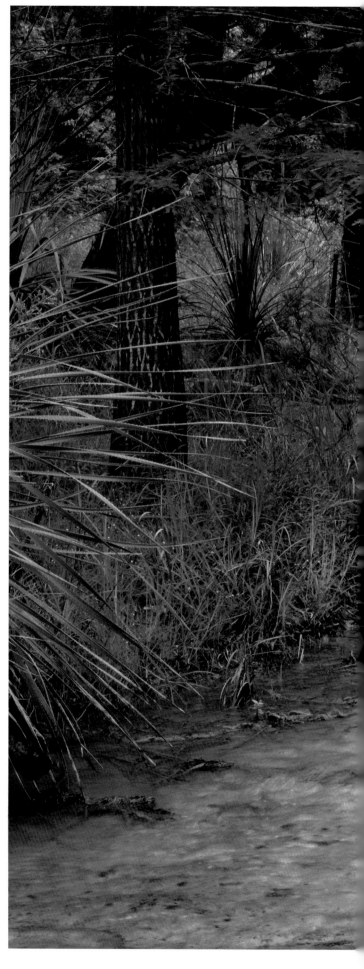

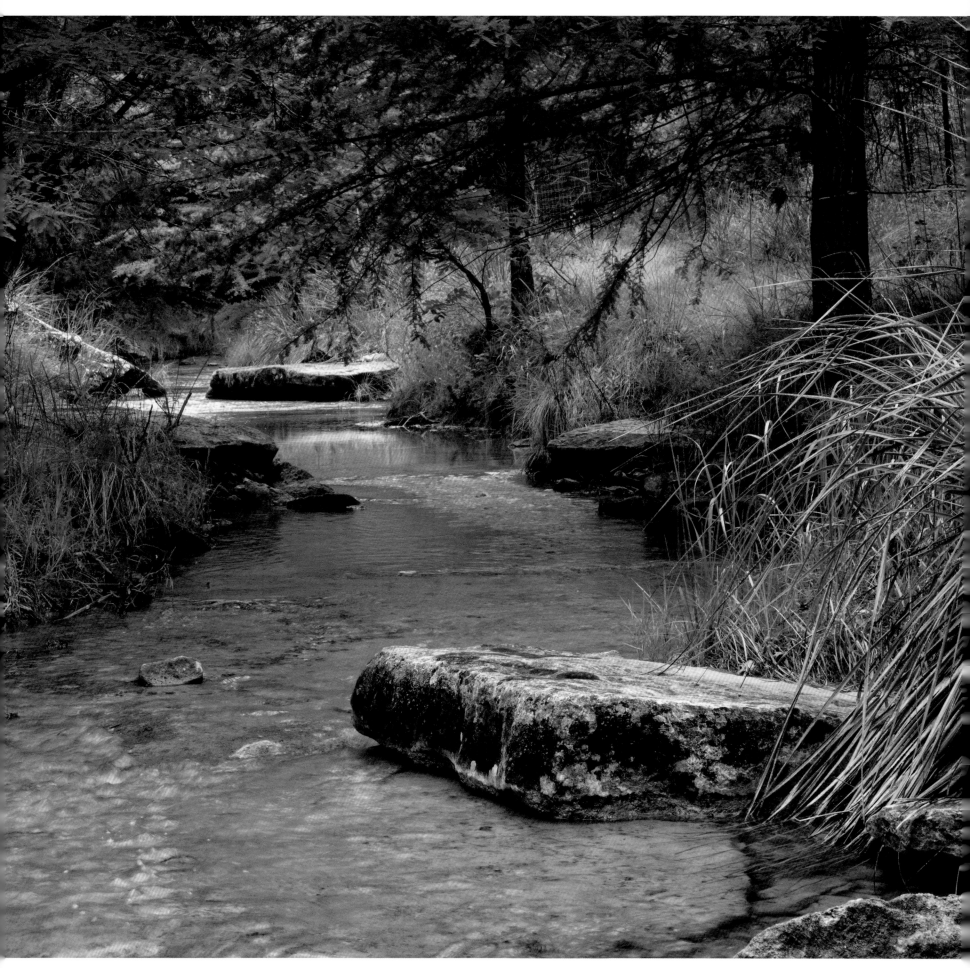

Miller Creek meanders through forests and rock outcroppings along the Louis Bromfield Trail.

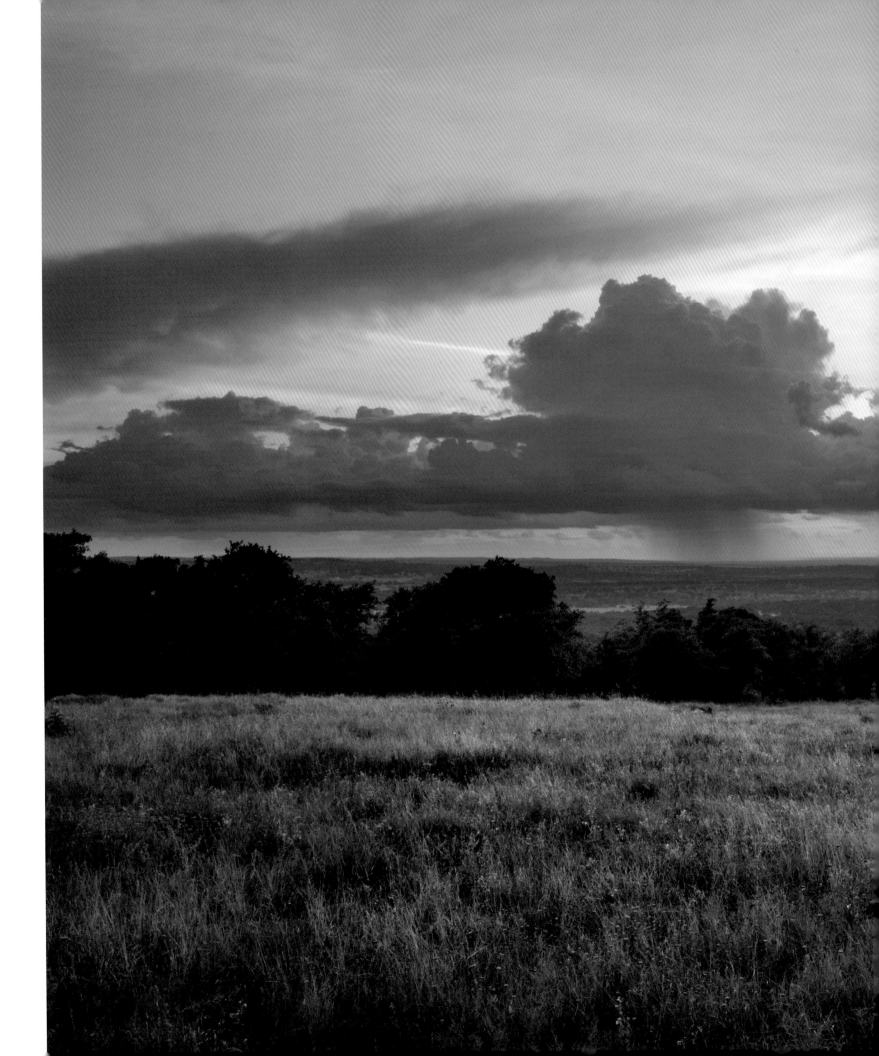

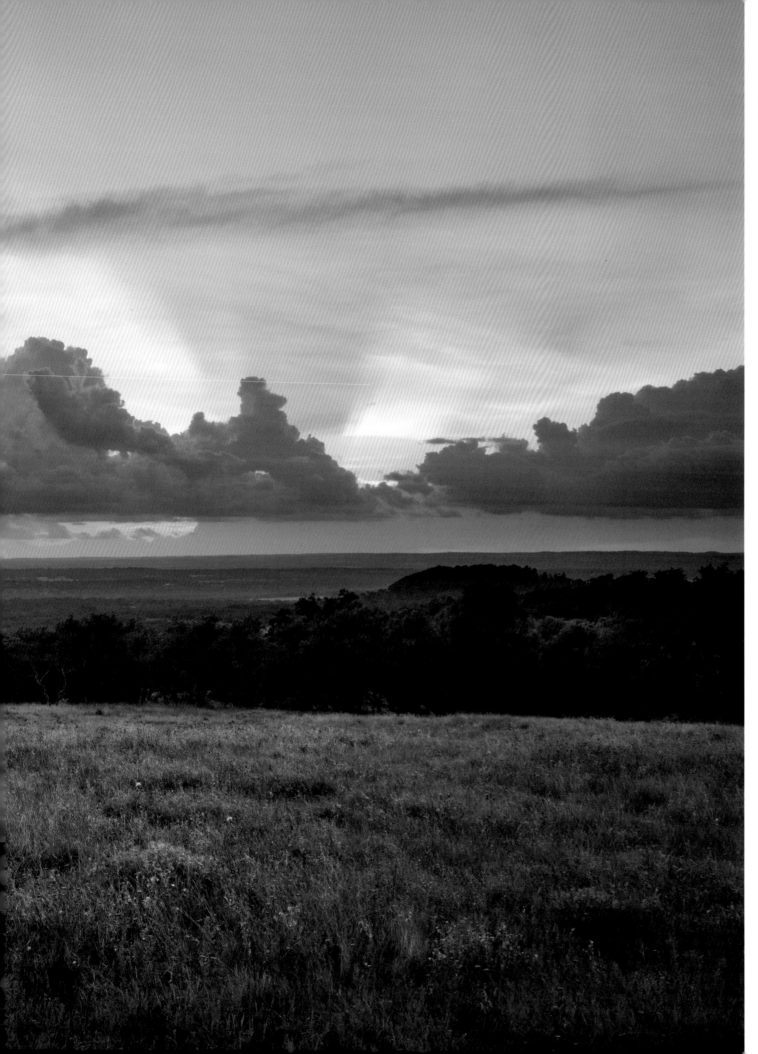

Thunderstorms passing to the west as seen from headlands of the West Slope Pasture.

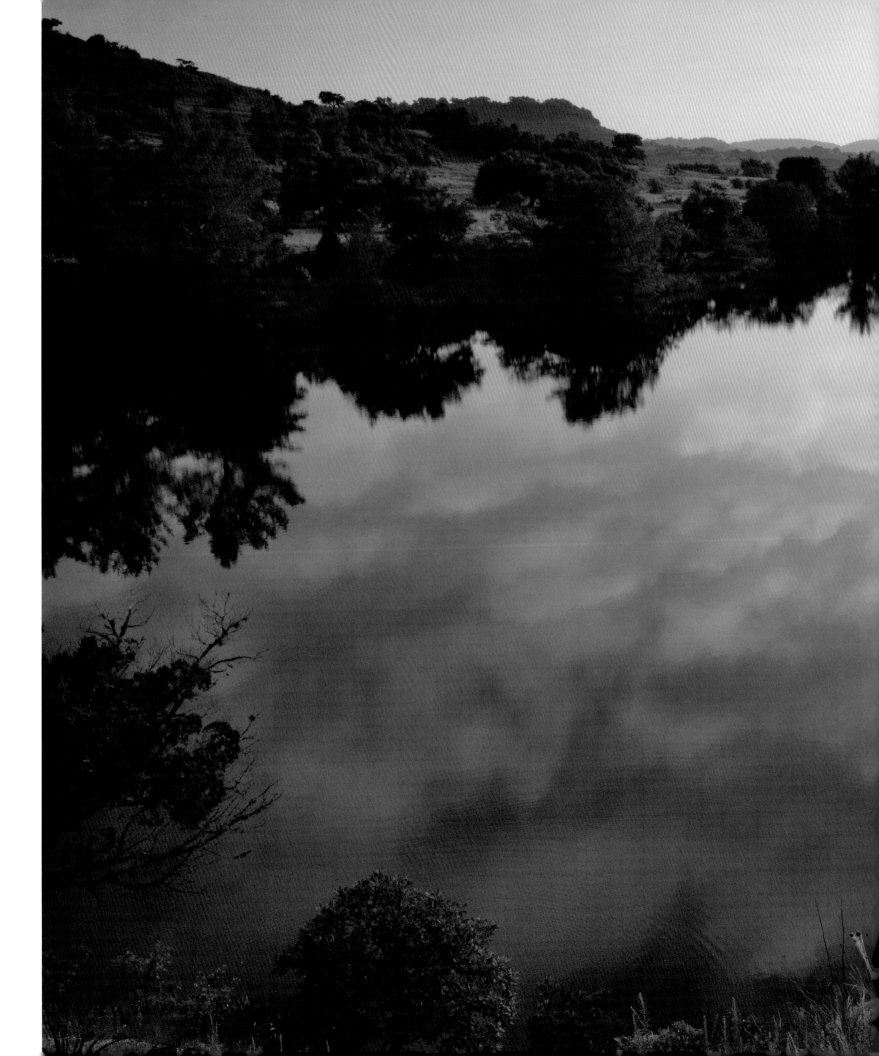

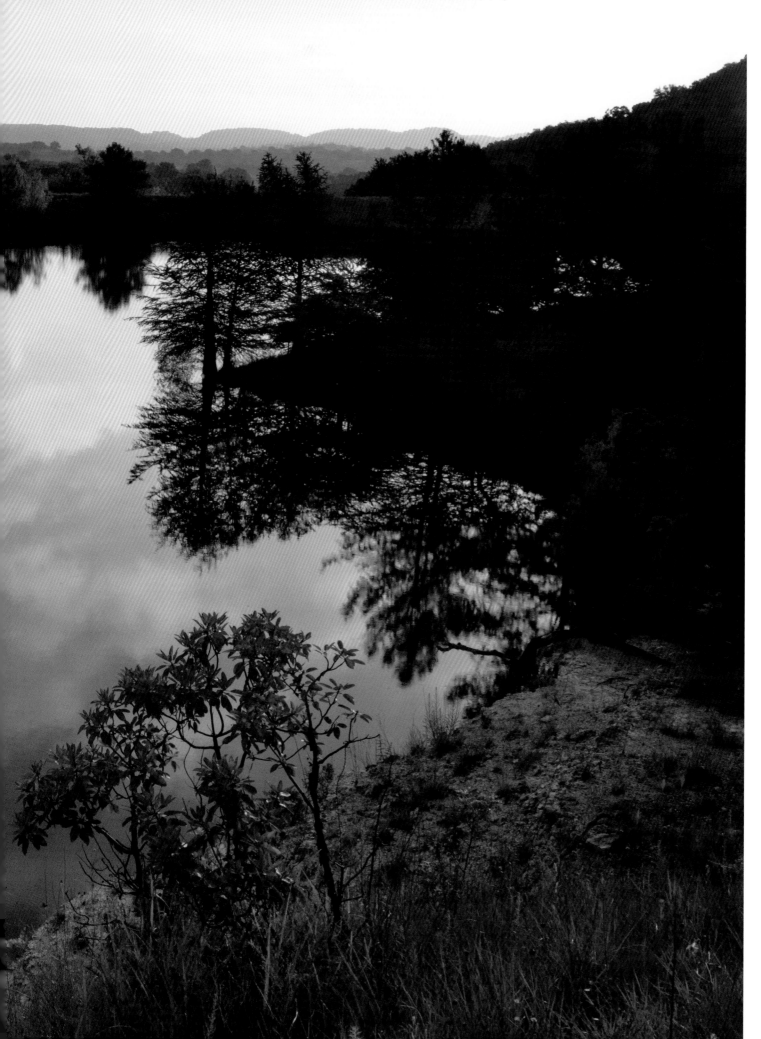

Dawn as seen from the Madrone Lake Overlook.

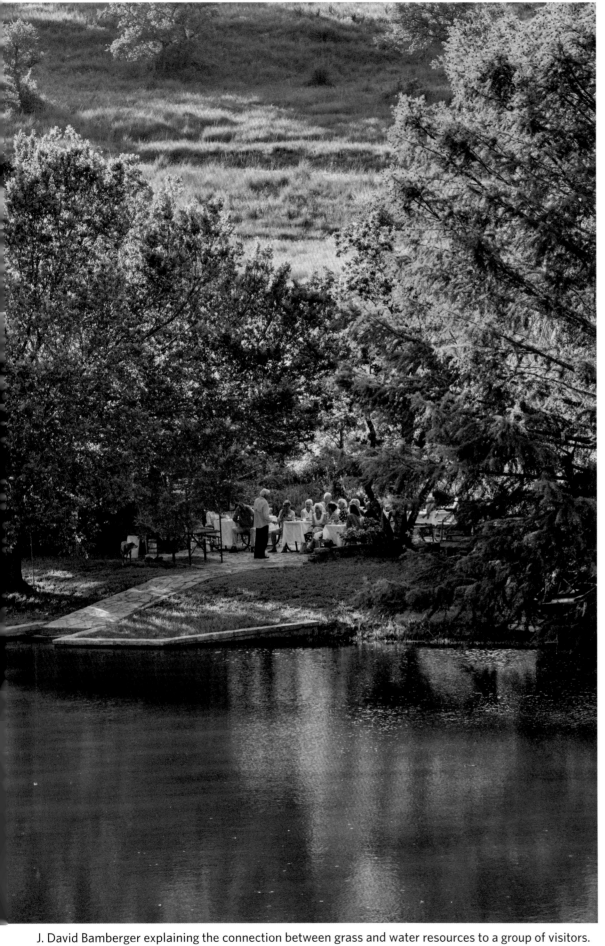

J. David Bamberger explaining the connection between grass and water resources to a group of visitors.

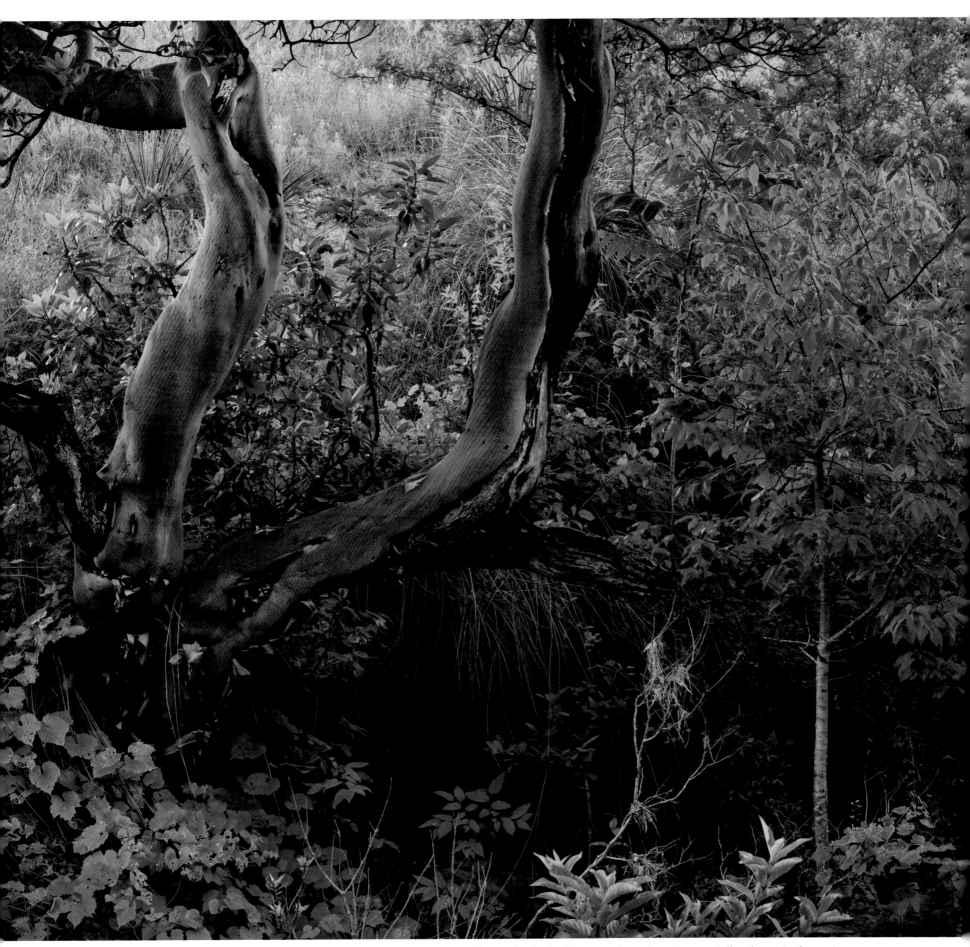

The red bark of a Texas madrone tree is especially vibrant in the spring.

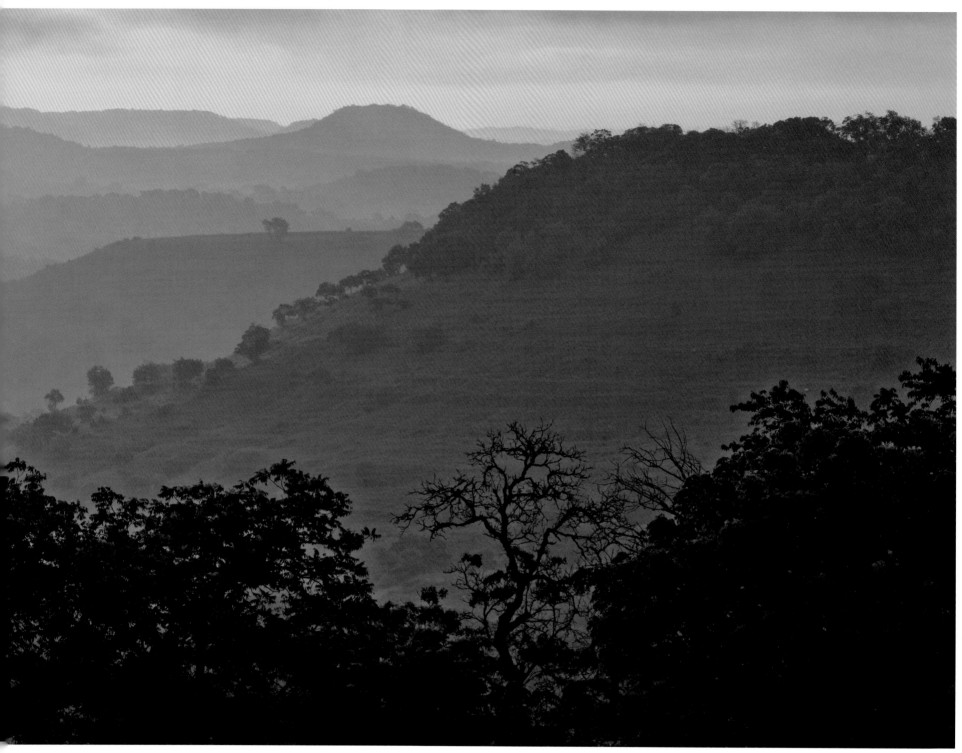

Sunrise overlooking the valleys below the High Lonesome Pasture.

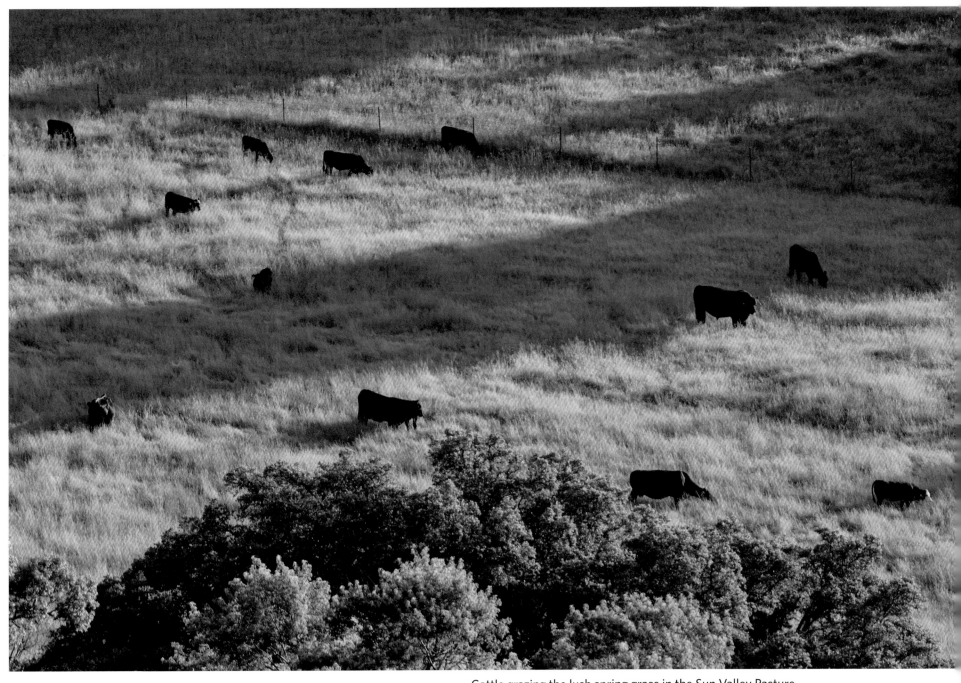

Cattle grazing the lush spring grass in the Sun Valley Pasture.

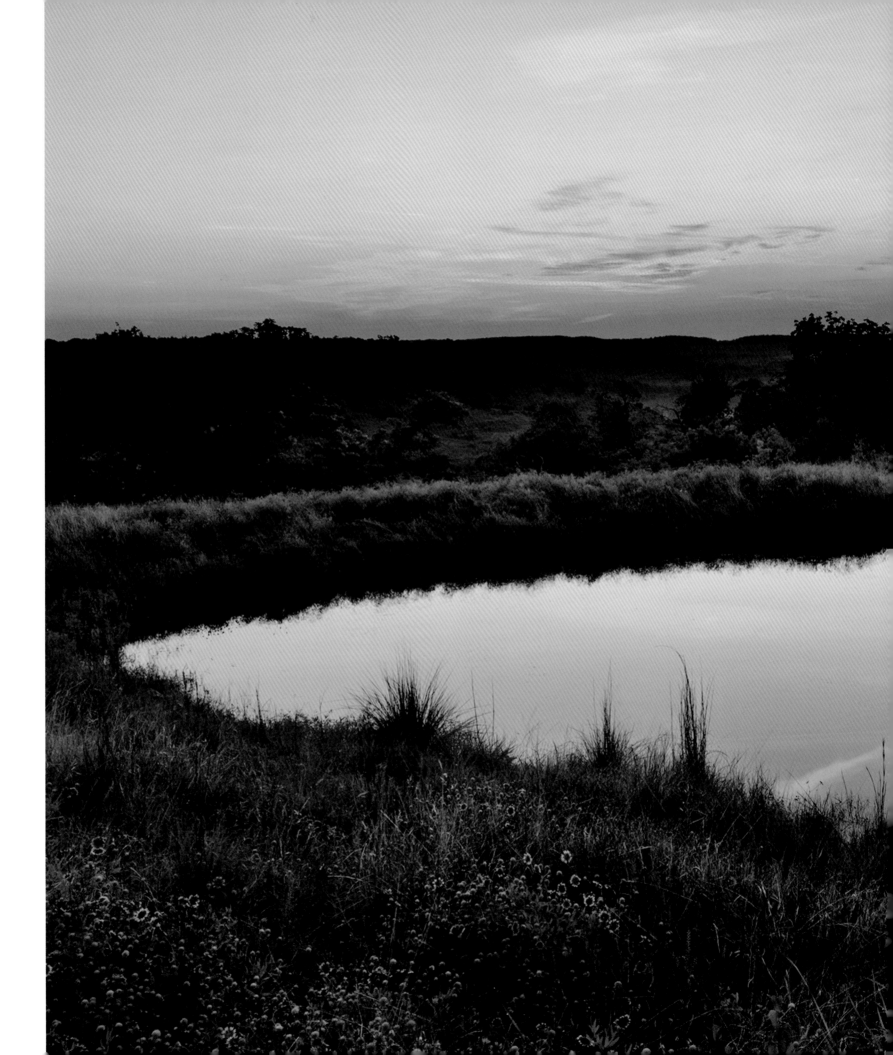

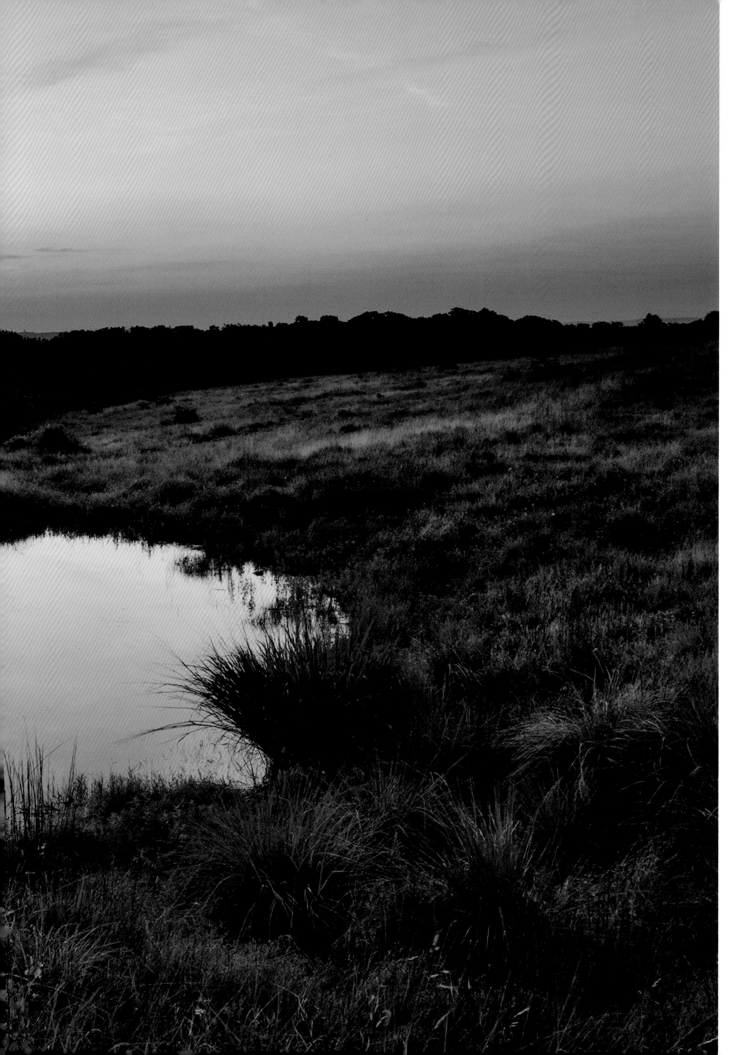

Sunrise reflected in a seasonal water catchment in the High Lonesome Pasture.

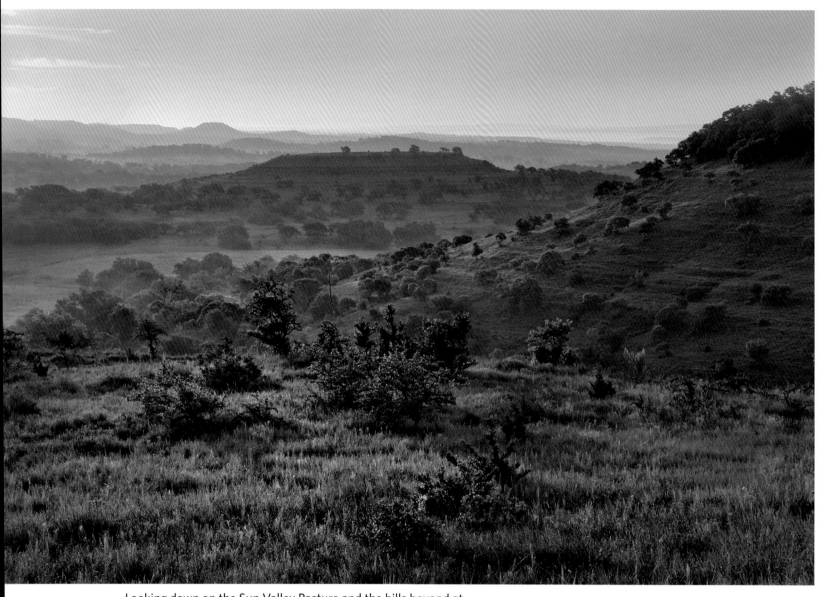

Looking down on the Sun Valley Pasture and the hills beyond at dawn.

(following spread) Dawn at the pond in the Malabar Pasture.

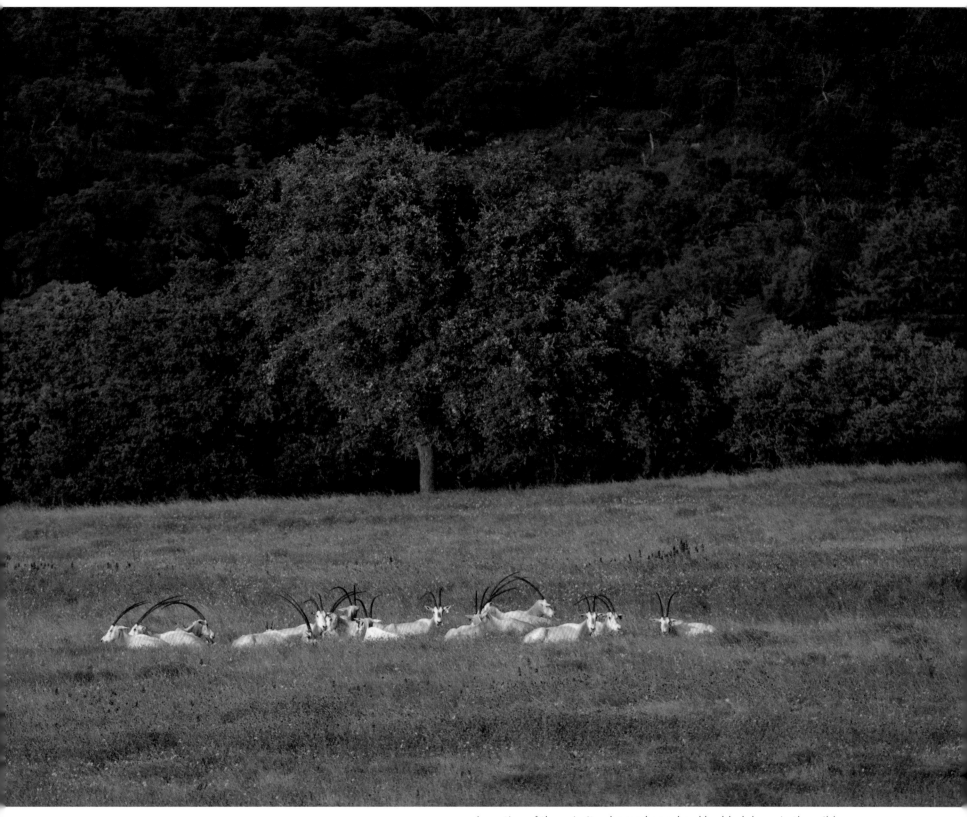

A portion of the scimitar-horned oryx herd bedded down in the wild-flowers of the Little Mexico Pasture.

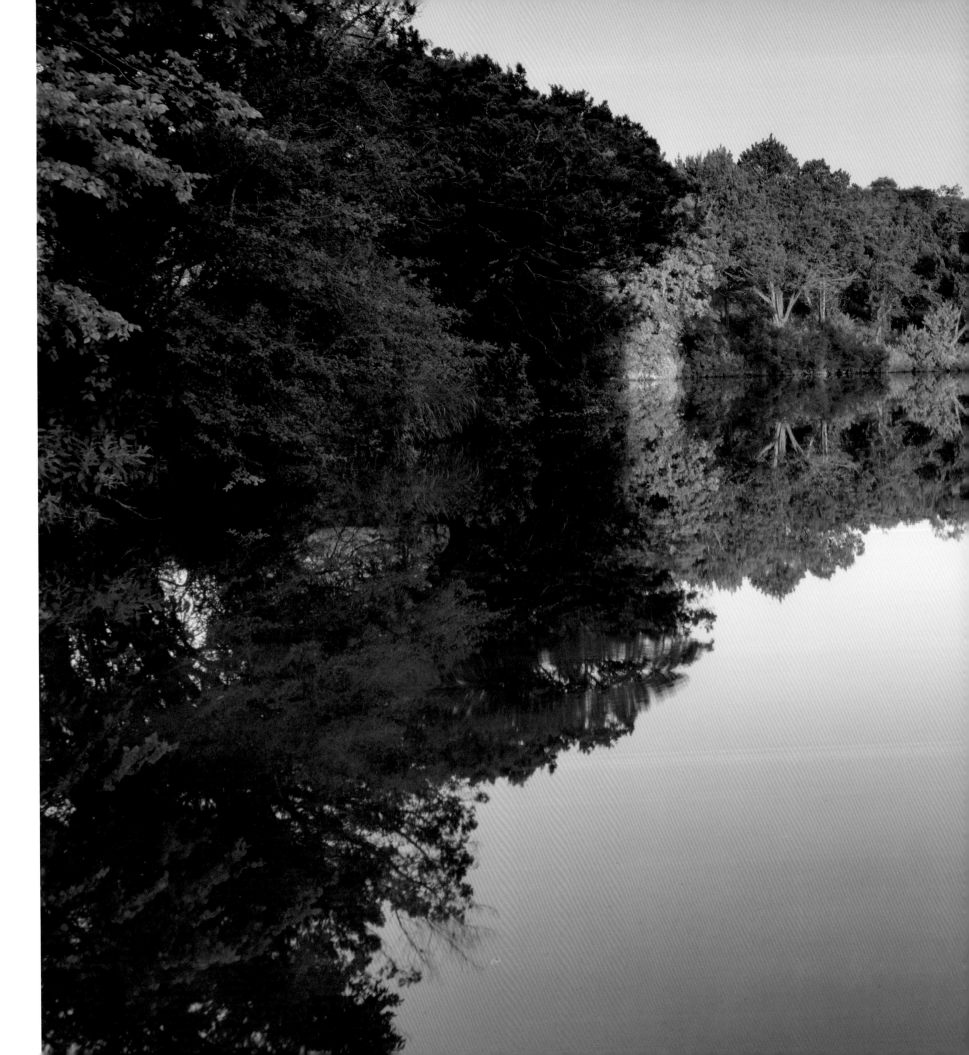

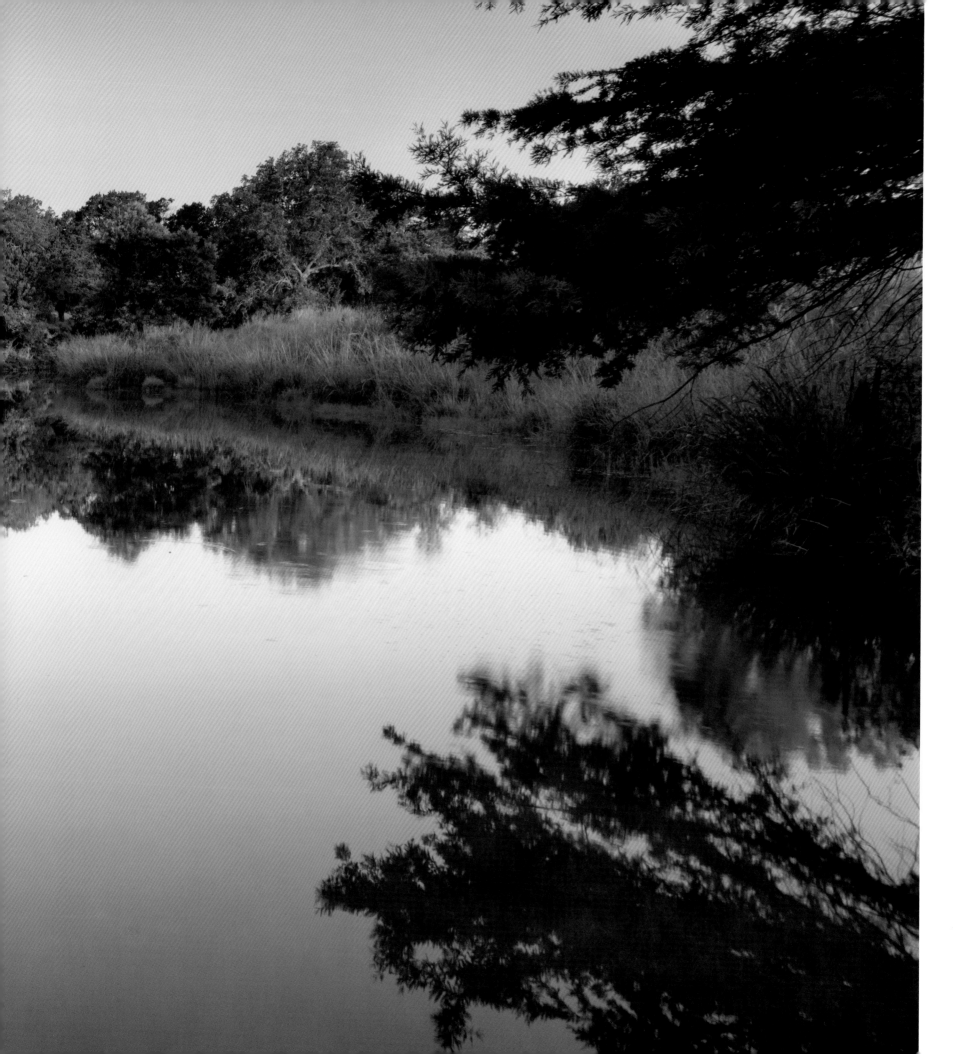

LIVESTOCK

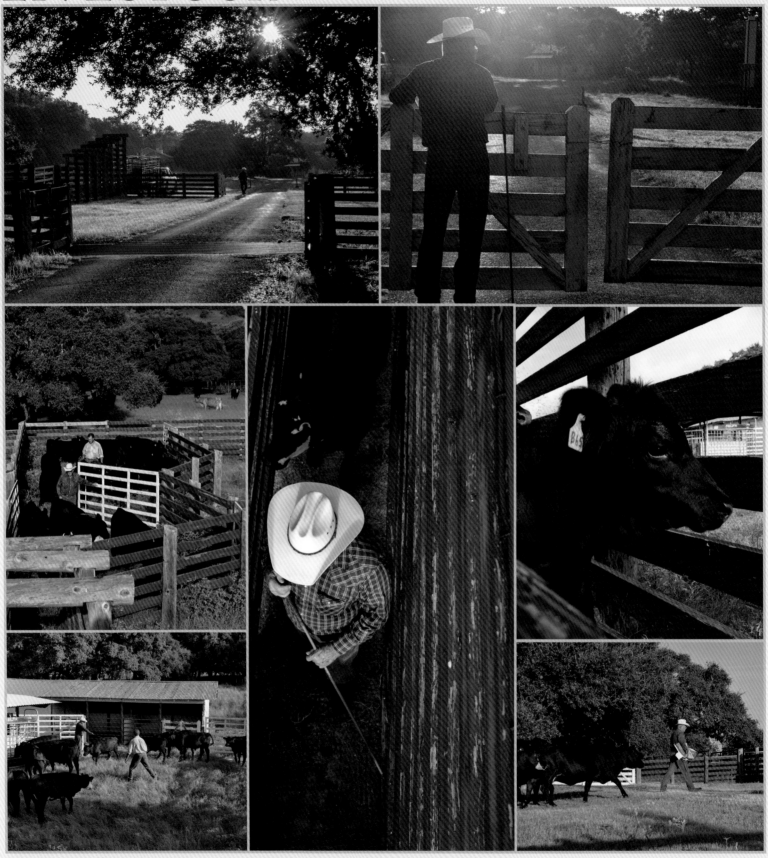

Experienced staff using dependable management practices and old-fashioned hard work under-
take livestock operations at the Bamberger Ranch Preserve.

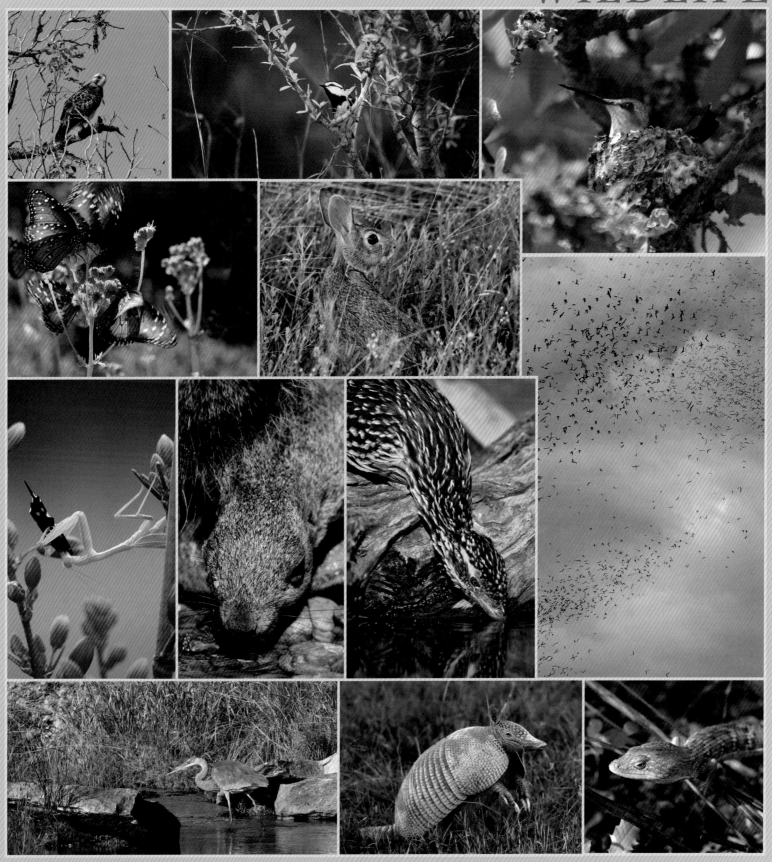

From bats to birds to bees, Selah is home to a variety of wildlife species living in healthy restored habitats supporting biodiversity at the ranch.

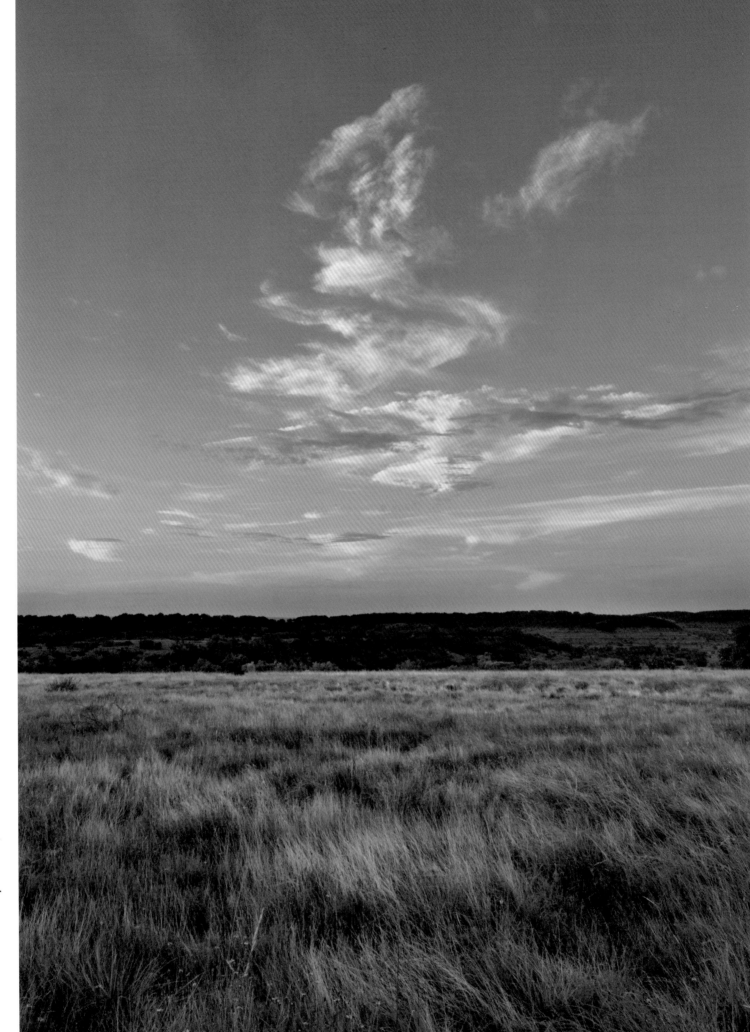

The High Lonesome Pasture sits over a perched aquifer, which feeds the life-sustaining springs of Selah.

SUMMER

In the summer of 1990, I left The Nature Conservancy to work for the Texas Parks and Wildlife Department, and I was eventually tapped to be its executive director by the Texas Parks and Wildlife Commission, whose members are appointed by the governor. It was an election year in Texas, and the expectation was that the Republican candidate for governor, oilman Clayton Williams, would win hands down.

But barely three months into my new job, Democrat Ann Richards was elected in a stunning upset, only the second woman to hold that office in Texas. Since I had been appointed by the previous Republican administration, I hunkered down and wondered what was going to happen to me. In early December, she called me to her office. She was a formidable politician, and I was terrified.

But in the best meeting I believe I have ever had with a supervisor, the governor-elect sat me down, just the two of us, and told me that she had grown up hunting and fishing along the Brazos River with her father and that she was not only supportive of the changes I had in mind to make at the department but would do whatever she could to help me.

My colleagues and I did make a lot of changes that first year, in a culture that had remained pretty much the same since the department's creation in the 1960s. These included expanding our efforts in wildlife conservation to so-called nongame species, those that are not hunted or fished. We moved aggressively to increase the role of women in key management positions, the educational level of our game wardens, and the overall diversity of our workforce. I was never sure that everyone was fully on board with what amounted to a kind of revolution, so, following the governor's first legislative session, I called J. David Bamberger and asked whether I could bring the governor and my team at the department out to Selah for a retreat in the summer of 1991.

Not only did the new governor accept my invitation and thoroughly entertain, inspire, and motivate the Texas Parks

and Wildlife leadership, she hit it off in a big way with our host. In some ways, it seemed meant to be: two brash, charismatic leaders who had reached great heights from modest beginnings, who loved the outdoors, and who defied convention.

J. David sent honey from the ranch to the Governor's Mansion, and she invited him to accompany us on an unforgettable float trip down the Rio Grande adjacent to Big Bend National Park. My opinion is that in the long run, their two big personalities were just too much for the same space, and they never really became an item as a couple. But the governor appointed J. David to serve on the Governor's Task Force on Nature Tourism in the Lone Star State, which I cochaired along with Debra Kastren, at the time the head of the Texas Department of Commerce.

By this time, J. David had coined the phrase "people ranching" to describe a big part of the effort at Selah, which was to introduce people to the outdoors and educate them about the importance and value of nature and open spaces, and it was catching on around the state and nation in institutions like Texas A&M University and in publications like *National Geographic*. In Texas, as Ann Richards assumed power, tourism was already the third-largest industry in the state at $23 billion in yearly expenditures. The fastest-growing segment of that emerging economic powerhouse was nature-related tourism, which during the 1990s exploded in our state (and around the world). The Governor's Task Force defined nature tourism at the time as "discretionary travel to natural areas that conserve the environmental, social, and cultural values while generating an economic benefit to the local community." Hundreds of thousands of hunters, anglers, campers, bird-watchers, and more come to Texas every year to pursue their favorite pastime in the outdoors. The state ranks first among all the states in hunting opportunities and second in fishing, and it is generally thought to be one of the best destinations for bird-watchers in the world.

In Texas, where the landscape is almost entirely owned by private citizens, J. David's concept of "people ranching" fit the nature tourism idea like a glove, creating an opportunity for landowners to attract those seeking to learn about and enjoy a broad range of outdoor activities that have little

negative impact or even a beneficial effect on the environment. For J. David, "people ranching" offered traditional ranching families a supplementary or even alternative source of income while imbuing guests with an ethic of land and water stewardship. Thus, with the passion and dedication of Bamberger and his team on the ranch, Selah increasingly became a destination, a sanctuary, and a model for other private landowners to emulate.

Although J. David's vision of "people ranching" was well established by the mid-1990s, the coming of Margaret Campbell to the ranch was transformational.

It didn't go well at first. Margaret, an environmental activist and volunteer at the Austin Nature and Science Center, was actually introduced to J. David by a former colleague of mine at The Nature Conservancy, Mary Kay Sexton. By this time, J. David had been divorced from his first wife, Donna, for several years.

Margaret had grown up in Louisiana in a family of intellectuals. Her father was a professor at Louisiana State University, and her sister became a distinguished microbiologist in Europe. Margaret was dyslexic, and her condition was not discovered until she was in middle school, by which time she was well behind her peers, having struggled with book learning. Her father, the professor, neglected her so cruelly that he would often ignore her at family events, preferring her sister, whom he proudly introduced to his colleagues and acquaintances. Maybe in part as a result, Margaret became a marijuana-smoking hippie with little education who went through two failed marriages and multiple jobs before bringing her three children to Texas to start a new life.

One of Margaret's daughters, Margie Crisp, who is today a distinguished author and artist, was herself a free spirit who did her best to stay away from school. Margie told me she was forced by the truant officer in the town of Buda, south of Austin, to enroll in Jack Hays High School, where she was miserable. So her mother moved the family to Sayersville, an old railroad stop off Highway 95 in Bastrop County, where the kids could attend the Greenbriar Free School down the road.

In time, the family of four moved to Greenbriar, located on 170 wooded acres in the post oak savanna east of Austin. Now known as Greenbriar Community School and bearing little resemblance to "school" in the usual sense of the word, Greenbriar was part of the free school movement of the 1960s, which focused on sustainability, home schooling, and alternative learning.

In Bastrop County, Margaret plunged into environmental activism, founding Central Texas Lignite Watch, which successfully fought off two coal strip mines proposed by the powerful Lower Colorado River Authority. Her work in the environmental community led Margaret to the Austin Nature and Science Center, where she experienced her own transformation. She found that she had an ability to learn directly from nature and that the environmental movement's highest calling was, in turn, to convey that knowledge of nature to children, introducing them to its joys, wonders, and responsibilities.

Margaret, like thousands of other conservationists across America, began to understand that in our modern, urban, technological society, children have become increasingly estranged from the outdoors. Author Richard Louv writes in his seminal book *Last Child in the Woods* that as this separation occurs, "their senses narrow, physiologically and psychologically, and this reduces the richness of human experience."

Today, more and more empirical research is yielding evidence linking physical and mental health to experience with nature or the lack thereof. The increasingly broken bond between children and the natural world has consequences for society as well. Hunters, anglers, and others who enjoy the outdoors have historically funded virtually all government fish and wildlife conservation programs in both our state and national governments. Those who pay entrance and camping fees to access state parks provide most of their funding. When conservation programs are threatened in state legislatures or in Congress, it is these enthusiasts who are outside knocking on the doors of elected representatives, writing to political leaders, and demanding that they stand up for the environment.

What we know is that if our kids are not being exposed to nature, they are missing out on an experience that is

good for them. Empirical evidence tells us that connecting with the outdoors can be a powerful form of therapy for everything from childhood obesity to attention deficit disorder.

Margaret Campbell instinctively knew these things, and although she and J. David did not exactly hit if off at first, later on a summer day at Selah they realized they had much in common. The chicken king's existence and purpose was again transformed when Margaret came into his life for good. In 1998, Margaret and J. David were married, and through her his thinking evolved to make reaching out to educate the children and the public a fundamental component of the liturgy at Selah.

Today, an average of three thousand visitors come to the ranch annually to participate in educational programs inspired largely by Margaret, and each year, more and more of them are children. The centerpiece of this noble effort is Camp Selah, launched in 2005 as an educational and adventurous multiday nature camping experience. At Camp Selah, the nine- to eleven-year-old beginners swim in the lake and climb in the hills, turning over rocks and looking for dinosaur tracks, in an initial exposure to the wonders of nature. The program targets kids who cannot afford to attend the fancy summer camps in the Hill Country and features leadership and mentoring from Camp Selah alums who serve as junior counselors.

"There is something special about teaching nature. You can feel it in yourself. It's called passion and when you are talking, those who are listening will feel it too."

Older youth, generally twelve- to fourteen-year-olds, move beyond general nature observation to more formal scientific investigation. This experience is for youngsters with a strong interest in nature, and it imbues them with both a greater understanding of the environment and the idea of a personal environmental ethic.

On a sunny weekend soon after J. David and Margaret were married, Margaret and ranch executive director Colleen Gardner were demonstrating the "rain machine" at a summer festival in nearby Johnson City. The contraption is a funky but wonderful tool for showing the differ-

ence between what happens to raindrops that fall on land infested by cedar and rain that falls on land carpeted with grass. Water flowing through the former comes out of the machine a dirty brown, while the water filtered through the latter emerges crystal clear.

In the midst of the demonstration, a young man approached them with a snake around his neck. At the time, Jared Holmes was a herpetology student at Texas A&M, and at first he was skeptical of the Rube Goldberg contraption. But he soon fell under the spell of Margaret Bamberger and began volunteering at the ranch. Jared told me that he and Margaret shared the quality of seeing the

world with a child's curiosity and perspective, and he is still there, now full time, still with a snake around his neck and still educating kids and coordinating research in biodiversity at Selah. That research is the underpinning for the Margaret Bamberger Research and Education Center and could not have been imagined when Margaret took the youngster with the snake around his neck under her wing.

One of the most wonderful experiences I ever had at Selah was when I accompanied Jared and a bunch of kids into the field on "Snake Day." Mary Kay Sexton and Margaret had the idea that many kids who don't participate in football or other athletic activities are often labeled geeks by the more popular, trendy youth. They decided to create activities at the ranch for kids they proudly called "nature nerds," and Snake Day was designed just for them.

At nine in the morning, my wife, Nona, and I arrived at Hes' Store and joined a gathering of excited children carrying the sticks they would use to pry up rocks, along with special gloves for handling reptiles. One young man was wearing a T-shirt that said "I'd Rather Be Herping." Jared, with infectious enthusiasm, greeted them by telling the kids there would be three rules: 1. Have Fun! 2. Be Safe! and 3. Don't Spoil My Fun. For the next several hours, I have rarely seen young people having more fun than these intrepid snake hunters spread out across the back end of Selah, turning up rocks, squealing, and gleefully showing their finds to the rest of us. Within two hours, they had caught fifteen different species, and before the morning was over, they had collected a total of sixty specimens of various reptiles. And they had a blast.

Each find was carefully recorded and passed around for all to examine while Jared and several volunteer experts he had recruited explained to the group the life history of the particular critter and its place in the ecosystem. The excitement of these "nature nerds" warmed me like the sun on a basking lizard as I realized what a blessing the opportunity to participate in Snake Day was for them. Once again, I was also reminded of the many blessings that have come to me since I met J. David Bamberger.

"I didn't know how we would use the country store . . . a weekend rental or housing for deer hunters. For the most

part that never happened. What did happen, however, was the education of so many visitors, young and old about conserving family history and culture. From the porch of the country store, children are encouraged to visit a grandparent, to ask them questions.

The best letter of my life came from a 92-year-old grandfather who told me his granddaughter now visits him once a week with a clipboard asking all kinds of questions. 'Thank you sir.'"

Shortly after that memorable Texas Parks and Wildlife staff retreat in 1991, I had occasion to take advantage of J. David's

hospitality again. In my time at Parks and Wildlife, it had become abundantly clear to me that my biggest problem was *money*. Inspired by J. David and others, we launched a whole series of entrepreneurial initiatives to try to supplement the increasingly limited resources we received from the state. We put gift shops in the state parks. We formed "Friends Groups" to bring private support through volunteer labor, donations, and more. We established conservation license plates to support everything from fish hatcheries to wildlife research to the state parks themselves.

Along the way, I discovered that in California, a foundation had been established to secure philanthropic support for the park system there, and that its founder was the legendary William Penn Mott, director of the National Park Service in the administration of another Californian, Ronald Reagan. Mott created the California State Parks Foundation in 1969, the year I accepted an internship with the National Recreation and Park Association in Washington, DC. Mott was already a national figure at that time, and it was through the connections I made in those days that many years later I was able to contact Mott, who had retired from the Park Service, and invite him to Selah to show us how to set up a foundation.

My bosses at the time were nine commissioners on the Texas Parks and Wildlife Commission who had been appointed by both Republican and Democratic governors. To a man and one fine woman, they understood the need for more revenue, and several were significant philanthropists themselves. They also were eager to meet the man who had been running the National Park Service, so when I asked J. David whether I could bring another group out to Selah, the stage was set.

Like Bamberger himself, William Penn Mott was an extraordinary man, starting his long and distinguished career as a landscape architect in the 1930s, and in 1946 becoming superintendent of the City Parks Department in Oakland, California. On his way to the National Park Service, he served as CEO of park systems at the local, regional, and state levels, including the California State Park System. In each of these roles, he led his organization to the forefront of the parks movement in America. I can't recall whether it was chicken that J. David served us in his home at the ranch that

evening, but as we sat in the living room and listened to this remarkable man, it felt like a new beginning.

Essentially, what we learned from Bill Mott was that in the late 1960s, conservation in California was in the same shape we now found ourselves in, and revenues from the state were simply not enough to meet their needs. The first, most important principle in establishing California's foundation, he told us, was that the foundation existed explicitly to serve the department. Its bylaws and operating procedures specified that it would cooperate with the agency. Importantly, he further informed us, upon creating the California State Parks Foundation, he asked Reagan, who was then governor, to not only approve it but also announce it.

We took Mott's advice to heart on both counts, and the chairman of the Texas Parks and Wildlife Commission, Ygnacio "Nacho" Garza, and I informed Governor Richards that we had met at the Bamberger ranch to discuss the creation of the foundation. She was instantly supportive. She took the lead in helping us recruit former commission chairman Edwin L. Cox Jr. to be the Texas Parks and Wildlife Foundation's first chairman. She also held a reception at the Governor's Mansion and invited oilman and philanthropist Perry Bass, chairman emeritus of the commission, to join her in announcing it.

To date, the Texas Parks and Wildlife Foundation, born at Selah, has saved thousands of acres of important natural lands in Texas, built state-of-the-art fish hatcheries, raised more than $125 million for conservation in the state, and become a model for similar institutions across America.

Around the same time, J. David invited me to lunch at Club Giraud in San Antonio. He told me he had done what he set out to accomplish on his second tour as chairman of Church's Chicken and had retired permanently from the company. Word had gotten around that he was free from his responsibilities there, and several conservation organizations were recruiting him to serve on their boards. Notable among them were The Nature Conservancy of Texas and Bat Conservation International (BCI). I was an alumnus of both organizations, and though I love the conservancy and got more from the organization than I ever gave it, I told him I thought the need was greater and he could do more at BCI. He took my advice, and thus began the transformation

of the remarkable place where we first met, Bracken Cave. At the time, BCI was headed by its charismatic founder, Merlin Tuttle, and I probably should have foreseen that sparks would inevitably fly between these two incredibly strong warriors.

Although I had tried, I had been unsuccessful in my attempts to purchase Bracken Cave from the Marbach family for The Nature Conservancy before I moved on to the Texas Parks and Wildlife Department. J. David's first act as a BCI board member was to team up with fellow trustee Don Grantges of Fort Worth and attempt to buy the site for the organization. The combination of J. David's down-to-earth ability to connect with all kinds of people, his unbelievable tenacity, and his unmistakable charisma charmed the Marbachs to the extent that they ultimately treated him as one of the family. Between Bamberger and Grantges was a wealth of real estate experience, and with their efforts and the generosity of the Ewing Halsell Foundation of San Antonio, BCI finally purchased the cave, which is now protected forever.

What a victory for conservation! Each evening from March to October, as dusk begins to deepen around the mouth of Bracken Cave, fifteen million to twenty million Mexican free-tailed bats swirl into the twilight in one of the globe's most unique and spectacular natural phenomena. Virtually all of them are females. Having mated in Mexico before migrating north to Texas, the pregnant mothers concentrate in caves throughout Central Texas. The insulation provided by the limestone formations, along with the very magnitude of their numbers, creates the ideal temperature for incubation of the newborns.

"I remember my experience with Bracken Cave. I called it the ninth wonder of the world, seeing the emergence of twenty million bats. It wasn't just the bats but the whole experience of going deep into the ranch on a dusty road to get to this special place, unspoiled and truly in its natural state. It's the experience of sitting on a log, hearing the wing beat, smelling the guano that is utterly intoxicating."

Unsurprisingly, J. David did not stop with the purchase of the cave. He brought his Dam Aggie, Leroy Petri, to the site,

and between them they fashioned and installed an elegant but understated system of trails, interpretive signage, and a composting toilet, which enabled BCI to begin to unobtrusively share this marvelous resource with other people.

With the kind of opportunity to view bats that the installation at Bracken Cave provided, coupled with the educational outreach at BCI, bat watching soon became a significant attraction throughout the Hill Country of Texas. And as public interest in the pursuit grew, the idea of developing Bracken Cave as a full-on tourist attraction began to build. Tuttle, some of his board members, and boosters from San Antonio envisioned a major development at the cave, an elaborate architectural facility that would include exhibits and be able to accommodate large numbers of people.

This push to commercialize the site was too much for J. David, whose toil and sweat at the cave had enabled it to become much more accessible but in a low-key and sensitive manner that did not threaten the natural resource itself. Following an inevitable clash with Tuttle, J. David retired from the BCI board and did his own thing.

At the age of sixty-nine, when most people are about done, J. David decided to create his own bat cave—in his words, "the world's largest man-made structure specifically designed for the free will use of half a million mammals." As construction got under way, I went out to Selah and met

Jim Smith, the project engineer for the undertaking, whom J. David had met in New Mexico.

Only Bamberger would have spent more than $150,000 to build what, at that point in its construction, resembled giant playground "monkey bars," with thousands of pieces of steel rebar wound together in the shape of a huge igloo. As the project—quickly dubbed "Bamberger's Folly"— evolved, it began to resemble the domes of a cathedral, and before it was done, in addition to twenty tons of rebar and eight thousand square feet of wire lath, the structure included fully two hundred cubic yards of gunite cement.

I have to admit even I was skeptical. By this time, based on the near-miraculous things I had seen him accomplish at the ranch, I knew he could pull it off. But as he spread guano on the floor to attract what he hoped would be thousands of new residents to what he now called his "chiroptorium" (from Chiroptera, the scientific order bats belong to, and the word "auditorium"), I fervently hoped he was right.

An interminable five full years passed with no bats, and it looked like it wasn't going to work. J. David had included an observation chamber inside the structure for the purpose of viewing the little creatures at close range. I remember thinking during construction how cool it would be to be inside the habitat and watch their behavior through three large plate-glass windows. As it turned out, the bats apparently did not like the glass at all. After the ranch crew covered the windows for good in the winter of 2003, several thousand bats arrived the following summer.

One of the great moments of my long relationship with J. David Bamberger came when he invited Nona and me to sit on the back of his pickup and be among the first to watch the nightly emergence of his Mexican free-tailed bats, which by August of that year totaled more than a hundred thousand.

Today, Bamberger's Folly has been written about and recognized for its success around the world. The bats come every year now, and J. David is pushing to have the word "chiroptorium" officially listed in the dictionary. I would bet he succeeds.

"To Whom It May Concern:

We would like to introduce the following word for inclusion in the next edition of the Oxford Dictionary of the English Language:

Chiroptorium n. A large man-made underground or ground covered cave-like structure designed as a roosting site for thousands of free ranging bats."

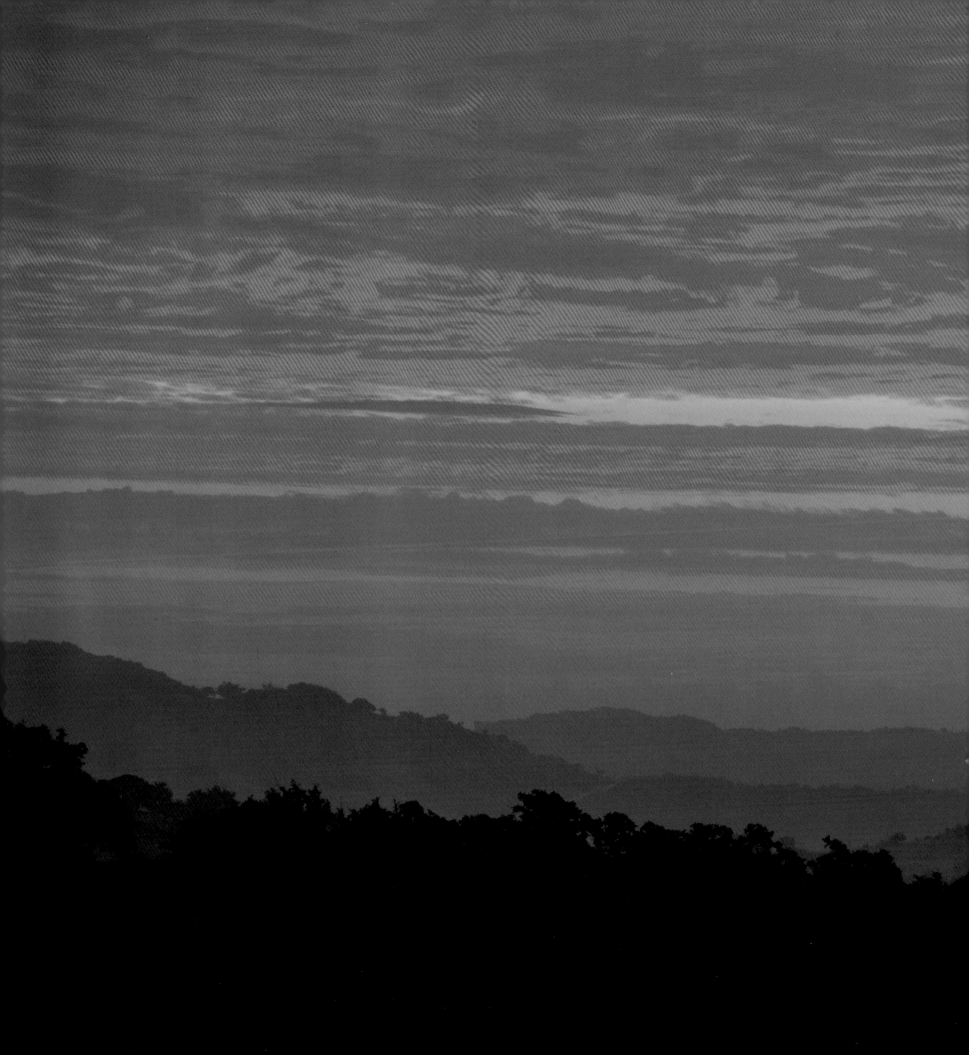

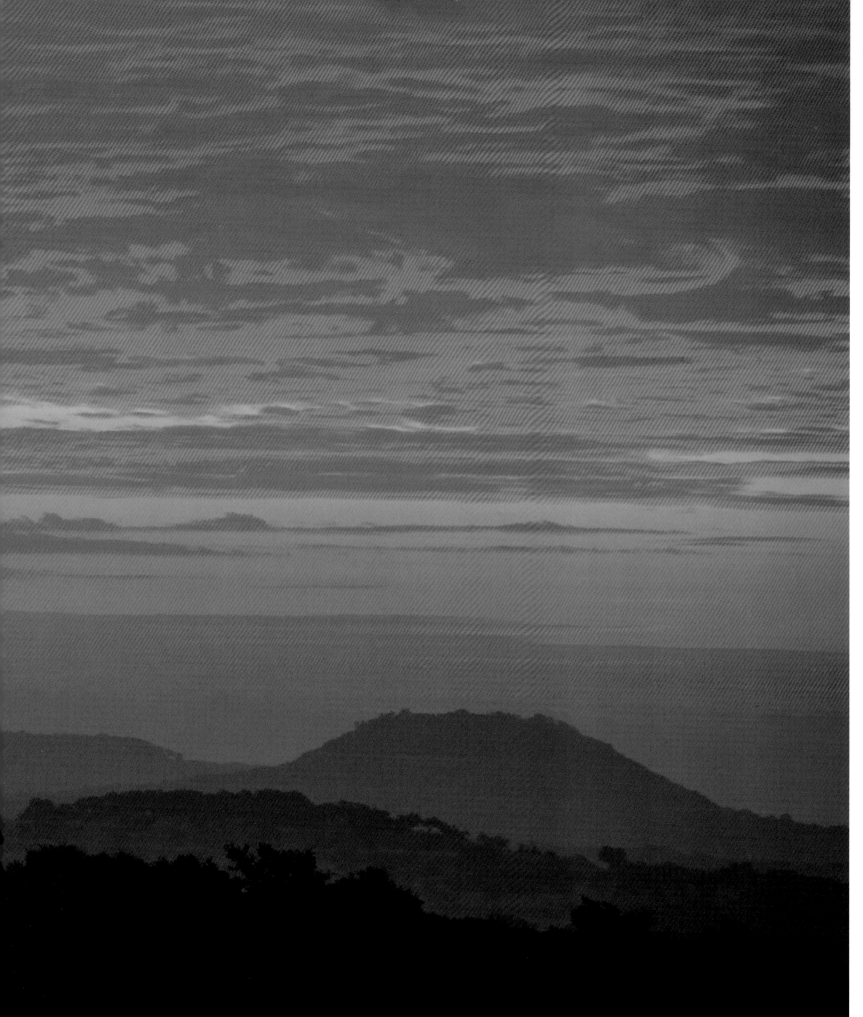

Sunrise from the south road to the top of the High Lonesome Pasture.

81

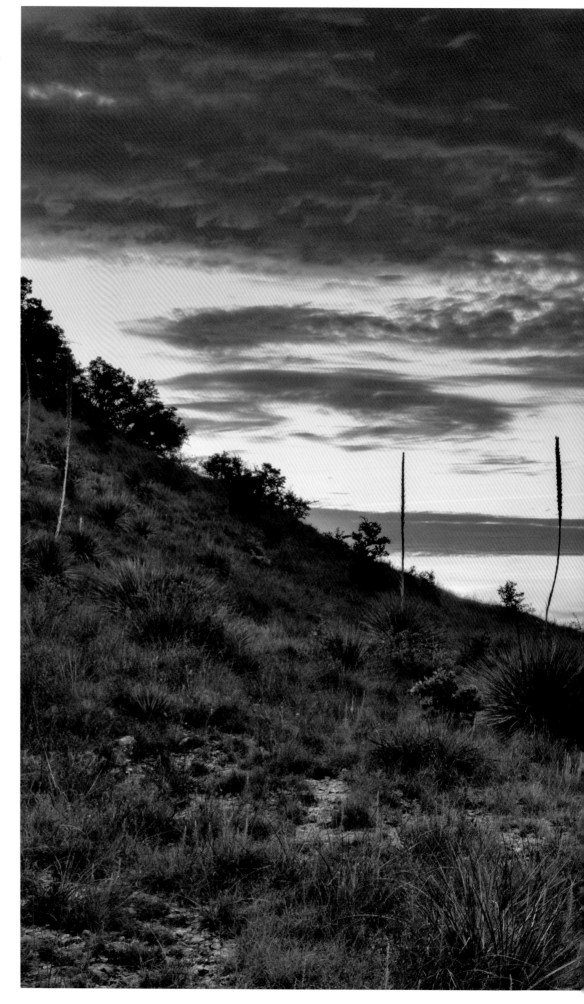

Texas sotols adorn the slopes.

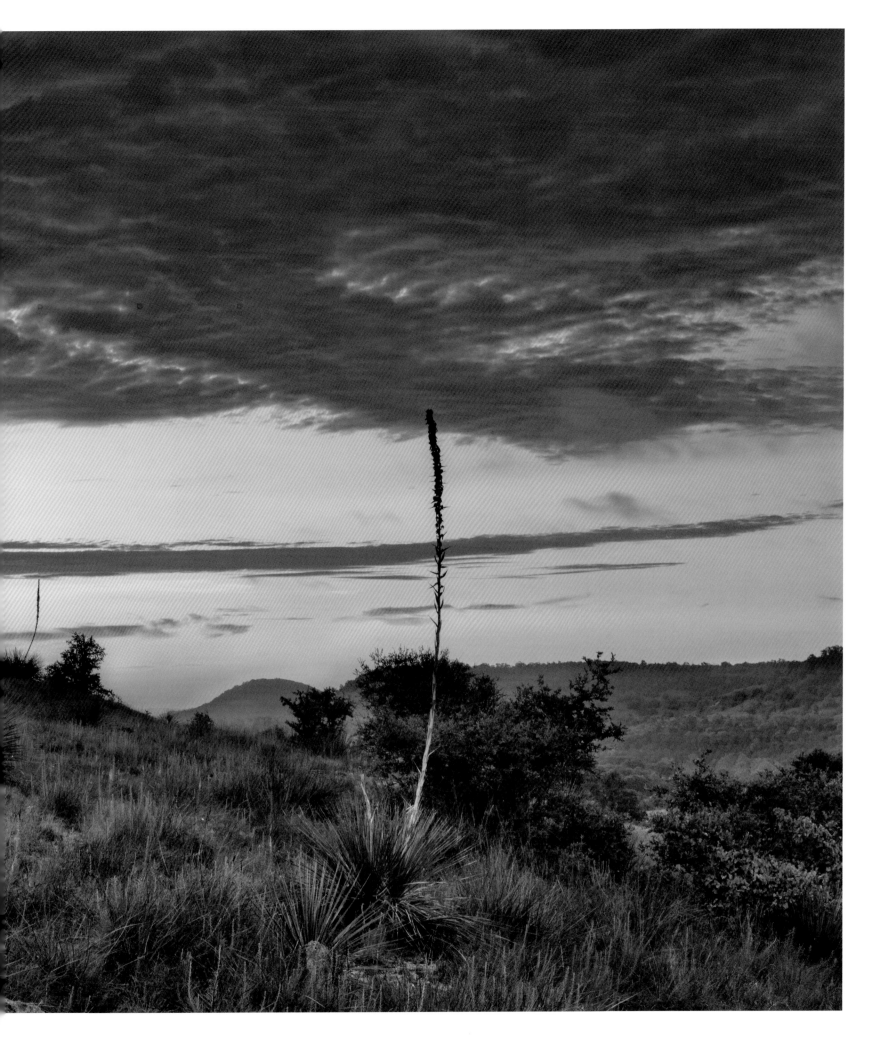

The abundant grasses of the uplands are critical for recharging the aquifer.

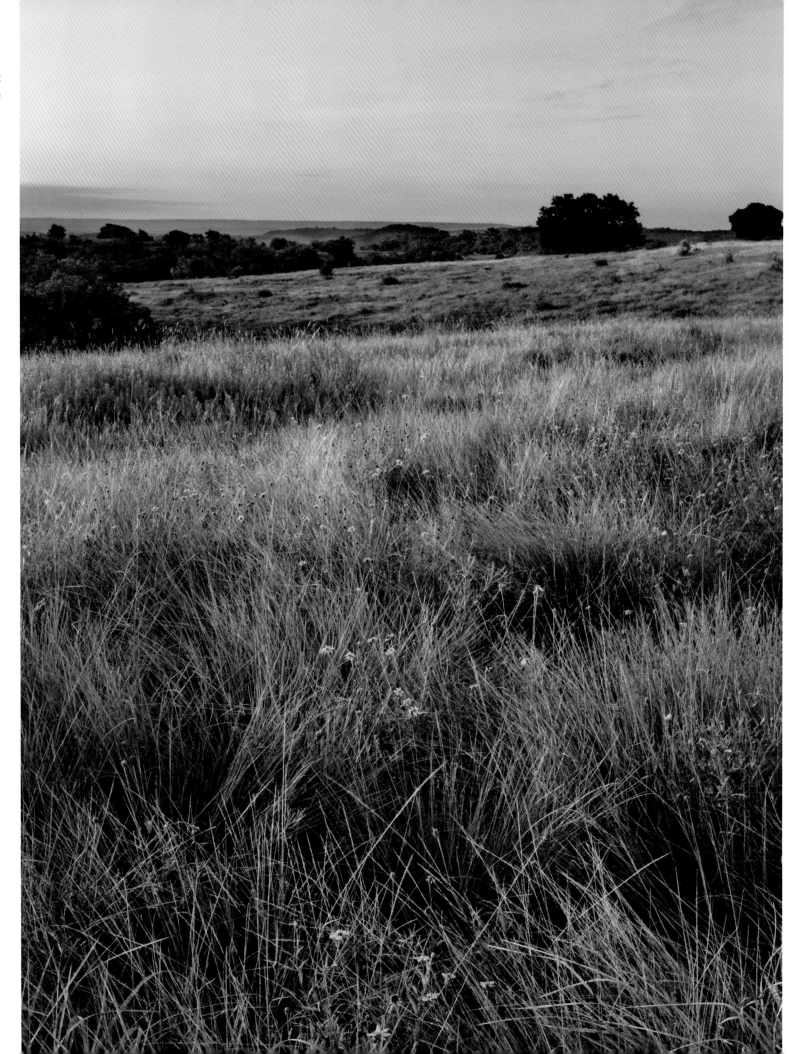

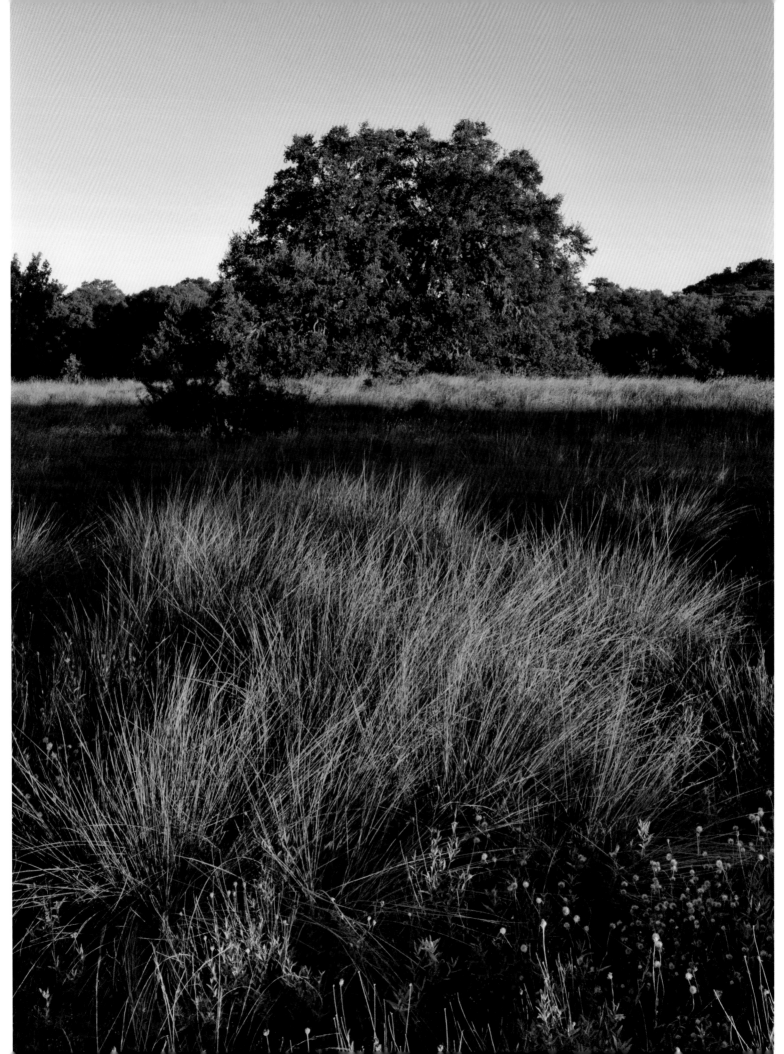

The grasses of the Big Valley Pasture start to dry by late July.

SEASONS AT SELAH

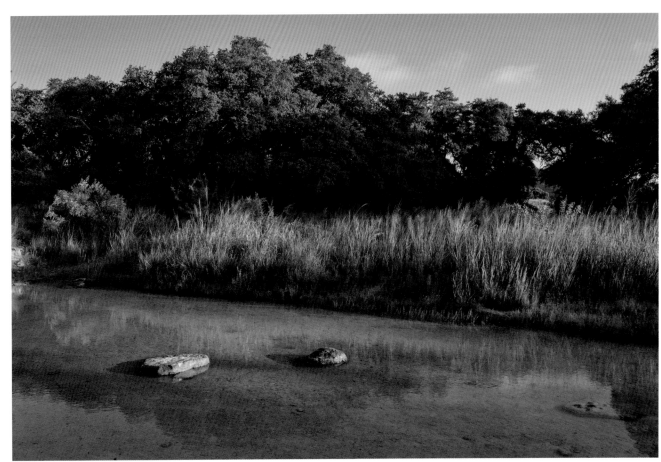

A scene just north of where the main road crosses Miller Creek.

Stones and sky reflections in the
water of Miller Creek.

Backlit Texas walnut at dawn.

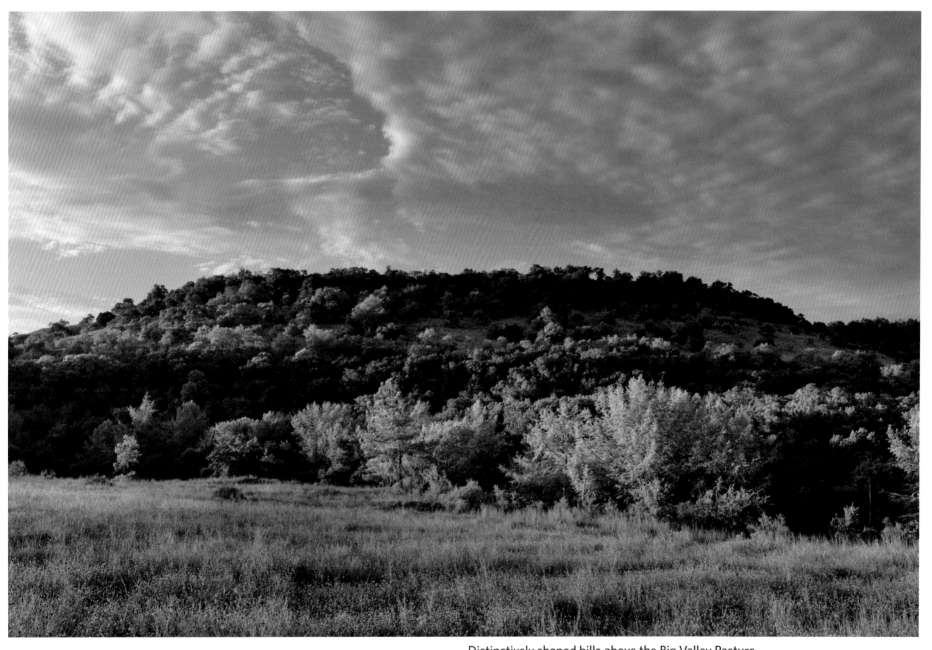

Distinctively shaped hills above the Big Valley Pasture.

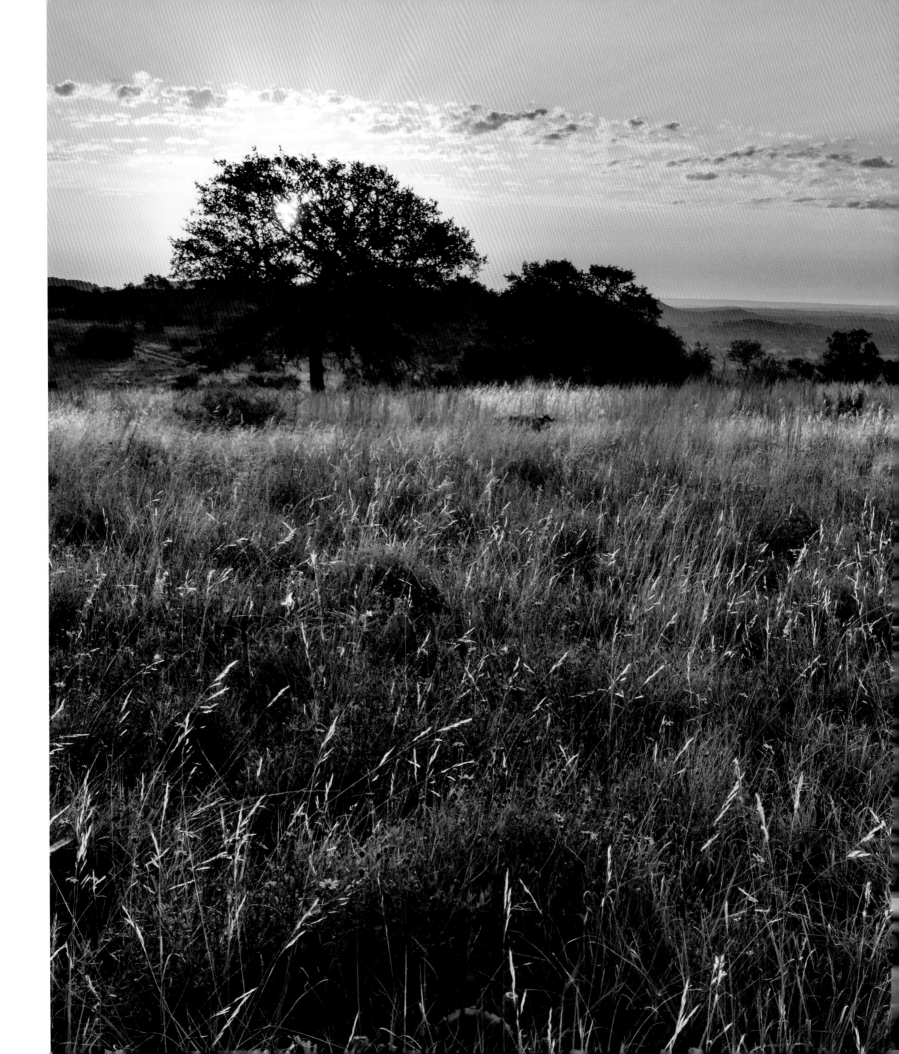

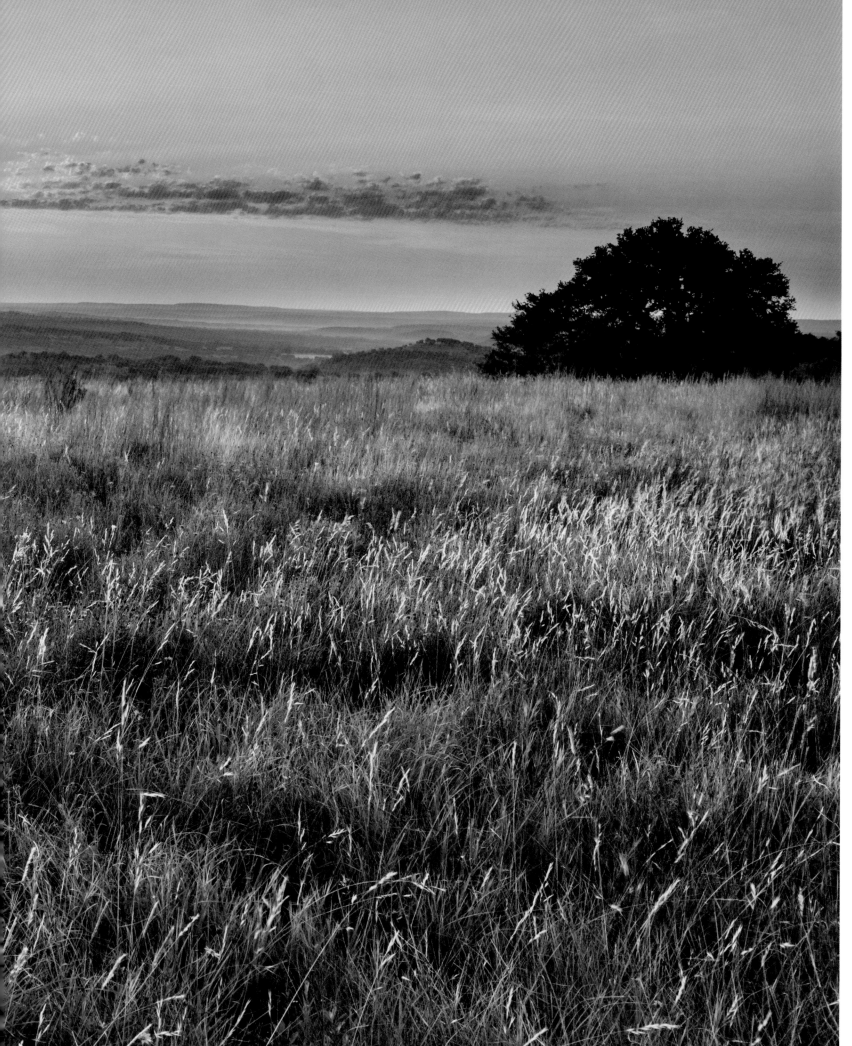

Selah's extensive upland grasslands are the result of many years of brush management.

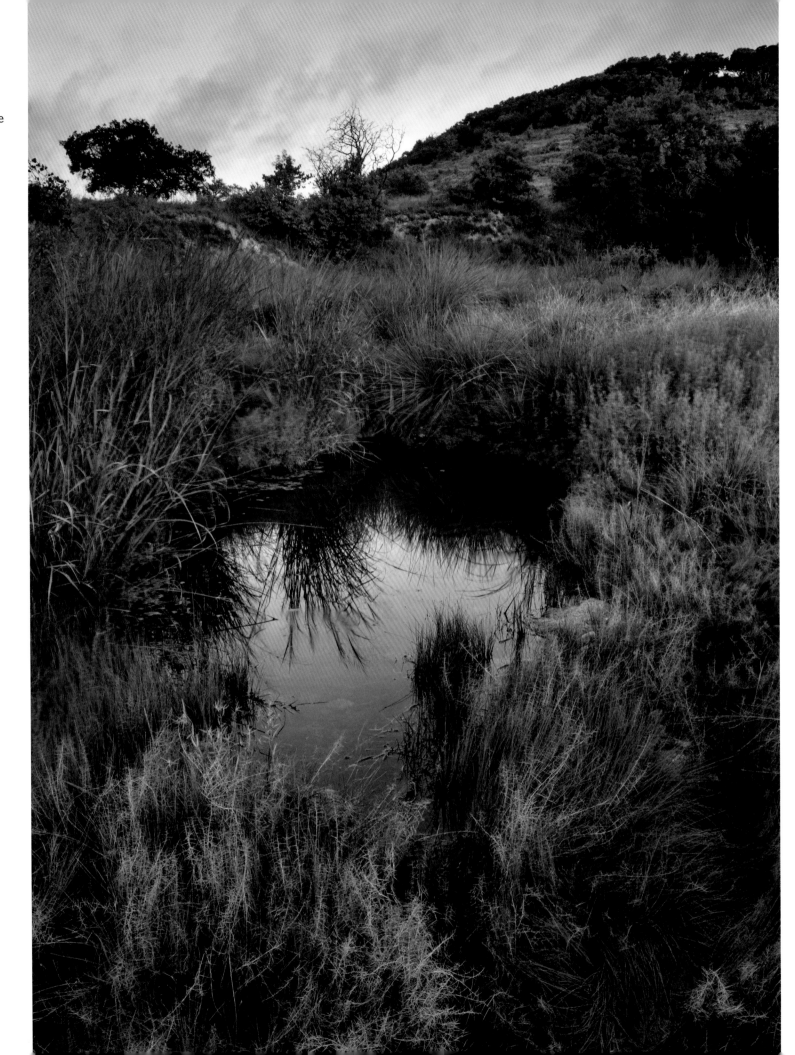

Numerous seep-fed pools provide water for wildlife even in summer.

Dew sparkles on a bald cypress cone.

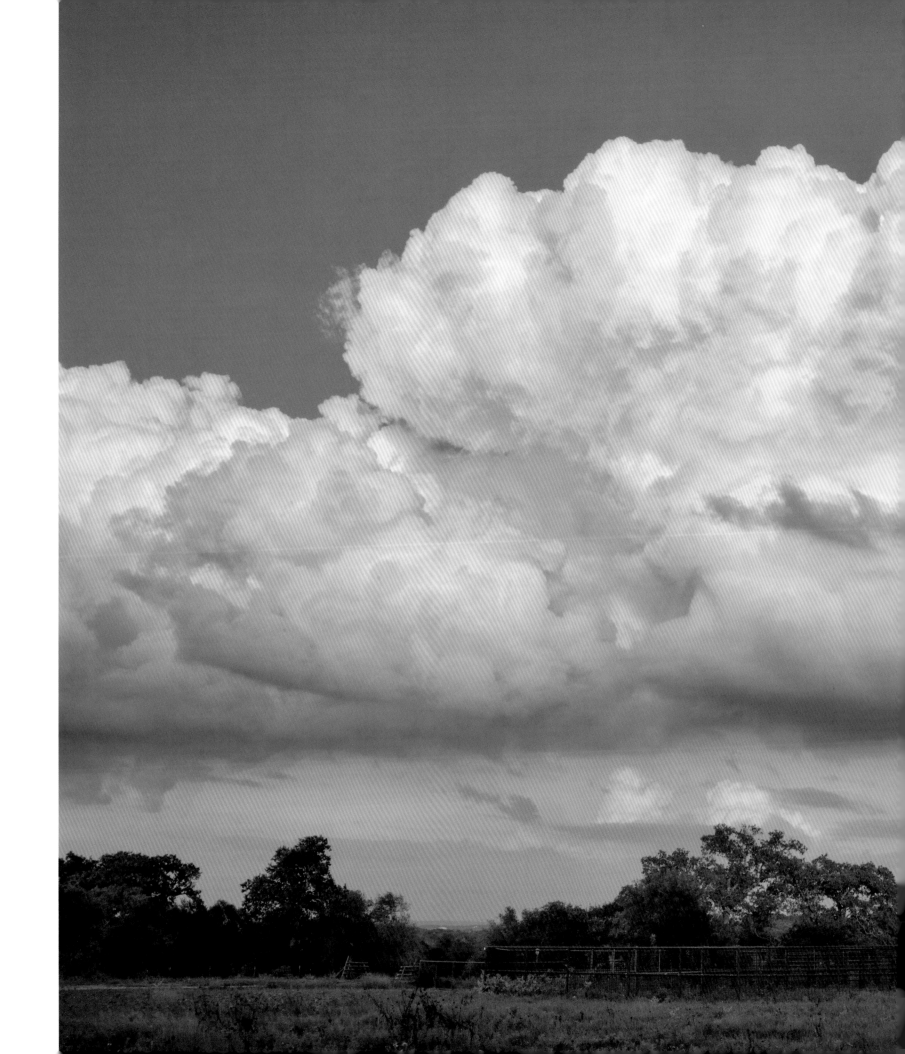

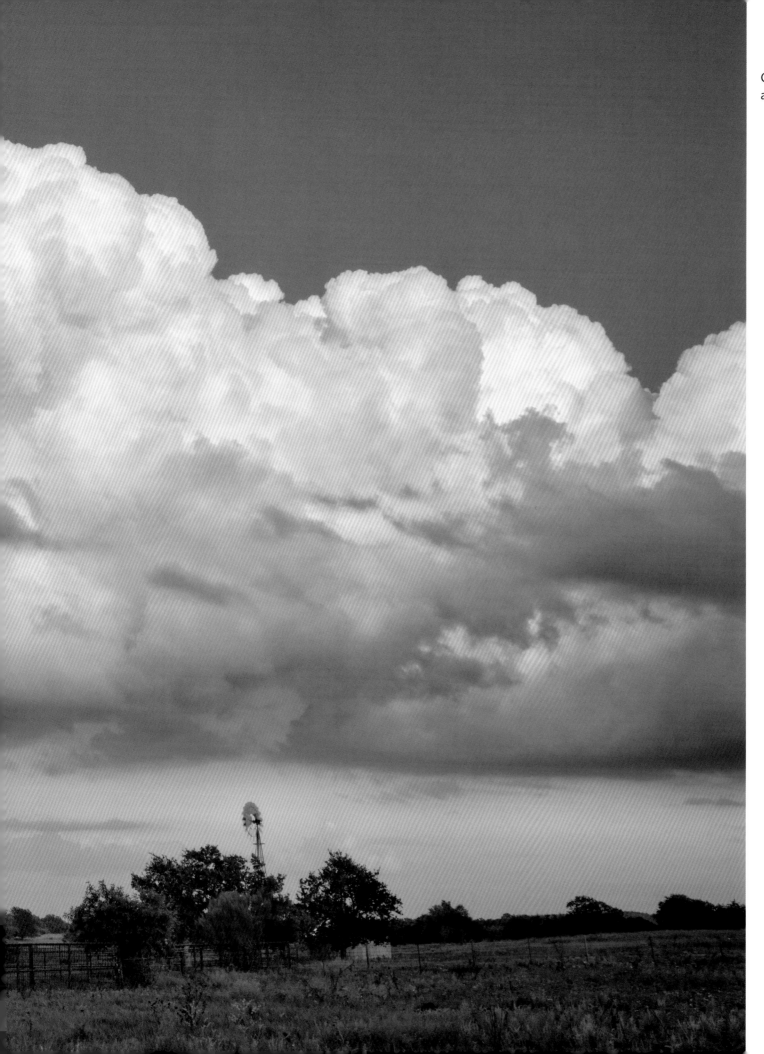

Cumulus clouds building over an old windmill.

Many of the mature Ashe junipers (commonly called cedars) have been sculpted to allow sunlight to reach the understory. Dotted gayfeather adds color to this slope in the High Lonesome Pasture.

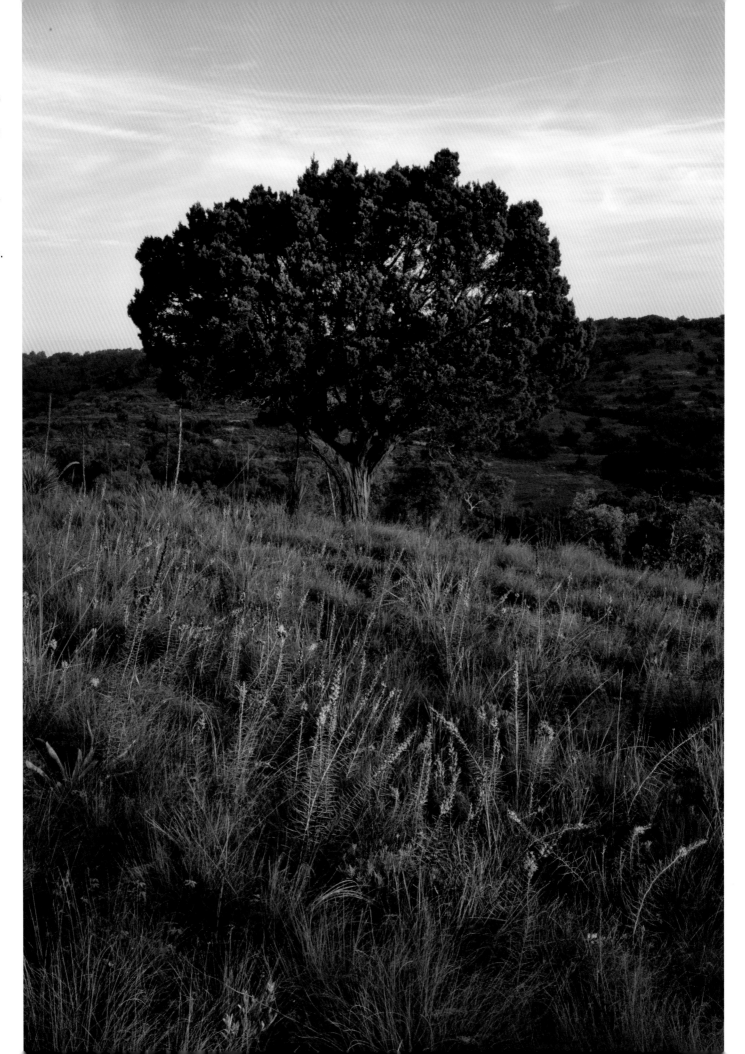

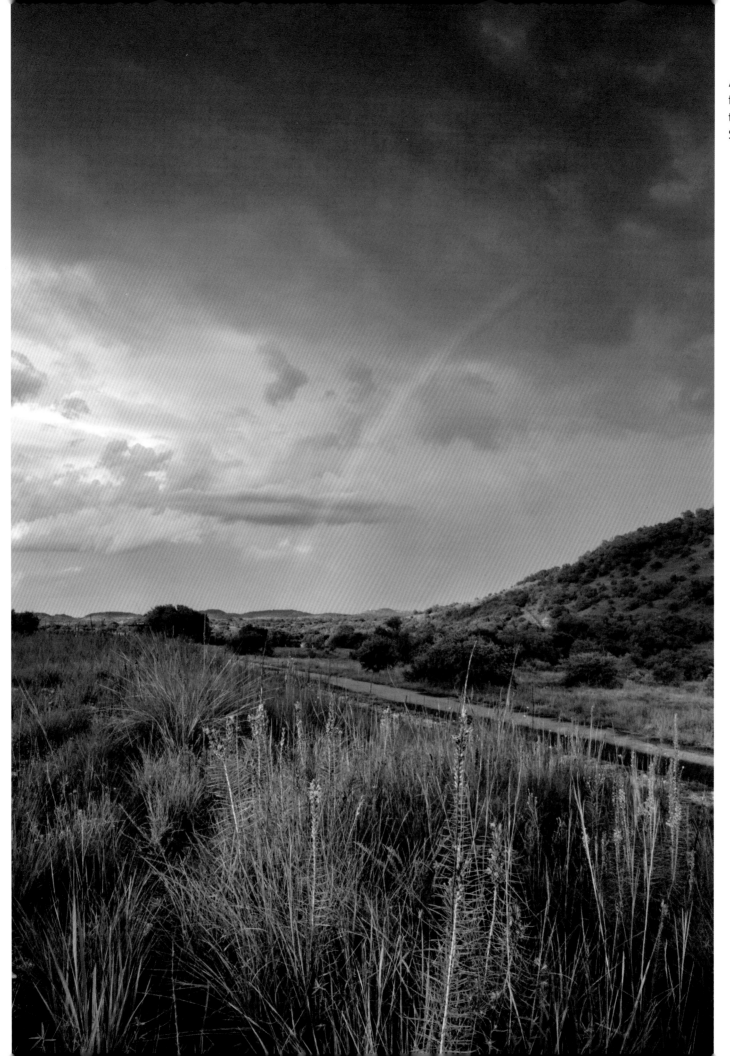

A rainbow and gay-feather add color to the road through Selah.

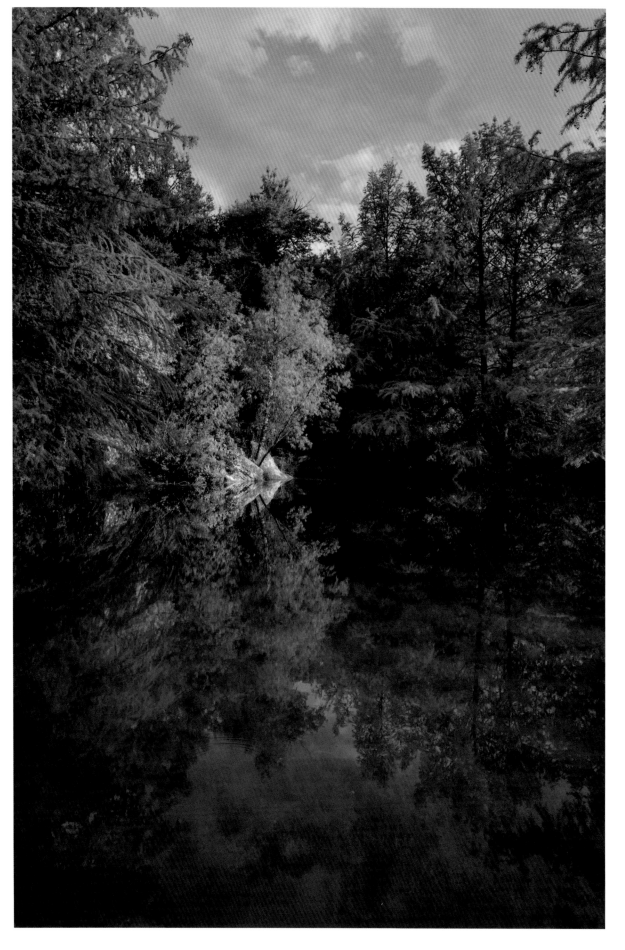
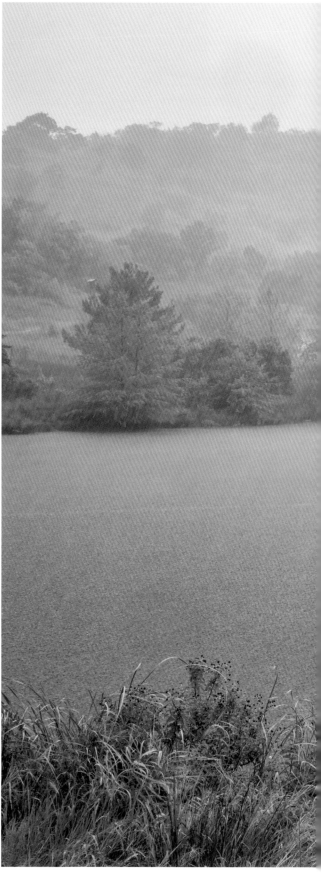

Jacob's Ladder Pool, lined with bald cypress, is one of the many beautiful low-water crossings on the preserve.

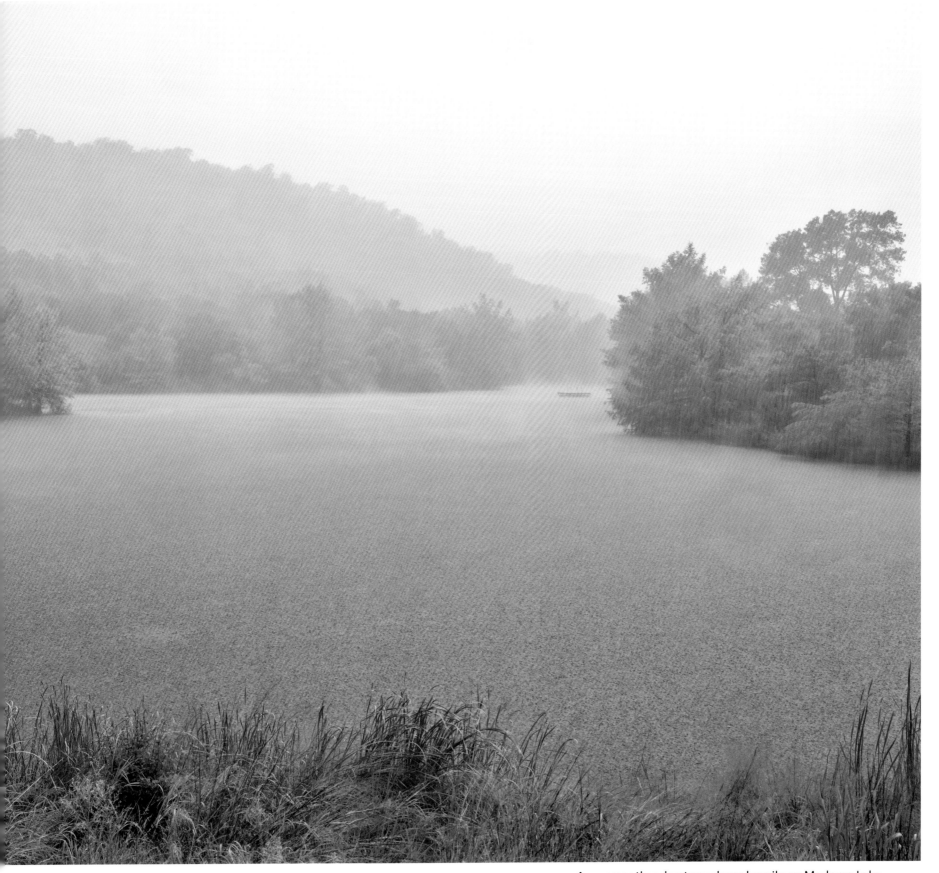

A summer thunderstorm drops heavily on Madrone Lake.

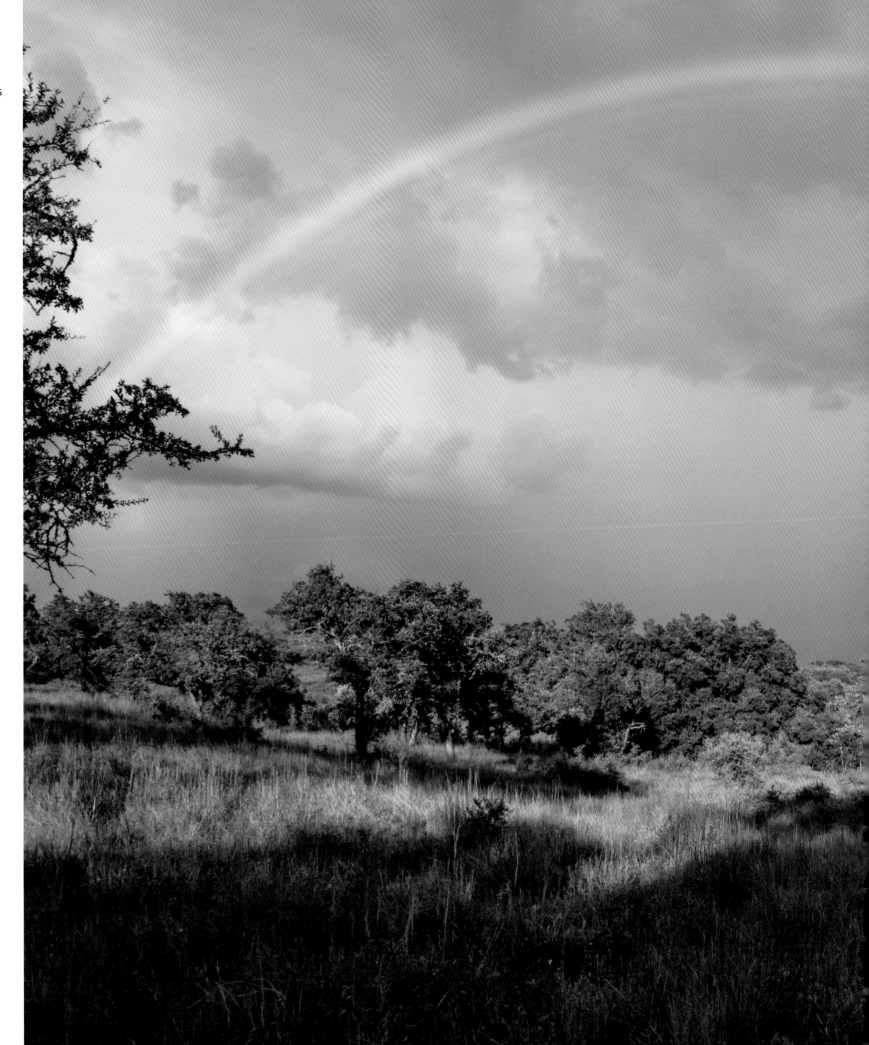

A full rainbow appears over the Big Valley Pasture.

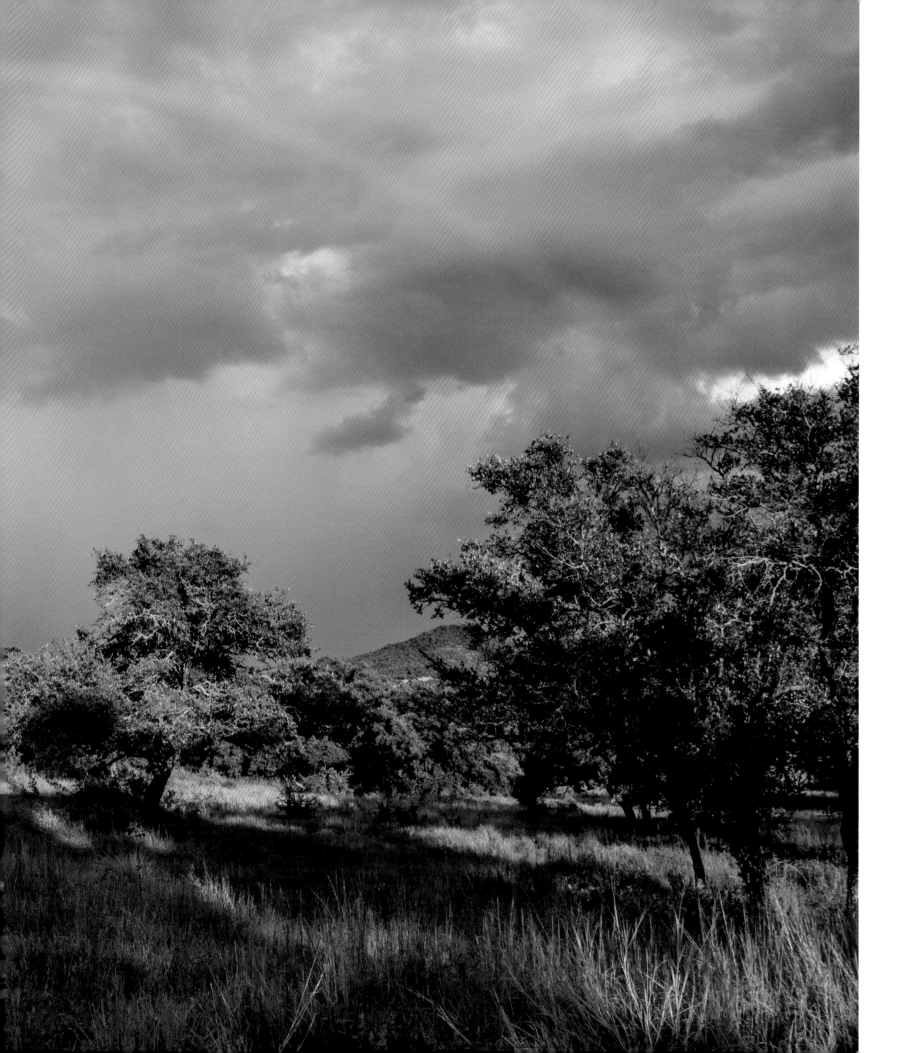

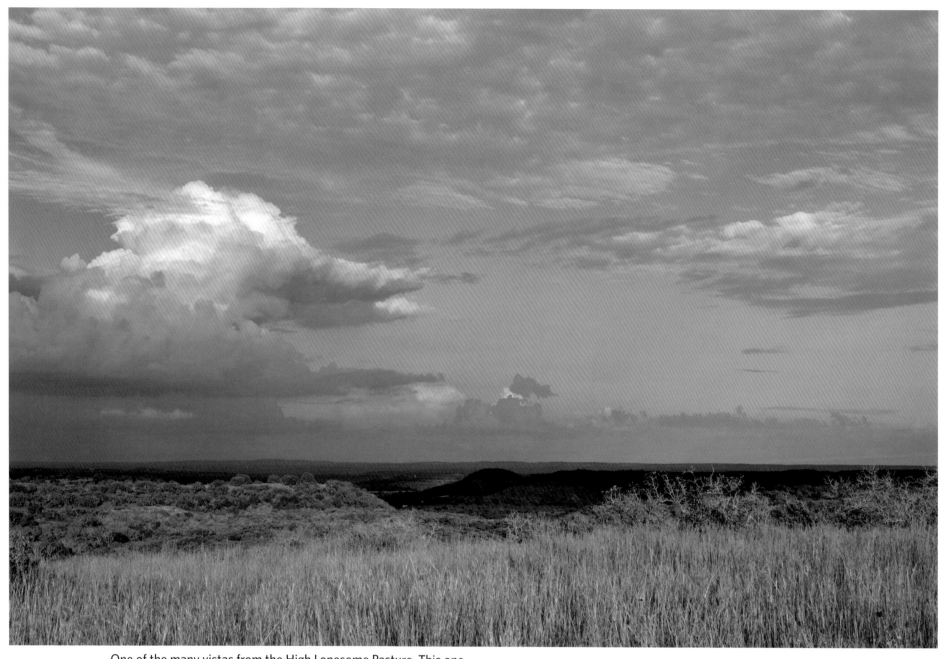

One of the many vistas from the High Lonesome Pasture. This one looks southeast over the Big Valley Pasture.

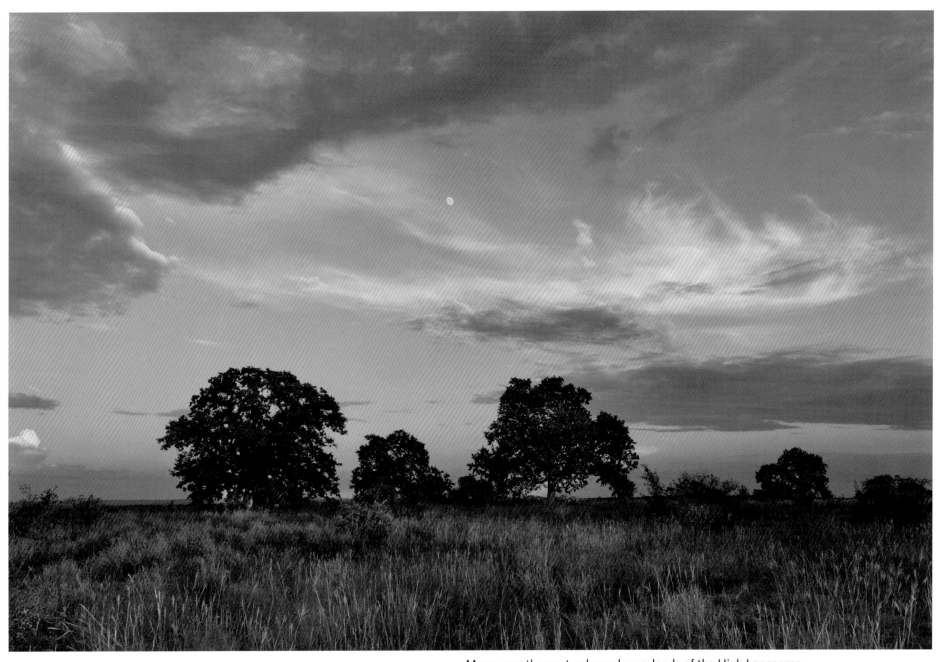

Moon over the post oaks and grasslands of the High Lonesome Pasture.

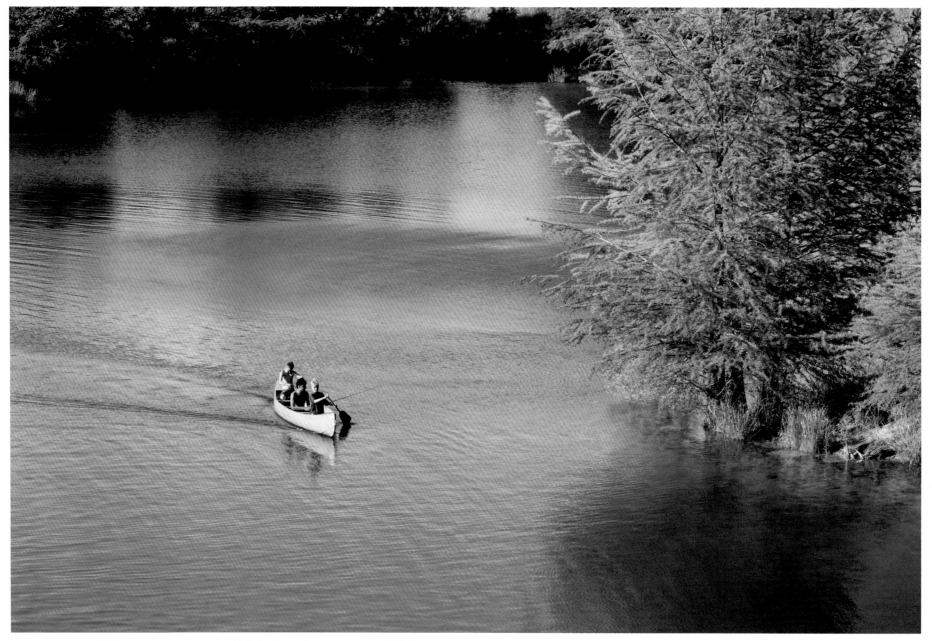

Three summer campers fish for bass from a canoe on Madrone Lake.

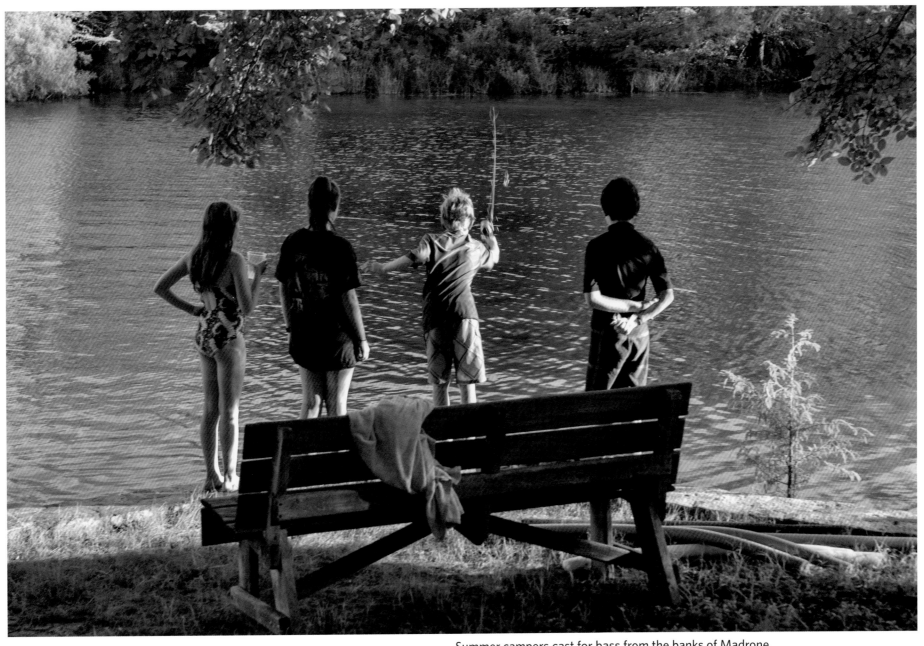

Summer campers cast for bass from the banks of Madrone Lake.

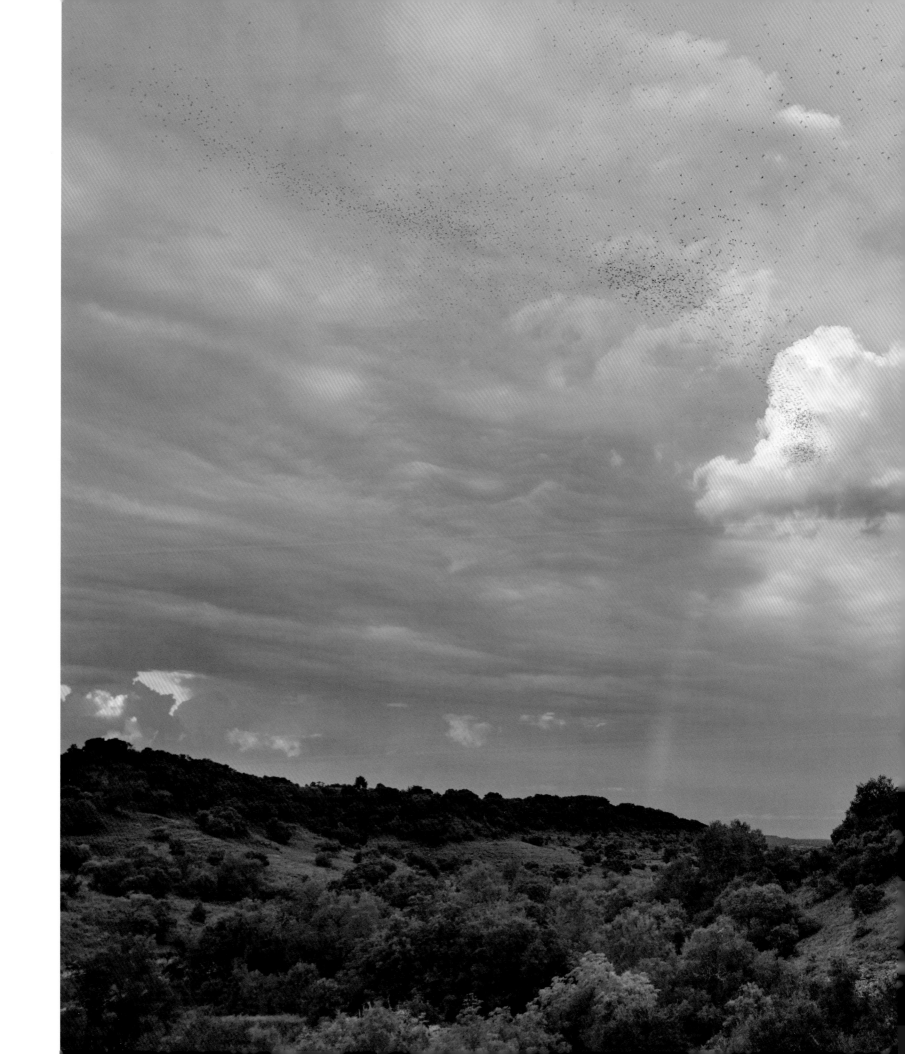

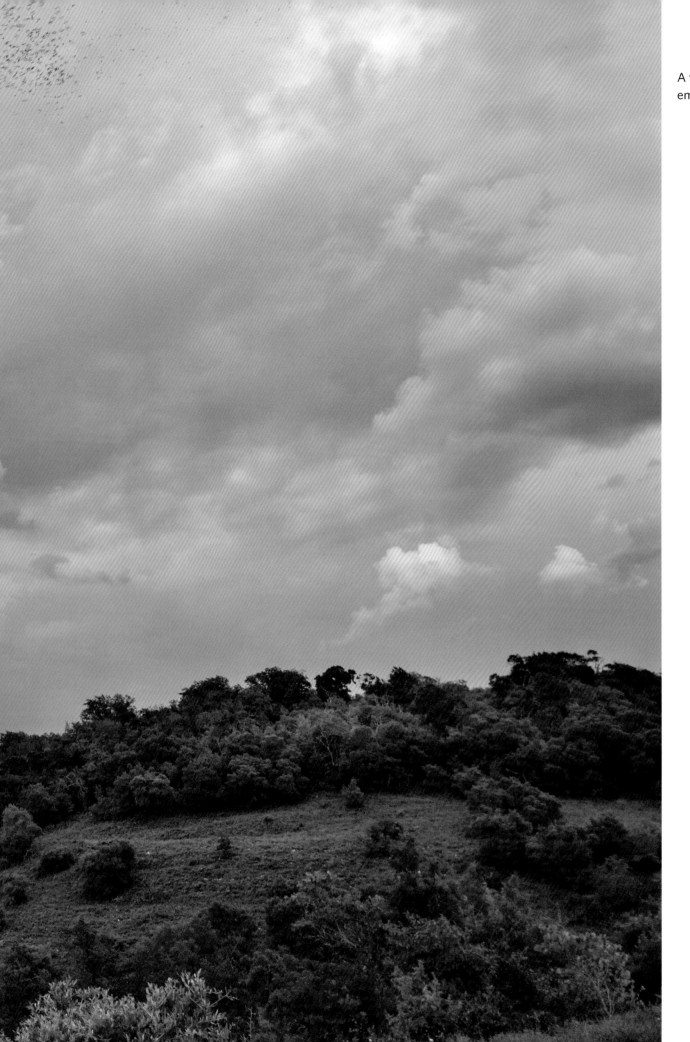

A thunderstorm clears as bats emerge toward a rainbow.

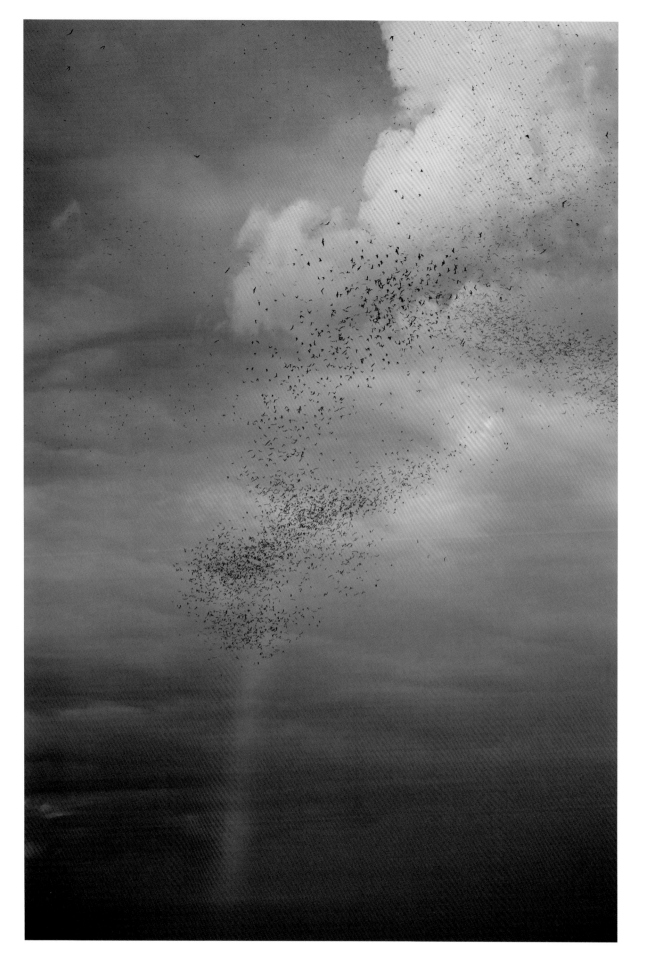

After a spectacular emergence from Se-lah's Chiroptorium, Mexican free-tailed bats fly into a rainbow.

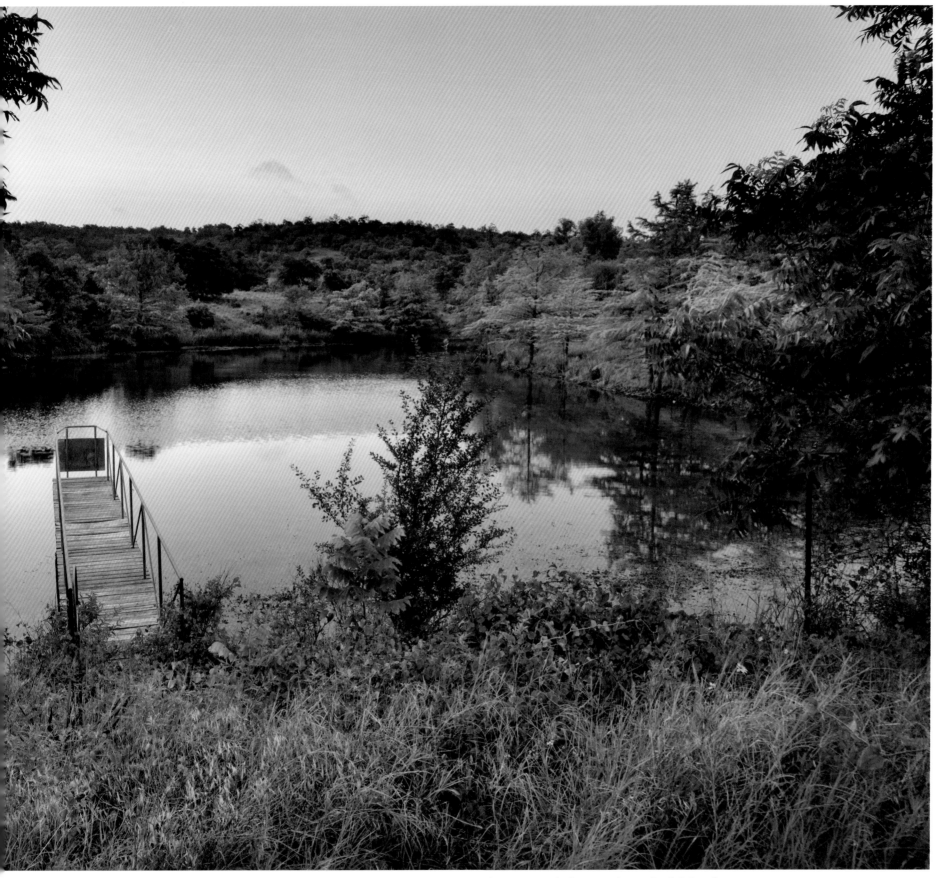

A few minutes before sunrise at Catfish Pond.

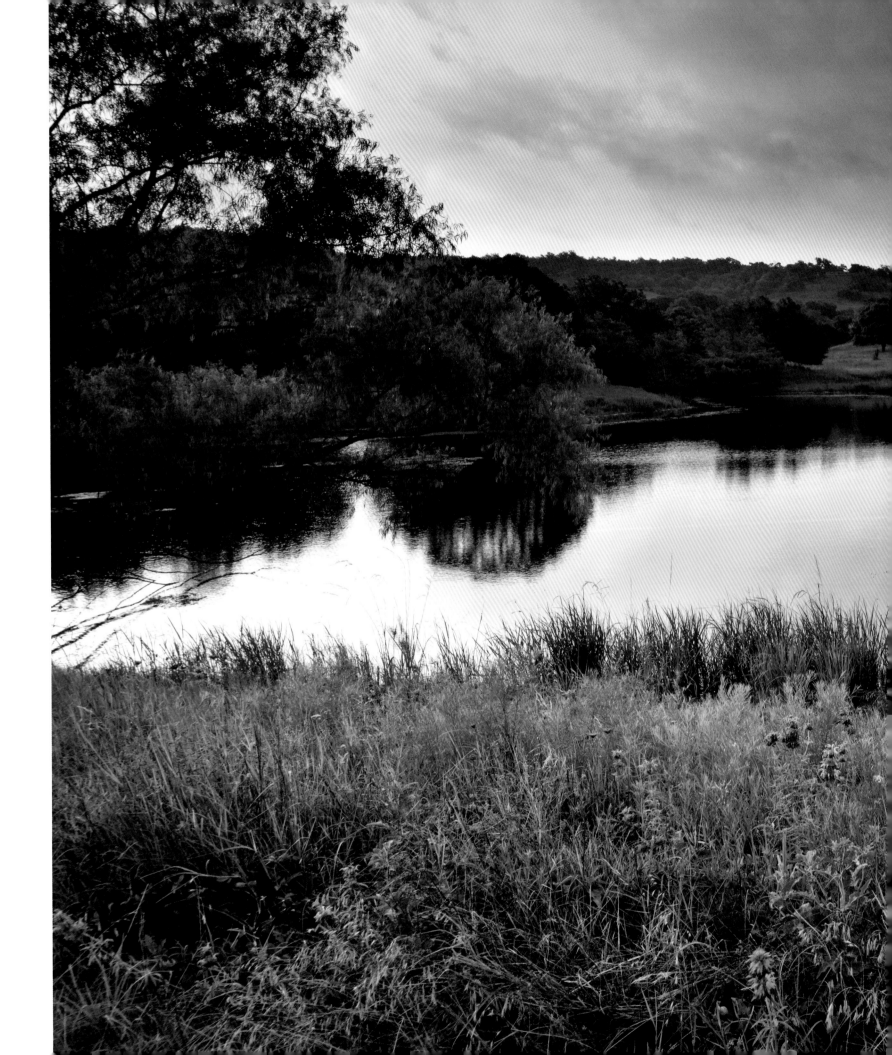

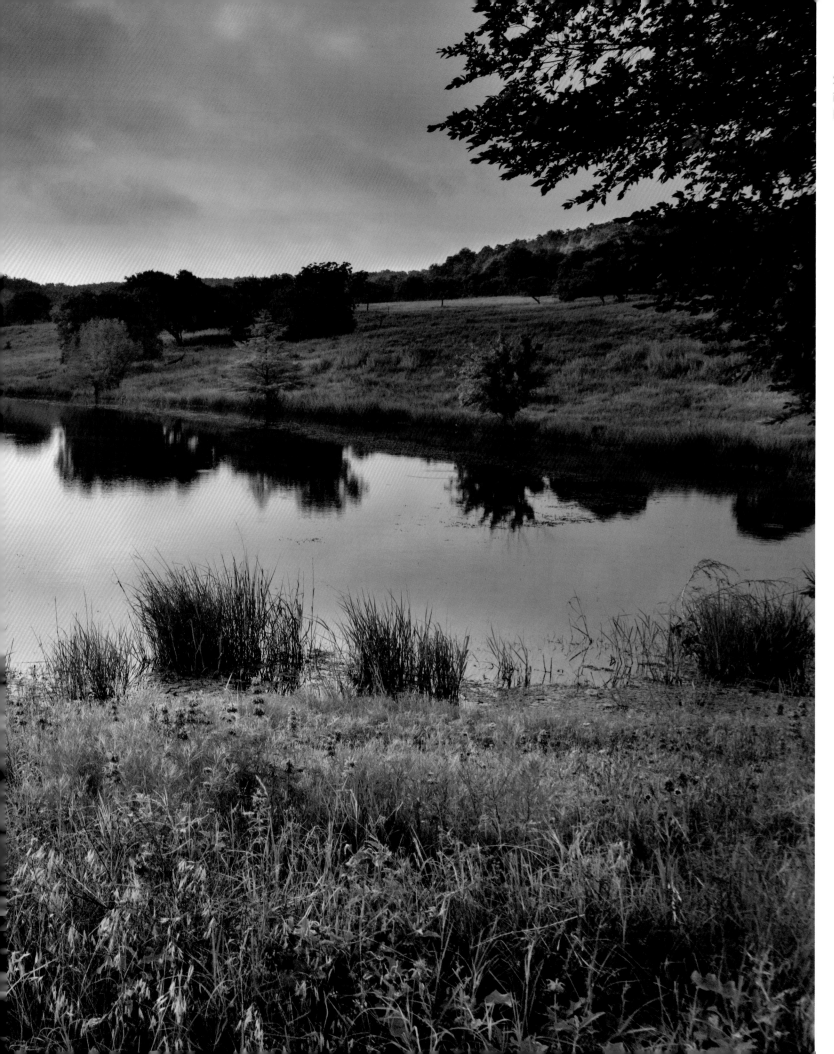

Sunrise at the pond in the Little Mexico Pasture.

111

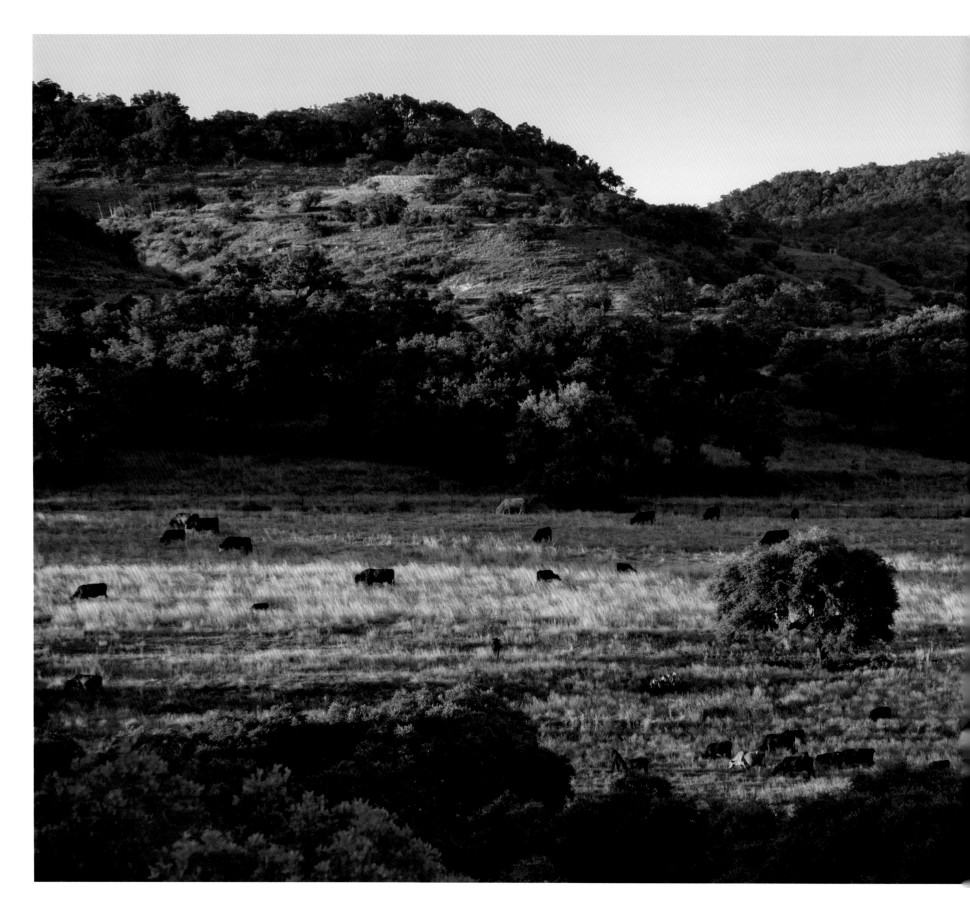

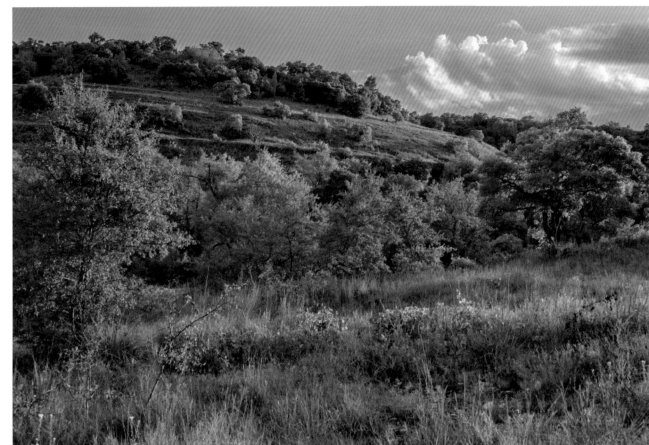

Late evening along the road by the Recycled Cabin.

Cattle graze at sundown in the
Round Mountain Pasture.

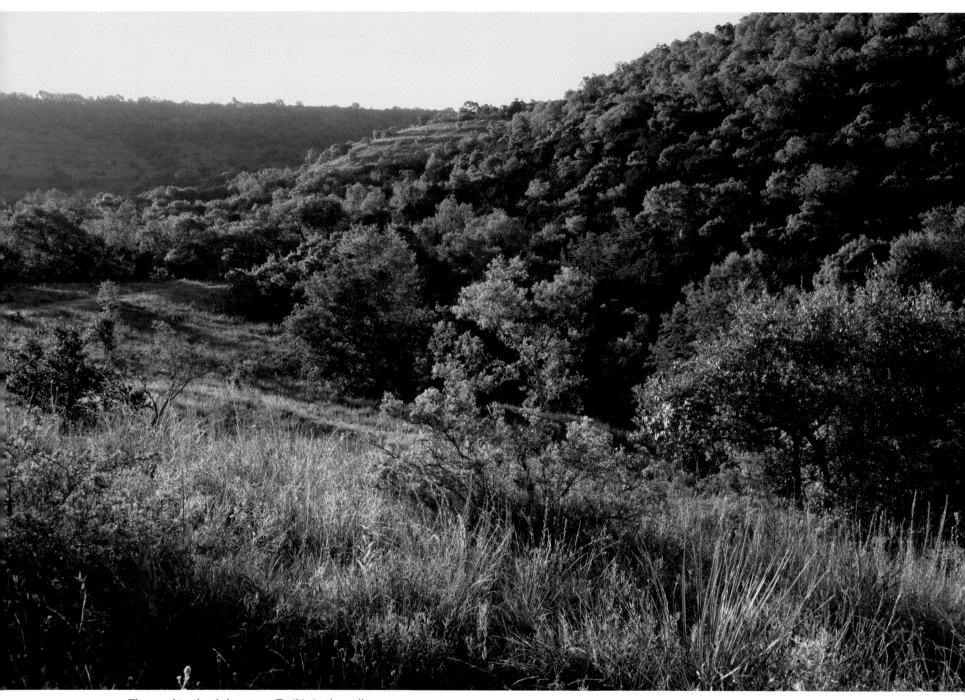

The road to the Arboretum Trail is in the valley.

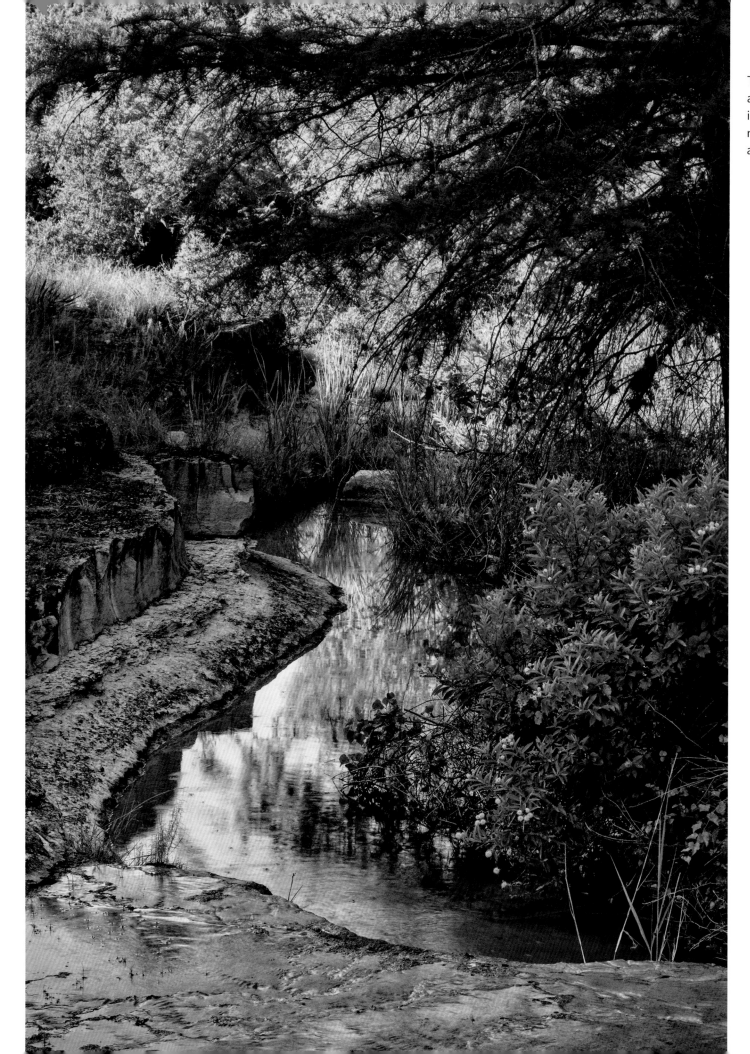

This rock ledge along Miller Creek is framed by common buttonbush and bald cypress.

115

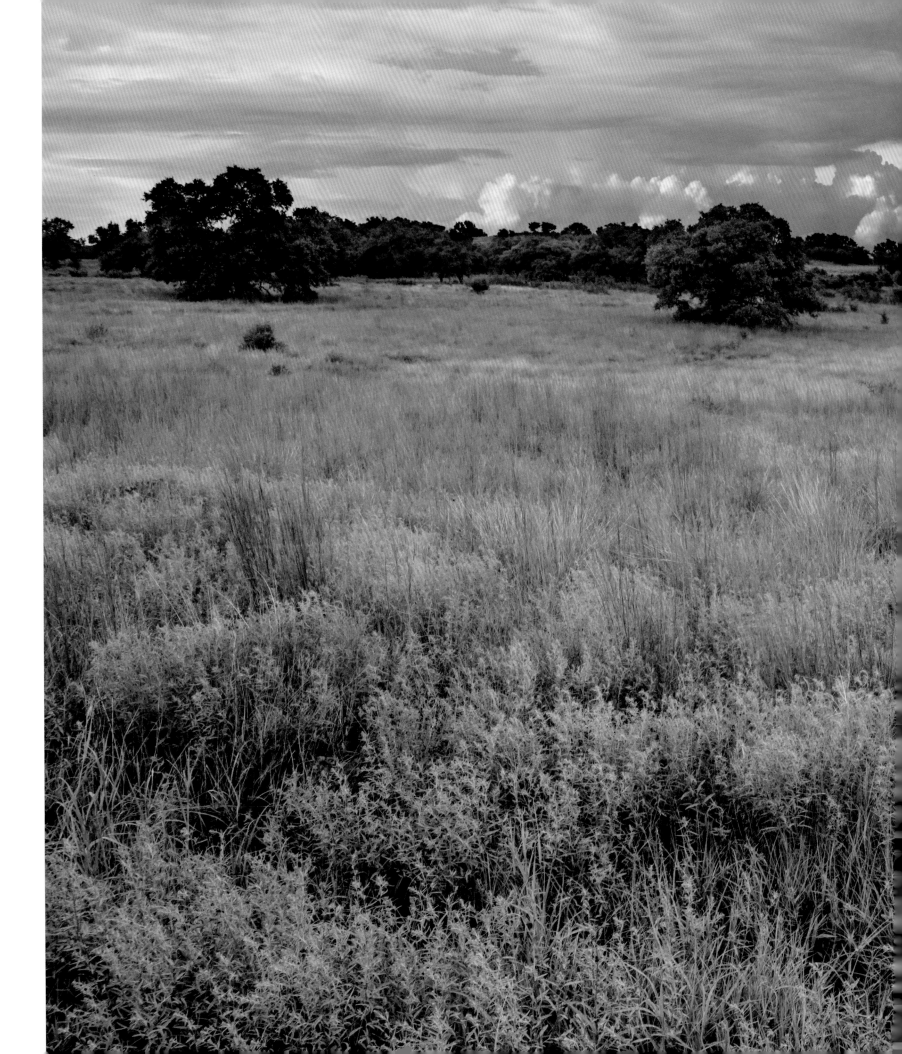

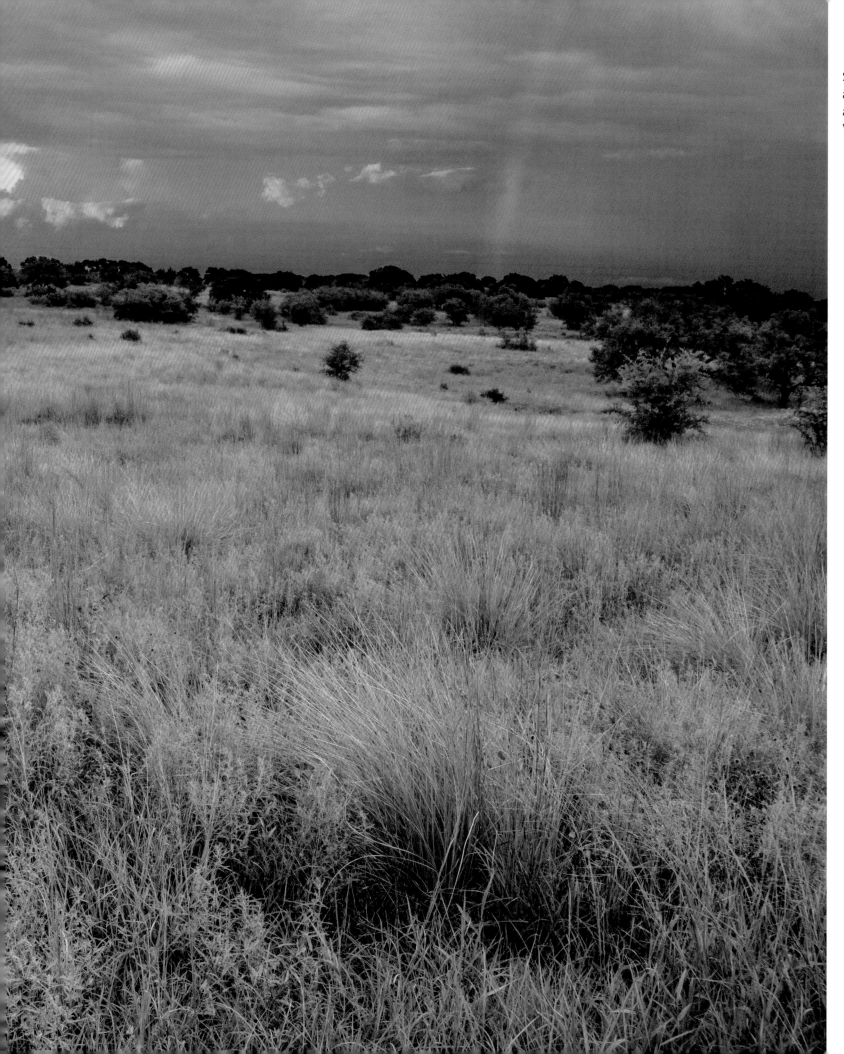

Storm clouds and a rainbow after a rain in the Big Valley Pasture.

117

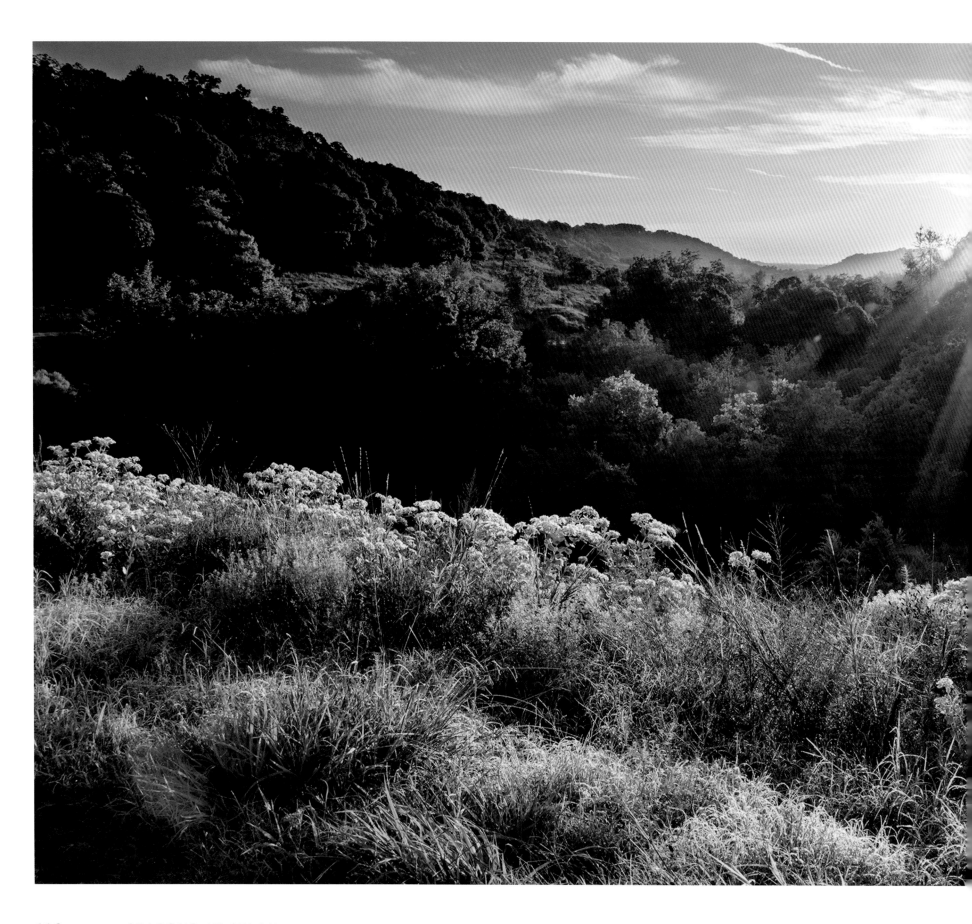

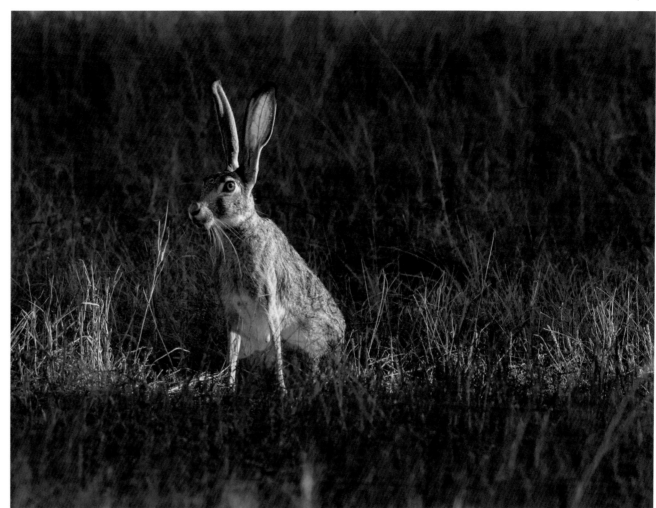

Early morning sun spotlights a black-tailed jackrabbit.

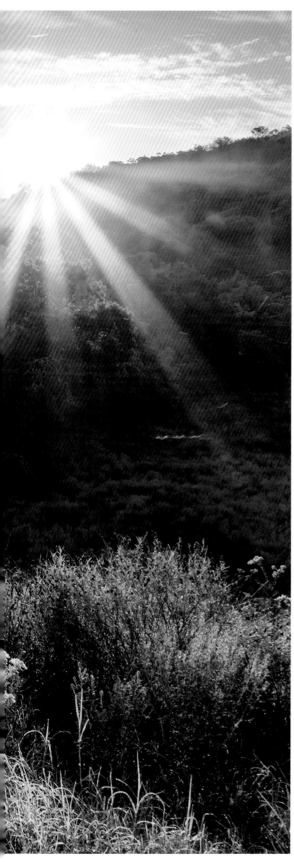

Sunrise illuminates snow-on-the-mountain blooms.

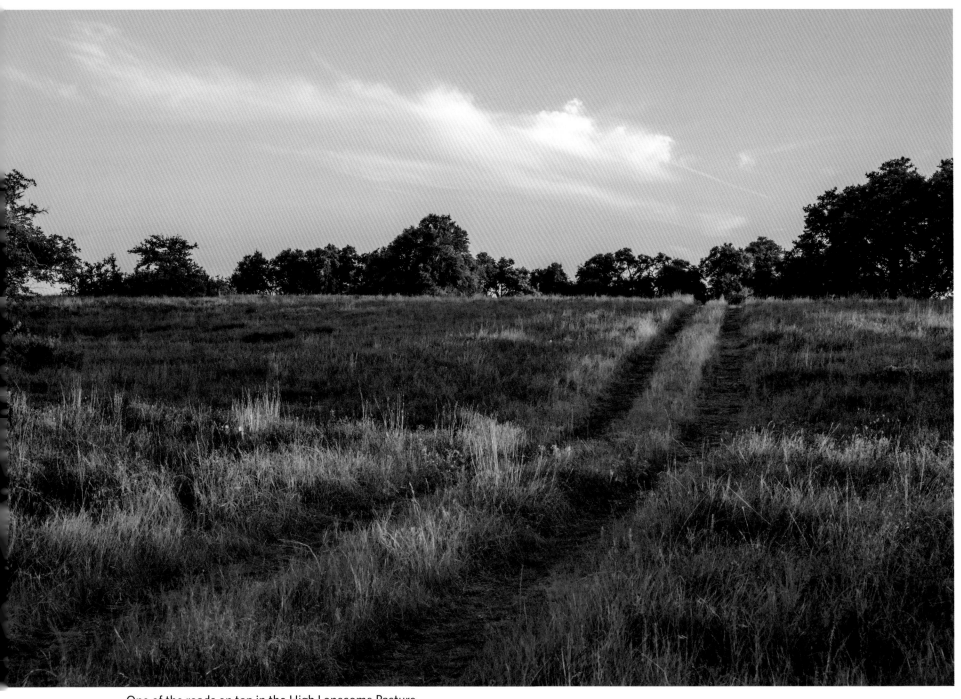

One of the roads on top in the High Lonesome Pasture.

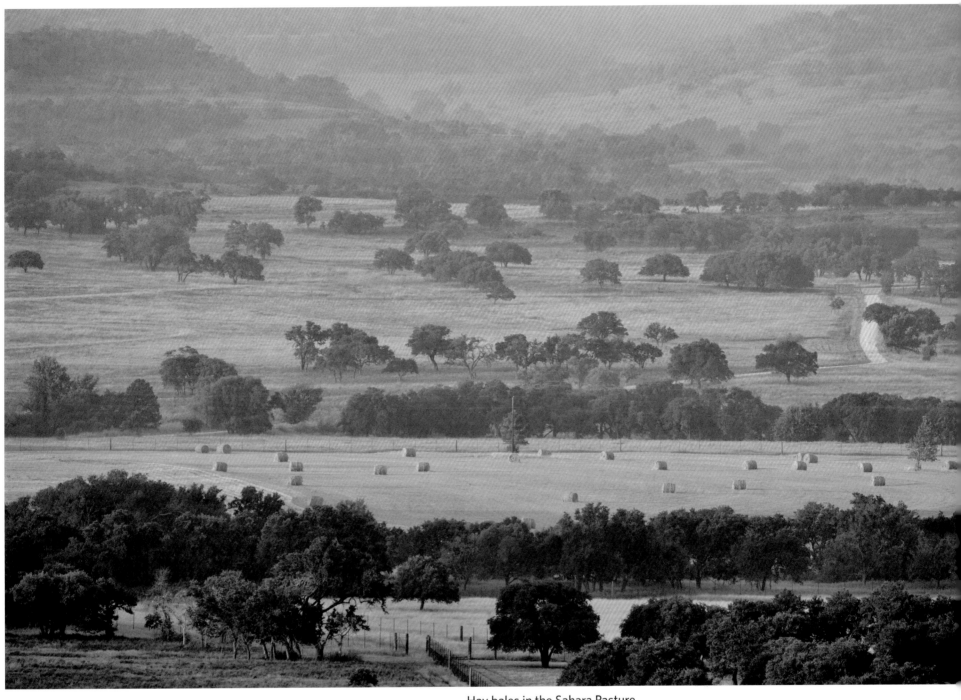

Hay bales in the Sahara Pasture.

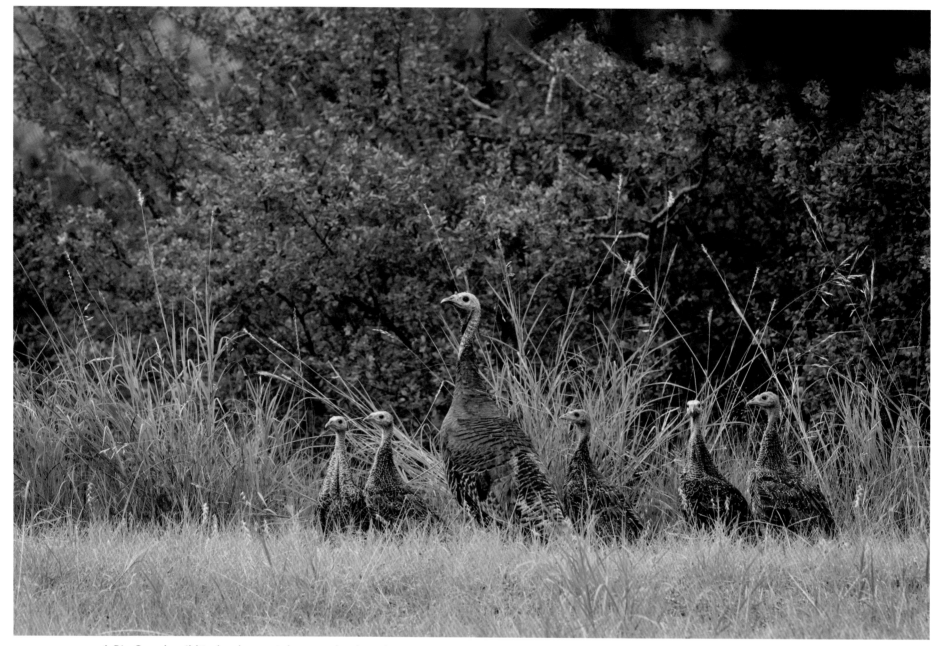

A Rio Grande wild turkey hen watches over her brood.

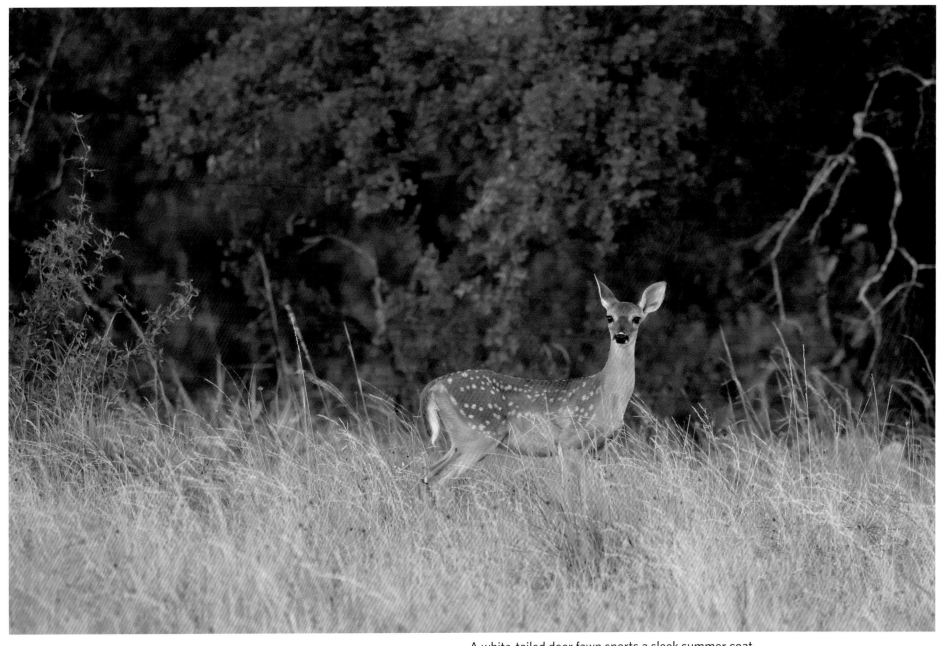

A white-tailed deer fawn sports a sleek summer coat.

The Texas Hill Country's night sky during the Perseid meteor shower.

125

EDUCATION

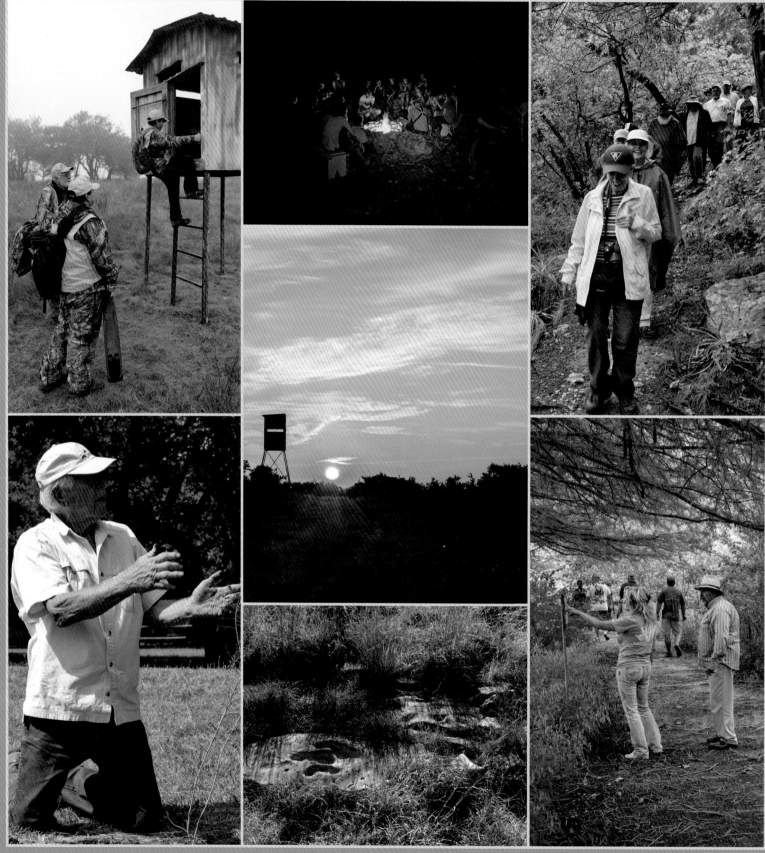

The Bamberger Ranch Preserve offers hunting leases to supplement educational opportunities
for school programs, group tours, and landowner workshops in wildlife biology, botany, ornithology, herpetology, and astronomy, to name a few. Selah's natural open spaces offer unique outdoor
classrooms featuring everything from cetaceous-period dinosaur tracks and marine fossil beds
to fresh-water springs, creeks, and lakes and extensive nature trails winding through diverse
habitats.

AUTUMN

Each year in the fall, J. David opens up the ranch for one day to those he calls "leaf peepers." In the early 1990s he became fascinated with one of the most beautiful native trees of Texas, the bigtooth maple. Found in the canyons of the western Edwards Plateau, the small, drought-tolerant tree commonly grows in the limestone soils of the Hill Country, preferring sheltered ravines and the banks of clear-flowing streams and occurring in disjunct populations, such as the one at Lost Maples State Natural Area near Uvalde west of Selah.

The little maples display absolutely beautiful red and gold fall color, and to date, J. David has planted more than four hundred of them at the ranch, each of which is tagged and numbered and some of which now reach heights of more than forty feet.

"People say I am crazy," he told Pam LeBlanc of the Austin American-Statesman in an interview, "but I am building a forest." That he is—inspired, I am sure, by his mother's love of trees, which are gorgeous in autumn. During the drought of 2011, J. David lost more than two thousand Spanish oaks, but all of his bigtooth maples survived but one. "You don't need to go to Vermont to see fall color," he says. "Come to Selah!"

Despite J. David's breakup with BCI, I remained involved with the organization, and I managed to talk J. David into letting me hold a retreat for the board on the ranch one splendid fall weekend when Selah was ablaze with color. J. David's departure had not been the only casualty of an organization afflicted with a classic case of "founder's syndrome." Merlin Tuttle, who has done more for the protection of bats than any other person on the

Vibrant bigtooth maple leaves floating in one of the many stone-lined pools of Miller Creek.

planet, simply could not bring himself to delegate well or to share in decision making. In part as a result, other board members and key staff had left, and so we were going to regroup at the Bamberger ranch to try to chart a new beginning and a new direction.

Over time, memory tends to fade, but there are at least two things I will never forget about that meeting. The first arose from our urgent need to attract new board members and to establish criteria for those whom we would seek to recruit. Our chairman emeritus, a wonderful gentleman from Milwaukee who, along with Merlin Tuttle, was responsible for the creation of BCI, told the rest of us, "My criterion for board service is that I only join boards with people I like." In all the organizations I have been associated with since, I have never forgotten that.

The second gem to come out of that meeting was the beginning of the organization's reconciliation with J. David Bamberger, whose energy and generosity had resulted in the acquisition and transformation of Bracken Cave. Merlin Tuttle once again became a visitor to Selah, and J. David's work with the bats at Selah was embraced by those in the bat research community from whom he had once been estranged.

Another community that was, at least initially, suspicious of J. David was traditional Texas private landowners, historically known for resistance to outsiders, change, and anything that even hinted at a connection with government. Worse than being an eccentric, says my colleague J. David Langford, Bamberger was a Democrat who did not understand why anyone would be paranoid about the Endangered Species Act, considered by most private landowners in Texas as an indefensible threat to private property rights. Over time, with the realization that taking care of the land was paramount, this rift closed. There are still some landowners who are suspicious of J. David, says Langford, "but they are suspicious of everybody."

Yet J. David Bamberger enjoys portraying himself as a maverick and is prone to saying things like "they thought I was a nut!" Undaunted by the knowledge that some of his neighbors questioned his unconventional ideas about bat conservation, cedar removal, and land restoration in general, J. David, along with my friend Pam Reese, herself

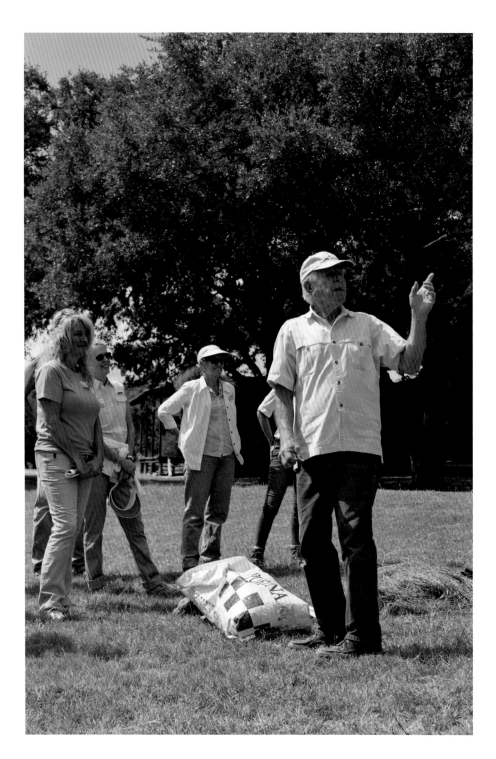

a major figure in conservation, invited a group of landowners whose properties lay, as Selah does, in the Pedernales River basin to the Reese River Ranch to get acquainted and talk about common issues and concerns. Among the guests at that first meeting were Nona and I and our treasured friend and conservation heroine, the late Terry Hershey.

"I've spent many years of my life being different, saying as well as doing things that were outside the mainstream of popular and academic thought. In building Church's Fried Chicken, that 'new thinking' was at first scorned, especially by the analysts of Wall Street. I have stuck to my ideas since turning to conservation and it has been in this arena that new thinking, education, and research is so very needed."

I remember that Bamberger was adamant that this gathering would not be the beginning of a new organization. There would be no dues, no bylaws, and especially no executive director. We stuck to J. David's rules, and from that small but auspicious assembly of a handful of kindred souls at the Reese home came succeeding Sunday afternoon get-togethers on other ranches in the Pedernales watershed. These meetings drew as many as eighty to one hundred like-minded landowners seeking to improve the stewardship of their properties and discuss conservation opportunities as well as threats to the basin.

The second gathering, which took place in J. David's home at Bamberger Ranch, got off to a rocky start. Attempting to fire up the still relatively small group, including probably some of the most conservative people in Texas, J. David sought to remind them that great things often begin with the inspiration and dedication of very small numbers of people. In making his case, the former chicken tycoon reflected that one of the world's most influential movements began with thirty people meeting in a basement: the Communist Party.

As I looked around the room, the reactions displayed on the faces of J. David's guests ranged from confusion to apprehension but seemed mostly to express, "What in the world have I gotten myself into?"

After the meeting, one of the guests leaned over to me and whispered, "This is an awesome initiative but please see if you can get our host to drop the bit about the Commu-

nist Party." I did, he did, and the regular, informal gathering of landowners along the Pedernales River is now one of the most successful private land stewardship exchanges in Texas.

More and more of these landowners are new to the area and come from all over the world. Although many of them have the best of intentions with respect to caring for their properties, they often arrive with no background in land stewardship. In my opinion, they are following in the footsteps of J. David Bamberger himself, who came to the Hill Country with virtually no experience in land management.

J. David's new neighbors usually acquire smaller parcels than what he bought at Selah. Although, ironically, they are contributing to the problem of land fragmentation as the larger ranches are divided into smaller lots and subdivisions, as a general rule these newcomers are interested in land ownership primarily for recreation and thus come with a desire to improve wildlife habitat, game populations, bird life, and more. Thus, the work at Selah has become an increasingly important model as well as an educational opportunity for inexperienced landowners who want to learn about land restoration and management.

Landowners from across the Hill Country and beyond are able to come to Selah and, through the workshops offered at the ranch, gain the essential knowledge for restoring the lands now in their care. Following J. David's example, they learn about cedar management, pond creation and maintenance, tree planting, spring restoration, and wildlife management. Other regular visitors and disciples of J. David's are academics, college students, Texas county extension agents, and Texas Master Naturalists, who then leave and carry the Bamberger message to hundreds of other landowners. As a result, many thousands of acres on ranches across the Hill Country are being restored to health today.

One lovely fall weekend, J. David and Margaret invited Nona and me to spend Sunday afternoon with them on the ranch. We sat around the island in the ranch house kitchen and I told J. David that what I really wanted that afternoon was for him to tell us about the chicken business. For the

next three hours, he recounted how he and Bill Church, a couple of vacuum cleaner salesmen, built one of the most successful franchise operations in the country and, in the process, became millionaires.

J. David told us about charming a Mexican American family in Laredo into selling him a corner lot for his first chicken stand outside San Antonio and about supplying his employees at the business's Walmart locations with roller skates so they could police the parking lots and collect litter during slow times and thus stay in the good graces of their host. He stayed in the good graces of the employees as well. J. David loved to hire and boost up the people he called the "unders": undereducated and underpaid. He built incentives into their pay, enabling them to not only share in the profits at their location but also have the opportunity to buy their own franchises and become business owners themselves. This was all part of J. David's philosophy that every customer should go home with "more than a box of chicken" and every employee should go home with "more than a day's pay."

Through the afternoon, under the spell of one of the best storytellers I have known, it became clearer than ever that the character traits that made J. David a skilled businessman, especially his willingness to think outside the box, were essential ingredients in his success on the ranch. Nowhere did this combination come into play more clearly than in his efforts to save endangered species, both plants and animals, beginning with the establishment of a captive breeding herd of scimitar-horned oryx, one of the rarest animals in the world.

Now extinct in the wild, the oryx, often thought to be the inspiration of the mythical unicorn, was originally from the plains of sub-Saharan Africa. In the late 1970s, as an outgrowth of his service as a board member of the San Antonio Zoo, J. David defied both private landowners across the country who considered the Endangered Species Act a Communist plot and those in the zoological community who sniffed at the idea that cowboys on a Texas ranch could manage endangered wildlife. He dedicated a section of the ranch to the project, planted Klein grass from southern Africa for the grazing oryx to eat, and embarked on the noble objectives of both preserving the genetic integrity

of the species and ultimately reestablishing them in their native habitat in Africa, a huge and complicated undertaking that has achieved limited success.

In perhaps an even more compelling effort to demonstrate that ranchers care about and can save endangered species (without government help), Bamberger hatched a bold plan to save the Texas snowbell, a small understory tree that is native to the western edge of the Texas Hill Country and is officially listed as endangered.

The major threat to the snowbell is browsing by deer and goats, and many landowners who found the snowbells on their property worried that their presence might bring some kind of government regulation because of the land management requirements of the Endangered Species Act. Taking it slowly, J. David first set out to prove that the plant was more plentiful than originally thought. Then, as he gradually gained the confidence of other landowners, they began to allow him to plant snowbells on their ranches. With J. David's persuasion and example, ranchers have come to understand that, in the words of one convert, "you're working with the help of the government agencies, rather than worrying about them stopping you from grazing cattle or other things."

Since the inception of J. David's crusade, more than seven hundred Texas snowbells have been planted on dozens of ranches in an area totaling 120,000 acres. At Selah, a greenhouse has been erected for propagating them.

Today, there are also scimitar-horned oryx on many ranches in Texas, along with a number of other species of nonnative wild animals. Though not without controversy, it is big business. According to the Exotic Wildlife Association, "the total impact of the industry, combining breeding and hunting components, is $1.3 billion annually." It is estimated that there are several hundred thousand exotic animals on privately owned land in Texas, comprising at least 125 species, some of which, like the oryx, no longer exist in the wild.

Depending on your point of view, it is either immoral to hunt these animals on lands to which they have been artificially introduced, or it is honorable to enable these animals to survive through the creation of a profit incentive for their management. In a now-famous interview on the televi-

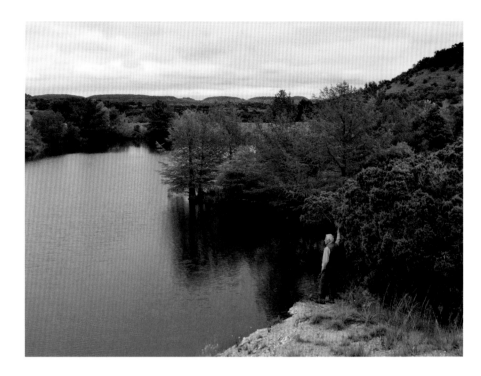

sion news show *60 Minutes*, J. David opined that while he himself was not fond of hunting animals like the oryx, he recognized that without the incentive provided by income from hunting, they would long ago have disappeared from the earth.

"We should always be looking and thinking of alternatives because changes in economies, the environment, and technology could have an impact on what we are doing and the story we are telling."

But there are plenty of challenges associated with introduced or exotic species. Throughout the Texas Hill Country, herds of exotic animals, including axis deer originally from the Indian subcontinent and blackbuck antelope from Pakistan, India, and Nepal, roam freely across the landscape, where most ranches do not have fences high enough to contain them. These free-ranging exotics compete with native game and domestic livestock for food and can put undue pressure on the habitat itself.

The worst of the invaders are feral hogs. Through a toxic mixture of introduced European wild boar in Texas and the escape of domestic pigs, free-ranging feral hogs have over time become one of the greatest threats to the

landscape in Texas. They can produce several litters a year and their populations have exploded, resulting in significant damage to the habitat Texas landowners are working so hard to restore.

At Selah, ranch manager Steven Fulton has declared war on the hogs. Steven, a gentle giant, is a college-trained biologist who is responsible for all land-management decisions at the ranch, all game management and predator control, and other outreach and research activities as well. He started his attack on the hogs by shooting them in the evenings but soon realized that this method would not make a dent in the population. He now traps them and sells them to processors who market the meat on the East Coast and in Europe as "Texas Wild Boar." In 2016, Steven told me, he trapped nearly two hundred wild hogs on the ranch, and yet thinning their numbers and reducing the damage is still an uphill battle. Today, feral hogs can be found in thirty-eight states, and an estimated 2.6 million of them are in Texas.

Feral hogs do provide recreational hunting opportunities at Selah along with white-tailed deer. When J. David first bought the ranch, he leased it to a group of deer hunters for $3,000. At that time, the biggest deer killed on the place weighed about fifty-five pounds. When asked whether they wanted to renew the lease for the following year, the hunters exclaimed, "Mr. Bamberger, those deer were so small, we took them home in plastic grocery bags." They did not renew.

Thanks to J. David's massive improvements in the habitat at Selah and to methodical herd management, the smallest deer can weigh as much as 105 pounds, and hunting adds $40,000 to $50,000 a year to the ranch's bottom line.

Hunting also provides another wonderful opportunity to get kids involved in the outdoors, and each year Selah, Bamberger Ranch Preserve participates in the Texas Youth Hunting Program. A partnership of the Texas Parks and Wildlife Department, the Texas Wildlife Association, and private ranches across the state, the program offers hunts for youth that are safe, educational, and affordable. Parents are welcome to accompany the young hunters, and guides, lodging, and meals are provided through the program.

My former colleague at Texas Parks and Wildlife, Linda Campbell, who was head of the private lands program there, was the hunt master for the event I attended on the ranch. I was extremely impressed with the level of organization, the attention to safety, and the affection shown to the kids, many of whom would otherwise never have had the opportunity to experience the outdoors in this way. Programs such as this are critical to the future of conservation in America, as both the financing and political support for conservation programs of all kinds have traditionally come from the people who "use" the outdoors—hunters, anglers, birders, campers, hikers, and more. Thus, the more that landowners like J. David can do to encourage all kinds of healthy outdoor experiences for children, including hunting, the more support for conservation is instilled in the next generation.

Lois Sturm and her husband, Ted, first came to Selah from Pennsylvania as paying hunters. They met J. David, had a great time, and began to consider retiring in the Hill Country, where Lois could volunteer at Selah. They put down the deposit for a return hunt the following year. Sadly, Ted passed away unexpectedly, and Lois asked that their deposit be converted to a donation to the preserve. Nonetheless, she returned to the ranch alone for the fall leaf walk. During her visit, J. David reached out to her and proposed that she become a salaried member of the ranch family. She has never left.

"There is something almost sacred about Hes' store. Nearly everyone who steps in feels it and enjoys it. It's not just the building and the things inside it, it's also the outside . . . on the road like an old time store would have been. It's been my pleasure to stand on the porch and tell the story of Hes hundreds of times and get this reaction from people of all ages."

Following our afternoon of storytelling in the Bamberger kitchen, Nona, J. David, Margaret, and I walked down to Hes' Store and shared a bottle of Hill Country wine on the porch. The country store was modeled after an old roadside grocery in Welfare, Texas, not too far from Johnson City, and I believe it is the place where J. David most profoundly feels the spirit of the ranch. After finishing the structure, J. David told us he filled it with everything he could find that had belonged to his mother, except, he said, her passion.

Still living at the time, Hes told J. David that she knew he had made a lot of money, but she never wanted to be a burden to him. "Just don't put me in one of those warehouses." When J. David was a boy, they had planted apple trees and she reported that two of them were still bearing a few apples. "When my time comes and you can't find me, look for me at our trees."

As the sun went down that evening over Hes' Store, J. David recounted that when her time had indeed come, they found her at the foot of the apple trees with a bouquet of flowers in one hand and pruning shears in the other.

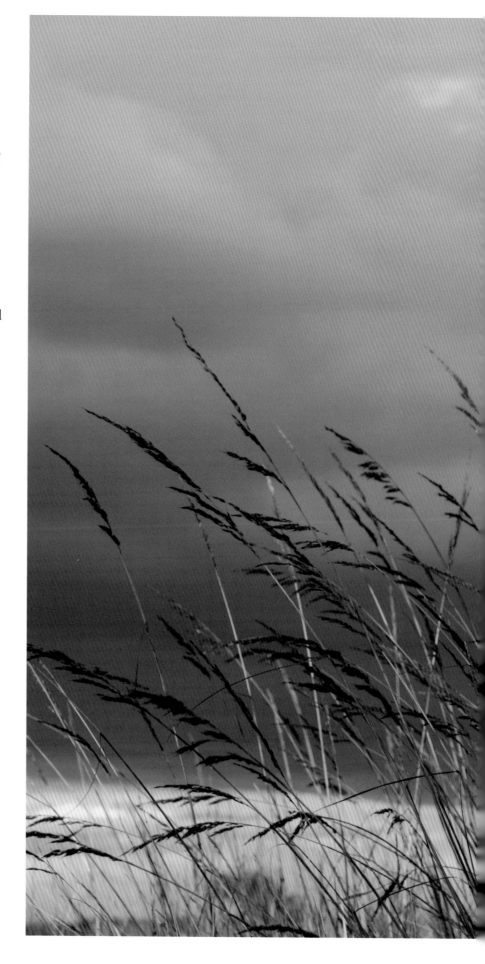

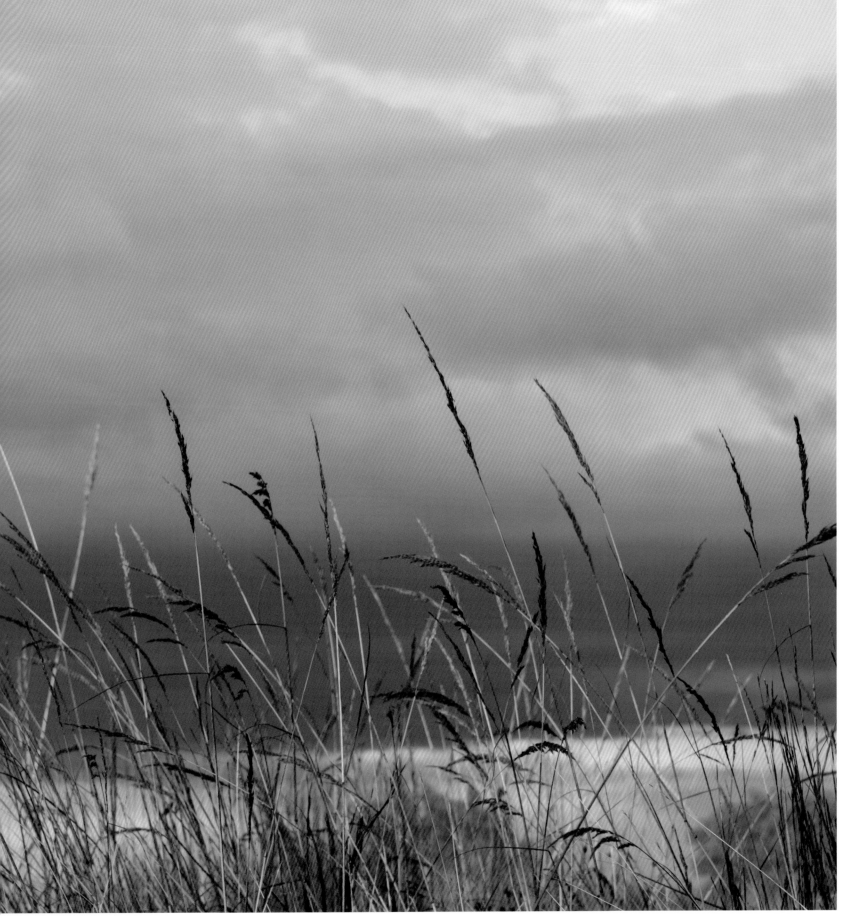

Indiangrass
with dramatic
sky.

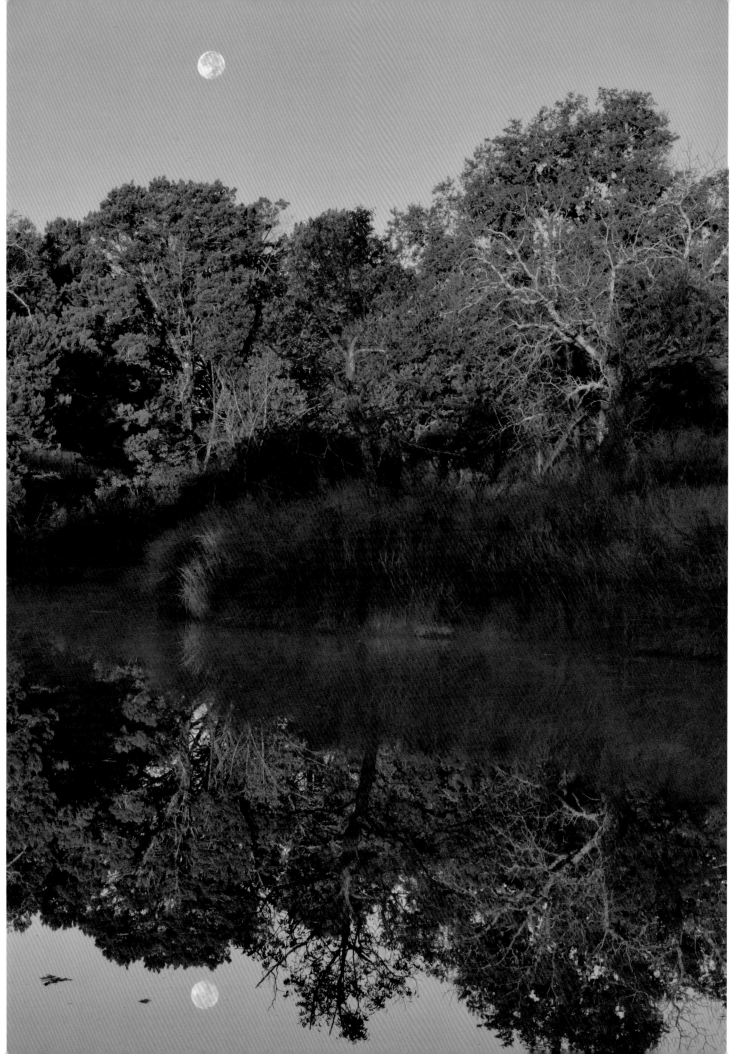

The Hunter's Moon
sets over and casts
its reflection on
Malabar Pond.

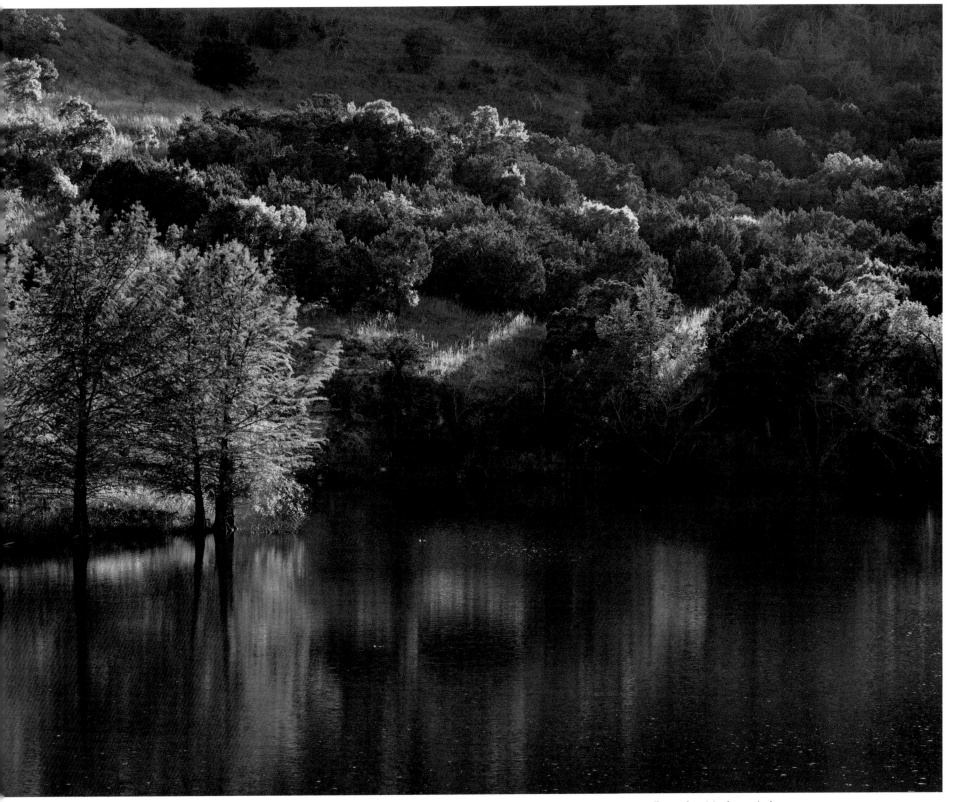

Golden leaves of bald cypress reflected in Madrone Lake.

Gayfeather
blooms in
the Big Valley
Pasture.

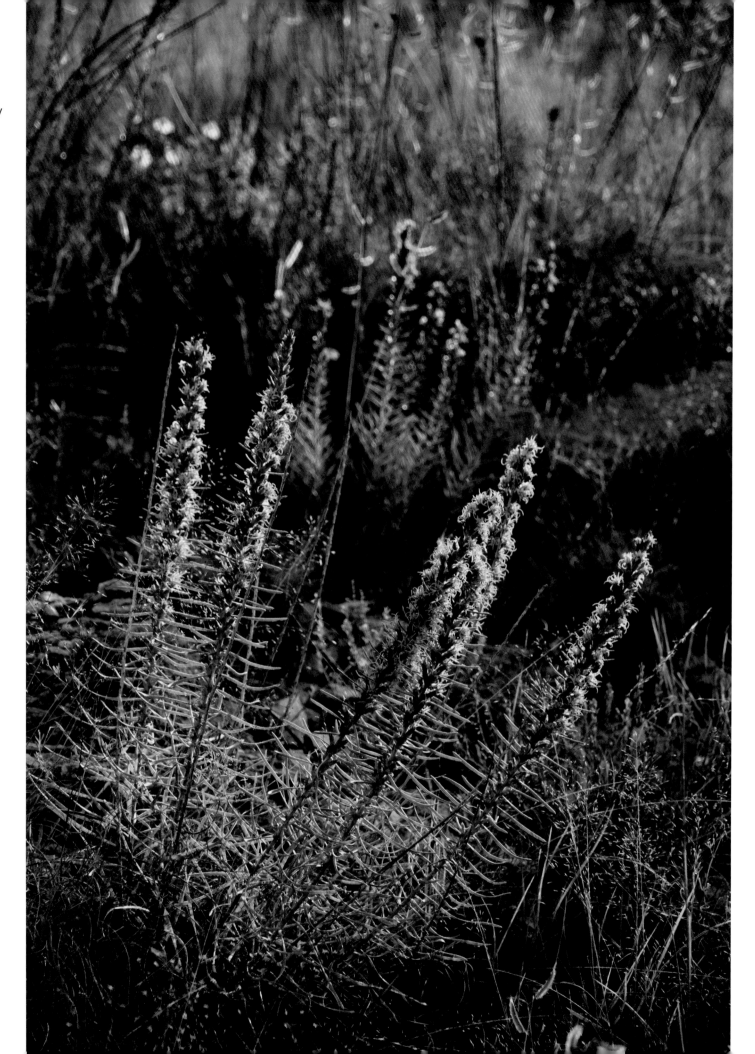

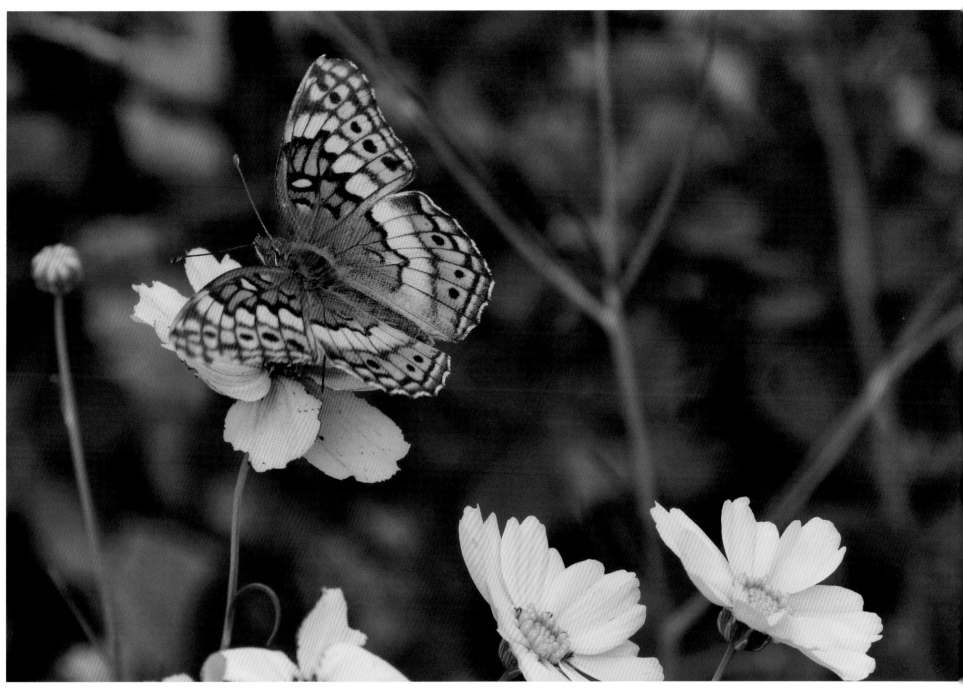

A variegated fritillary draws nectar from Navajo tea.

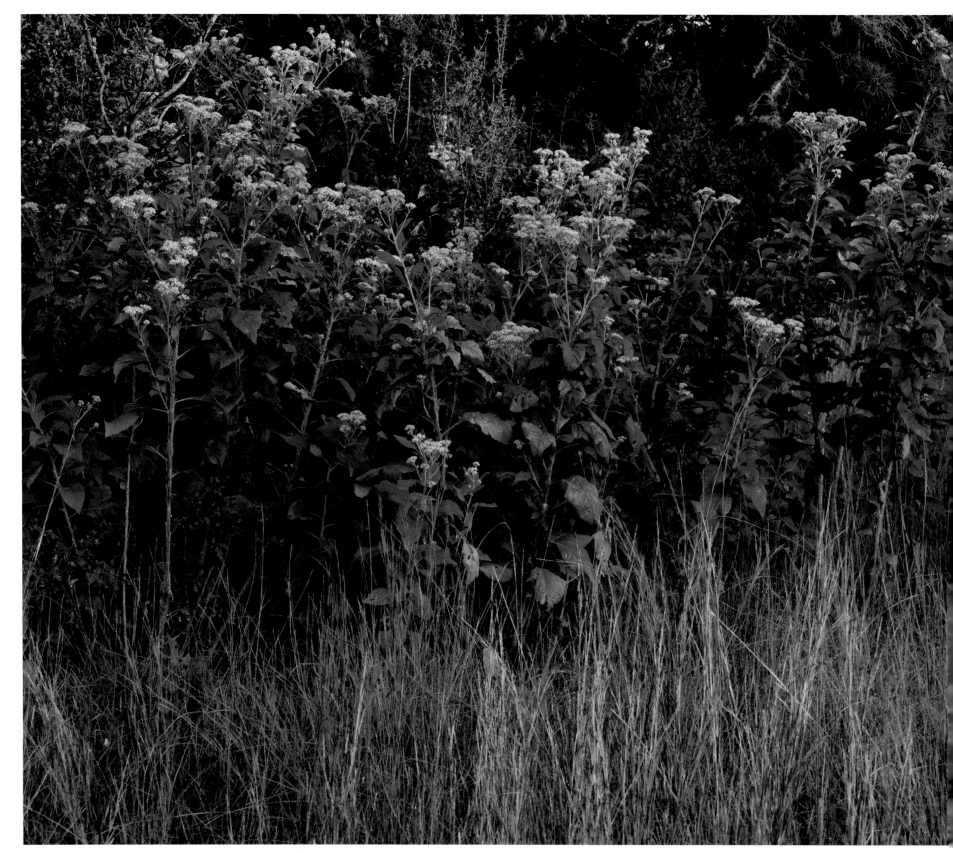

Frostweed blooms everywhere on the ranch.

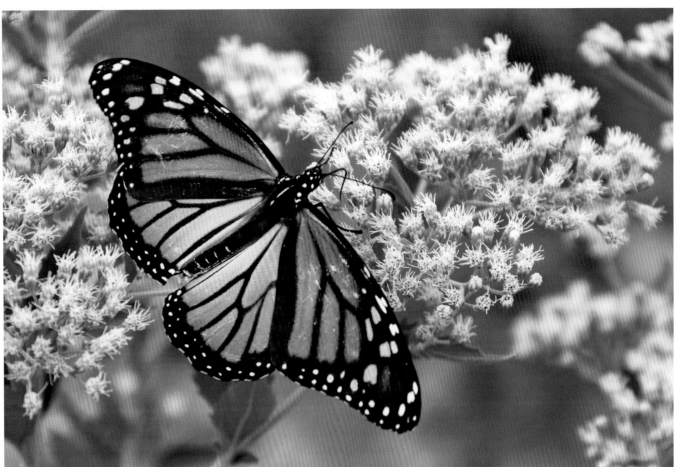

Perched on white boneset, a monarch butterfly shows evidence of fall migration fatigue.

Ring-necked
ducks swim
through fall
reflections on
Madrone Lake.

Blue-winged teal landing on Submarine Pond.

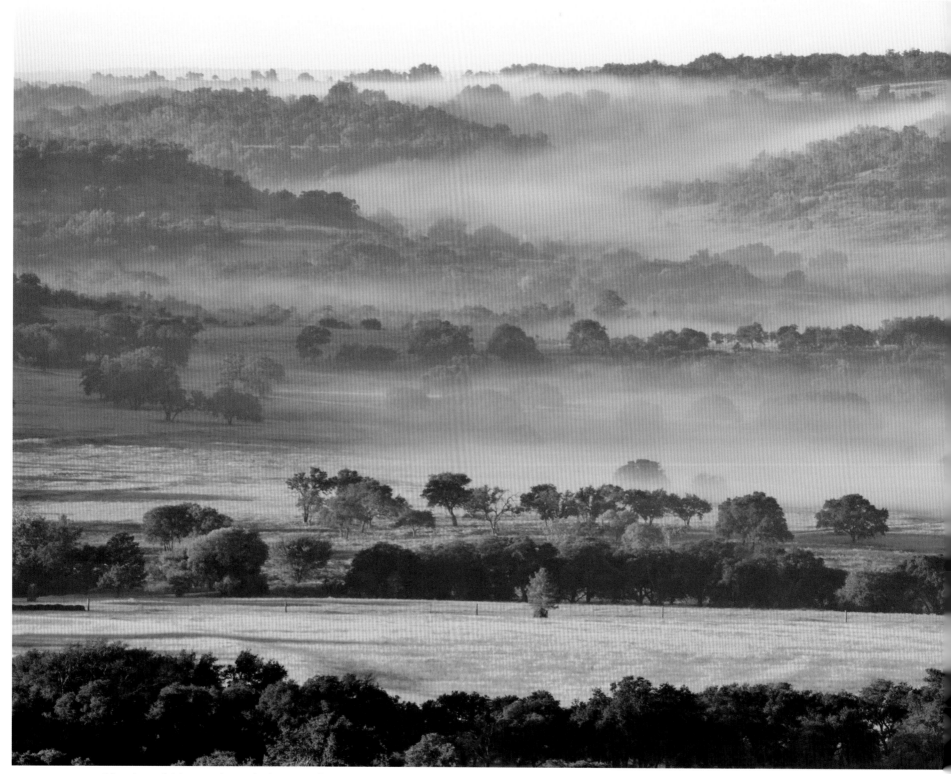

Morning mist hangs above the hay meadows.

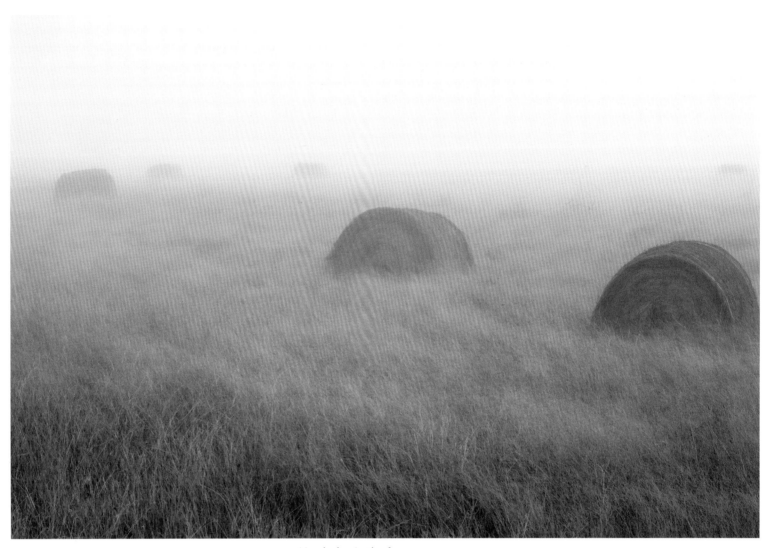

Hay bales in the fog.

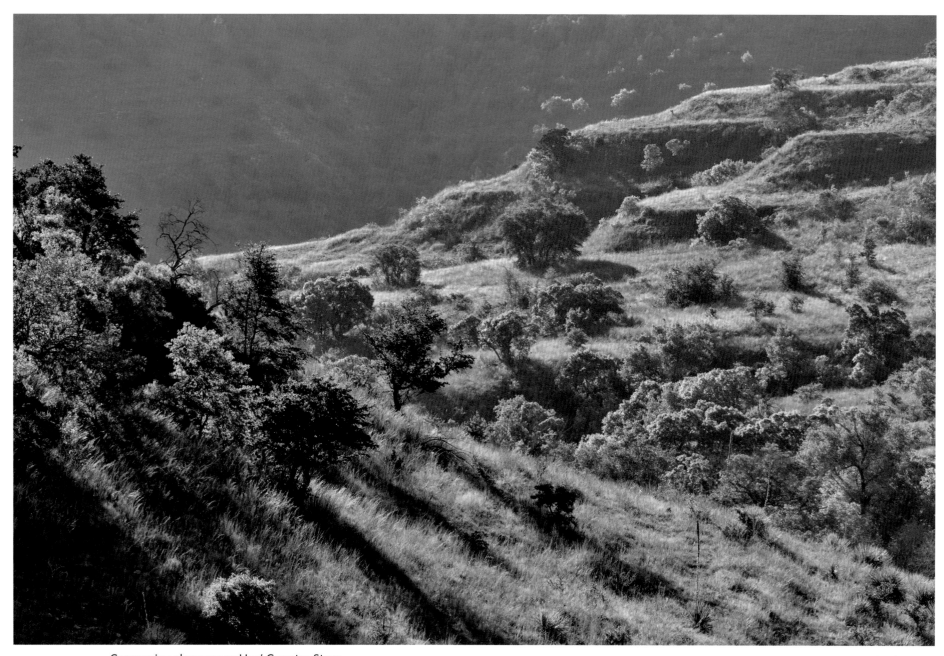

Converging slopes near Hes' Country Store.

Sunrise over the Big Valley Pasture with little bluestem in the fore-ground.

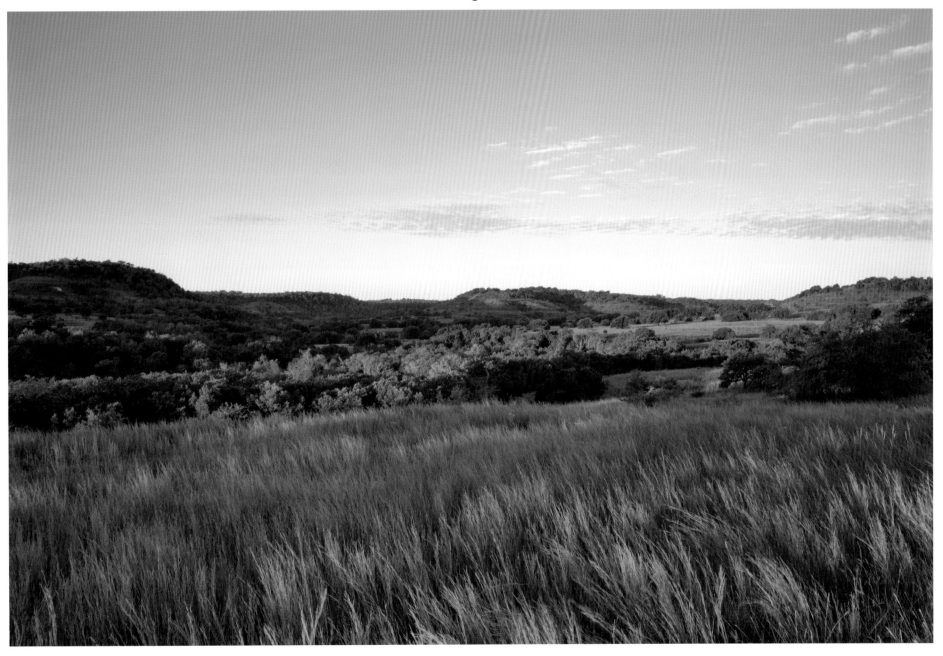

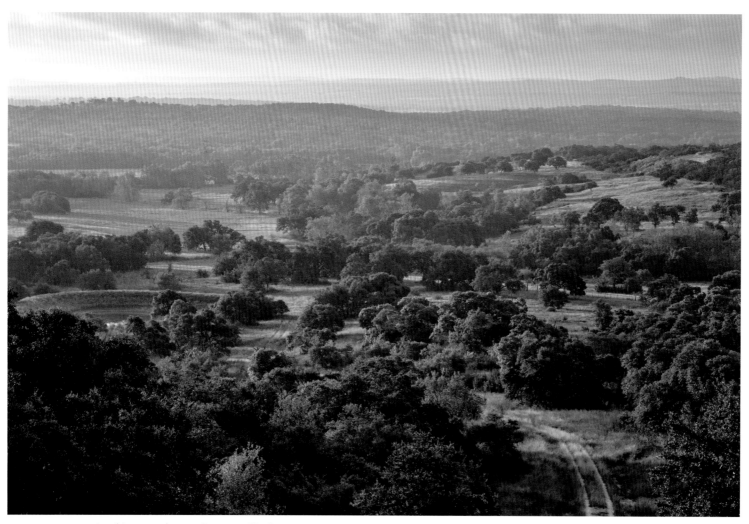

Looking south over Brownsville Corner at sunrise.

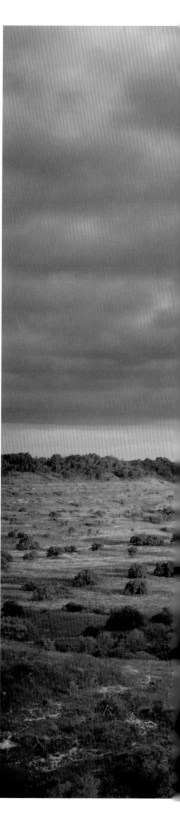

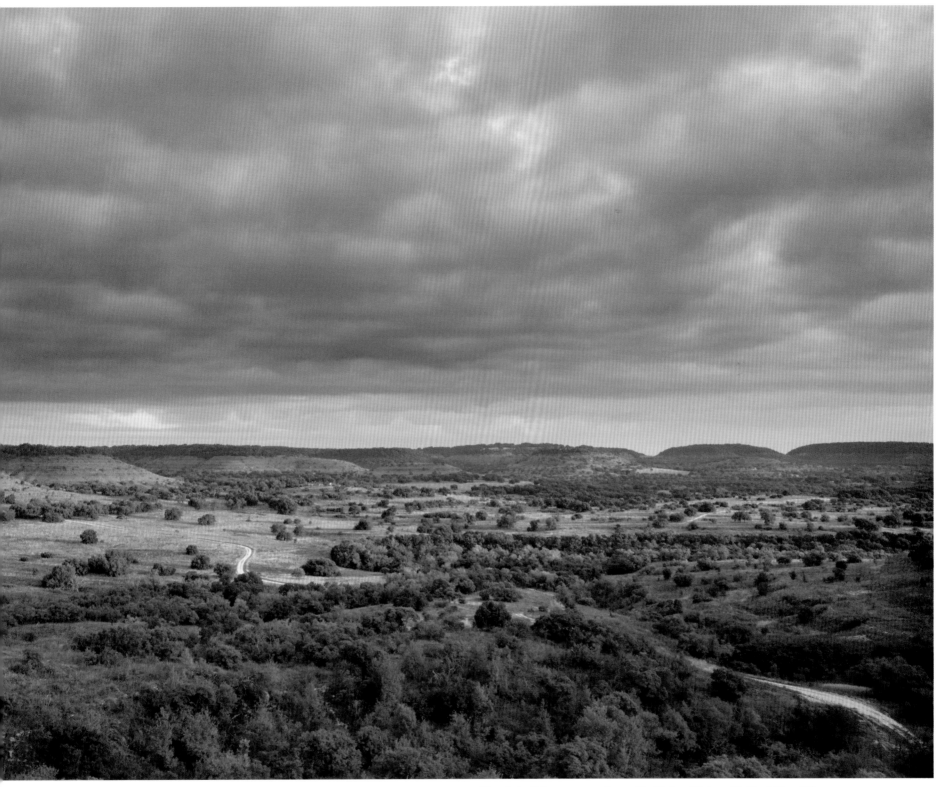

Clouds building as seen from Big Valley Vista with the hills of the
High Lonesome Pasture in the distance.

Switchgrass and Indian-grass thrive in the Little Mexico Pasture.

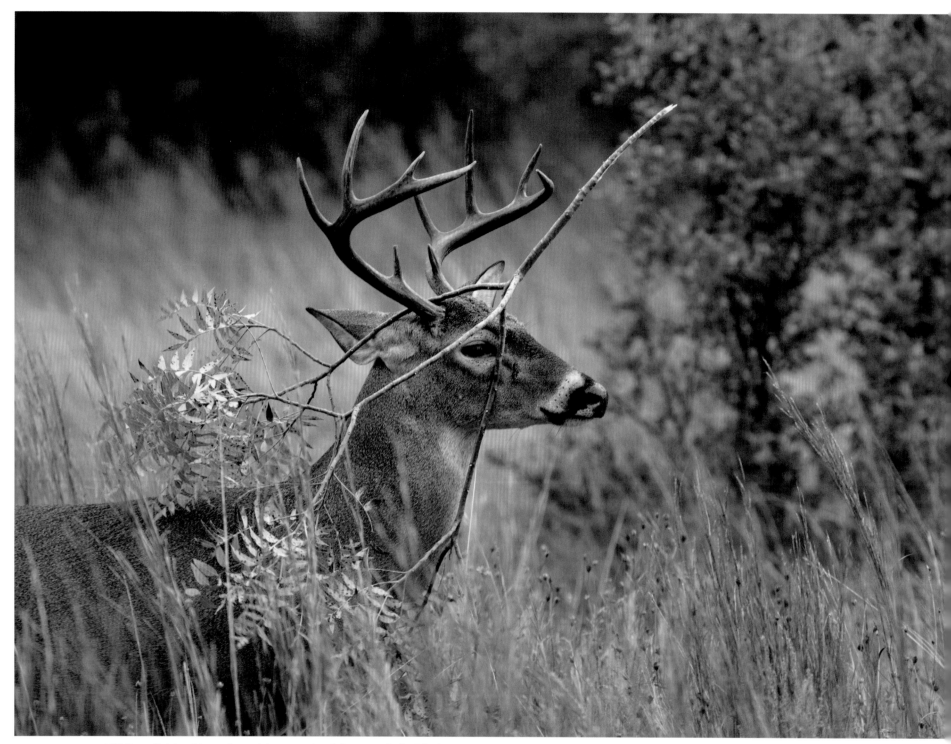

While polishing his antlers, this young buck has tangled with the wrong flameleaf sumac.

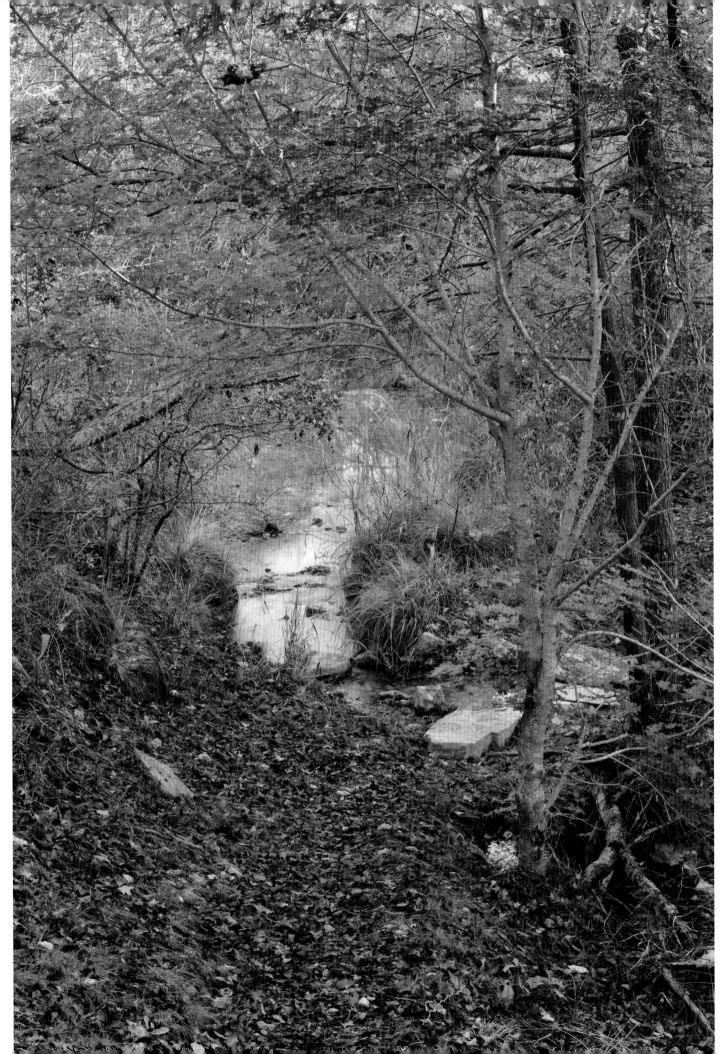

One of the many bigtooth maples along the Rachael Carson Trail.

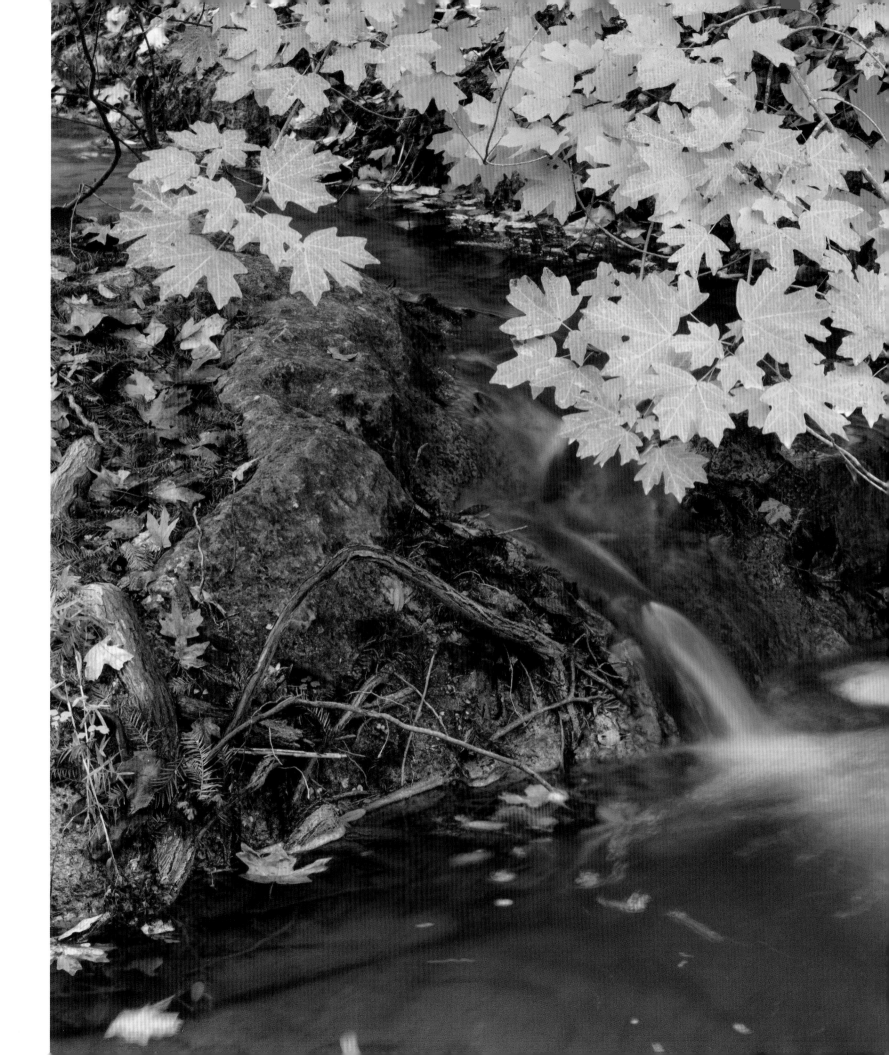

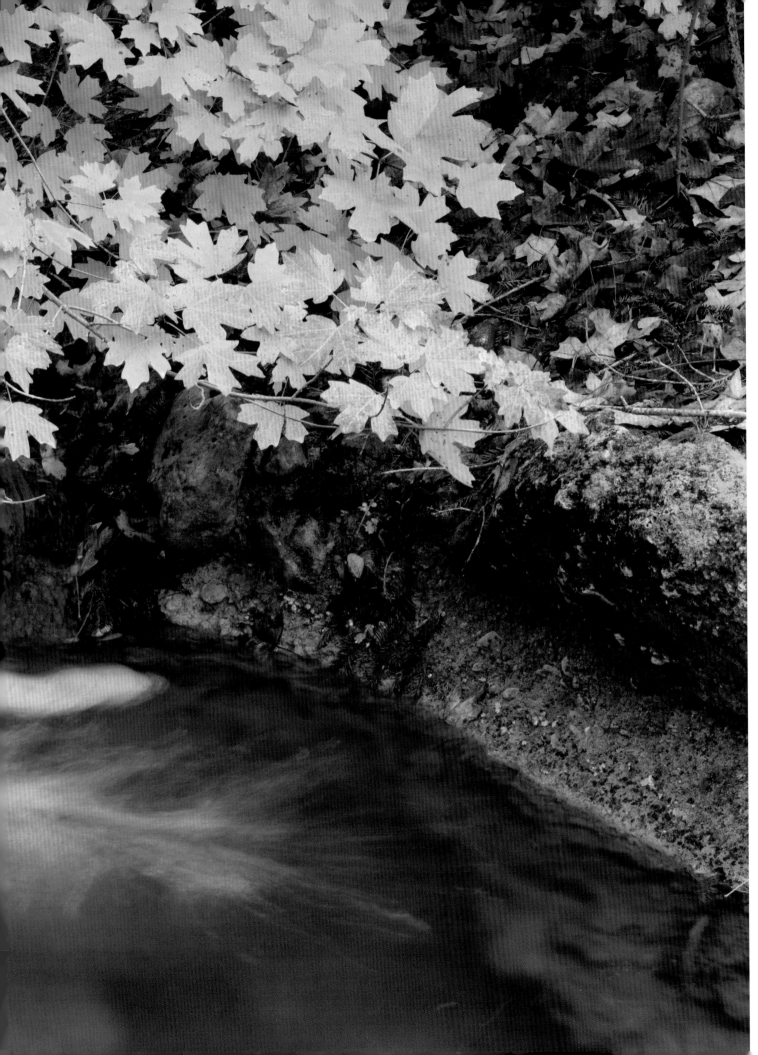

The bigtooth maple leaves above this pool are just starting to turn.

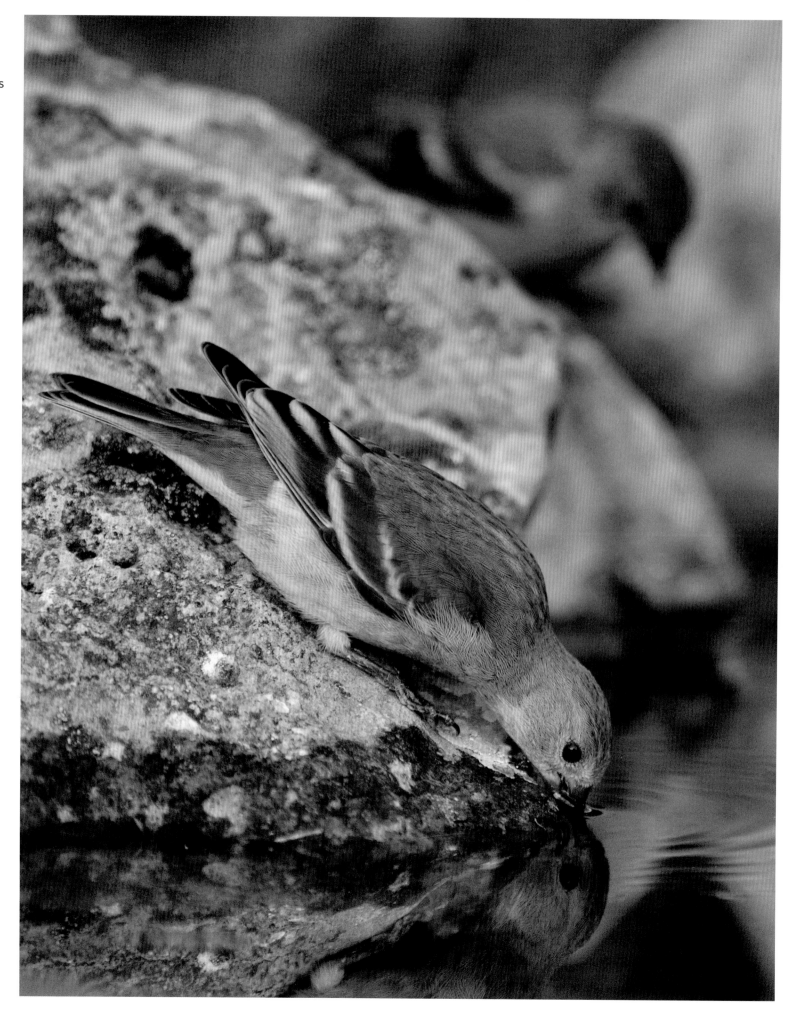

Lesser gold-finch females drink from spring-fed pools.

Stone steps covered in bigtooth maple leaves along the Arboretum Trail.

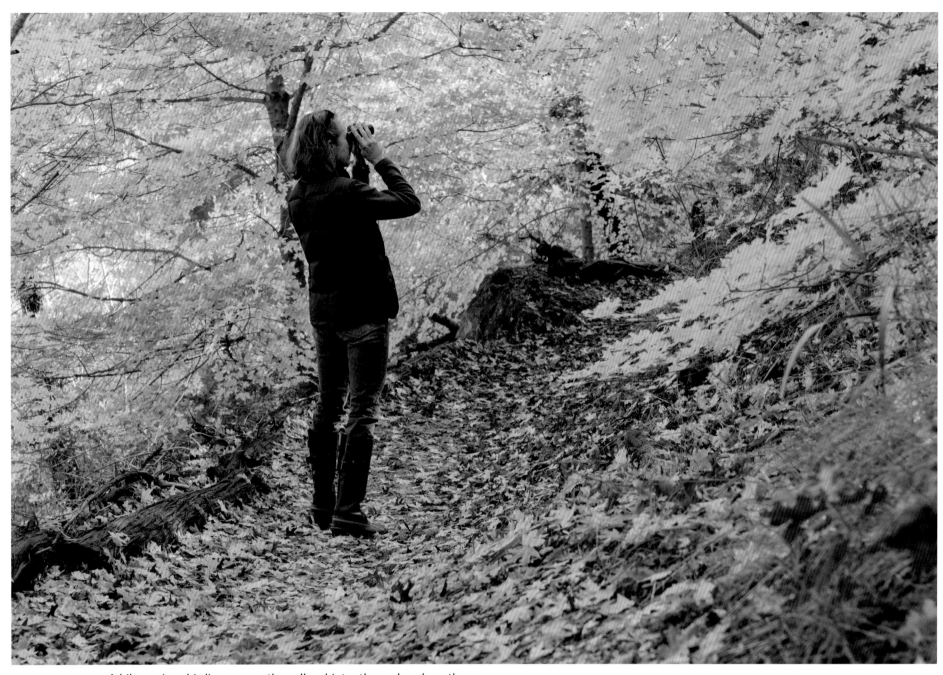

A hiker enjoys birding among the yellow bigtooth maples along the Bigtooth Maple Trail.

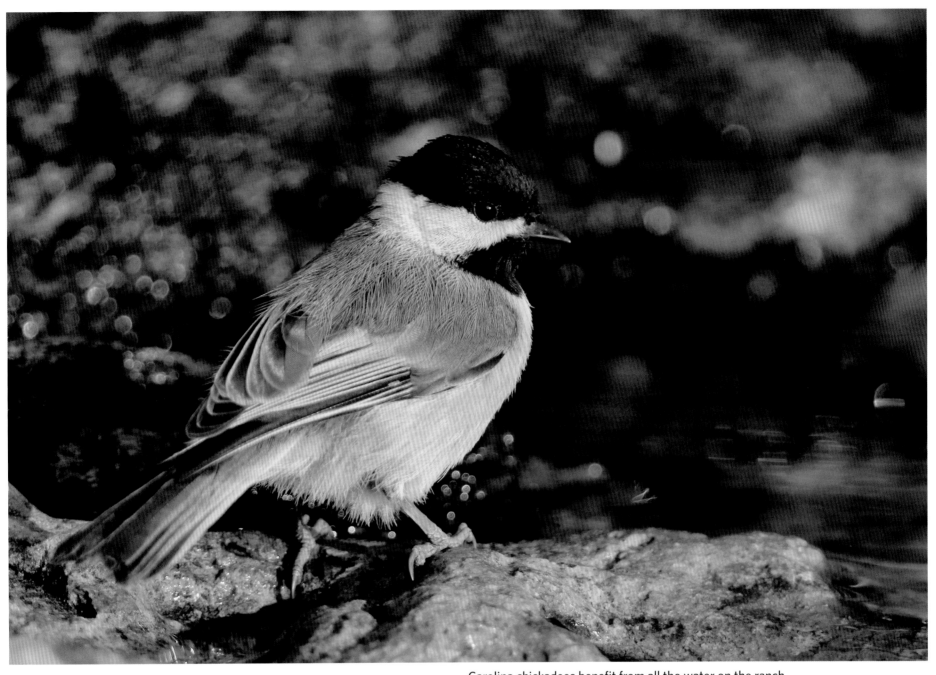

Carolina chickadees benefit from all the water on the ranch.

The diverse forested slopes above Miller Creek put on an impressive display in late autumn.

A Spanish oak above the Arboretum Trail catches the early morning light.

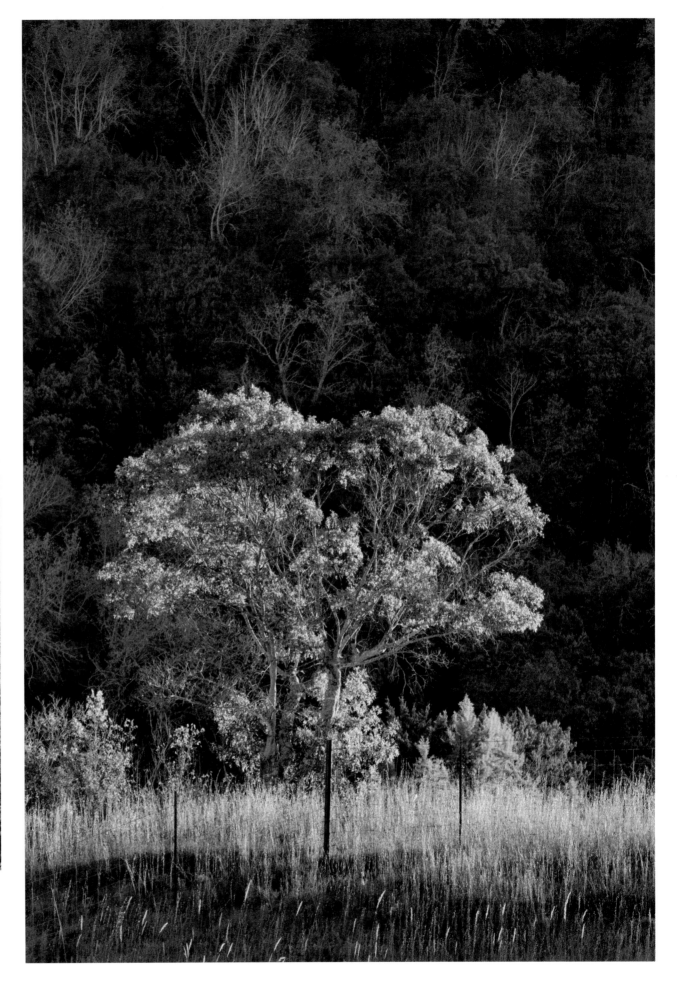

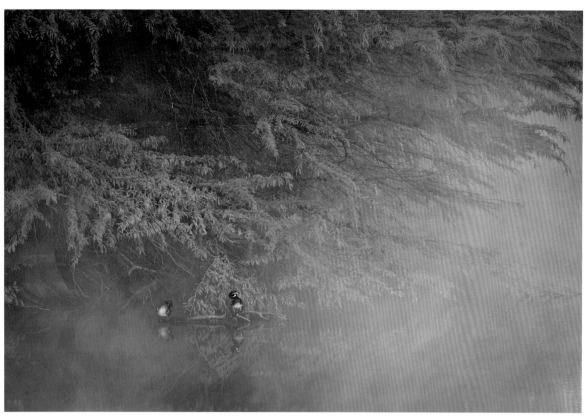

A pair of wood ducks preens under a bald cypress bough.

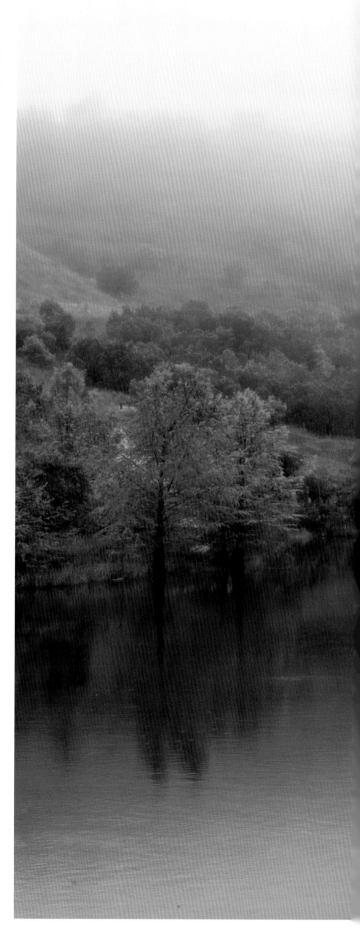

Foggy morning on Madrone Lake.

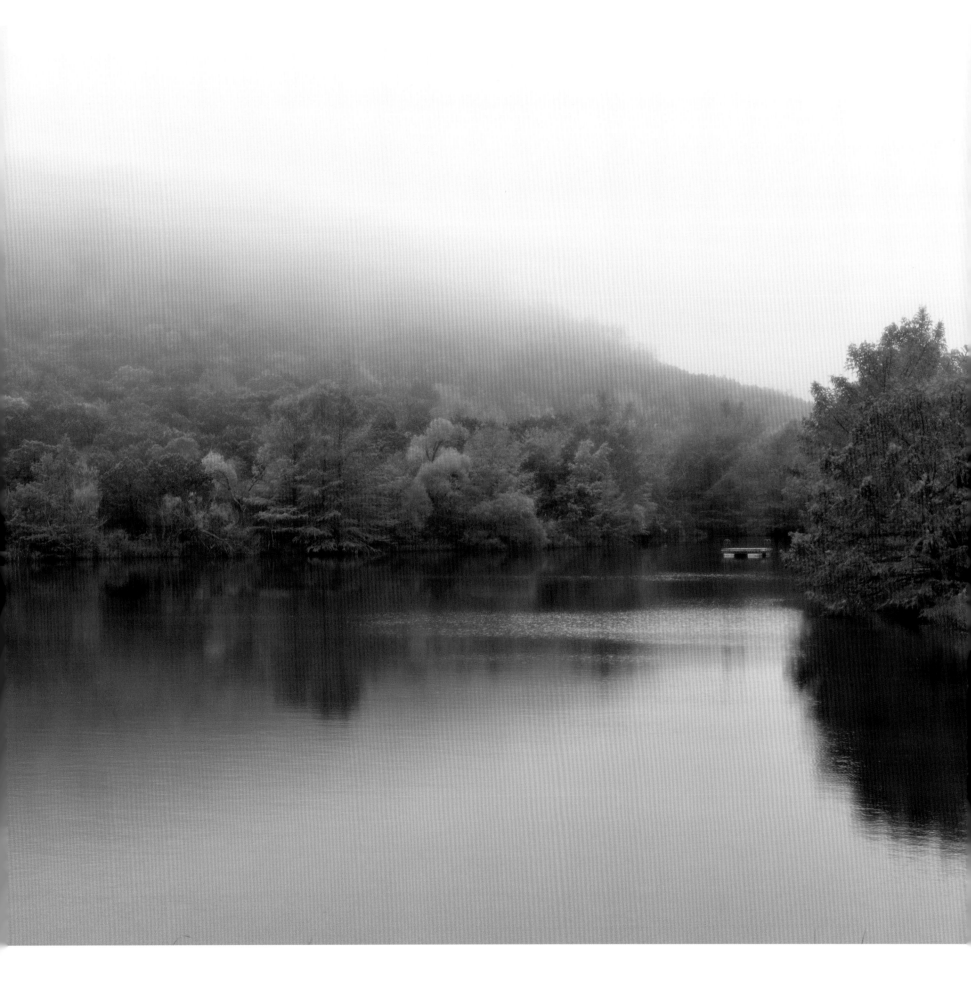

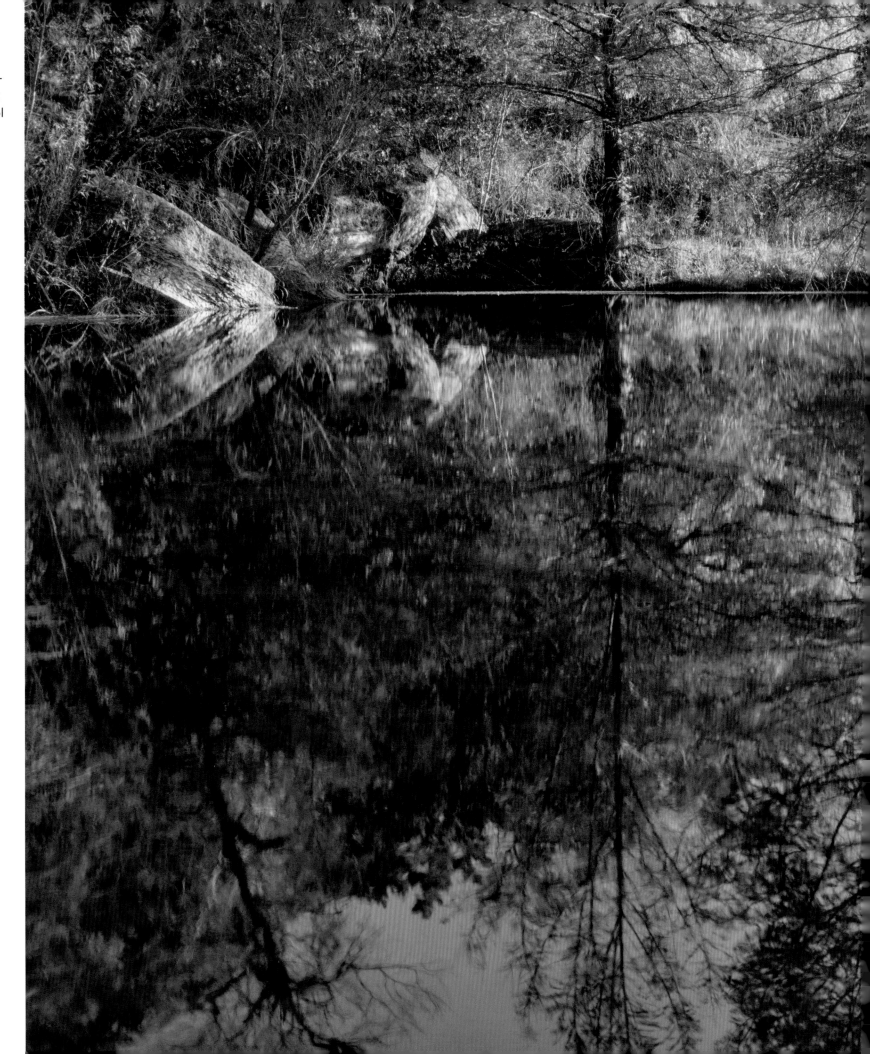

Late afternoon light at the pool known as Jacob's Ladder.

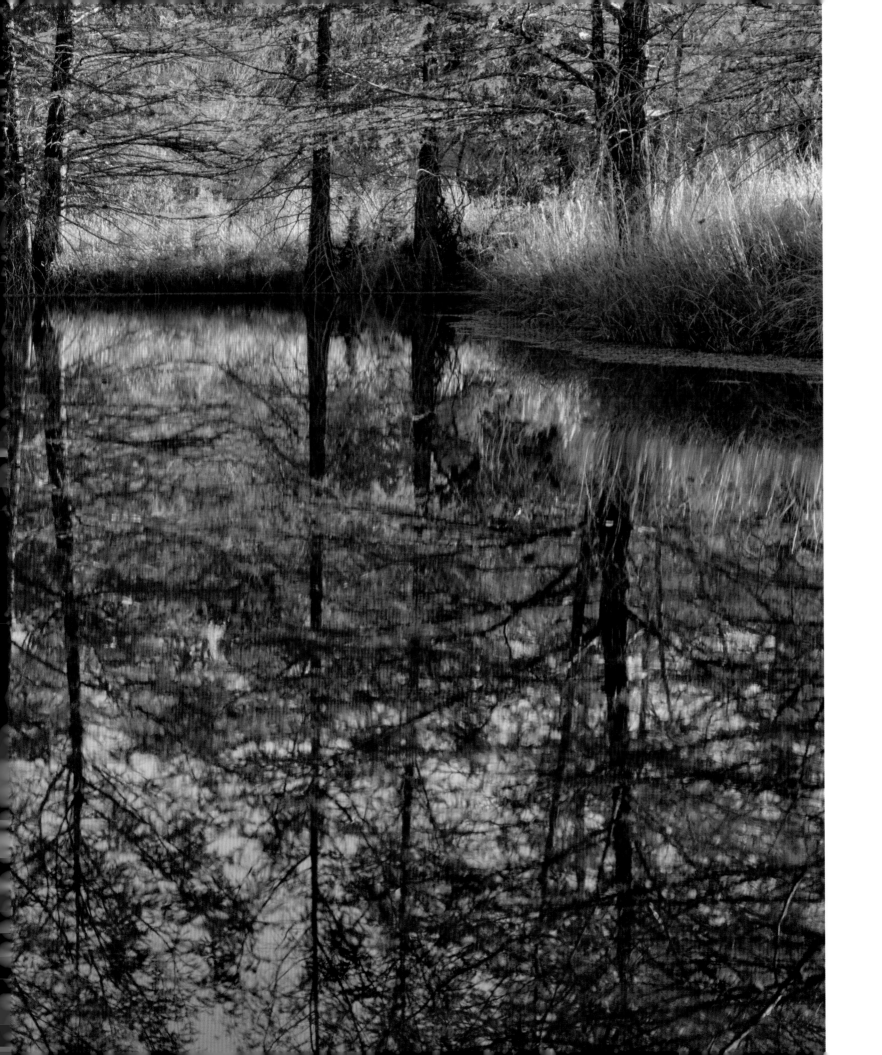

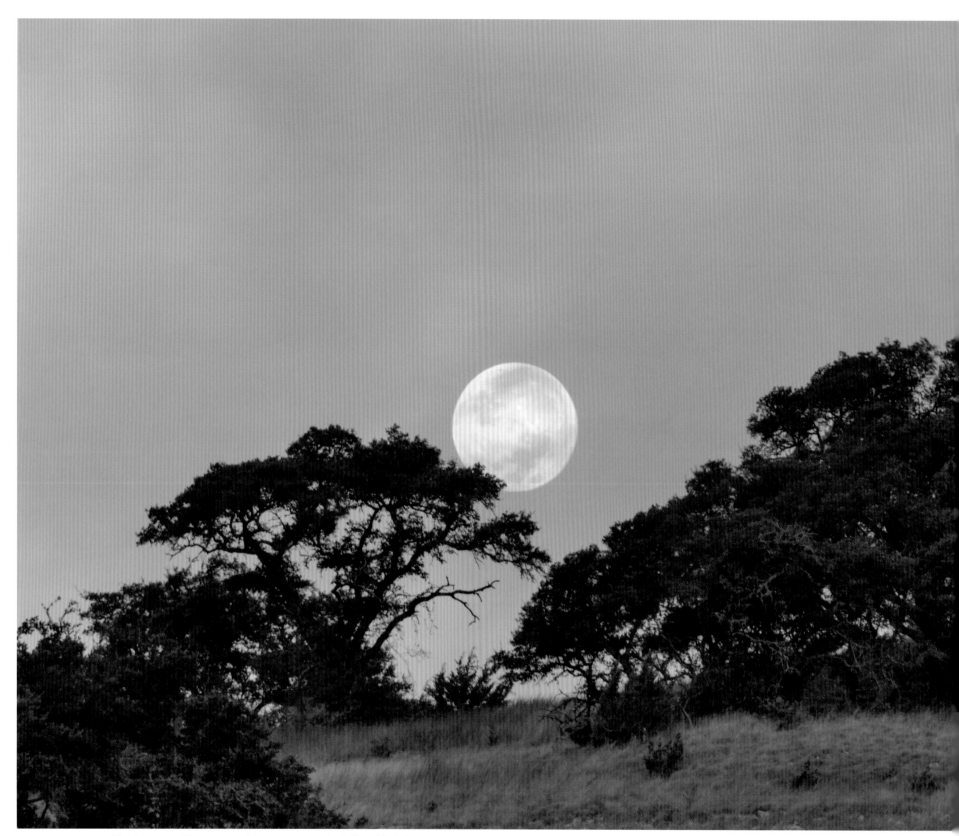

The Harvest Moon at perigee sets over the hills of Selah.

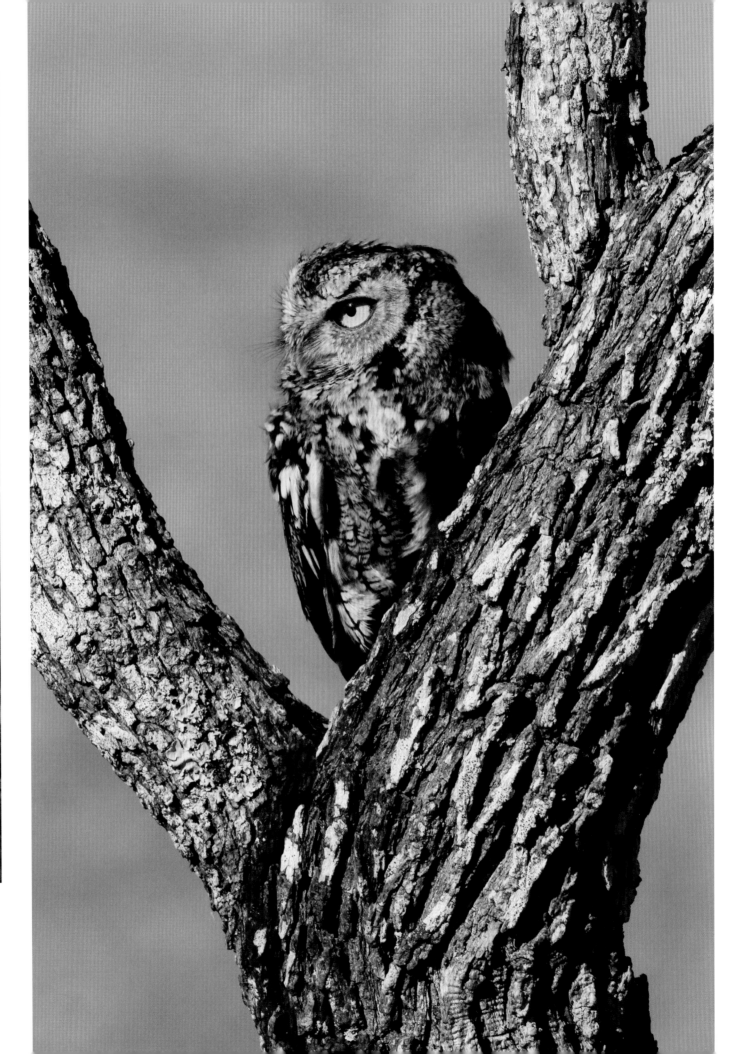

An eastern screech owl is perfectly camouflaged.

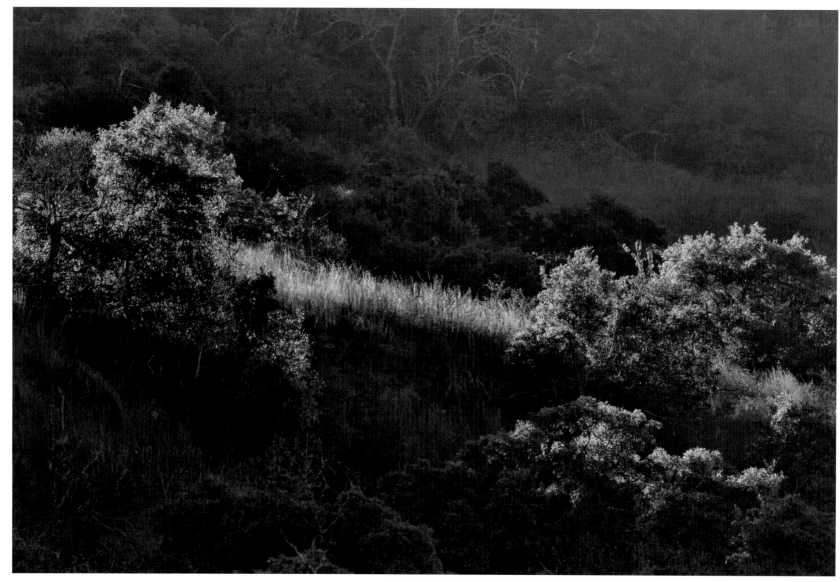

Sunrise highlights little bluestem on a ridge in the High Lonesome Pasture.

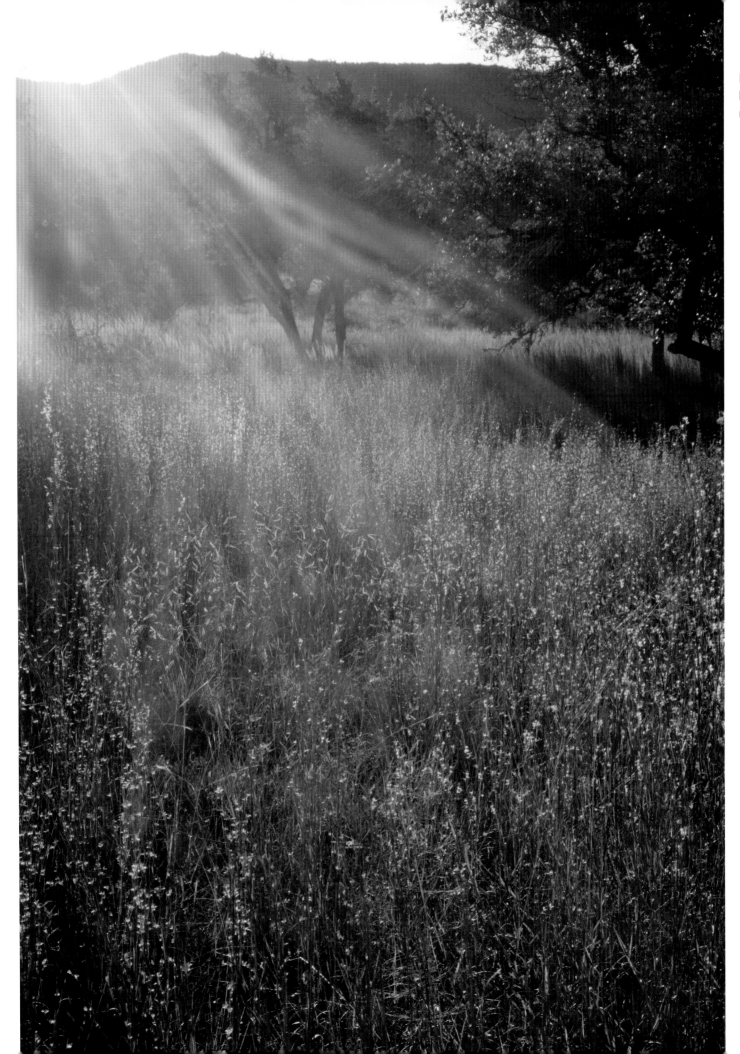

Little bluestem backlit by a sunrise.

169

Little bluestem at sunset in the Little Mexico Pasture.

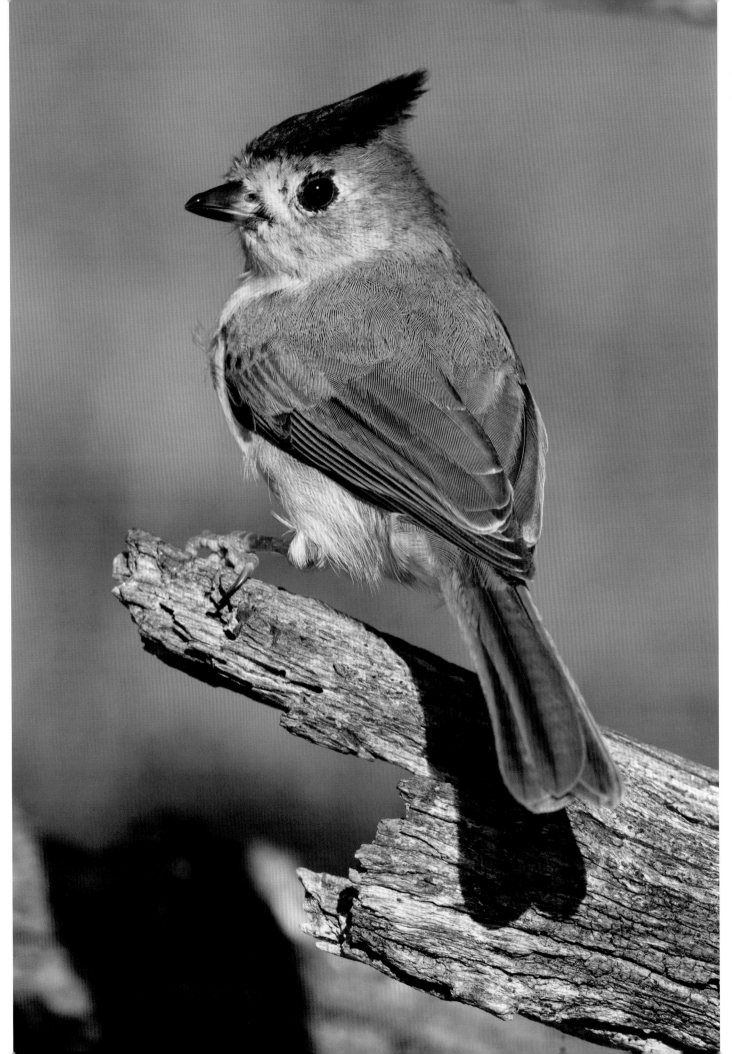

Black-crested titmouse, a plentiful resident of the ranch.

171

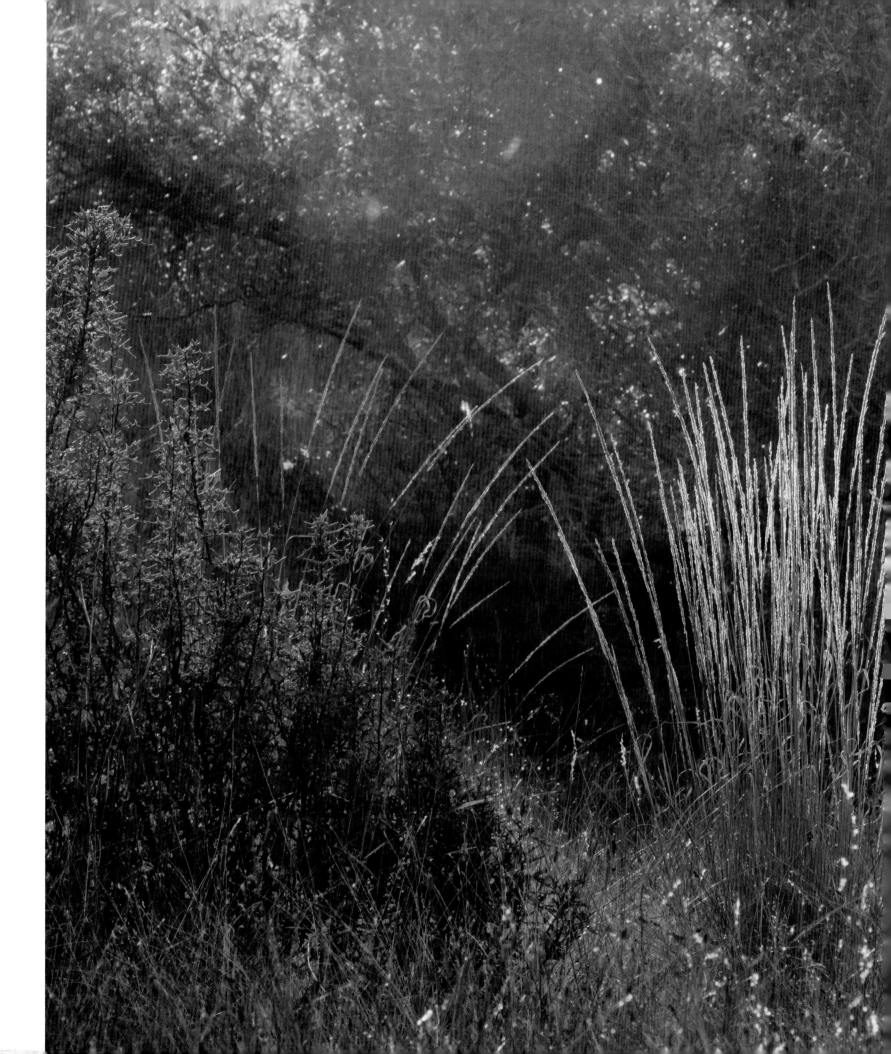

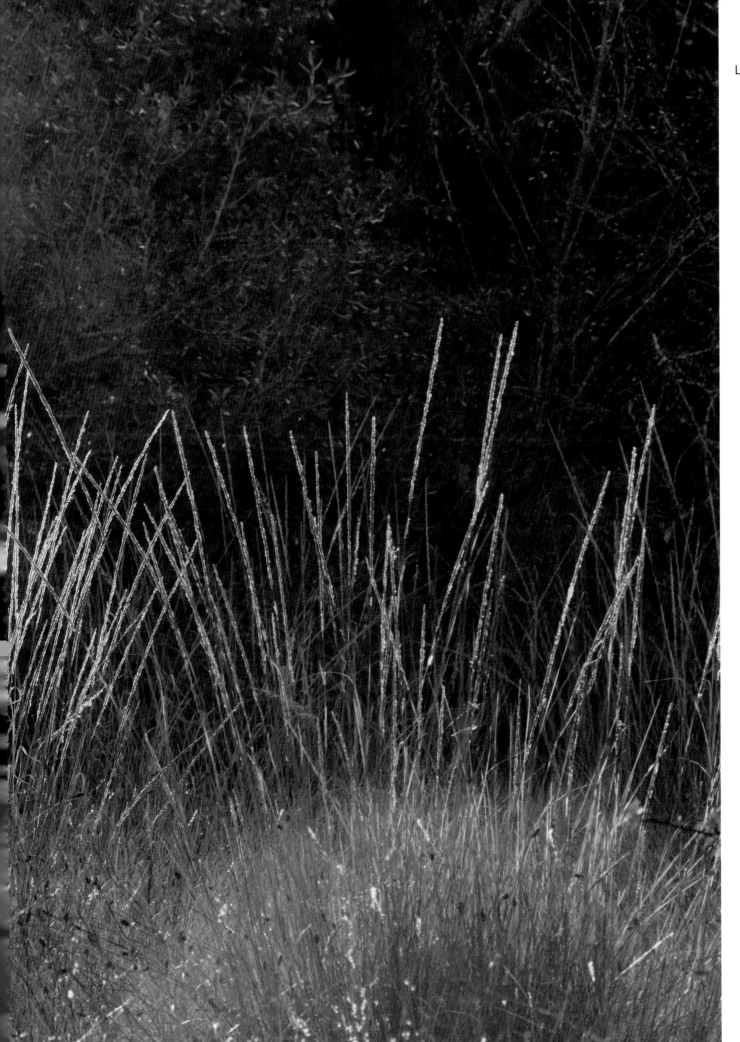

Lindheimer muhly at sunset.

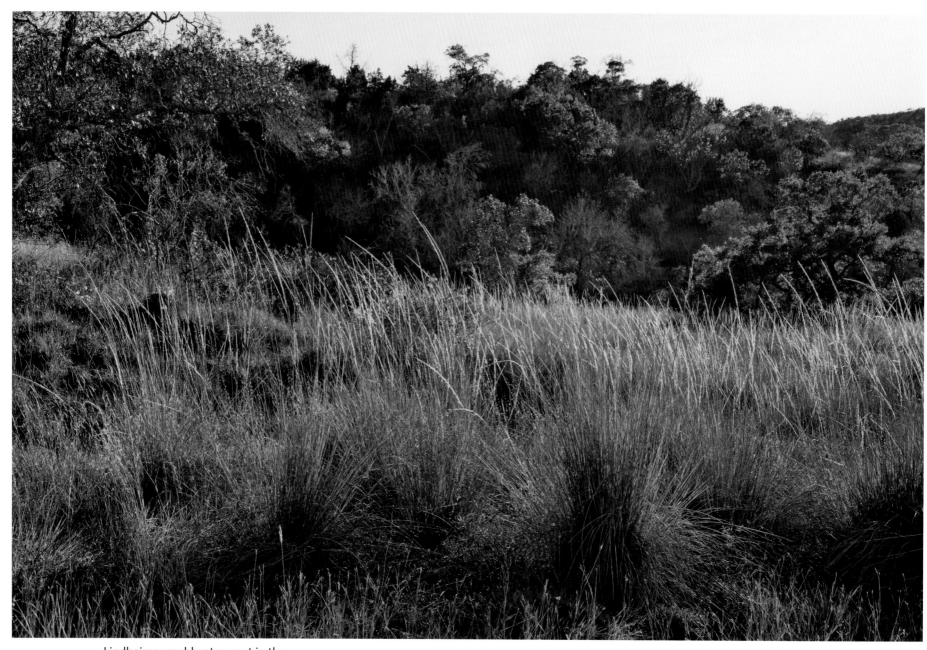

Lindheimer muhly at sunset in the
Southwest Slope Pasture.

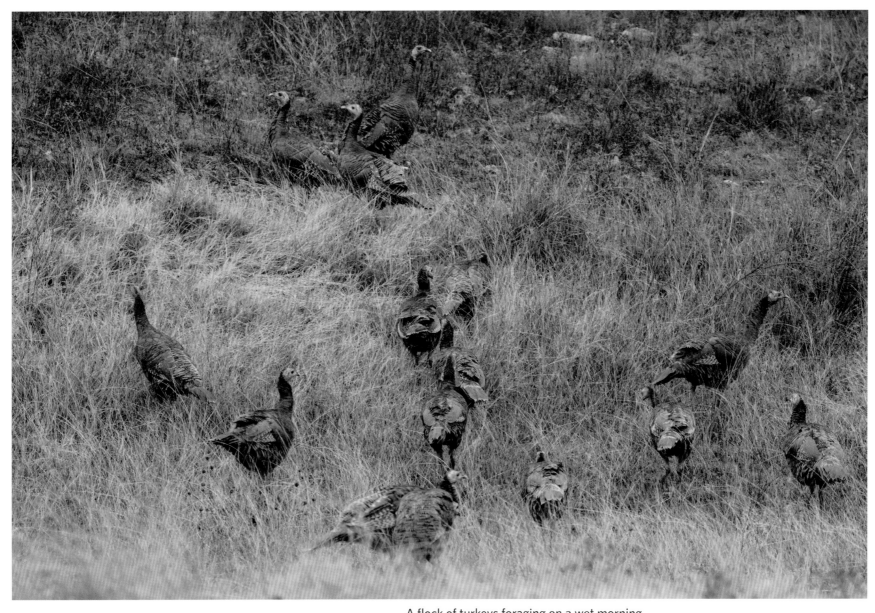

A flock of turkeys foraging on a wet morning.

Escarpment black cherry and Spanish oak trees show their colors near Wildlife Pasture Pond.

The escarpment black cherry is truly a beautiful tree.

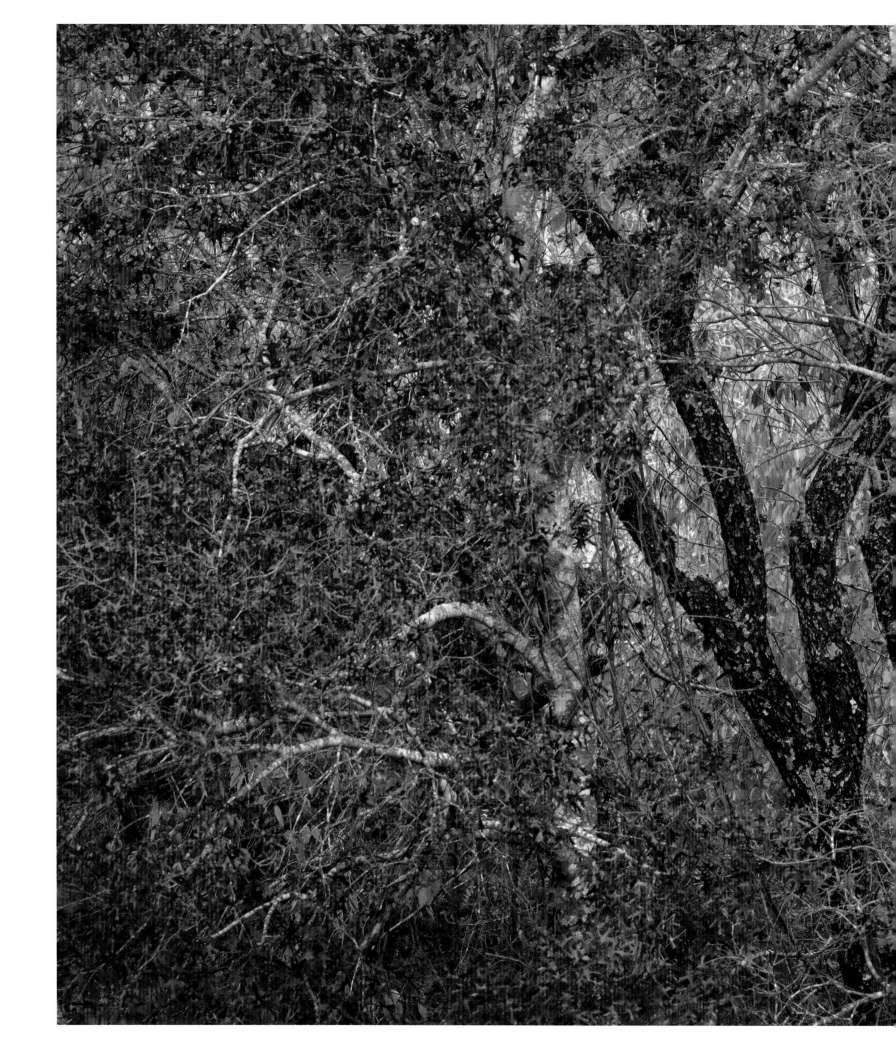

Spanish oaks and escarpment black cherry trees.

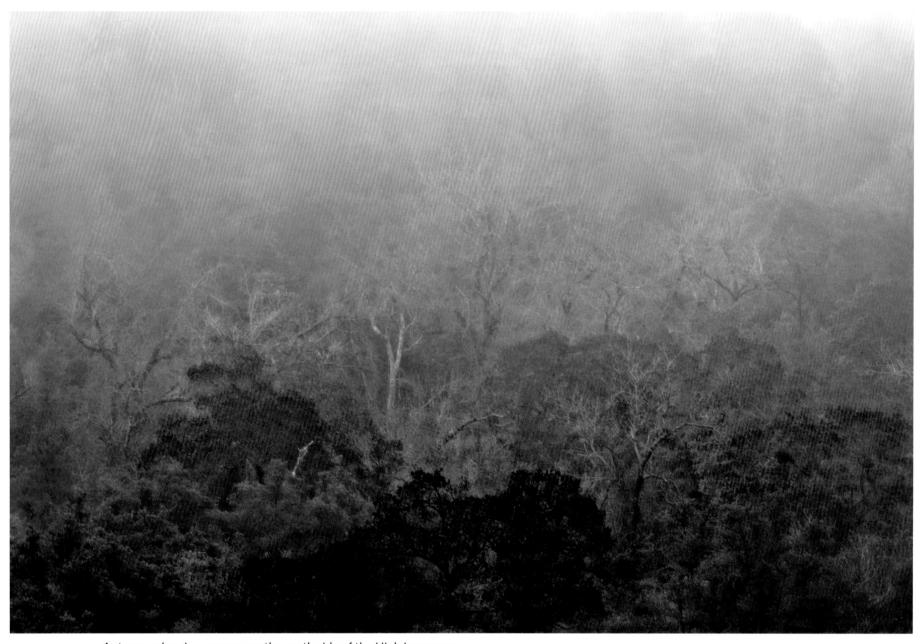

Autumn colors in a canyon on the north side of the High Lonesome
Pasture.

HES' STORE

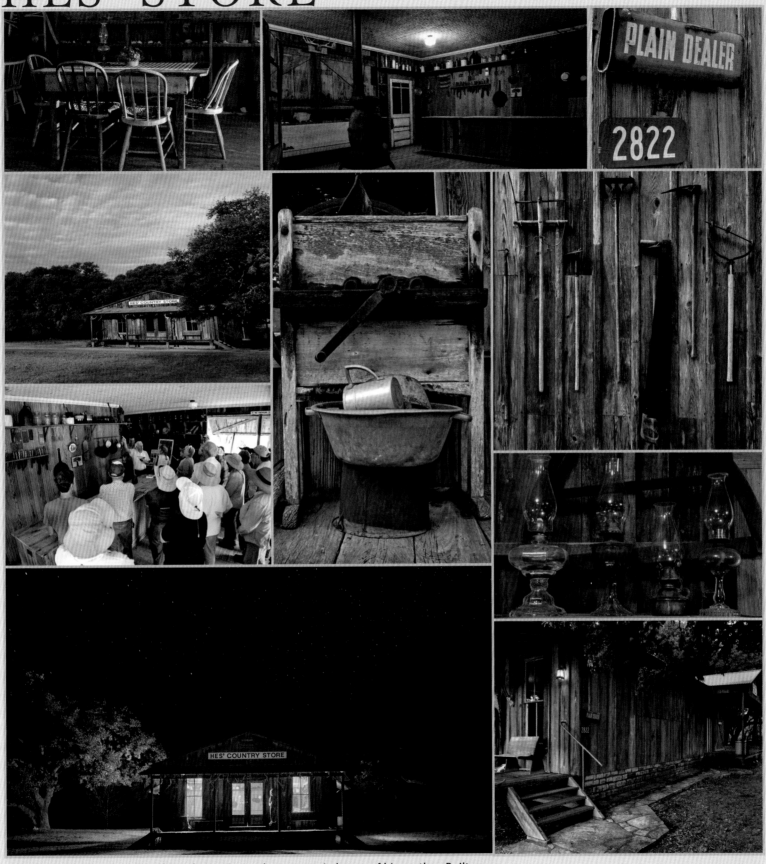

Hes' Country Store is J. David Bamberger's ranch museum in honor of his mother. Built as a replica of a historic Texas country store, his mother's heirlooms are on display to emphasize the importance of family and cultural preservation.

Frosty morning in one of the valleys of Selah.

WINTER

Of the many things I love about J. David Bamberger, one of the most endearing is that each year at Christmastime he returns to San Antonio to sell holiday trees to benefit the good work of the Optimist Club, which he has been a member of for many years. It was at the Optimist Club Christmas tree lot on a cold winter evening that an encounter with a customer would ultimately have a profound impact on J. David's work at Selah.

Colleen Gardner, like my wife, Nona, and I, attended Austin College, a small liberal arts institution in Sherman, Texas, near the Oklahoma border. Colleen had returned to Texas just before Christmas after serving two years in the Peace Corps in Niger. She and her mother were on the Optimist Club lot looking for the right tree to celebrate Colleen's return. Into their lives that evening walked the most celebrated vacuum cleaner salesman in America, and they soon had their tree.

In the process of completing the transaction, Colleen and J. David discovered that they had much in common, including the country of Niger, where J. David had visited in his effort to reintroduce the scimitar-horned oryx to its native habitat, and Austin College, where J. David and I served together on the Environmental Advisory Board.

And so, along with their Christmas tree, Colleen and her mother left that evening with an invitation to visit the ranch, which they soon did, and basically, Colleen never left. Starting as a volunteer, later working as an intern, and eventually becoming the executive director of Selah, Bamberger Ranch Preserve, Colleen is responsible for all administrative operations, educational programs, and public communications at Selah.

She earned a master's degree in geography with a focus on resource and environmental studies at Texas State University and there met Scott Gardner, also a graduate of Texas State, whom she married on the porch of Hes' Store, where she was given away by J. David Bamberger.

A few years after Colleen arrived, in a blow to the work at Selah that was also devastating to J. David and a loss to the earth, Margaret Bamberger was diagnosed with cancer. This courageous lady, who had beaten the lignite mines in Bastrop County, tamed J. David Bamberger, and transformed the outreach mission at the ranch, fought back against the disease that had savaged her lungs and liver and achieved what seemed to be a miraculous recovery. But in time, the cancer returned, and her daughter Margie moved to the ranch to care for her.

Facing her death, and typical of this extraordinarily talented and exuberant woman, she directed that her memorial service be conducted while she lived. Among her many attributes, Margaret was a gifted artist, and we gathered around her at the Benini Foundation and Sculpture Garden near Selah for what can only be described as a joyous occasion. I'll never forget that even Donna, J. David's first wife, with whom Margaret had become a close friend, was there to celebrate her life. As we friends of Margaret mingled and reminisced, the guest of honor held court on a settee and was able to participate in and enjoy the commemoration of her life and to see the gift she was to J. David, to Selah, and to all of us. Margaret, unsurprisingly, specified that she be laid to rest on the ranch in a green burial.

Though her legacy at Selah is tangible and her spirit there palpable, especially for those of us who knew and loved her, her loss brought a measure of despair to Selah as well, mirroring the often gloomy prospects for the environment she worked so hard to protect.

Nowhere on the ranch is the grim reality of the challenges faced by humanity in protecting the earth felt more profoundly than at the historical marker that J. David erected many years ago near the entrance. Inside a small fenced plot reminiscent of a country cemetery, and fully consistent with his often unconventional and provocative approach, stands a small monument representing the gravestone of the human race.

<div align="center">
In Memory

Of Man

2,000,000 B.C.–20?

He Who Once

Dominated The Earth

Destroyed It

With His Wastes

His Poisons And

His Own Numbers
</div>

Standing at the iron fence and reading the bleak inscription, I have a hard time getting my head around the fact that this stark view of the future was erected by quite possibly the most optimistic person I have ever known.

It is J. David's unbounded optimism that compels me each winter to invite him to come to Texas State University in San Marcos and speak to my class in conservation leadership. He shows up carrying a huge clump of native grass, and other than when he is standing on the porch at Hes' Store, it is with a clump of Lindheimer muhly in his hand that he is most eloquent and evangelical.

For J. David, the idea that grass is Mother Nature's greatest conservation tool is scripture. With the usual Bamberger intensity, he explains to my students that one square yard of native grasses can have as much as nine miles of roots, which like a huge sponge help absorb more than 80 percent of the rain that falls into the soil. This as opposed to areas infested with cedar, which absorb less than 20 percent

of rainfall. The renewed springs at Selah, Bamberger Ranch Preserve are a notable example of the impact native grasses can have on water and soil erosion.

The students in my classes are not the only congregation treated to the grass sermon. J. David's appearance before a committee of the Texas legislature is legendary. Pulling a big clump of grass out of a garbage bag, J. David approached the podium with grass in hand, roots draping to the floor, dirt raining down. Reactions from the representatives ranged from amused to appalled. To strenuous objections from the chair of the committee, J. David talked beyond his time limit and laid the grass on the dais for the politicians to inspect at close range. As the chair banged the gavel for order, J. David kept preaching and the audience applauded.

His message has never been more urgent, and his contributions to our understanding of the relationship between water and the landscape now resound through every corner of Texas and beyond.

We are going to have twice as many people in Texas in the next fifty years, and yet we have already given permits for more water to be withdrawn from most of our rivers than is actually in them. This means that if all the water rights the state has issued over our history are actually exercised, our most beautiful and iconic rivers and streams will be dry.

Largely as a result, we depend on groundwater from our subsurface aquifers for 60 percent of our needs, and as J. David likes to say, the wells in the Hill Country are like straws in a milkshake. We drill thousands more of them each year with little or no restraint, which threatens to deplete our groundwater altogether. Even worse, because our laws treat groundwater as private property and surface water in our rivers and lakes as owned by the state, we are on a collision course between the two that could ultimately cost us the spring flow that not only nourishes our rivers and streams but also restores our souls.

We continue to waste too much water. The average city in America loses 10 to 20 percent of the water in its system just through poorly maintained water mains. While the Texas cities of San Antonio and El Paso have decreased water consumption per capita by 40 percent, in other com-

munities water consumption per capita is still increasing. We know we can do better. San Antonio has grown in population by more than a million citizens in the last decade or so and yet its overall consumption of water has been flat.

Thanks to the work at Selah, there is now a much greater appreciation for the connection between land restoration and stewardship and groundwater. The practices pioneered on the ranch provide one critical pathway to sustainability for this most critical resource.

"One of my better admonitions—'Never initiate an action you are unable to sustain'—has saved me a lot of time, trouble, and money, as well as a lot of frustration."

Just as important, if not more so, Texas is no longer a place where most people live in small towns with agricultural economies or on the land itself as farmers and ranchers. When we were a rural society, weather conditions were felt directly and personally by most of the state's inhabitants. Today, the vast majority of Texans live in urban centers, and as long as the tap in the kitchen continues to flow and the toilet continues to flush, today's Texans are left to believe that everything is okay.

In that context, the most profound contributions made at Selah in the end will be in the education of our children. Their future may well depend on the extent to which they understand where their water comes from and what they can do to ensure that it is available for them, for their own children, and for the environment.

These days, whenever J. David goes on the road with his grass, he is accompanied by his partner, Joanna Rees. Some time after Margaret's passing, Joanna, a Texas Master Naturalist, showed up at a book signing for *Water from Stone*, the biography of the man and his ranch written by J. David's brother-in-law, Jeffrey Greene. Standing in line to have J. David sign her book, Joanna made the innocent mistake of bringing a copy of the paperback edition. Having a stubborn but staunch belief that the only worthy edition of the book is the original hardbound edition with a dust jacket, J. David refused to sign it.

If you knew Joanna, you would not be surprised to learn that she was not deterred and soon became a devoted volunteer at the ranch. Despite the less than auspicious beginning, she came into the Selah family in 2009 and became a devoted partner for J. David. Joanna, originally from England, is an impressive person and may well be J. David's equal as a storyteller. She is also willing to puncture his balloon when appropriate (which he loves).

Along with seventeen other Bamberger loyalists, Joanna is a member of the board of directors of Selah, Bamberger Ranch Preserve. Together, they have formed a nonprofit organization to carry on the mission when, inevitably, J. David is gone—although I recently caught him down at Madrone Lake clearing brush with a chain saw at age eighty-eight. In spite of his enduring energy and enthusiasm, J. David's focus is increasingly on ensuring the sus-

tainability of all that he and his army of friends, employees, volunteers, and disciples have accomplished.

Colleen is thankful that they've got Lois, who knows "where J. David leaves his reading glasses, what his dog Corey eats, as well as all the financial information. She is his dictionary, his confidant, and his connection to the baffling world of technology, and she is all that and more to me. She is his right hand and she is my left hand."

Actually, J. David has two right hands. The other is Leroy, who now cares for the remaining cattle on the ranch for both income and habitat management purposes. When J. David and Leroy began working together, the played-out ranch required forty-one acres to support one cow; that number is now down to eighteen acres. Still, everyone there is conscious of the imperative to create a business model that will keep their work moving forward not only beyond J. David's lifetime but also beyond theirs.

Not long ago, J. David asked me to come out to the ranch to meet with Colleen and the board of Selah, Bamberger Ranch Preserve to visit with them about sustainability, which at this special place and time had a double meaning. I had no trouble addressing the many accomplishments at the ranch and the relentless land fragmentation taking place around it, which caused their stewardship of the landscape itself to be the very essence of sustainability.

"What will Selah be when I am gone? Will new people too young, too preoccupied, too wrapped up in the high tech world appreciate what has been accomplished here? Will the fact that nature has not been replaced by buildings, gift shops, cafes, and vending machines resonate with the next generation?"

What was less evident was how an organization built on the great accomplishments and charisma of one extraordinary man could become an institution in its own right, create new wealth necessary for growth, and become truly self-sustaining. Although a transitional phase such as this is common to many organizations, J. David's reputation and the obvious substantial investments he has personally made in the ranch may actually inhibit other large gifts for projects such as the education center or a permanent endowment. Says Colleen, "What people don't understand is that he has given it all away to his dream."

J. David's dream is aptly described as the "Light Bulb Phase" of an institution, as defined by author Bill Shore in his book *The Cathedral Within*. In this phase, writes Shore, the founder has an idea and is challenged, often against substantial odds, to bring it to reality.

With a small team—in J. David's case, his Tree, Deer, Cow, and Dam Aggies—he gave birth to the future institution. In the "Light Bulb Phase" sensationally demonstrated at Selah, the idea was attractive because of its novelty, the enthusiasm and charisma of the founder, and the obvious relevance of stewardship to the ranch.

Since I first met J. David, he has kept the dream alive and sold it as only he could to an unbelievably larger and larger audience, photocopying and recording the news clips and broadcast interviews and distributing them thousands of times. He has morphed from the eccentric fast-food CEO to one of the most well-known and highly respected conservationists in America and is repeatedly asked to tell his story at meetings and conferences across the country.

At Selah, Bamberger Ranch Preserve, Colleen and the board know that moving to the next phase will require different skills, resources, and strategies than those employed by the extraordinary man who has toiled on the land and lived the dream for the last half century. Surely there is still

much to learn from the founder, but there is even more to learn as the organization moves forward into the future. Having created a successful business from scratch and then devoted his life to another noble institution, his lesson is that it is not easy to create an organization, but it is even more difficult to grow and sustain it.

Sustainability at the ranch will be challenging as Colleen, Steven, and Jared increasingly assume their roles as the faces of Selah and as pressure increases to expand programs and increase visitation to bring new revenue into the operation. They and the board, which includes J. David's sons, know that it is not J. David's intent that the land be "loved to death" or that the very people who need the experience of Selah the most be priced out of the opportunity to obtain it.

Above all, the greatest challenge will be to find a pathway to grow, institutionalize, and endure while maintaining the vision of the man who made it all possible. Thomas Jefferson, another founder who I think would have had much in common with J. David Bamberger, wrote, "I am not an advocate for frequent changes in laws and constitutions but laws and institutions must go hand in hand with the progress of the human mind. As that becomes more enlightened, as new discoveries are made, new truths discovered and manners and opinions change, institutions must advance also to keep up with the times. We might as well require a man to wear still the coat of a boy as civilized society to remain ever under the regimen of their barbarous ancestors."

What will truly continue to make Selah, Bamberger Ranch Preserve a unique and special place will be that J. David's successors will develop resources and programs for growth and longevity, while distinguishing between the core values and enduring purposes that should never change, and the operating practices and business strategies that must evolve with a world certain to keep changing.

In a classic Bamberger move after Colleen and Scott were married, J. David became concerned that Scott would find employment elsewhere and he would lose Colleen, his protégé and extraordinary executive director. Enter another extraordinary woman, Elizabeth Barlow Rogers, whose father, a building contractor, constructed many of the military installations in San Antonio during World War II. In the process, he acquired a ranch near Johnson City, which is known as the Browning Ranch and is now owned by his daughter.

In the 1960s, "Betsy" Rogers moved from San Antonio to New York City, where she became involved in the preservation and restoration of historic landscapes. The first person to be named administrator of Central Park, she has written eight books on landscape design and was instrumental in founding the Central Park Conservancy, a unique public-private partnership that supports the restoration and management of America's most famous urban park. It was inevitable that when the Browning Ranch became her responsibility, she would seek out her neighbor, J. David Bamberger, for advice.

As is usual with J. David, she got more than just a box of chicken. Never one to miss the opportunity to engineer a win-win situation and anxious to ensure that Colleen's good work at Selah continue, J. David introduced Rogers to Scott Gardner, who became manager of the Browning Ranch and is not going anywhere anytime soon.

As you enter the Bamberger ranch, the road is lined with signs that tout the awards J. David and his team have received from all over the United States. I take much pleasure from this drive for multiple reasons. Foremost among them is that when I first met this amazing man, many in my line of work thought he was out of his mind, and now the conservation world has beaten a path to his door. Second, one of the awards, the Lone Star Land Steward Award, resulted from the first major effort to recognize private landowners for exemplary stewardship, which began when I worked at Texas Parks and Wildlife. I actually appointed J. David in those days to serve on the Private Lands Advisory Board, which presents the award each year at an impressive ceremony in Austin.

The Lone Star Land Stewards program then led to what many have called the Nobel Prize for private land conservation in America—the Leopold Conservation Award. I was privileged to be at the Four Seasons Hotel in Austin when the Bamberger ranch received this award, named for Aldo Leopold, author of the classic work *A Sand County Almanac* and one of America's most revered conservationists.

The Leopold Conservation Award "recognizes and celebrates extraordinary achievement in voluntary conservation by private landowners, inspires countless other landowners by example and provides a prominent platform by which agricultural community leaders are recognized as conservation ambassadors to people outside of agriculture."

Surely no person or property has been more fitting to receive the Leopold award than J. David Bamberger and his beloved Selah. Stepping to the podium to accept the award in Austin in May 2009, J. David, who is never at a loss for words, struggled to articulate the tremendous emotional impact of being recognized for all the sweat, worry, perseverance, and exultation leading up to this moment, while also feeling the reality that Margaret, who had poured her heart and soul into the ranch, had died two months earlier.

With this recognition by his peers—the landowner community that was once so dubious of him—the inspiring work at Selah continues thanks to a devoted team: an army of volunteers, many generous supporters, and the old cathedral builder himself, who stands before thousands of children, with like-minded landowners, in the halls of the legislature, and on the porch of Hes' store, preaching the gospel of grass.

Blue ridges in early morning fog.

Sunrise illuminates the hills above the Sahara Pasture.

A lone bigtooth maple holds on to its fall foliage in late December.

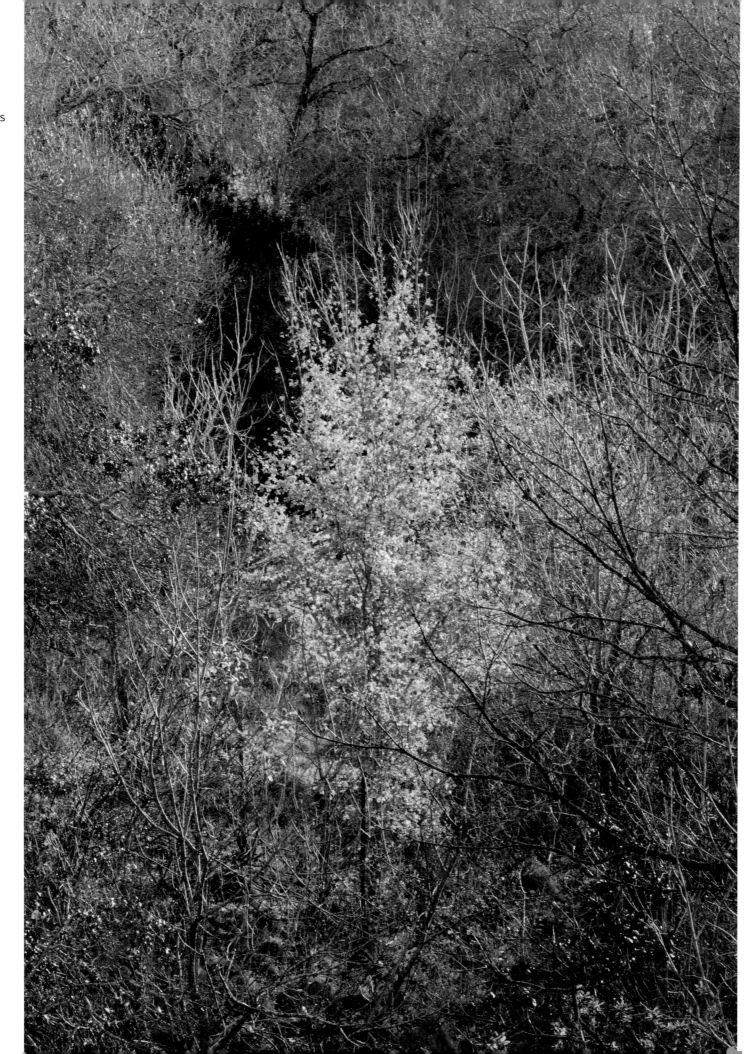

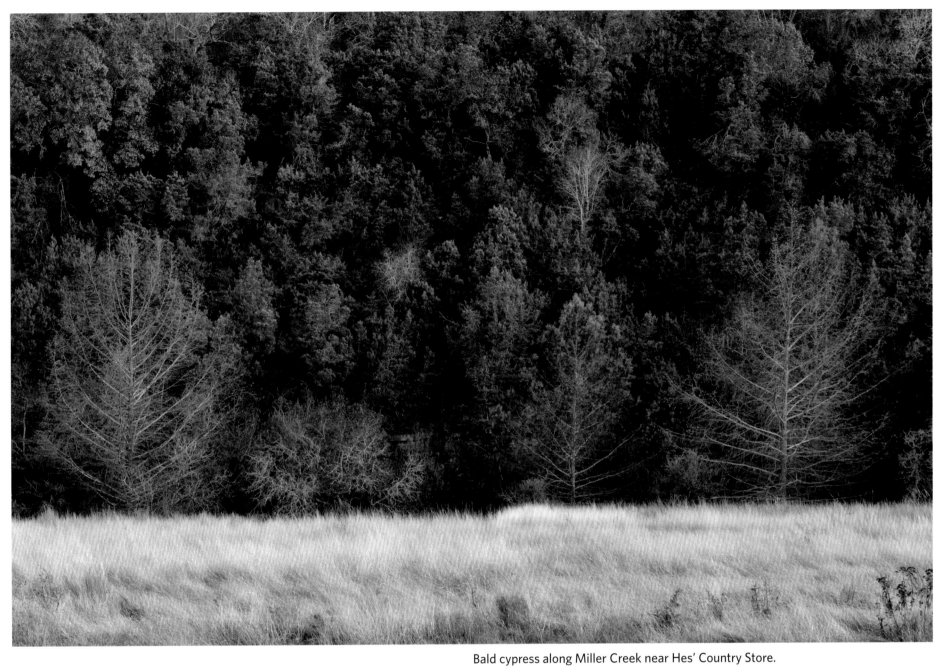

Bald cypress along Miller Creek near Hes' Country Store.

Looking north from a ridge in the Middle West Slope Pasture.

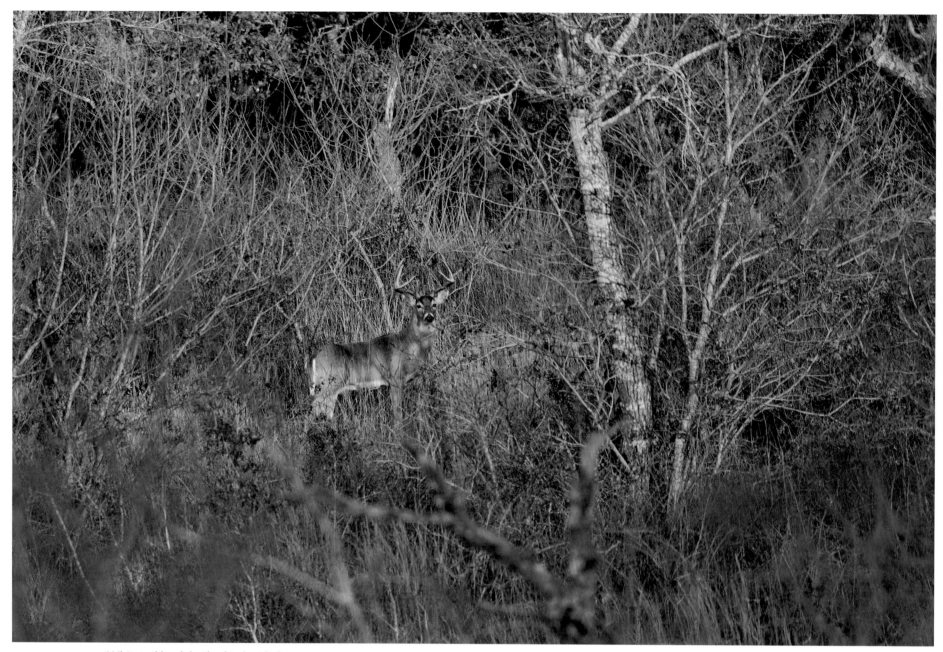

Whitetail buck bathed in last light.

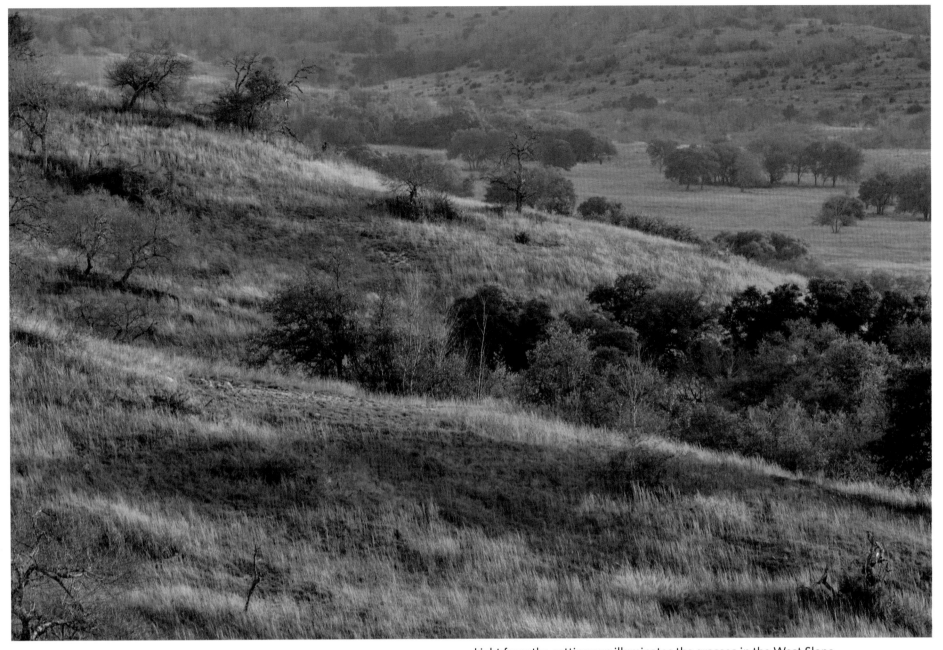

Light from the setting sun illuminates the grasses in the West Slope Pasture.

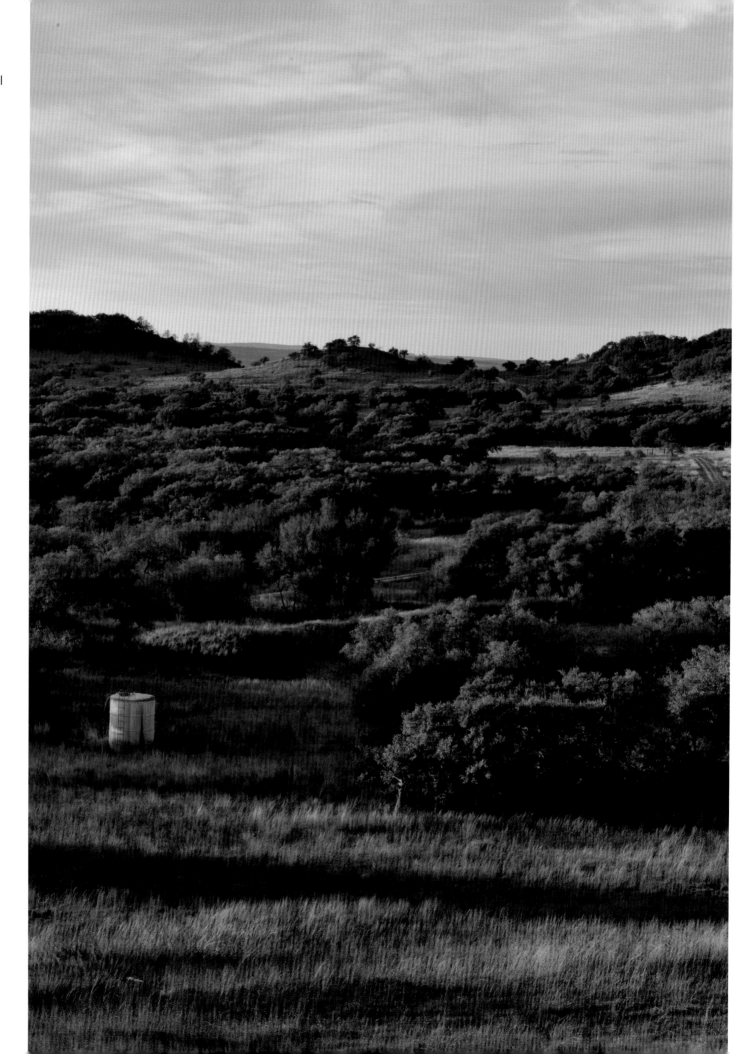

Selah has several cisterns, including this one in the West Slope Pasture.

198

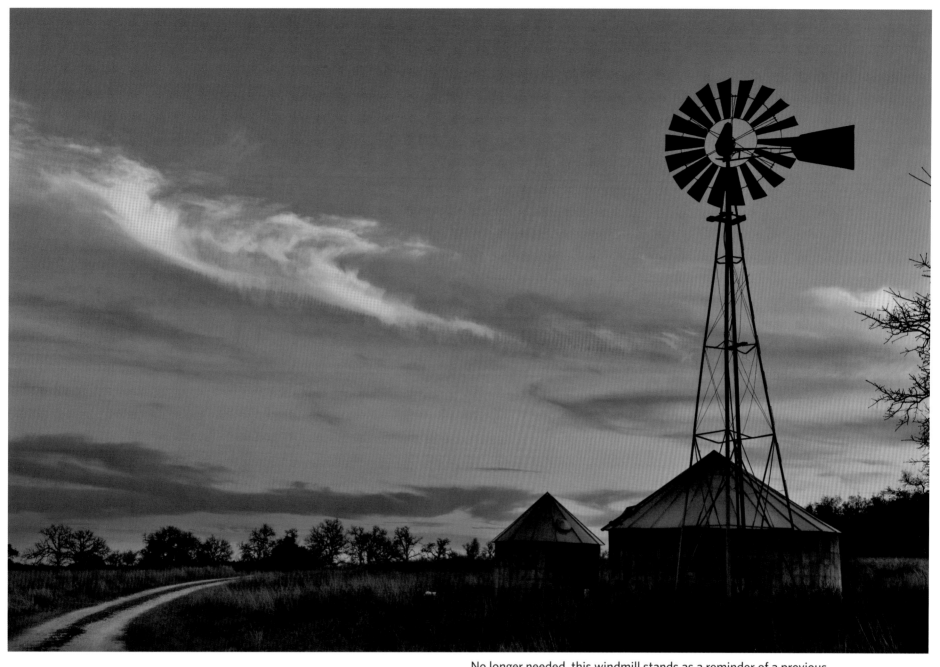

No longer needed, this windmill stands as a reminder of a previous owner.

Winter
sunsets can
have many
varied hues.

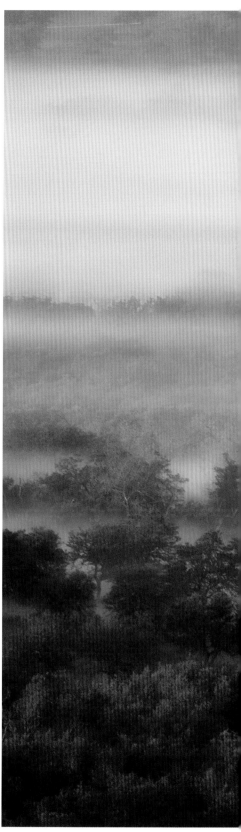

Frostweed bursts after a
single-digit freeze.

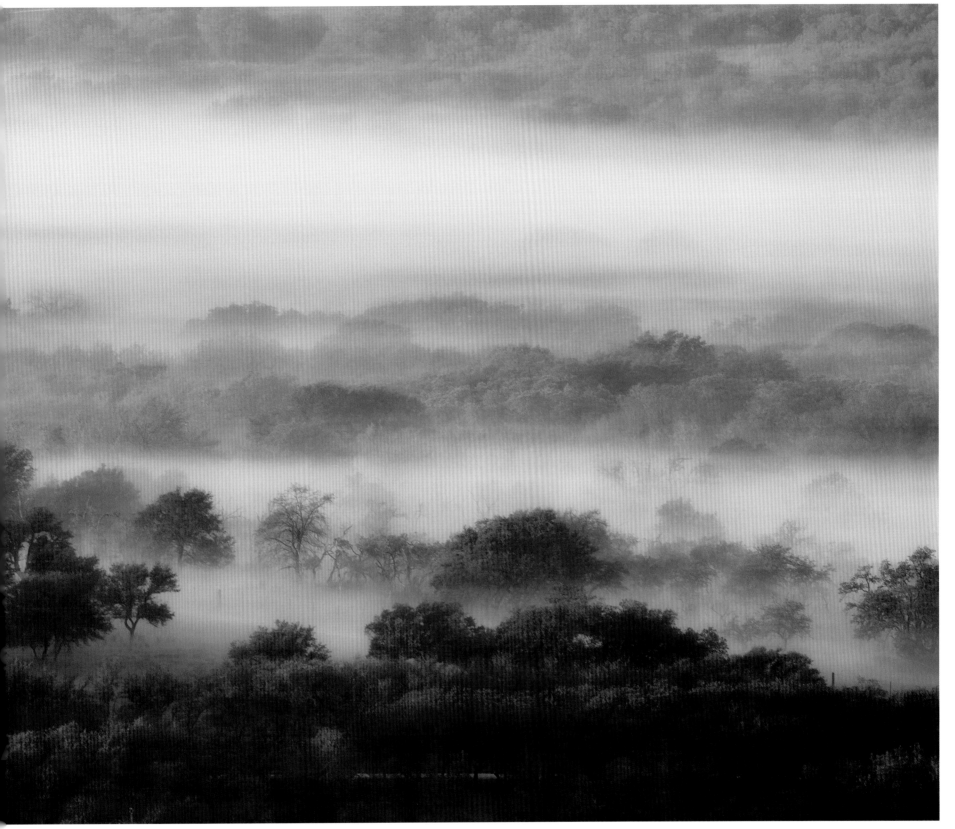

Early morning fog settles among the trees of the Sahara Pasture.

Early frost on Spanish oak leaves.

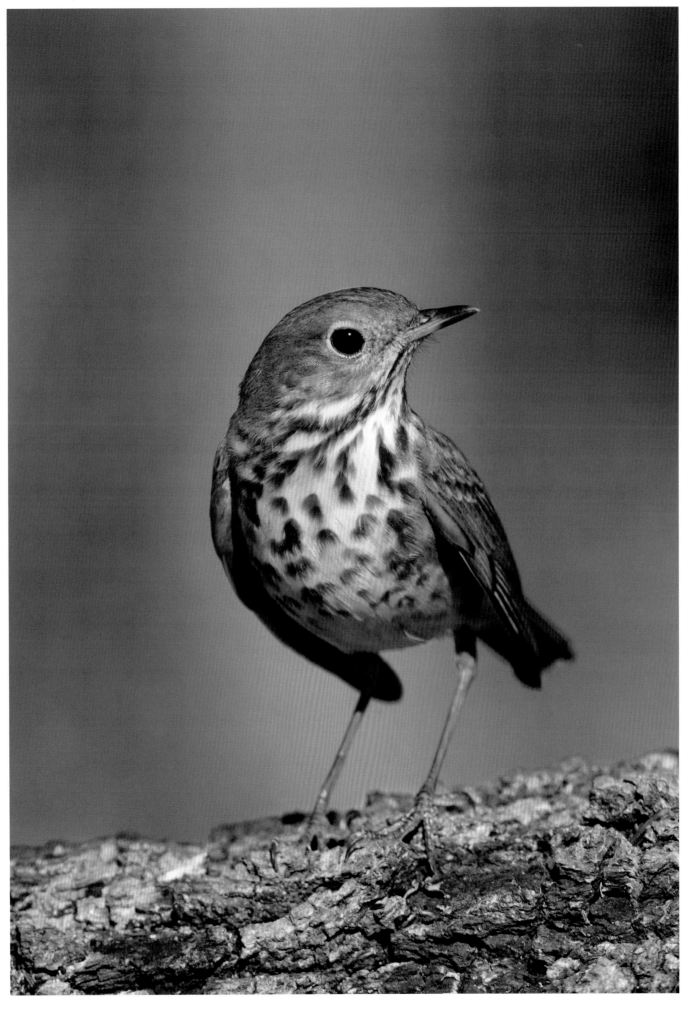

The hermit thrush is a winter visitor to the Texas Hill Country.

205

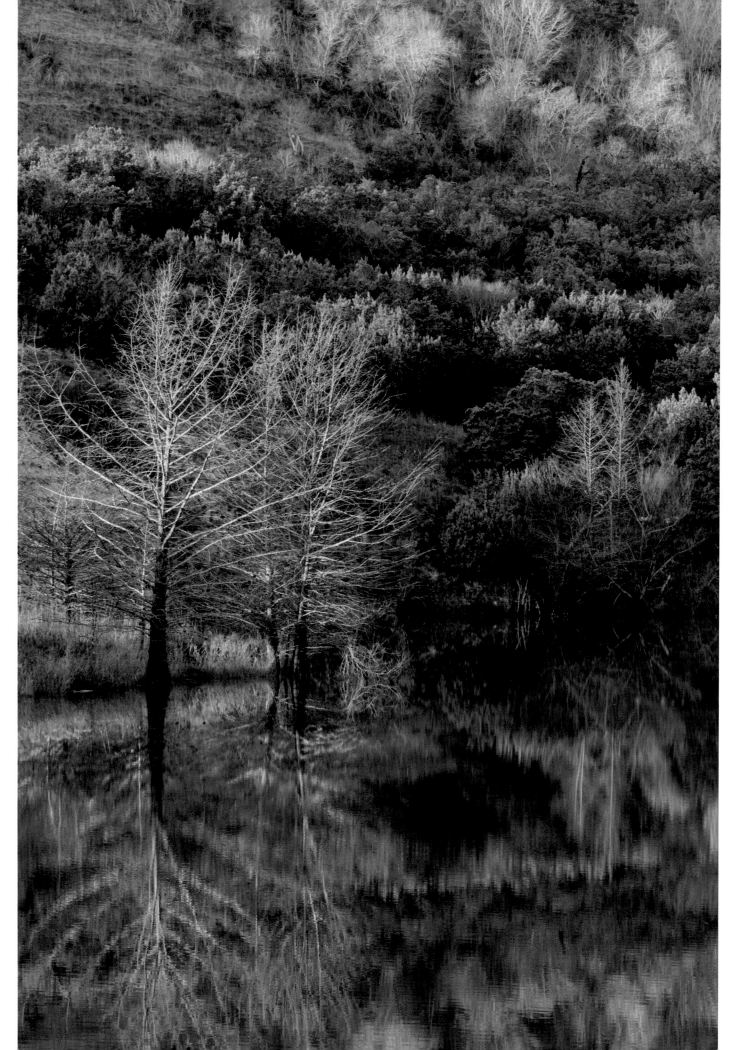

Leafless bald cypress reflected in Madrone Lake.

Winter grass greening the Madrone Lake dam.

Panoramic view of Madrone Lake.

Cattails on the banks of Madrone Lake.

The water of Madrone Lake provides a beautiful backdrop for its namesake tree.

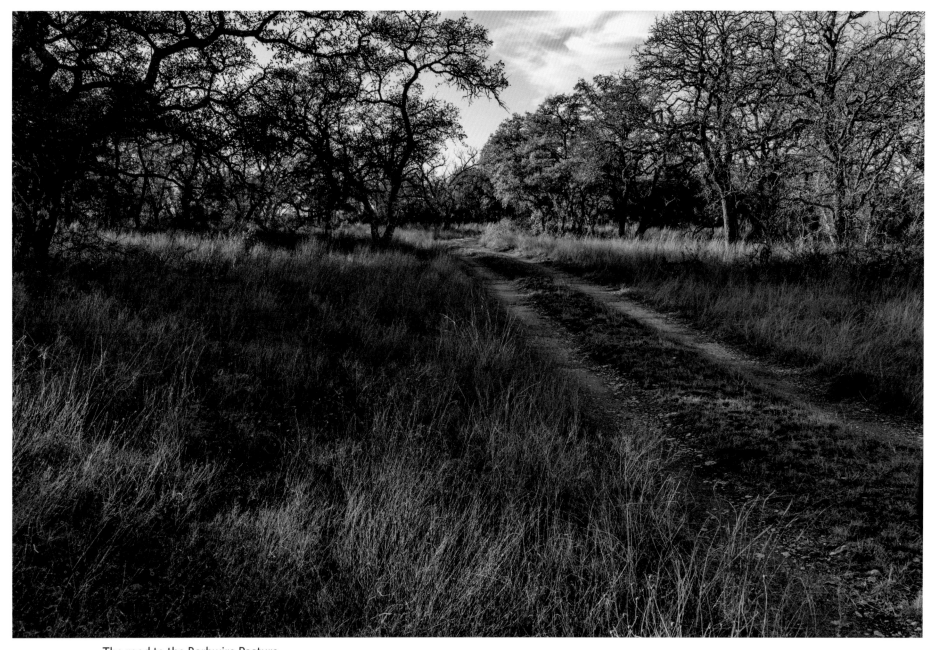

The road to the Barbwire Pasture.

Young Rio Grande turkey gobblers, called "jakes," in vegetation that retains a green hue even after many freezing nights and days.

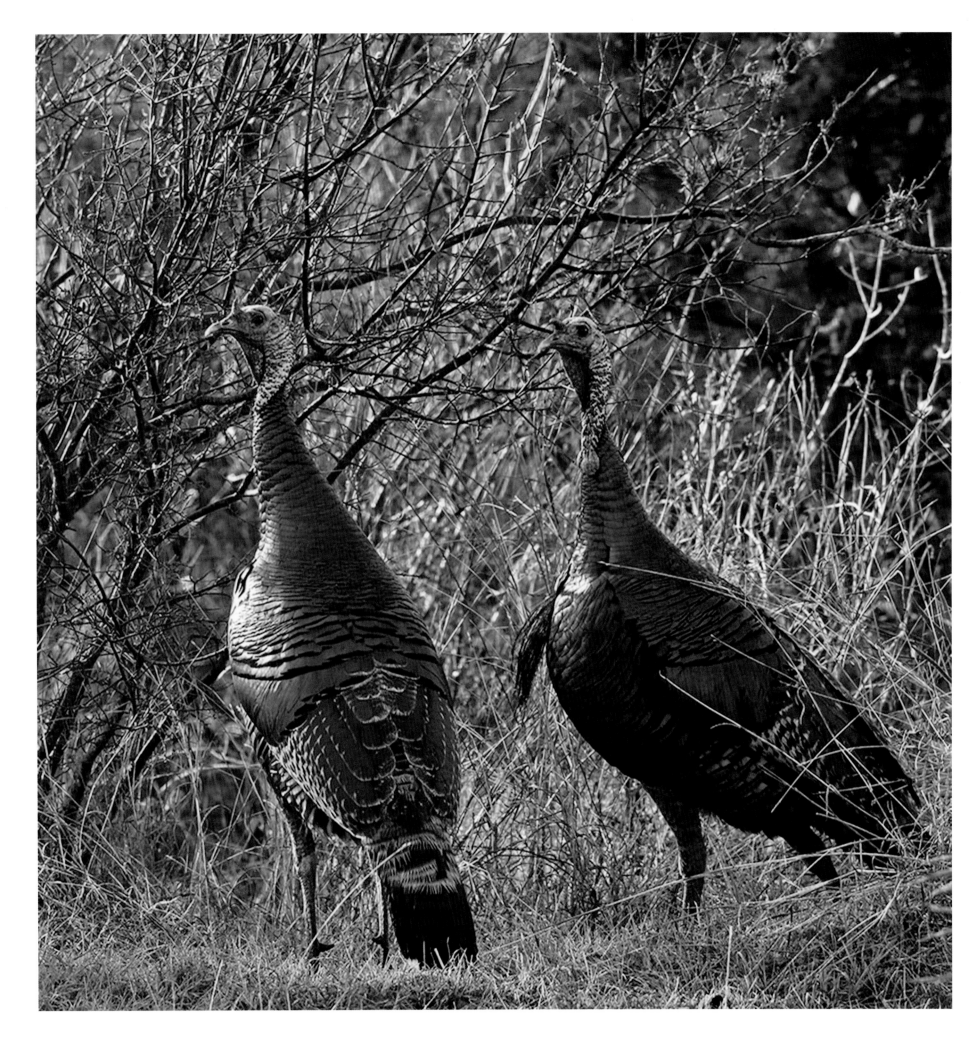

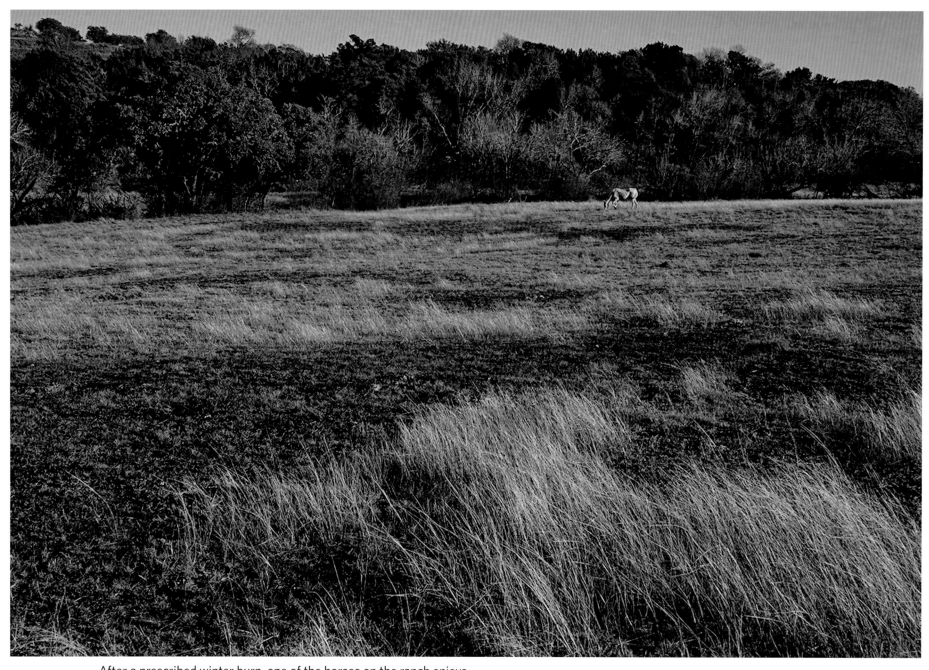

After a prescribed winter burn, one of the horses on the ranch enjoys the tender regrowth.

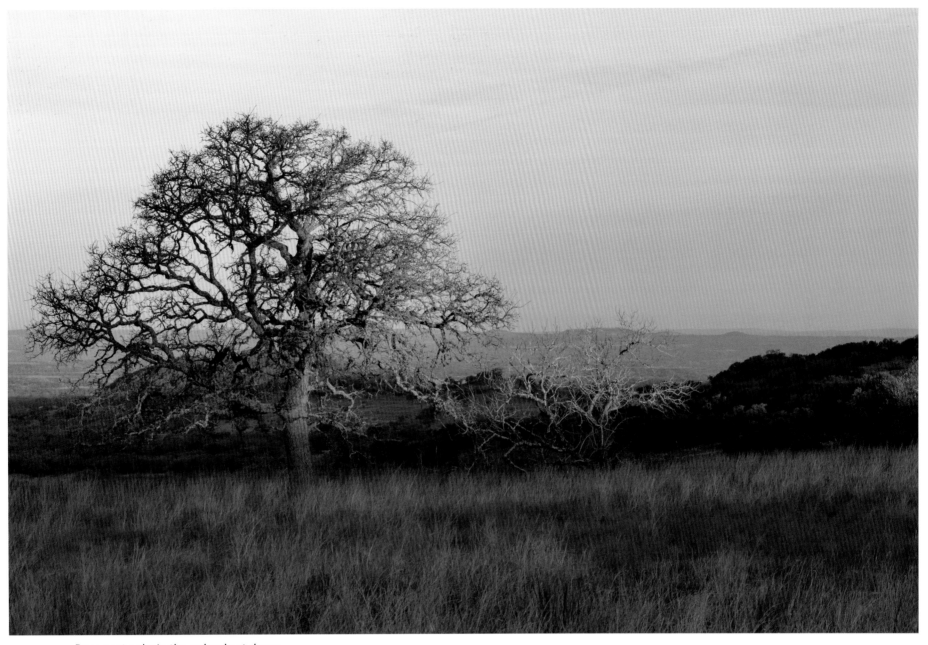

Bare post oaks in the uplands at dawn.

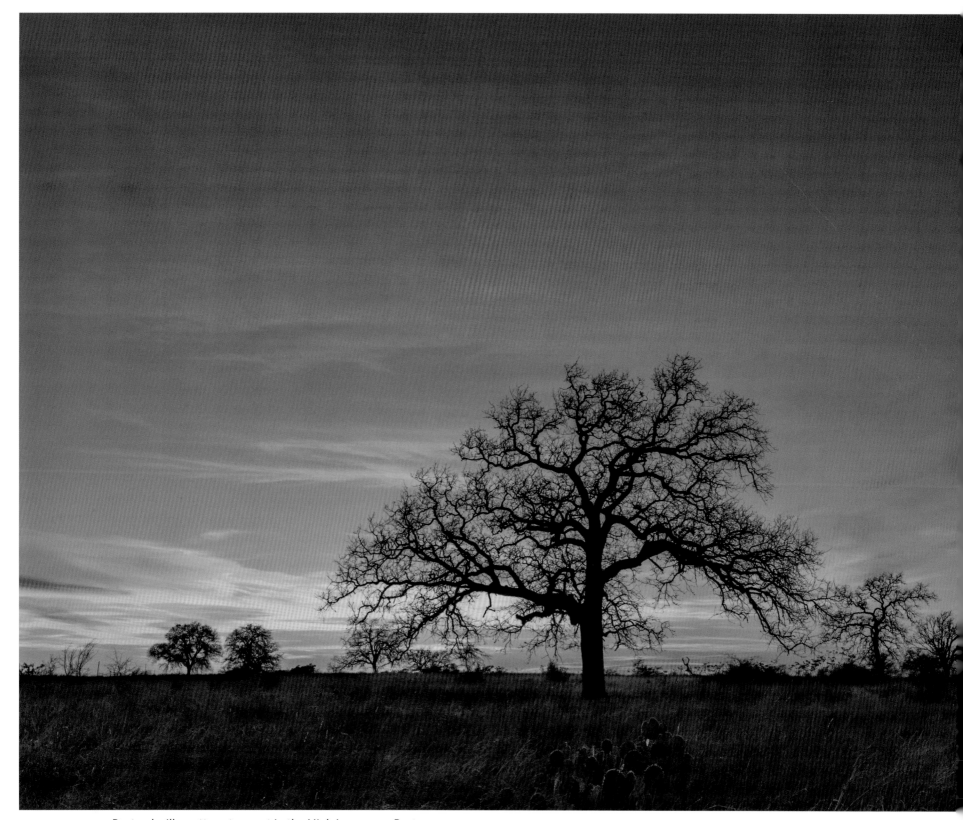

Post oak silhouettes at sunset in the High Lonesome Pasture.

Morning fog clings to the western slopes.

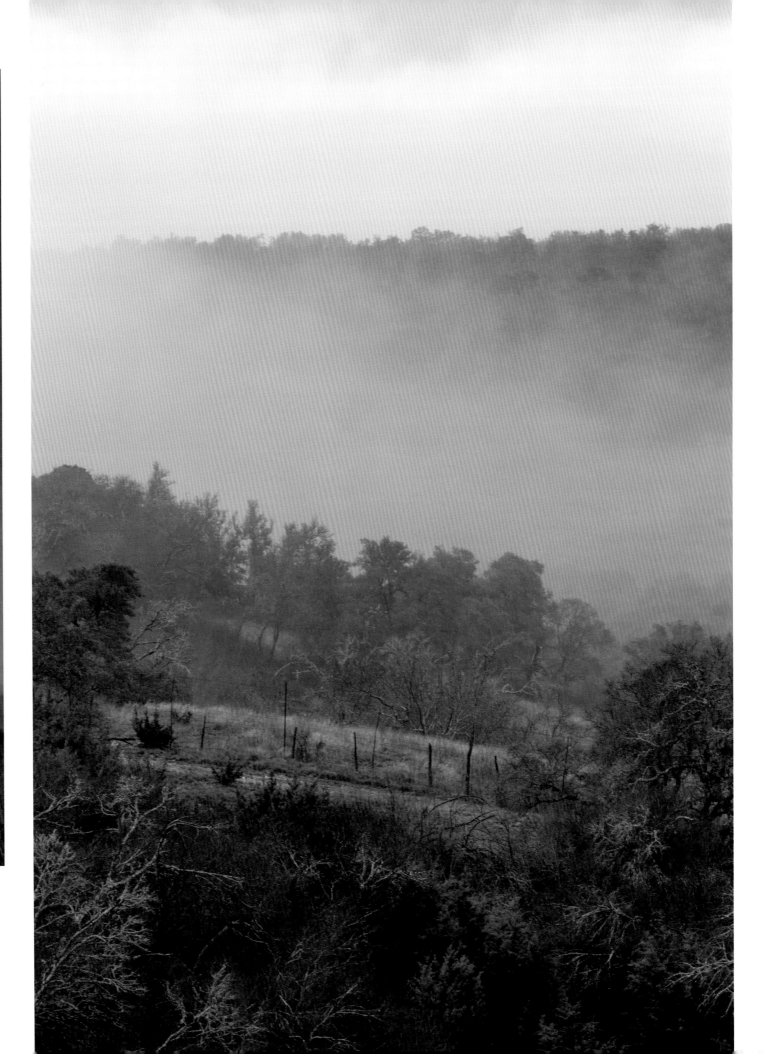

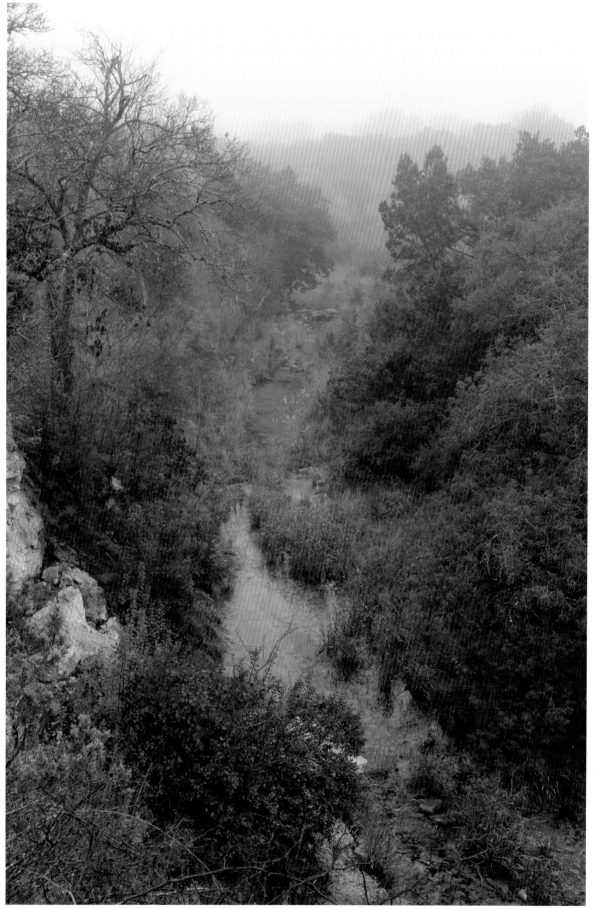

Turkey Hollow Overlook along the Aldo Leopold Trail.

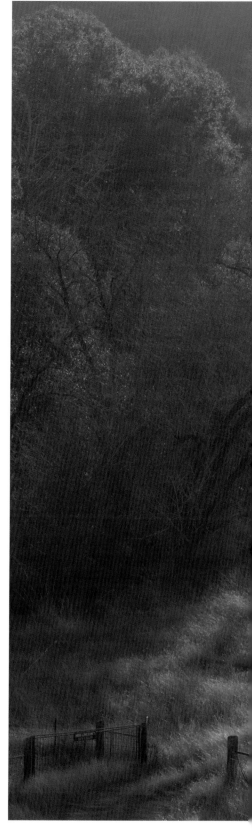

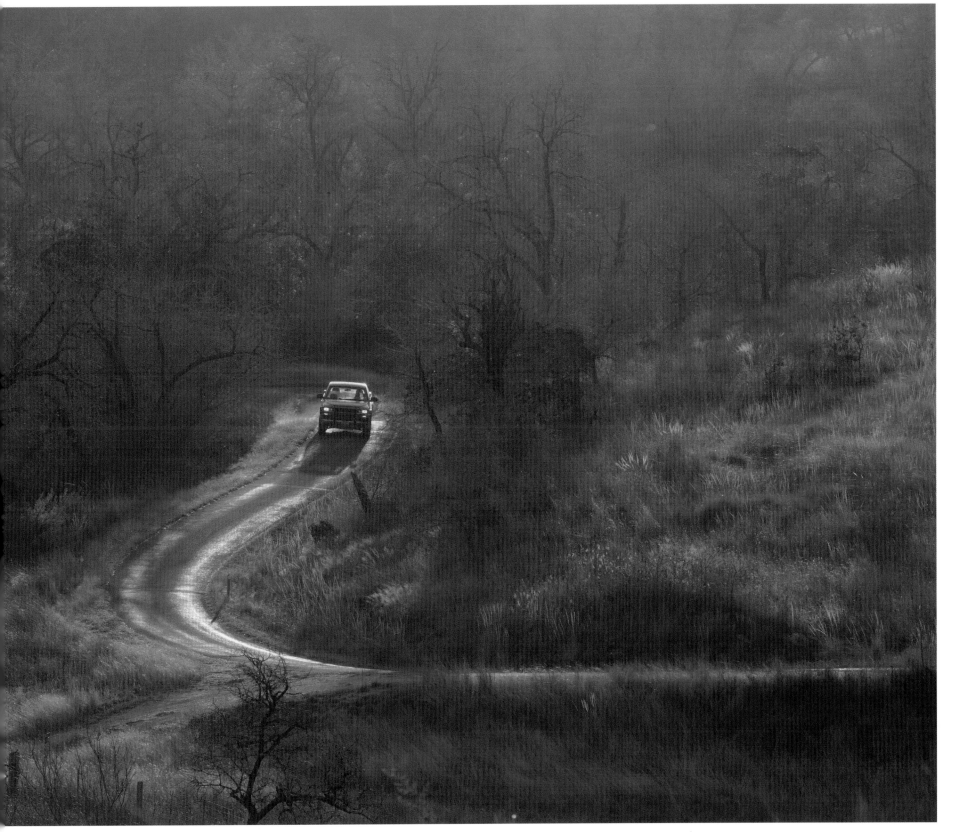

Pancho heads out on his morning rounds.

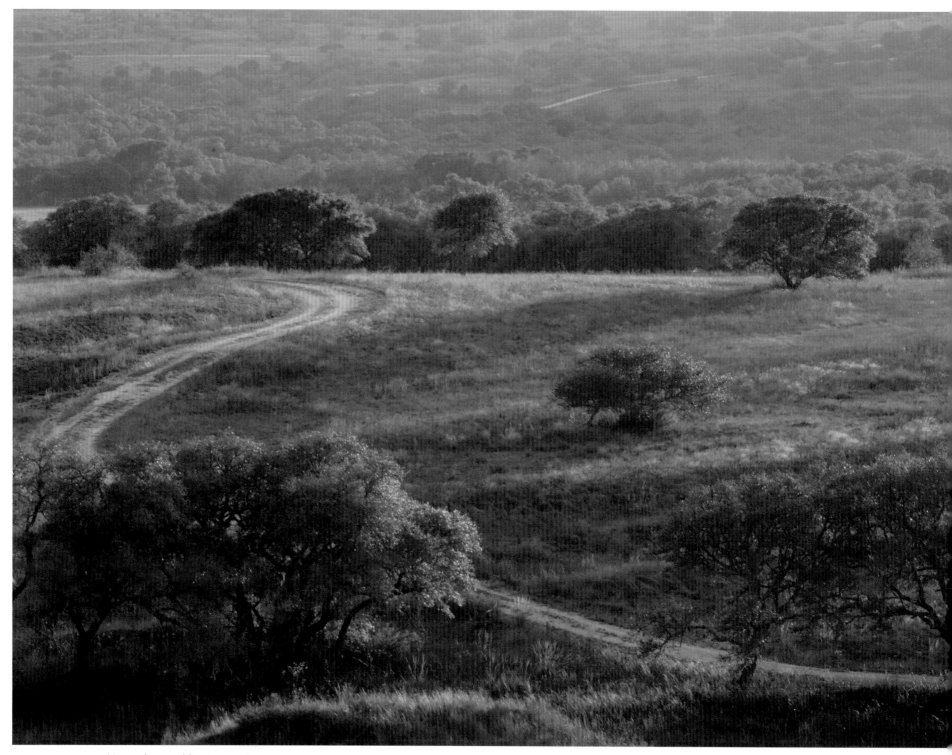

Live oaks sparkle at sunset.

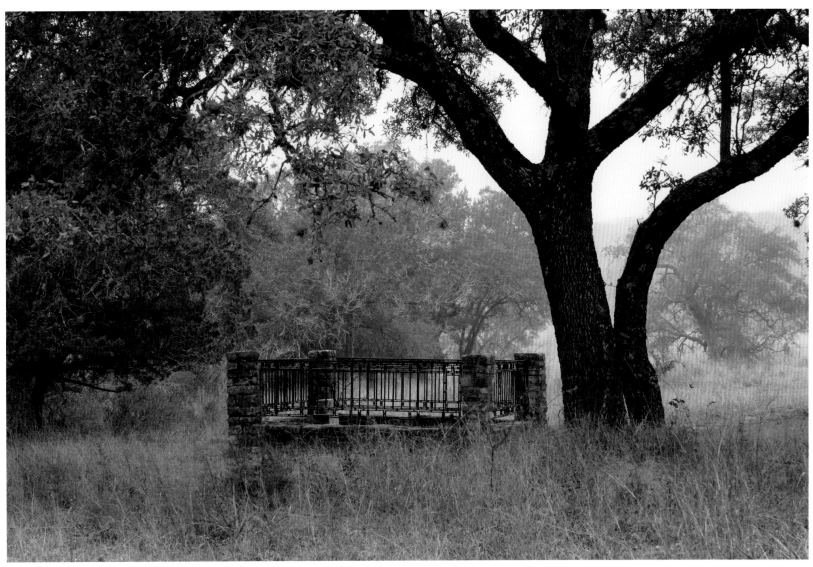

Morning at the historical marker underneath a live oak.

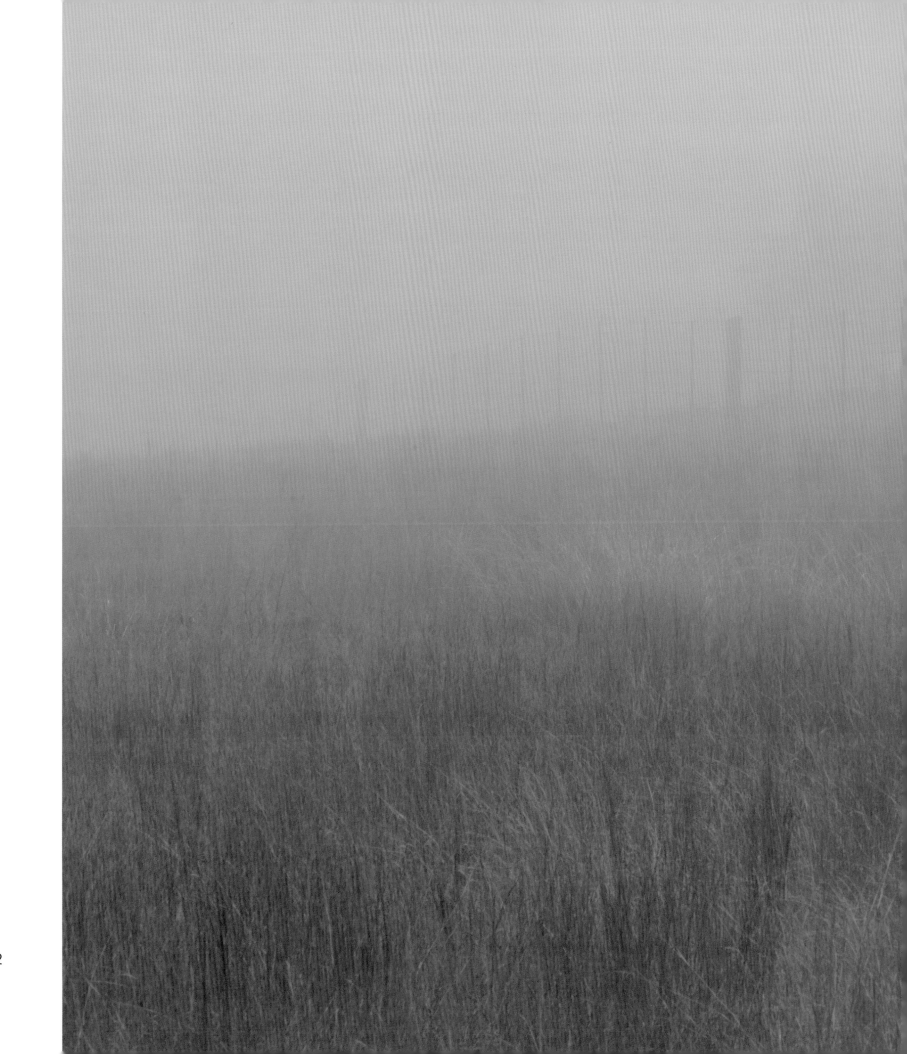

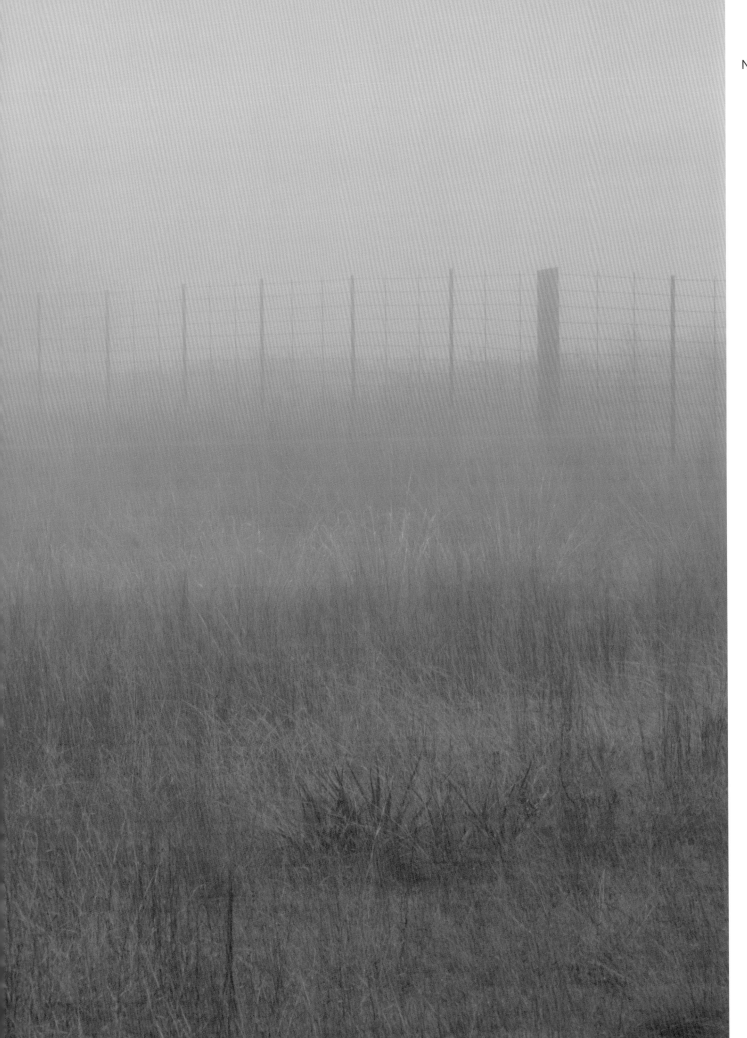

Native grasses and fence line in fog.

A lone Spanish oak on the uplands of the Wildlife Preserve Pasture.

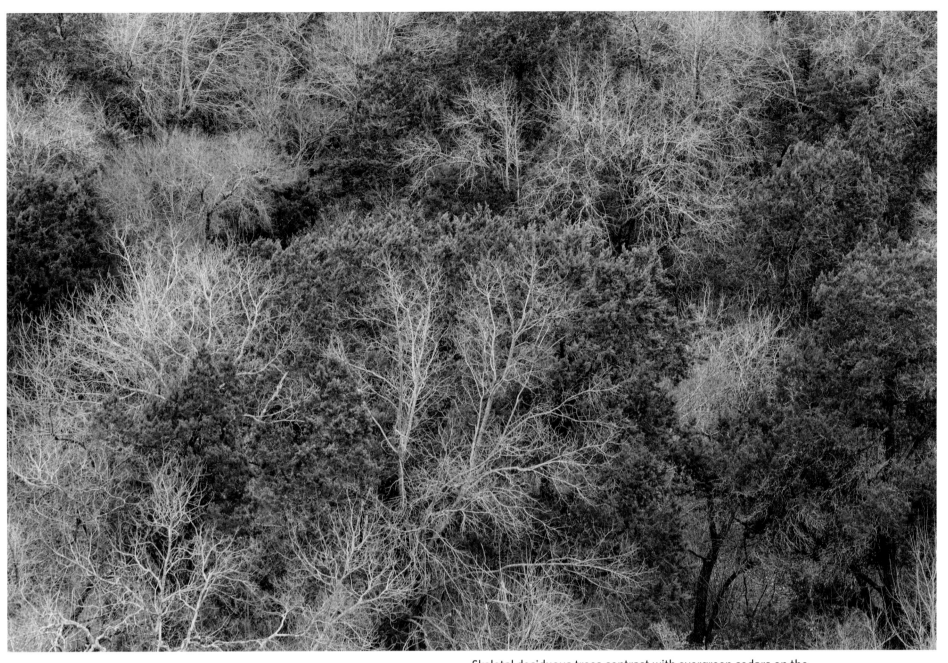

Skeletal deciduous trees contrast with evergreen cedars on the steep slopes above the Rachael Carson Trail.

The berries of the possumhaw, a member of the holly family, pro-
vide food for birds and add color to the winter landscape.

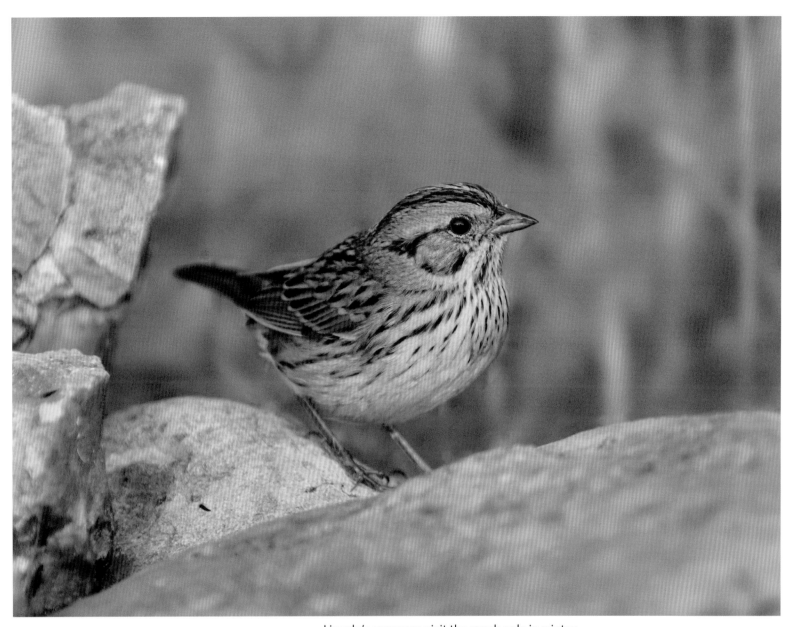

Lincoln's sparrows visit the ranch only in winter.

Bald cypress with no leaves beside Catfish Pond.

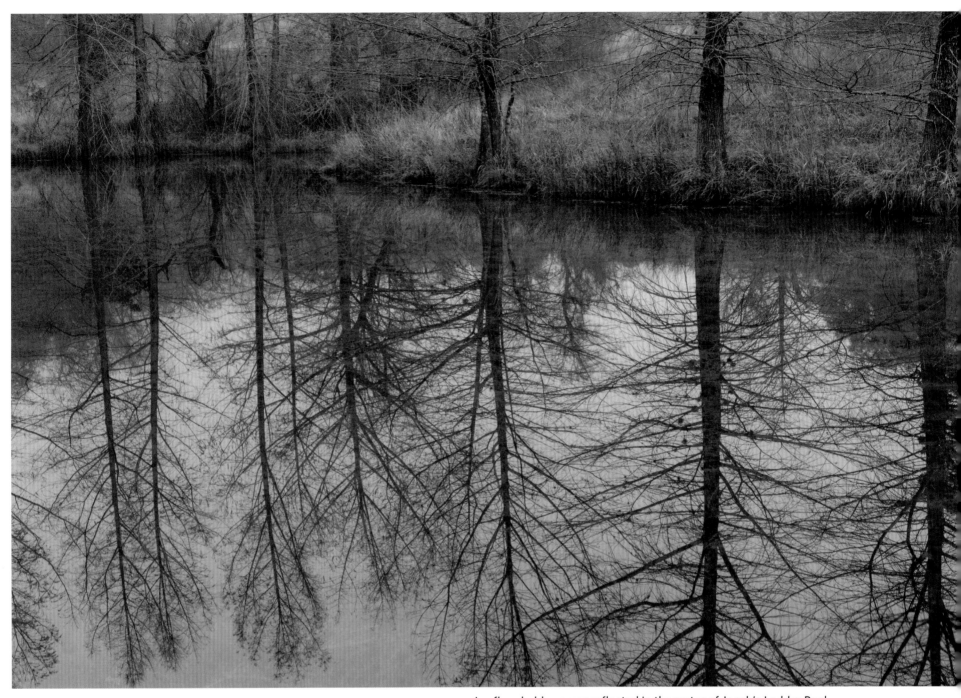

Leafless bald cypress reflected in the water of Jacob's Ladder Pool.

Stones, bald cypress litter, and ferns frame a small pool along the Louis Bromfield Trail.

230

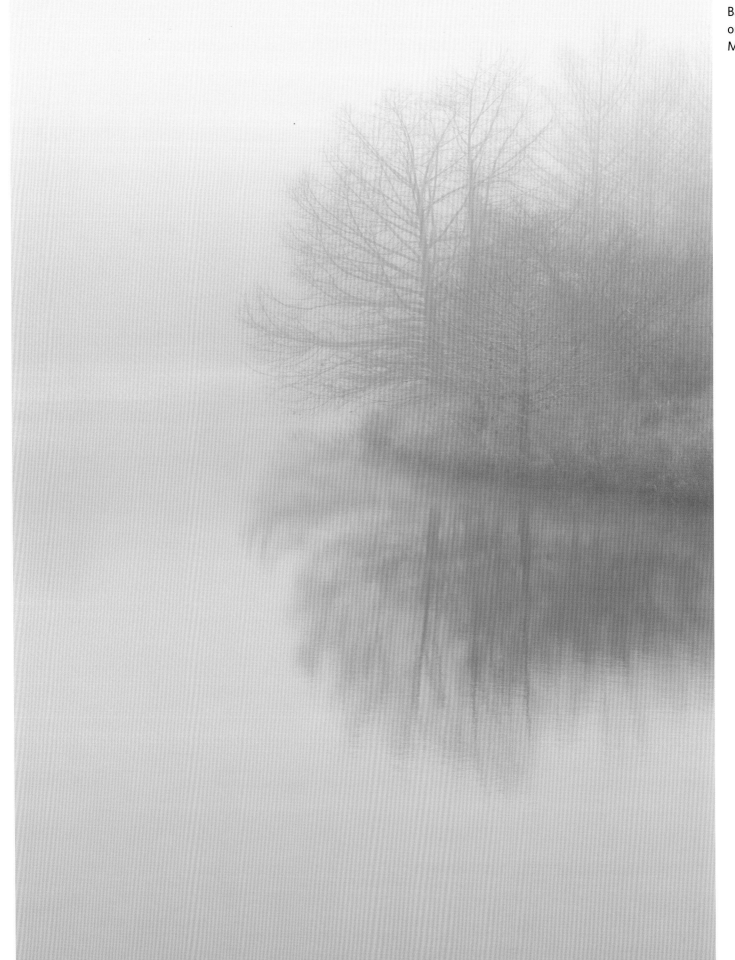

Bald cypress in fog on the banks of Madrone Lake.

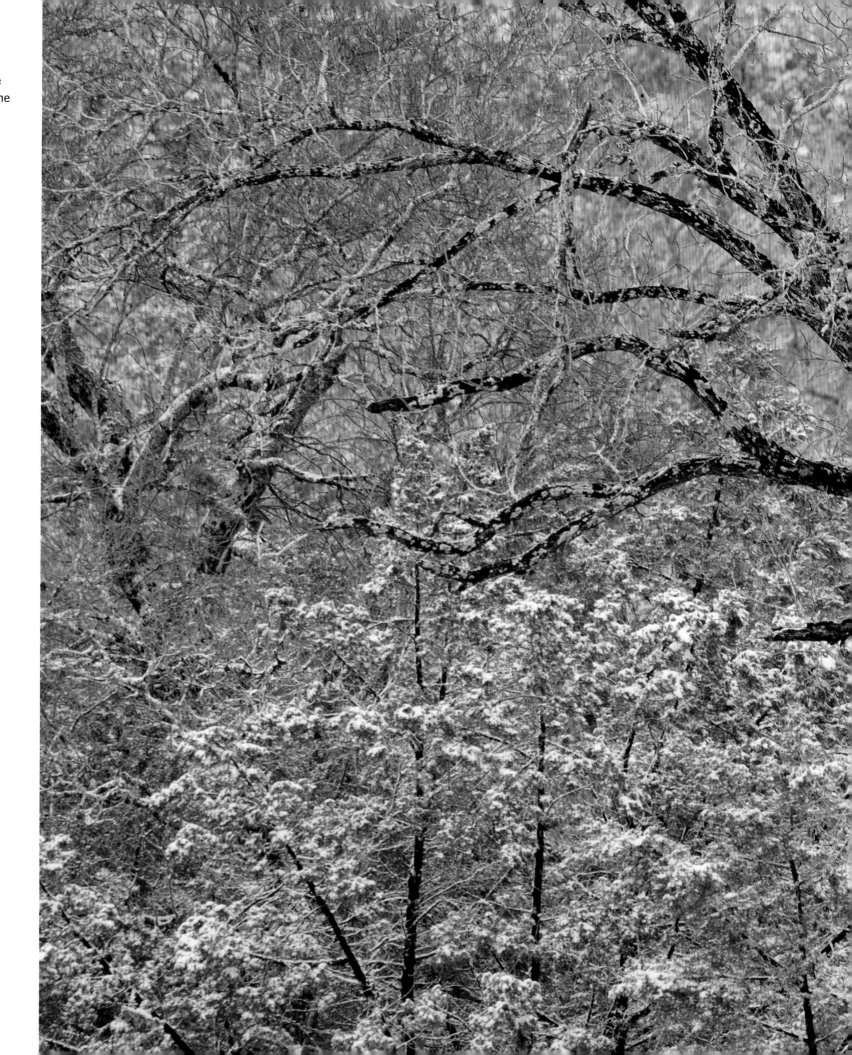

Snow graces the trees in one of the many canyons.

232

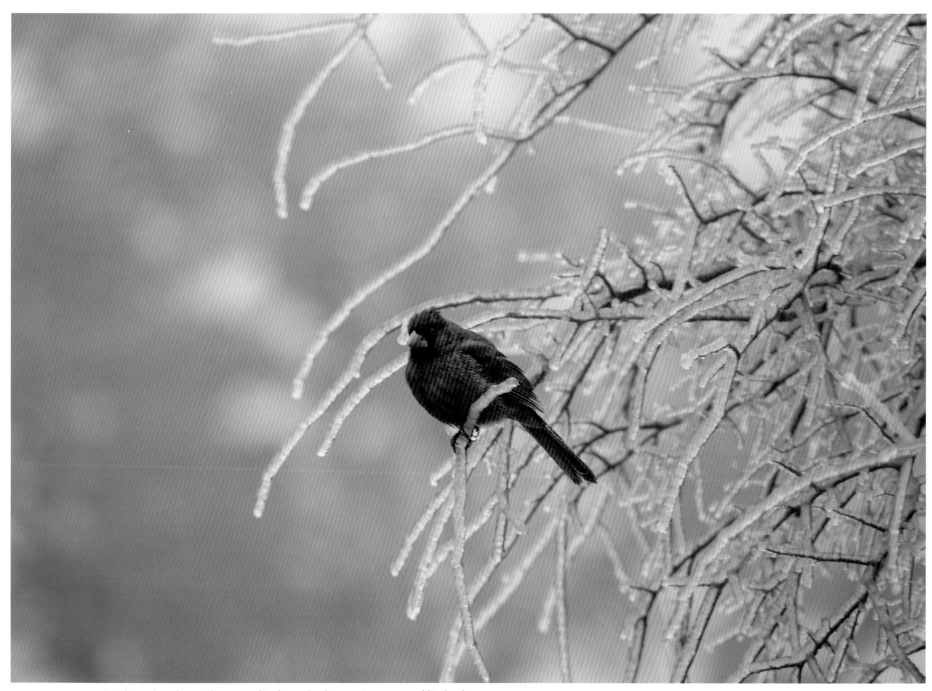

Bright red male northern cardinal perched on an ice-covered limb of a cedar elm.

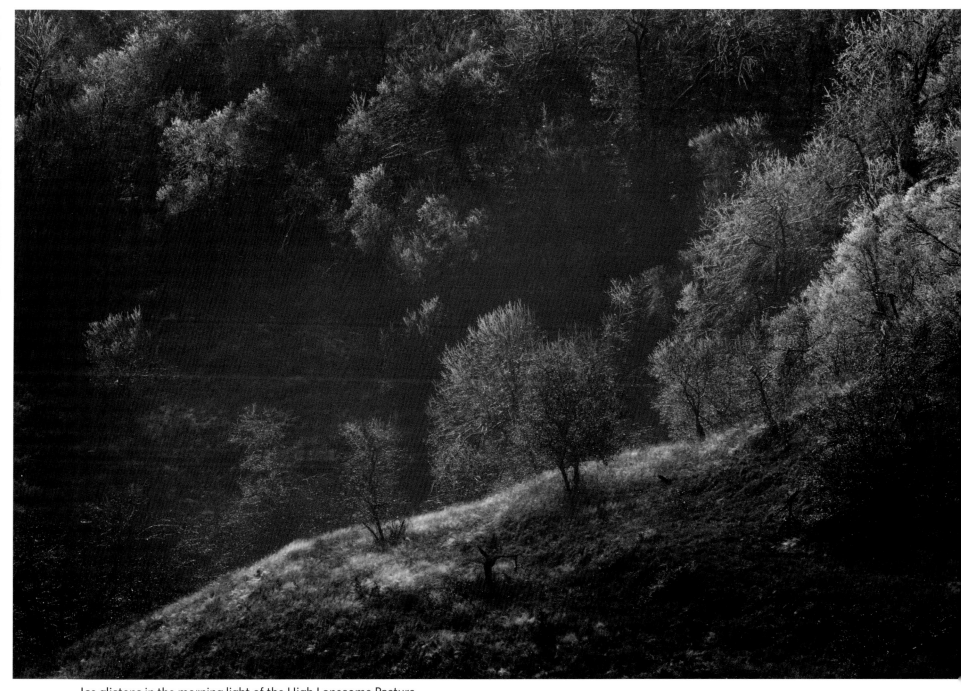

Ice glistens in the morning light of the High Lonesome Pasture.

Frozen grasses along a fence line.

CHALLENGES

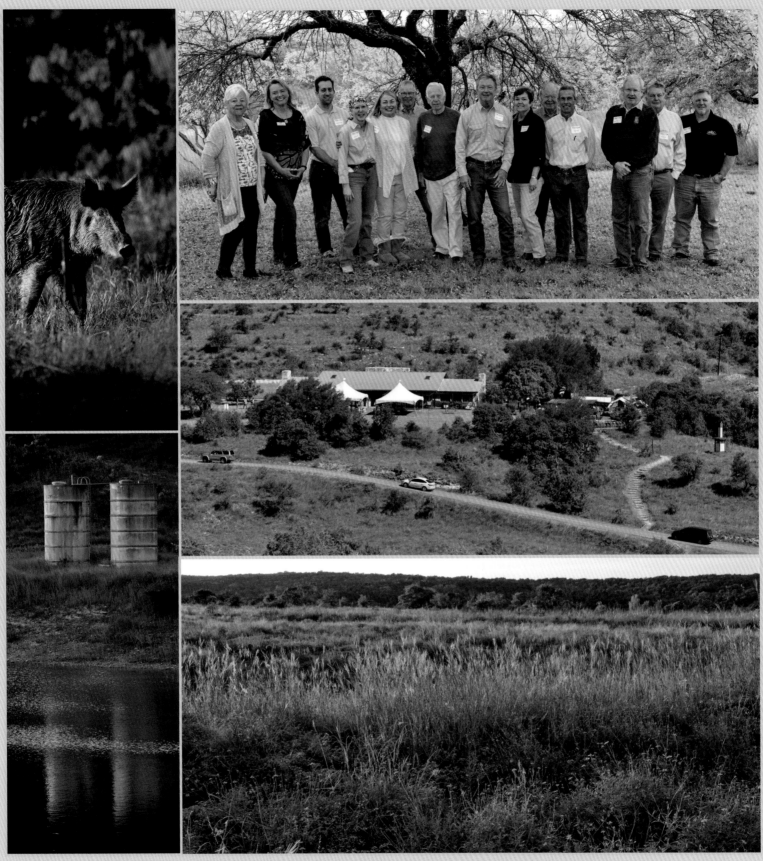

For almost five decades, Bamberger Ranch Preserve has been a model for ethical land stewardship and private landowner conservation. With all of the known and unforeseen challenges ahead, it is through the dedication and hard work of the board of directors, ranch advisors, staff, interns, and volunteers that will ensure the conservation legacy of the Bamberger Ranch Preserve and Margaret Bamberger Research and Education Center.

Index

Note: Page numbers in *italics* indicate images and associated captions.

Adams, Ansel, xv, xvi
Adtech Photo Imaging, xi
Aldo Leopold Trail, *41, 218*
American sycamore, *14*
Angelina Farms, xvi
aquifers, *9,* 21, *84,* 184–85
Arboretum Trail, *40, 114, 157, 161*
Army Corps of Engineers, 19
Ashe juniper (cedar)
 and Bamberger's legacy at Selah, ix, 129
 and character of Hill Country, 17–18
 and original state of Selah, *1*
 and Rachel Carson Trail, *225*
 sculpted, *96*
 water consumption of, 19, 20, 184
Austin American-Statesman, 129
Austin College, 183
Austin Nature and Science Center, 74
autumn season, 129–34, *160–65, 176–80, 192*
axis deer, 132

Bacall, Lauren, 19
Balcones Escarpment, 21
bald cypress
 on Arboretum Trail, *40*
 autumn colors, *162*
 at Catfish Pond, *228*
 cones, *93*
 at Jacob's Ladder Pool, 98
 at Madrone Lake, *34, 136–37, 206, 231*
 at Middle West Slope pond, *34–35*
 at Miller Creek, *115, 193*
Bamberger, Dax, 16

Bamberger, Hester (Hes), 18, 20
Bamberger, J. David, xi, xii, xv, *75, 76, 78*
 background, ix, 16–17, 18–19
 and bat habitat, *79*
 and Christmastime, 183
 and conservation awards, 187–88
 and conservation efforts, 16, 129–31, *130,*
 185–87
 and Hes' Country Store, *181*
 and hunting at Selah, 133
 and native grass restoration, *5, 6, 8*
 optimism of, 184
 and purchase of Selah, 13
 and sustainability issues, 186
 and Texas politics, 73
 and Texas snowbell plantings, *7*
 and visitor groups, *60*
 work and stewardship ethic, ix–x, 74, 129–32,
 185–87, *239*
Bamberger, Margaret, 15, 74–76, 183–84
Bamberger, Myrna, xii
Bamberger Ranch Preserve. *See* Selah, Bamberger
 Ranch Preserve
Bamberger's Folly, 79
Barbwire Pasture, *212*
Bass, Perry, 77
bass fishing, *105*
Bat Conservation International (BCI), 16, 77–78,
 129
bats and bat watching, 16, *71,* 78–79, *79, 106–7, 108*
beef, 18. *See also* cattle
bees, *71*
"before" images
 aerial view of, *8*
 cedar growth, *1*
 creek beds, *2*

Education Center construction, *8*
Madrone Lake construction, *4*
native grass restoration, *5, 6, 8*
road improvements, *3*
Texas snowbell plantings, *7*
Benini Foundation and Sculpture Garden, 183
Big Bend National Park, 73
bigtooth maples, *128, 153, 154–55, 157, 158, 192*
Bigtooth Maple Trail, *158*
Big Valley Pasture
 firewheels, *29*
 gayfeather blooms, *138*
 grasses, *85*
 hills above, *89*
 little bluestem at, *147*
 storms and rainbow, *100–101, 116–17*
 view from High Lonesome Pasture, *102*
 view to north, *48*
Big Valley Vista, *149*
biodiversity of Selah, 50, 71
birds
 and biodiversity at Selah, 71
 bird-watching at Selah, 73, *158*
 black-crested titmouse, *171*
 blue-winged teals, *143*
 Carolina chickadees, *159*
 Carolina wrens, *39*
 eastern screech owls, *167*
 hermit thrushes, *205*
 lesser goldfinches, *46, 156*
 Lincoln's sparrows, *227*
 northern cardinals, *234*
 painted buntings, *45*
 ring-necked ducks, *142*
 turkeys, *122, 175, 213*
 and winter foods, *226*
 wood ducks, *162*

bison, 18

blackbuck antelope, 132

black-crested titmouse, *171*

black-tailed jackrabbits, *119*

Blanco County, ix, 21

blue-winged teals, *143*

board of directors of Selah, Bamberger Ranch Pre-
 serve, 185, 186, 239

Bogart, Humphrey, 19

Bracken Cave, 16, 78, 129

Brazos River, 73

Bromfield, Louis, 18–19

Browning Ranch, 187

Brownsville Corner, Texas, *148*

brush management, *90–91*

burning, *214*

butterflies, *139*

buttonbush, *115*

California State Parks Foundation, 77

California State Park System, 77

camera equipment, xv, xvi

Campbell, Edward R., xi

Campbell, Linda, 133

Campbell, Margaret, 74–76

campers, *104*

Camp Selah, 75

canyons, *22–23*

Carolina chickadees, *159*

Carolina wrens, *39*

Catfish Pond, *108–9*, *228*

The Cathedral Within (Shore), 186

cattails, *210*

cattle, *17*, 18, *63*, *70*, *112–13*, 133, 186

cedar. *See* Ashe juniper (cedar)

cedar elms, *234*

cedar sage, *46*

Central Park Conservancy, 187

Central Texas Lignite Watch, 74

children and nature education, 74–75, 76

chiroptorium, ix, 79, *79*, *108*

Christiansen, Gayla, xi

Church, Bill, 16–17, 131

Church's Chicken, 16–17, 18, 77, 131

cisterns, *198*

Civil War, 18

Clabaugh, Patricia, xi

Comal County, 21

Comanches, 18

common buttonbush, *115*

conservation ethic

 and Bamberger's background, 18–20

 and conservation programs at Selah, 74

 ecological perspective on, *17*

 and Johnson, 21

 and the Leopold Conservation Award, 187–88

 Selah as model of, *239*

 volunteers at Selah, 20

 See also grasses and grasslands

cottonwoods, 20

Cox, Edwin J., Jr., 77

creeks, *2*, *50–51*, *86–87*

Crisp, Margie, 74

cultural preservation, 181. *See also* Hes' Country
 Store

cumulus clouds, *94–95*

cypress trees, 17. *See also* bald cypress

Davies, Shannon, xi

deciduous trees, *24*, *225*

deer, 132, *152*

dinosaur tracks, *127*

dotted gayfeather, *96*, *97*

eastern screech owls, *167*

Education Center, *8*, 76, *239*

education programs, *126–27*, 185

Edwards Plateau, 17, 129

Eisenstark, Stacy, xi

elms, 20

El Paso, 184

endangered species, 131–32

Endangered Species Act, 129, 131, 132

environmental movement, 74

erosion control, 19–20

escarpment black cherry, *176*, *176–77*

evergreens, *225*

Ewing Halsell Foundation, 78

exotic species, 132

Exotic Wildlife Association, 132

fall foliage, *160–65*, *176–80*, *192*

feral hogs, 132–33

finances and funding for Selah, 186

fireflies, *41*

fires, 18

firewheels, *29*

fish hatcheries, 77

fishing, *104*, *105*

flameleaf sumac, *152*

fog, *38*, *145*, *188–89*, *202–3*, *217*, *222–23*, *231*

Forbes, 21

founding of Selah Ranch, ix

free school movement, 74

freezes and frost, 182, *202*, *204*

Friends Groups, 77

frostweed, *140–41*, *202*

Fulton, Steven, xi, 133, 187

funding issues, 77

game, ix

Gardner, Colleen, xi, xv, 15, 75, 183, 185–87

Gardner, Scott, 183, 187

Garza, Ygnacio "Nacho," 77

gayfeather, *96*, *97*, *138*

Genesis Spring, *9*

Gillespie County, 21

Grantges, Don, 78

grasses and grasslands

 and Bamberger's legacy at Selah, ix

 of Big Valley Pasture, *85*

 and character of Hill Country, 17

 and fog, *222–23*

 of High Lonesome Pasture, *103*

 Indiangrass, *134–35*, *150–51*

 inland sea oats, *40*

Klein grass, 131
 at Madrone Lake dam, *207*
 native grass restoration, *5, 6, 8,* 19–20
 upland grasses, *90–91, 215, 224*
 and water retention, 20, *72, 84,* 184
 and winter prescribed burns, *214*
grazing lands, ix, *63*
Greenbriar Community School, 74
Greenbriar Free School, 74
Greene, Jeffrey, 185
Grossman, Kevin, xi
groundwater, 20, 184–85
habitat management, 186

Harvest Moon, *166–67*
hay fields, *121, 144, 145*
Hays County, 21
herd management, 133
hermit thrushes, *205*
herpetology, 75–76
Hershey, Terry, 21, 130
Hershey Ranch, 21
Hes' Country Store, *181*
 author's visits to, 76
 and Bamberger's conservation efforts, 188
 Miller Creek at, *193*
 slopes near, *146*
 and visitors to Selah, 133–34
 weddings at, 183
High Lonesome Pasture
 autumn colors, *180*
 from Big Valley Vista, *149*
 little bluestem, *168*
 moonrise over, *103*
 and perched aquifer, *72*
 plant diversity, *50*
 road through, *120*
 sculpted Ashe Juniper, *96*
 sunrise view, *62, 64–65, 80–81, 168, 235*
 sunset view, *216*
 view of Big Valley Pasture, *102*
hiking, *158. See also* trails

Hill Country
 and bat watching, 78
 and bigtooth maples, 129
 character of, 17–18
 and land stewardship groups, 130–32
 night sky, *124–25*
 and origins of Selah, 15
 and population growth, 21
 roads of, ix
 and suburbanization, 21
 and Texas snowbells, 132
Hillingdon Ranch, xvi
Hipp, Bob, xii
historical marker at Selah, 184, *221*
historic landscapes, 187
hollies, *226*
Holmes, Jared, xi, 75–76, 187
horses, *214*
Houston Ship Channel, 21
Hudson River school, xvi
Hunter's Moon, *136*
hunting, ix, 132, 133
hydrologic cycle, 20

India, 132
Indiangrass, *134–35, 150–51*
inland sea oats, *40*
introduced species, 132
invasive plants, 19. *See also* Ashe juniper (cedar)

Jack Hays High School, 74
jackrabbits, *119*
Jacob, Mary Ann, xi
Jacob's Ladder Pool, *32–33,* 98, *164–65, 229*
Jane Goodall Trail, 37, *50–51*
Jefferson, Thomas, 187
Johnson, Lyndon Baines, 17, 18, 21
Johnson City, 75, 187

Kansas, 18
Kastren, Debra, 73
Kendall County, 21

Kirby vacuum cleaners, 16
Klein grass, 131

lakes. *See* Madrone Lake; ponds and pools
land fragmentation, 131, 186
land management, 131–32
land restoration, 131. *See also* grasses and grasslands
land stewardship groups. *See* stewardship ethic
Langford, David K., x, xii, xv, xvi, 129
Last Child in the Woods (Louv), 74
"leaf peepers," 129, 133
LeBlanc, Pam, 129
Leopold, Aldo, ix, 187
Leopold Conservation Award, 187–88
lesser goldfinches, *46, 156*
Lincoln's sparrows, *227*
Lindheimer muhly, *172–73, 174,* 184
little bluestem, *147, 168, 169, 170*
Little Mexico Pasture
 grasses, *150–51*
 little bluestem, *170*
 pond, *110–11*
 and scimitar-horned oryx, *66–67*
 sunset view, *170*
 wildflowers, *26–27*
live oaks, *220, 221*
livestock photography, xv
Lone Star Land Steward Award, 187
Lost Maples State Natural Area, 129
Louis Bromfield Trail, 49, *54–55, 230*
Louisiana State University, 74
Louv, Richard, 74
Lower Colorado River Authority, 74
low water crossings, 98–99
Luminists, xvi

Madrone Lake
 author's early visits to, 16
 autumn colors, *162–63*
 bald cypress, *34, 136–37, 206, 211, 231*
 brush clearing at, 185
 cattails, *210*

construction of, *4*

dam, *36, 207*

fishing, *104, 105*

misty morning, *38*

overlook, *58–59*

panoramic of, *208–9*

and recovery of Selah's water system, 20

ring-necked ducks, *142*

summer storm at, *98–99*

Malabar Farm, 19

Malabar Pasture, *68–69*

Malabar Pond, *136*

Marbach, Elgin, 16

Marbach family, 16, 78

Margaret Bamberger Research and Education Center, *8*, 76, *239*

Mexican free-tailed bats, 16, 78–79, *108*

Middle West Slope Pasture, *194–95*

Middle West Slope pond, *34–35*

migratory species, *141*

Miller Creek

 autumn colors, *160–61*

 and bigtooth maples, 129

 cascades and pools, *52–53*

 at Hes' Country Store, *193*

 limestone bed, *54*

 at Louis Bromfield Trail, *49, 54–55*

 at main road, *87*

 verview of Selah, ix

 rock ledge on, *115*

 stones and sky reflections, *86–87*

 Texas toadflax, *37*

monarch butterflies, *141*

Mott, William Penn, 77

municipal water systems, 184

museum, *181. See also* Hes' Country Store

National Geographic, 73

National Park Service, 77

National Recreation and Park Association, 77

Native Americans, 18

native grasses. *See* grasses and grasslands

The Nature Conservancy, 15–16, 73, 74, 77, 78

"nature nerds," 76

nature tourism, 73

Navajo tea, *139*

Nepal, 132

Niger, 183

nongame species, 73

northern cardinals, *234*

oak trees, 20

Observatory, *42–43*

oil pipelines, 21

Optimist Club, 183

organic farming, 19

oryx, *44–45*

owls, *167*

painted buntings, *45*

Pakistan, 132

Peace Corps, 183

pecan trees, 20

"people ranching," 73–74

perched aquifers, 20, *72*

permanent endowment for Selah, 186

Permian Basin, 21

Perseid meteor shower, *124–25*

Petri, Leroy, 19, 78, 186

philanthropists, 77

pigs, 132–33

Pleasant Valley (Bromfield), 19

ponds and pools

 and bigtooth maples, *154–55*

 and bird life of Selah, *156*

 Catfish Pond, *228*

 Jacob's Ladder Pool, *32–33*, 98, *164–65, 229*

 at Little Mexico Pasture, *110–11*

 on Louis Bromfield Trail, *230*

 Middle West Slope pond, *34–35*

 at Miller Creek, *52–53*

 and recovery of Selah's water system, 20

 and wildlife diversity, *92*

 Wildlife Pasture Pond, *176*

population growth, 21

possumhaw, *226*

post oaks, *103, 215, 216*

prairie fires, 18

preservation efforts, 130, 181, 187. *See also* conservation ethic

private financial support, 77

Private Lands Advisory Board, 187

public outreach mission, 73–74

purple horsemint, *36*

Rachel Carson Trail, *153, 225*

rainbows, *100–101, 106–7, 108, 116–17*

rainfall, 18

rain machine, 75

Reagan, Ronald, 77

Recycled Cabin, *113*

Rees, Joanna, xi, 185

Reese, Pam, 129–30

Reese River Ranch, 130

refugium, ix

restoration practices, 19

Richards, Ann, 73, 77

Rindler, Eric, xii

ring-necked ducks, *142*

Rio Grande, 73

Rio Grande turkeys, *122, 213*

roads

 to Arboretum Trail, *114*

 to Barbwire Pasture, *212*

 and derelict cisterns, *199*

 at High Lonesome Pasture, *120*

 and live oaks, *220*

 sunrise view of, *219*

 sunset view of, *220*

 and wildflowers, *97*

Rogers, Elizabeth Barlow, 187

Round Mountain Pasture, *112–13*

Sahara Pasture, *121, 190–91, 202–3*

San Antonio, Texas, 16, 184–85

San Antonio Zoo, 131